JOHN ADKINS RICHARDSON

Professor of Art and Design Southern Illinois University at Edwardsville

the way it is

Prentice-Hall, Inc., Englewood Cliffs, N. J. Harry N. Abrams, Inc., New York I am grateful to the University of Illinois Press for permission to use brief passages from my book Modern Art and Scientific Thought.

DESIGNED BY BETTY BINNS

Library of Congress Cataloging in Publication Data Richardson, John Adkins. Art: the way it is. Bibliography: p. I. Art. I. Title. [N7425.R48 1973] 701'.I 73-14637 ISBN 0-13-049221-3

Library of Congress Catalogue Card Number: 73-14637 All rights reserved. No part of the contents of this book may be reproduced without the written permission of the publishers Harry N. Abrams, Incorporated, New York PRINTED AND BOUND IN JAPAN

Contents

	Preface and Acknowledgments 7	
I	Who's putting on whom?	13
	WHAT IS ART? 15 THE INCOMPETENT ARTIST THEORY OF STYLE IN ART 24	
2	Image creation and convention	32
	RELIGIOUS BELIEF AND ARTISTIC CONVENTION 40 ECONOMICS AND ARTISTIC CONVENTION 45 SOCIAL CONVENTION AND ARTISTIC CONVENTION 53	
3	Line and form	56
U	THE SHAPES OF VENUS 68	0
	LINE, FORM, AND FEELING 77	
4	Light and shade	80
	CHIAROSCURO AND MODELING 84	
	THE MEANING OF LIGHT AND DARK 99	
5	Color	110
	HUE III	
	VALUE II4	
	INTENSITY II5	
	FUGITIVE SENSATIONS 117	
	PIGMENTS 120	
	HISTORIC COMBINATIONS AND CONSEQUENCES 122	
	EMOTIONAL EFFECTS OF COLOR 131	

6	Space GEOMETRIC PROJECTIONS 143 SCIENTIFIC PERSPECTIVE 144 ATMOSPHERIC PERSPECTIVE 156 SPACE IN FRENCH IMPRESSIONISM 160 CÉZANNE'S PERSPECTIVE OF COLOR 162 THE UNCANNY SPACE OF CUBISM 164	134
7	Formal composition content 169 the interdependence of form and content 171 formal "rightness" and families of forms and colors 175 some comparisons and contrasts 189	167
8	Styles of vision	202
	WÖLFFLIN'S THEORY OF STYLE AND "INSTANT" CONNOISSEURSHIP 205 INDIVIDUAL STYLES WITHIN A STYLE OF VISION 217 THE DILEMMA OF MODERN STYLES 221	
9	Modern art, its variety and unities	223
	NEOCLASSICISM 224 ROMANTICISM 227 REALISM AND IMPRESSIONISM 229 THE RATIONALIST-FORMALIST CURRENT 234 THE SUBJECTIVE-EXPRESSIONIST CURRENT 239 SOME SYNTHETIC STYLES 253	
10	Media and methods	256
	SOME MEDIA IN TWO DIMENSIONS 256 Painting media 257 Printmaking 268 Photomechanical reproduction 285 SOME MEDIA IN THREE DIMENSIONS 286 Sculpture 286 Architecture 294	
	NOTES TO THE TEXT 315	
	GLOSSARY 320	
	GUIDE TO THE PRONUNCIATION OF ARTISTS' NAMES 331 BIBLIOGRAPHY 334	

INDEX 340

PHOTO CREDITS

Preface and acknowledgements

This is a different kind of book. On leafing through it, you will find not only the customary masterpieces and diagrams but also cartoons, comic strips, popular illustrations, and other things rarely encountered in an art appreciation book. Normally, only masterworks appear. And usually the writer spends his time demonstrating why serious painting is more complex and genuine, more sincere and more profound, than the kinds of pictures most people like when they're not pretending to be "cultured."

But it does not necessarily follow that one should always prefer what is more complex, genuine, sincere, and profound. Those of us who spend our lives concerned with the arts usually do not like what is commonplace or simple, and that is natural. The true sports fan is bored by routine performance; he is fascinated by the exceptional. The professional mathematician would go mad had he nothing to do but routine applications of the calculus. The more we know of a thing the less concerned we are with its ordinary manifestations.

Similarly, when one knows very little

about a subject one is apt to like what is most familiar and to be impressed with what seems difficult. As it happens, what is most familiar is quite often mediocre, and what a layman considers remarkable a professional would look upon as routine. College and high school art teachers wage eternal war against the hackneyed nature of most cartooning and illustration and dutifully oppose the shallowness of "dime-store" reproductions.

This book, however, accepts common taste as valid. But it is motivated by a genuinely serious concern for civilized values. The professional art historian or critic who reads it will realize that it takes its lead from the work of men like E. H. Gombrich, who recognize that a good deal of what appeals to people in popular art is not what is simpleminded so much as what is fundamental, and that what appears in Michelangelo in elevated form may be present in another fashion in the work of the cartoonist. And, since people unfamiliar with art are more likely, as a rule, to grasp the significance of "Tarzan" than they are to appreciate the subtleties of either Rembrandt or Picasso, it seems a good idea to begin with Tarzan rather than Rembrandt. This is not to argue that a Tarzan cartoon is equal to a Rembrandt painting; I contend only that one can learn a great deal about the latter by way of the former. In other words, this volume is based on the assumptions that it is possible to talk sensibly about art without demeaning it, to convey its values without preaching, and to do this in a book of rather modest cost.

We should not presume that one art book can do *everything*. Lectures, discussions, supplementary reading, and exposure to actual works in museums, galleries, and studios are also necessary. Yet, learning is not dependent on any of that. To help in moving beyond this volume, a bibliography and a glossary are provided. The index contains the names of all the artists mentioned. And, because many of the names are foreign, a pronunciation guide has been supplied.

Several of the reproductions are repeated over and over again. The purpose of doing this is threefold: (1) It enables the reader to grow familiar with a number of great works and to appreciate the fullness and richness of some exemplary ones; (2) it assists the reader's understanding by limiting the sheer mass of factual material to be digested; and (3) it makes it easy to refer to a picture without turning back fifty pages to where it first appeared.

Surely this book has faults. But it has some virtues too, and I cannot take credit for all that may be good within these pages. Much of that should go to others. Among these are the following: Dr. Harry Hilberry, who suggested by example the application to art appreciation of Heinrich Wölfflin's theory of style. Velta Inglis, who did yeo-person work in tracing down obscure photographic sources and securing addresses. Walter Welch of Prentice-Hall and his assistant, Marilyn Brauer, who have given more advice, support, and time than any author has a right to expect. And Paul Anbinder and Patricia Gilchrest of Harry N. Abrams, Inc., must be credited for editorial suggestions and, still more, for the exercise of superhuman restraint. My gratitude also goes to Barbara Lyons at Abrams for help in obtaining photographs. Of course, without the assistance of artists, museums, galleries, publishers, and photographic services, a book of this kind could never be produced. Although they are recognized elsewhere in the captions and the photographic credits, I offer them here my special thanks.

My colleagues at Southern Illinois University in Edwardsville have helped me by giving me altogether undeserved ego-reinforcement and have actively hindered me by election to the most time-consuming offices and committees. Perhaps in part because of

the latter, the administration has been graciously tolerant of my essays into the fields of cartooning and commercial illustration. The students at SIUE have proved invaluable as resources, critics, and good friends. But more than to anyone else this book owes its

existence to my wife, Dr. Betty Richardson, without whose friendship it would not have been begun and without whose sense of humor it could never have been finished.

JOHN ADKINS RICHARDSON

Art:

the way it is

l Who's putting on whom?

You and I, reader, might as well level with each other straight off. For it is important that we understand each other's position.

What you have in your hands is a book on what is commonly called art appreciation, that is, on the understanding and enjoyment of pictures, statues, and the like. To many it seems odd that anyone wishes to be instructed in such activity. An acquaintance with art has no direct bearing on earning a livelihood. Nor is it necessary to a happy and fruitful life; one can get along quite nicely without knowing a Picasso from a put-on.

Still, there is a peculiar universality about books on art appreciation; they are to be encountered everywhere. And such prevalence suggests a need.

Frequently, the need is connected with one's social life. Some readers may hope to gain a bit of confidence regarding home decor. Single men must realize that it's hard to "make out" if their principal topics of conversation are downdraft carbs, the World Series, and how many times they were intoxicated over the weekend. Today one can't move even among the dropouts of the world without knowing something of those arts that are called underground. Art is a puzzle to many people, even when they know what they like, and you may be hoping to find its key within these pages.

Such self-interested views are not altogether foreign to the writer who wishes to overcome what I call "creeping meatballism," that is, the increasing number of people whose idea of aesthetic progress is the paving over of all that is natural or happens to be old. What most laymen are apt to want is just a bit of polish. And that is the most an author dares hope to achieve. True, the attempt to apply a bit of polish often leads to something that is not so superficial. But I cannot promise to do more than gloss surfaces, for there are fundamental difficulties in dealing with a thing so all-encompassing as art.

A famous art historian, Erwin Panofsky, once raised against the idea of art appreciation the objection that it is doomed to mislead the very people it is supposed to serve. He wrote that "He who teaches innocent people to understand art without bothering about classical languages, boresome historical methods and dusty old documents, deprives naiveté of its charm without correcting its errors."¹ There is much to be said for this way of looking at the matter, but it fails to recognize that many other forces operate to deprive naiveté of any charm whatever. At least this is true in contemporary industrial society. It may not be true in other societies. A peasant rustic's enthusiasm for the folk crafts of his people is charming, and frequently the objects themselves are very appealing. But what passes for good taste in suburbia, the garish distractions that surround the urban dweller and the billboards afflicting the rural landscape, are all invitations to depravity. Perhaps art appreciation books can do little against these influences, but they can scarcely do more harm. The visual clutter that assails us all is, if you wish, a form of pollution as damaging to the sensibilities of the unwary as fertilizers are to a stream. As a matter of fact, the situation is quite similar. For, just as excessive nitrogen fed into a pond produces overgrowth that chokes out animal life, so the plethora of images in our culture tends to stifle the quality of perception.

But there is also something to be said on behalf of our excess. The dullest living layman is much better educated about pictures than were any of the generations that preceded him. He is exposed to more imagery by far than were his counterparts during the Italian Renaissance or the Golden Age of Greece. In Leonardo da Vinci's day his Mona Lisa was seen by but a few hundred of the elite. Today color reproductions reveal her smile to everyone. René Huyghe has said that all modern men are "importuned, and obsessed, by the visual."2 When one considers the degree to which our lives are dominated by motion pictures and television, by diagrams and news photos, by maps, advertising illustrations, and comic strips, one sees how aptly the description visual fits our everyday existence. Throughout most of history a picture of any but the rudest kind has been a thing of magic and delight, but today everyone takes "living color" pretty much for granted.

We are, all of us, experts at looking. What few of us can do is *see*. If all of us knew how to see, then all of us could draw. I know that sounds outrageous, absurd on the face of it, but I assure you it is true.

Figure 1 is a drawing of a man's head that I have done with a felt pen held in my teeth. Figure 2 is a similarly shaky rendering of my right hand done by my left, the one that rarely holds a pen. No claim of quality is made for either case. I do insist, however, that neither rendering looks amateurish. Manual dexterity has very little to do with art, even in drawing; what drawing has to

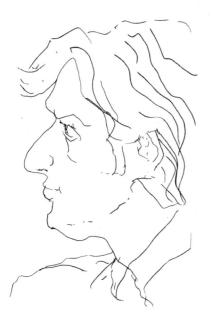

Drawing made with a pen held in the teeth

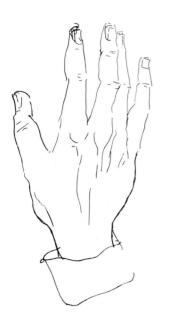

Left-handed drawing of the author's right hand

do with is understanding the visual. I am not particularly dextrous, but I have learned to see in terms of two-dimensional representation. Knowing how to draw is, for the most part, a question of knowing what to look for. Some will say that it is, in any case, a matter of something called "talent." Well, of course, some people have greater talent for grasping the visual facts than do others—just as some have a superior ability in mathematical reasoning, and others a gift for sleight of hand.³ But art appreciation requires no special aptitude. On the contrary, it is my conviction that the inadvertent education all of us received from magazines and comic strips can be the basis of real insight.

The premise of this book is that what is appealing in the popular arts is not what is naive so much as what is basic. From this it follows that the best way to understand art for those with no special interest in it is by way of its baser side.

What is art?

It is customary in art appreciation books to define the term art early on. In doing so authors hope to distinguish between what is worthy of attention and what is not. Curiously, it almost invariably occurs that-regardless of the definition-what is really art comprises a group of works such as those in figure 3 and excludes from consideration the kinds of things we find in figure 4. The reaction of the reader to this description is all too frequently "I guess I just don't like art," in which case he remains a sullen slob, or "I had better pretend to like only what Professor Smudgebottom, B.A., M.F.A., Ph.D., likes or I will seem a fool," in which case he becomes a phony, pure and very simple. I hope to avoid these consequences by a special strategem. But before I reveal my ploy I wish to turn some of yours aside.

It may be helpful to look at what many

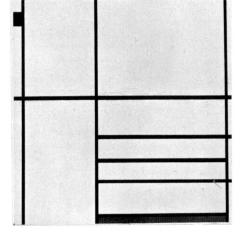

3 Types of images that are unquestionably "art" in the opinion of most authorities

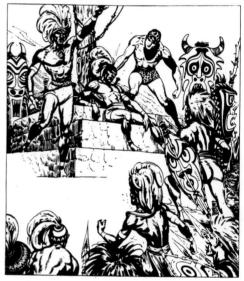

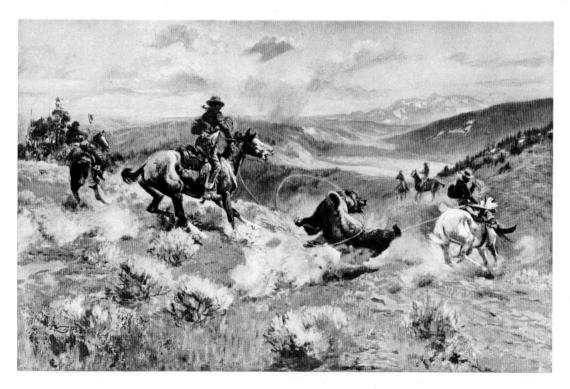

5

WILLIAM HARNETT. After the Hunt. 1885. Oil on canvas, $71 \times 48''$. California Palace of the Legion of Honor, San Francisco. Gift of H.K.S. Williams to the Mildred Anna Williams Collection

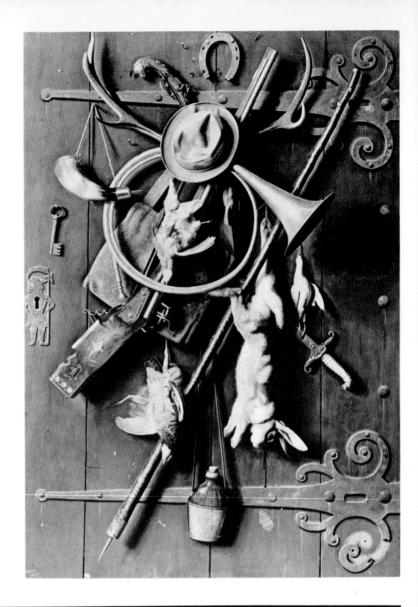

6

EDWARD KIENHOLZ. Back Seat, Dodge—38. 1964. Mixed media, height 66". Collection Lyn Kienholz, Los Angeles

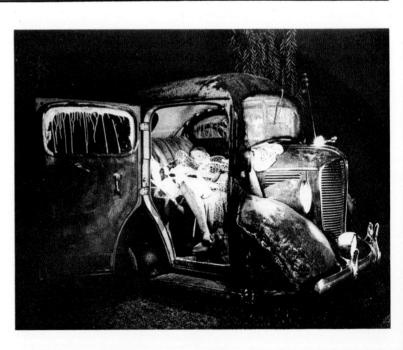

readers consider art. One of the most common presumptions is that art is an imitation of reality. And few of us would dispute that the amazing still lifes (fig. 5) of William Harnett (1814–1892) are art. After the Hunt seems so like the things it mimics that one might believe the rabbit could be taken up and cooked. Only an uncommon fool would deny that such illusion has artistic merit merely because the thrill it produces appeals to common tastes. But consider figure 6, a photograph of a tableau by Edward Kienholz (born 1927) entitled Back Seat, Dodge-38. The Kienholz is as realistic as you can get; it is real. This actually is a 1938 Dodge sedan, although it is so truncated that the rear seat is up against the fire wall. Probably most people would respond that it isn't realistic, it's just real; it's junk, trash.4

Very well, the obvious response to Kienholz is, "I don't mean a duplication of reality when I say 'imitation of reality'; I mean something that involves more apparent skill, more artifice . . . like the Harnett." Fine. Is figure 7 a work of art? It is exact and to scale, a perfect physical model of an old airplane. I built it and I don't consider it art. It's a trivial exercise in painstaking small-scale construction. It's worthwhile, you understand. And I got a kick out of doing it. But the fact is that I created it only to use as a model for part of a painting that I do consider art.

And how about this painting (fig. 8)? Roy Lichtenstein (born 1923) gives one the impression of imitating a comic-strip panel right down to the Benday dots that printers use to give color to the pictures (see page 285). I imagine that most readers would concede the possibility that the cartoonist on whose work this is based is some sort of artist but would think less of the man who copied the original.

Of course, you might respond to all these examples by using another presumption, say-

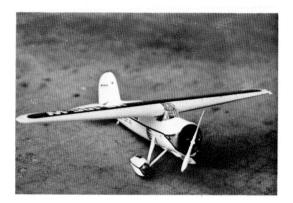

Model airplane

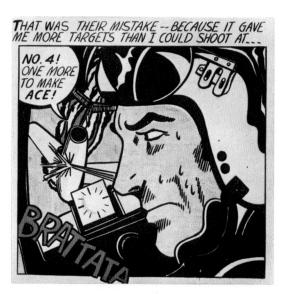

8 ROY LICHTENSTEIN. Brattata. 1962. Oil on canvas, 42×42". Collection Gail and Milton Fischmann, St. Louis

ing that art has to be beautiful and that this stuff "isn't even pretty." Possibly it is true that art has to be beautiful in some fashion or other. A good deal of it is, clearly. For example, *Le Moulin de la Galette* (fig. 9) by Auguste Renoir (1841–1919) is actually pretty. There is no better way of describing it. But, then, pinup girls, apple pies, mint juleps, and gardenias are also pretty. Usually we don't consider those things artistic in and of themselves. And a lot of what might be called art by many is not attractive in any sense normally connoted by the term.

If beauty is the measure of artistry, what

is one to make of such a work as the *Crucifixion* from the famous *Isenheim Altarpiece* (fig. 10) by Matthias Grünewald (active c. 1503– 1528)? It is an image of absolute ghastliness. This Christ does not suffer a purely spiritual pain; he suffers for all mankind in a horrible, perfectly physical way. The crown of thorns bites into his forehead and draws blood; his flesh, of a greenish pallor, is marked by the putrescent sores and scars of brutal treatment. His lips are blue, spotted by the foamflecked vomit of approaching death. The picture inspires disgust, even revulsion. And yet it is a powerfully moving image of sacri-

9

PIERRE AUGUSTE RENOIR. Le Moulin de la Galette. 1876. Oil on canvas, $51\frac{1}{2} \times 69''$. The Louvre, Paris

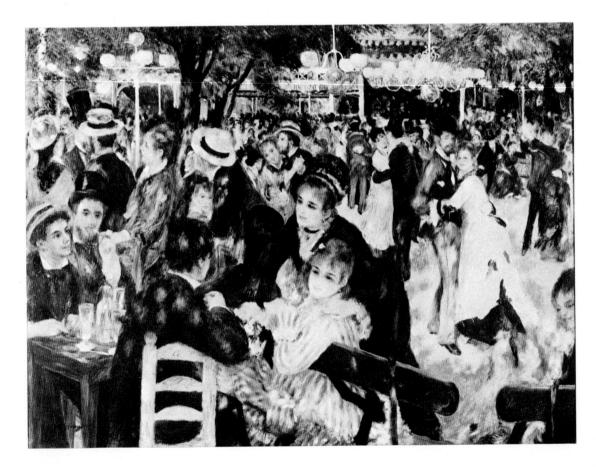

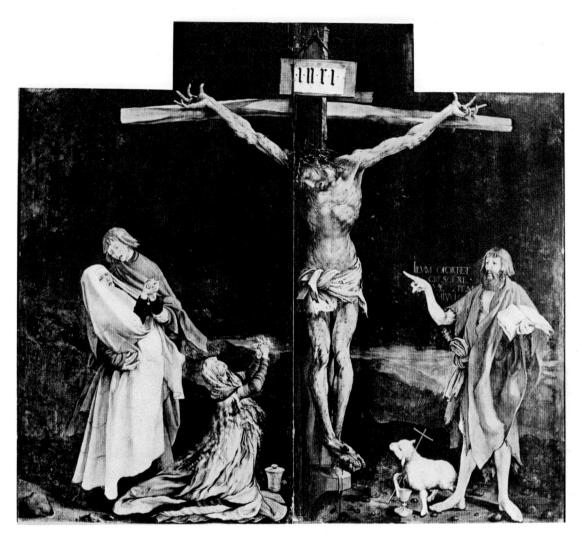

10

MATTHIAS GRÜNEWALD. Crucifixion, center panel of Isenheim Altarpiece (closed). c. 1510–15. Oil on panel, 8'10"×10'1". Unterlinden Museum, Colmar, France

fice, a conception that brings home the meaning of Christ's passion through an extremely naturalistic treatment. It is perhaps the outstanding example of ugliness put in service of devotion. Is it not art?

I could continue in this fashion, challenging commonplace conceptions of art with obvious exceptions, but I think the point is clear. No simple definition is sufficient to describe everything that comes under the heading of art. For that matter, I do not believe that any definition, whether commonplace or esoteric, could be true and also useful. My belief may be debatable. But that doesn't really matter. Fortunately, we don't need to define art in order to talk about it.

It may seem preposterous to assert that we can discuss a thing without knowing precisely what we are talking about, but we all do it constantly without troubling ourselves at all. The everyday speech of the most fastidious and lucid speakers is filled with inexactitude. A very important thinker, philosopher Ludwig Wittgenstein, once used the example of the term game to make this clear. He says that we can look at all sorts of games-board games, card games, ball games, Olympic games, and so on. We call each a "game," and yet they have very little in common. For example, compare a board game such as chess with contract bridge. There are many correspondences, but the element of chance is completely absent in chess. In most respects of actual play, the game of baseball is quite unlike either the board or card games. Moreover, some card games-solitaire for instance-are not competitive in the normal sense. Similarly, crapshooters are really playing against the odds, not against the other shooters. Likewise, a child playing a game of ball by himself, throwing the ball against a wall and catching it, is competing only with himself and gravity. Finally, think of ringaround-a-rosie, where almost all the features we associate with a game have disappeared; only the constant of amusement remains. Still, not everything amusing is called a game.

As Wittgenstein points out, what we see summed up by the word game is a series of family resemblances, like those of a real family. One can say that games form a family of activities. We are not stopped from using the word game because the network of similarities is so complicated.

When one deals with things in this way, he is using what logicians call an *ostensive definition*. That is, the term is defined by citing a number of examples. This is precisely the way one might distinguish between a "board" and a "stick" for a child. There are arenas in which we may not, amongst ourselves, agree. Thus, I may call boxing a game and you may not. Or your notion of "stick" might

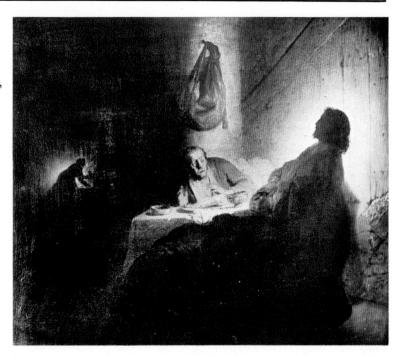

II

REMBRANDT VAN RIJN. Christ at Emmaus. 1628–30. Oil on paper, mounted on panel, $15\frac{3}{8} \times 16\frac{1}{2}$ ". Museé Jacquemart-André, Paris include mine of "log." But for the most part we will concur. In the same way we can deal with art while not defining it precisely.

I look upon art as another family of relationships. Some members are black sheep, some are elite. A Rembrandt such as *Christ at Emmaus* (fig. 11) is surely art, and bellybutton lint or metronomes are not. Of course, given so broad a description, it will be necessary for me to assume that art can be bad or indifferent in quality as well as fine. (This view is anathema to many art critics, but that is not my fault.)

Even my liberality does not allow me to evade every problem. Thus, figure 12 shows us a purported work of art, *Indestructible Object* by Man Ray (born 1890). It is nothing but a metronome with a photograph of an eye paper-clipped to the arm. Has the metronome become an art object because of its new acquisition? I should say yes, it is an art object of a very minor sort, although, as it happens, this object is of historical moment —largely because it represents an art movement which poked fun at the silliness of men concerning themselves with just such troublesome but inconsequential questions as "What is art?"

Artists themselves rarely worry about the matter; for them, art is simply what they do. If pressed, they may come up with elaborate verbal statements to justify their works. But if it could be shown that their art was inconsistent with their creeds, they'd revise the statements rather than the work. The art generates rules and definitions; the rules don't create art.

All this may seem to leave us quite at sea. Many people feel very unconfident and frustrated without some sort of guideline whereby they can evaluate specific works of art. Even very sophisticated men and women are apt to respond to my attitudes with this old bugaboo: "If there are no absolute standards—if we can't even be sure whether a thing *is* art or not—how do you know

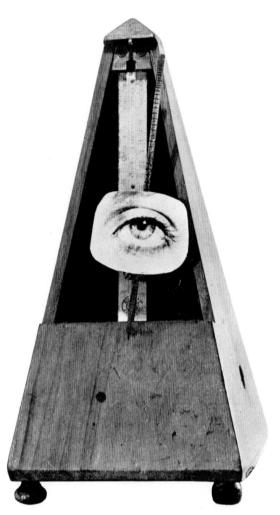

12

MAN RAY. Indestructible Object (Object to be destroyed) (1923 replica of destroyed original). Metronome with cutout photograph of eye on pendulum, $8\frac{3}{8} \times 4\frac{3}{8} \times 4\frac{5}{8}''$. The Museum of Modern Art, New York. James Thrall Soby Fund 13 PABLO PICASSO. Ma Jolie. 1911–12. Oil on canvas, $39\frac{3}{8} \times 25\frac{3}{4}^{"}$. The Museum of Modern Art, New York. Lillie P. Bliss Bequest

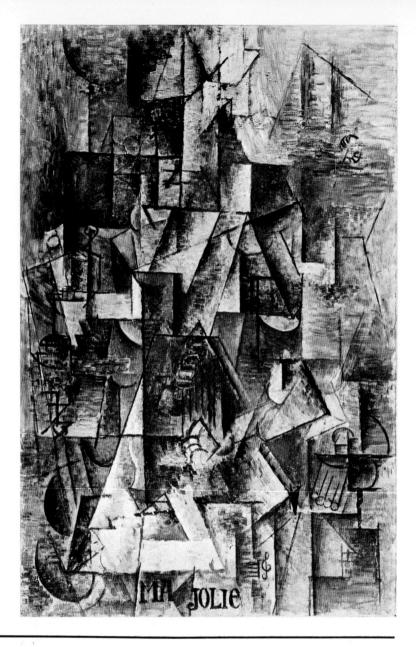

whether a painting or sculpture is good or bad?"

Granted, we do make judgments about individual works of art. Obviously, I have some kind of measure when I review art exhibits, teach painting and art history, or write art criticism. But it's rather loose and flexible. Like other standards in life. Do you know what a well-cooked steak is? Of course. Probably, you'll think I don't—I like mine cremated. No accounting for tastes, right? Right, it is just a matter of personal preference. But in gaining knowledge of a subject, people also acquire judgment.

The incompetent artist theory of style in art

You are not, most of you, professional musicians. This does not prevent you from making decisions of a very definite kind about popu-

lar music. By what rules do you operate when you decide that one rock or folk group is better than another? You make such evaluations as "This is good," "This is odd," "This is a fraud." But you don't demand rules. Again, this doesn't mean that you have no standards at all or no insight into popular music. Indeed, in this regard you have the advantage of me. And if you were going to explain popular music to me, you wouldn't begin by laying down a lot of rules and definitions for understanding it, would you? No, you would merely expose me to a lot of it, to try to show me what the performers are trying to convey—what the performers are try-ing to convey—what they do convey to you. And, if you were clever, you'd begin by using something I already appreciate—like Bessie Smith's blues or Cole Porter and Duke Ellington. Well, this is almost precisely what I propose to do with you in the general field of art.

There are other parallels between rejection of popular music and misunderstanding art. Among the things that older people say about the music young people like is that it's "just a beat" or that it's "just noise" or that the performers and their audiences are wrecked on some drug that makes rotten music sound good to them. The tacit assumption is that the performers play and sing as they do because they cannot do otherwise-that, in other words, they have devised a style which passes off incompetence as expression. In much the same way the layman is apt to think that Pablo Picasso (1881-1973), for example, began painting things like *Ma Jolie* (fig. 13) because he could not draw. And when an art professor like myself says that such work is very profound, really, the skeptic is ready to assume that the professor's defense is also a revelation of incompetence, that the professor is in the position of the pretentious fools in Hans Christian Andersen's famous story "The Emperor's New Clothes."5 Fortunately, it is easy to prove

that Picasso was not just a fraud and that I am not gullible.

First, my own work tends to be rather conservative. Figure 14 gives you a random sampling. I do not believe that these pieces are outstanding works of art; they are not. But they are at least routinely competent. And I do know how to draw. So did Picasso.

Pablo Picasso, even as a child, drew with "incredible facility. At the age of twelve he was already expert in drawing from Classical statuary (fig. 15). And his so-called Blue Period pictures, done between the ages of twenty and twenty-three, are very popular evocations of wistfulness and poverty (fig. 16). Most of the really important modern masters were gifted representationalists. The work of Wassily Kandinsky (1866–1944) may look sloppy and chaotic to the average lay-man (see fig. 17). It is easy to assume that he's just smearing paint on canvas. "My three-year-old can paint better than that!" is a common reaction, the imputation being that the artist cannot draw. But look at another picture by Kandinsky (fig. 18). From a conventional point of view it is really quite impressive. It is representational, charming, and very intricate. Well, then, is it the case that he finally learned how to paint after doing Improvisation Number 30? No, the picture of Russia was done in 1904 and Improvisation Number 30 in 1913. Ah! Did he, then, degenerate? Not at all. It's just that he was trying to do something different in the later work, something that does not have to do with representations of objects. Just what he was getting at we'll leave until later. My only point is that it is misleading to assume that people become abstractionists because of incompetence.

The Incompetent Artist Theory of Style has another, slightly more sophisticated version. This one frequently crops up among physicians who have some interest in art but no very firm grasp of what painting is all

14 Works by the author

15

PABLO PICASSO. Drawing from a cast. 1893–94. Conté crayon, $r8\frac{1}{4} \times 25\frac{1}{4}''$. Whereabouts unknown. Reproduced from *Cahiers d'Art*,

courtesy of the publishers

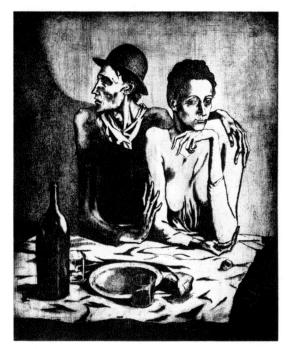

17

WASSILY KANDINSKY. Improvisation Number 30. 1913. Oil on canvas, $43\frac{1}{4} \times 43\frac{3}{4}''$. The Art Institute of Chicago. Arthur Jerome Eddy Memorial Collection 16 PABLO PICASSO. The Frugal Repast. 1904. Etching, 18¼×14¼". The Museum of Modern Art, New York. Gift of Abby Aldrich Rockefeller

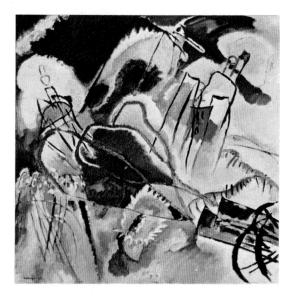

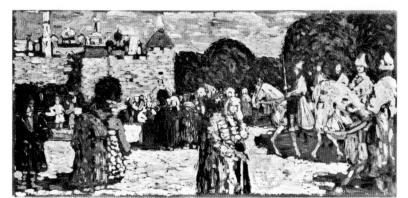

18 WASSILY KANDINSKY. Sunday (Old Russia). 1904. Oil on canvas, $17\frac{3}{4} \times 37\frac{8''}{8}$. Museum Boymans Van Beuningen, Rotterdam

19 EL GRECO. Resurrection. C. 1597–1604. Oil on canvas, $9'\frac{1}{4}'' \times 4'2''$. The Prado, Madrid

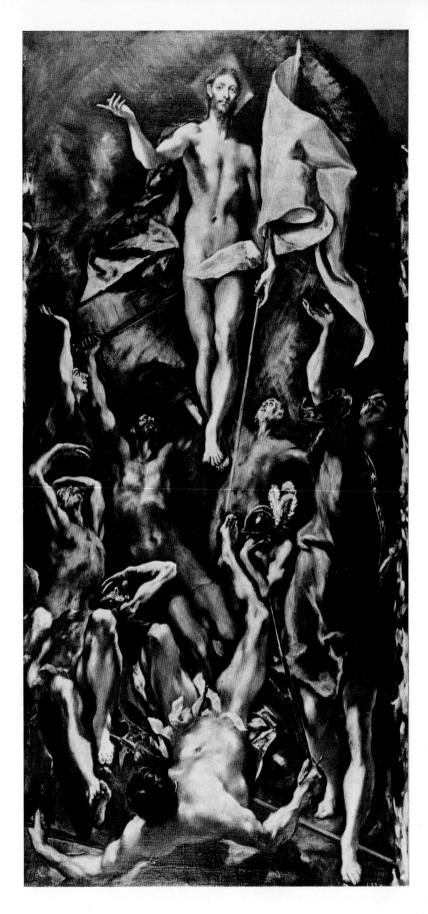

20 Astigmatic image

Normal image of the same subject

about. In this version it is assumed that radical distortions in pictures can be traced to some defect of vision in the artist. For instance, it is sometimes argued that the Spanish artist El Greco (1541-1614) drew men and women as he did (fig. 19) because he was afflicted with astigmatism. Astigmatism arises from an irregularity of the cornea in which light rays from a single point of an object fail to meet in a single focal point (as they do in normal vision), thus causing the image of a point to be drawn out into a line. Astigmatic lenses produce images such as the one in figure 20. When contrasted with the normal image (fig. 21), it is easy to see that El Greco's elongated figures are somewhat similar to the astigmatic distortion. It might follow then that the artist's style was the result of astigmatism. At least it sounds plausible. But a little thought will reveal just how muddle-headed the notion really is.

The cartoon (fig. 22) shows us what is supposed to happen. El Greco's models are fat, but because of his astigmatism he sees them as thin. Rendering them passively, just as he sees them, the plump Spanish girls appear wraithlike on his canvas. But this view of El Greco does not take into account the full experience of the astigmatic. For to an astigmatic eye the canvas, too, would appear elongated, and the image on it would look elongated. Besides, the astigmatic distortion is of such a nature that the reclining girl would not appear lean but would appear even fatter, as in figure 23. El Greco may or may not have had astigmatism, but his style does not depend upon it.

Explaining El Greco's work by referring to imperfectly formed eyes, scorning unrealisticlooking art as fraudulent, and putting down popular musicians as tone-deaf drug freaks are all alike. They are examples of prejudice. Usually prejudices are based on *some* sort of common-sense experience. After all, no one likes to think of himself as a pig-headed bigot.

22 Cartoon of El Greco in his studio with models

23 Cartoon of El Greco revealing his work

Yet prejudice can lead one far astray, even in things where the emotions do not play a role. Study the following columns of figures:

A	B	C	D
0	0	5	8
1	2	5	5
2	4	7	4
3	6	3	9
4	8	6	1
5	1	4	7
6	3	9	6
7	5	1	3
8	7	0	2
9	9	10	0

Column A is obvious in its order; the numerals are arranged in their conventional sequence. How about B? Yes, they are divided among even and odd. And C? A few moments of reflection should suggest the answer; they are so arranged that each successive pair of numbers add up to ten. What about D? Can you divine the order of that arrangement? It is no more complicated than any of the other patterns. No unusual mathematical ability is required to solve it. But if you can solve the puzzle of its order, you are in a real minority. Work on it a few minutes. If you get it, you'll understand the point I'm making. If you do not, you can find the solution on page 316.6

Our experience with numbers leads us to suppose, quite reasonably, that the order of column D will be arithmetical. And I reinforced this bias by giving three instances in which the prejudgment was borne out. The fourth instance did not play to your prejudice —that is, your prejudgment—and so you failed to solve the puzzle. (Yes, I know. Most of you didn't even try to figure it out. But if you had, you'd have blown it anyhow. Right? Right.) Your expectations played you false. And column D doesn't make any sense arithmetically. But if we wanted to index these numbers in an arithmetic book, it would make perfect sense to employ the arrangement that occurs in D.

The history of art since the end of the Middle Ages and the emergence of photog-raphy has led most of us to expect pictures to be more or less realistic. And Kandinsky's Improvisation Number 30 just doesn't make sense in those terms. The best you could say for it is that it's an incredibly clumsy portrayal of cannon firing at a city. But that is not what the artist was after. He once said: "The observer must learn to look at the picture as a graphic representation of a mood and not as a representation of objects." What Kandinsky was trying to do was make of painting an art like that of music, in which feelings are evoked by the art itself. That is, you do not expect music to sound like something else-birdsong, babbling brooks, or wind through trees-you respond to it in terms of melody, rhythm, harmony and so on. We all know, however, that music, although not at all representational, can convey moods. Kandinsky, who had studied music as seriously as he had art, envied the composer. He wrote:

A painter who finds no satisfaction in mere representation, however artistic, in his longing to express his internal life, cannot but envy the ease with which music, the least material of the arts today, achieves this end. He naturally seeks to apply the means of music to his own art. And from this results that modern desire for rhythm in painting, for mathematical, abstract construction, for repeated notes of color, for setting color in motion, and so on.⁷

Whether Kandinsky accomplished his objectives is, of course, another matter. That is a problem we shall take up elsewhere in this book. I'm not sure he did achieve his goals. I do think that he painted a very good picture. You may not agree. That's all right. But at least we'll be arguing about something that is relevant to the artist's interests and not attacking him for something he never intended to do.

2 Image creation and convention

When someone says that he likes only pictures or statues that look "real," we know pretty much what he means. At any rate, it is not hard to predict what he probably won't like. But the term reality is one that has worried philosophers since very ancient times. It may mean very different things to different people, and may even mean many different things to a given individual. For instance, which of my drawings of President Abraham Lincoln is the most realistic? Is it the precise outline (fig. 24), the one reducing all light and shade to either black or white (fig. 25), or the one made up of little dots of ink (fig. 26)? Obviously, none of these pictures shows the way Lincoln actually looked to someone encountering him in the flesh. Consider figure 27. It resembles nonrepresentational art until it is held up about fifteen feet away from you; then the units resolve themselves into another image of Lincoln. The image was "drawn" by a computer as part of a Bell Laboratories experiment to determine how little of an image had to be retained to preserve its identity.

What all this shows is that the creation of images does not have as much to do with the

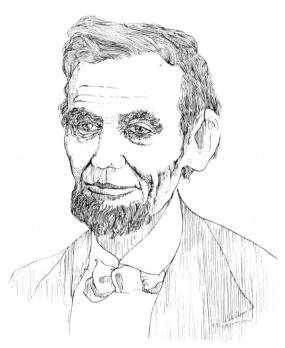

24 Outline drawing

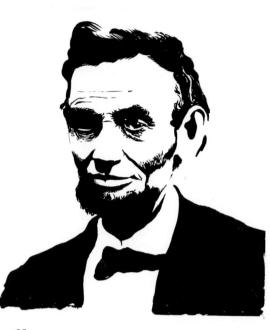

25 High contrast drawing

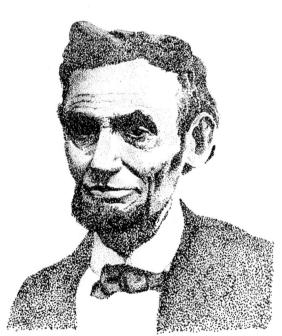

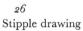

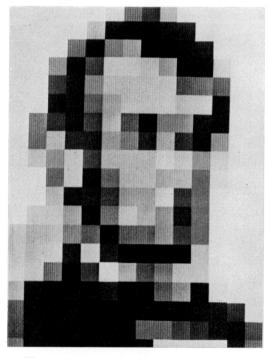

27 Computer drawing, an experiment by Leon D. Harmon. Courtesy Bell Laboratories, Holmdel, New Jersey

28 BILL BRANDT. Nude. 1953. Photograph

direct copying of details of reality as one might think. It has to do with highly selective choices about what to include and what to leave out. Moreover, this is two-way communication; the viewer is as much involved in creating the image as the artist is. The artist knows what marks to put into the picture and where to put them; the onlooker must understand what those marks mean. To people brought up surrounded by photographs this may seem to be a relatively simple matter. It is not.

Even the most familiar and convincing of all realistic images, the reflection in the mirror, is not quite what it seems. You are almost surely mistaken about how you appear in your looking glass. I am not talking about the fact that the image is reversed or that most of us see ourselves as being far more attractive than we appear to other people. In the mirror, your face isn't even the same size you think it is. Try this: take a piece of soap and trace the silhouette of your head as it is reflected in your bathroom mirror. You will be astonished by the small size of the traced shape. The psychological reality of the reflection is not at all like the reality of measurement. And if this most perfect of all realistic images does not correspond to our conceptions of visual reality, it is easy to see that a picture made of ink and paper or paint and canvas or emulsion on film will not match visual reality.

So-called photographic distortion, such as the effect in figure 28, is not a visual distor-

29 Measuring visual scale of things with a ruler

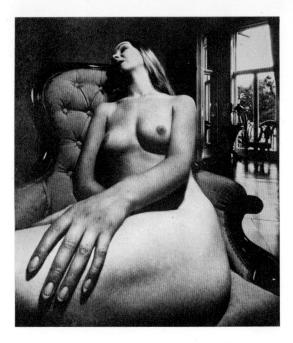

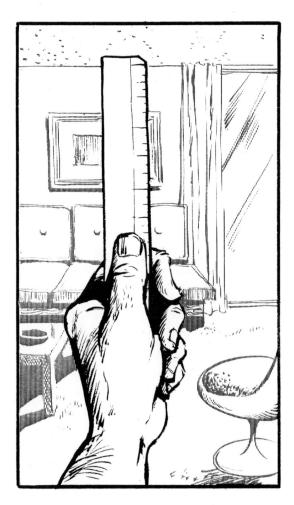

tion at all; it is a psychological one. Possibly you have noticed in snapshots of your home that the rooms tend to look more spacious than they really are. This is because an object ten feet away doesn't really seem smaller; it just looks farther away. But if you hold a ruler out at arm's length and measure off heights of objects (as in figure 29), you will see that in terms of measurements and magnitudes the photograph is relatively accurate. You see in these terms only when you make a deliberate effort to do so, whereas the camera "sees" in terms of geometric relationships at all times. Thus, with regard to your living room, you are struck by the reduction of moderately distant objects in much the same way that the reduction of the girl's head strikes you in figure 28. Normally we sense such scale relationships only when things are very, very far off, when we speak of people looking like ants or toy soldiers.

If the relation between images and reality is so opaque, how then do artists accomplish their ends? It is a matter of organizing elements. Figure 30 does not resemble anything very much, but when the elements are rearranged (fig. 31) we are confronted by "good ol' Charlie Brown," familiar to us from Charles Schulz's (born 1922) comic strip Peanuts. Charlie doesn't look human, of course. Yet cartoonists are able to convey all sorts of subtleties of human feeling through simple modifications of a few basic elements (fig. 32). We accept such marks as representative of living creatures in much the same way we accept letters on paper as representative of sounds. And the same thing is true when the drawing of the children seems somewhat more true to life.

One of *Peanuts*' forerunners was *Skippy* (fig. 33), a comic strip by Percy Crosby (1891–1964). In this strip the kids are more like real children, less like adult egos. But all the same, the strip is quite sophisticated. And the image is equally obscure insofar as copy-

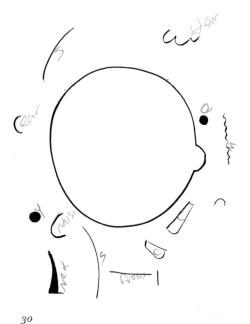

Some lines and marks

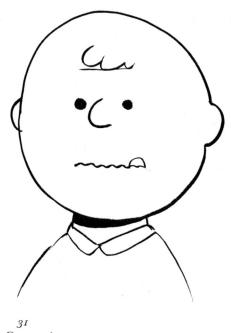

Cartoon image

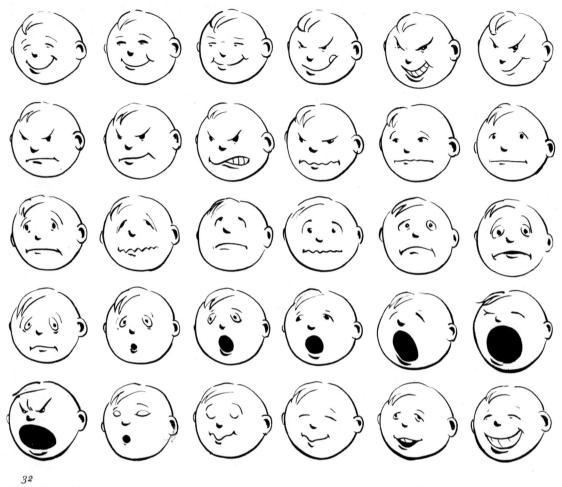

A number of faces

33 PERCY CROSBY. Skippy. © 1934, King Features Syndicate, Inc.

34 ALEX RAYMOND. Panel from Flash Gordon. © 1938, King Features Syndicate, Inc.

ing reality is concerned. The marks on the ground, the balloons, even the sketchiness of the figures, are all utterly beyond the experience of normal visual encounters. Are the two boys sitting on a curb? A stoop? Where? We can't really determine the setting.

What about strips done in what is often called the "illustrators' style," pioneered by Alex Raymond (1909-1956) and Harold Foster (born 1892)? Flash Gordon (fig. 34), Raymond's comic strip of the thirties, seems pretty realistic despite its other-world setting, doesn't it? And Foster's Prince Valiant (fig. 35) is certainly convincing. Or is it? When did you last see someone whose face was dead white and whose clean cheek contained thin black marks? That is shading, you say? True, that is what the marks represent. Still, you must admit that shadows look nothing at all like that. Moreover, all pen-and-ink renderings, all etchings, and all engravings are subject to the same analysis. The Self-Portrait (fig. 36) by Edgar Degas (1834-1917) is much more refined than any comic-strip image, but it is nonetheless made up of little black marks. Similarly, the sketch of an angel (fig. 37) by Michelangelo (1475-1564) is bounded by dark lines and shaded with inky blots that stand for edges and shadows but do not appear in any real figure. This is obvious, surely. But the obviousness is wrapped in complexity. Let us consider the matter from a different angle-the appearance of movement.

35

HAROLD FOSTER. Panel from *Prince Valiant*. © 1958, King Features Syndicate, Inc.

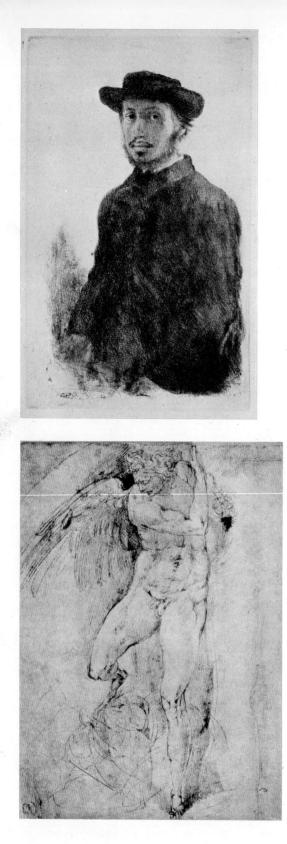

36 EDGAR DEGAS. Self-Portrait. 1855. Etching, $9 \times 5\frac{5}{8}$ ". National Gallery of Art, Washington, D.C. Lessing Rosenwald Collection

Michelangelo is one of the finest artists of all time, and his angel seems to be moving through space because of the way the torso twists on its axis and the foot shrinks into the distance. What if we wished to really emphasize the notion of movement; what if we wanted to give it tremendous stress? A cartoonist might do just what we see Sal Buscema doing in The Defenders (fig. 38). The opponents flash back and forth with superhuman speed. We know exactly what is happening because the lines indicating motion are always to the rear of the objects and describe their paths. This is not at all like the blurriness of rapidly moving objects as the eve perceives them. But we know how to read the symbol. Likewise, the use of lines to convey shadows is a symbol, a convention; that is, an agreed-upon method of indicating darkness. It is very systematic: the more dense the lines in the Degas etching, the more shadowy the region.

It is important to understand that I am not saying that only drawings are conventional in this way. The reference to speeding objects is worth exploring a bit. In figure 39 we have another superbeing, The Flash, who is supposed to be the fastest thing alive. We can see this because we are shown how terribly great his momentum is. Again a mass of lines is

37

MICHELANGELO. Avenging Angel, study for The Last Judgment. Ink drawing, $9^3_4 \times 8''$. Casa Buonarroti, Florence

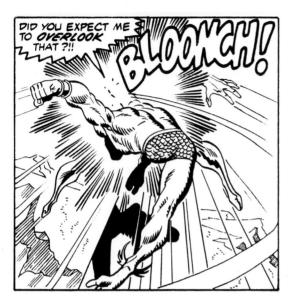

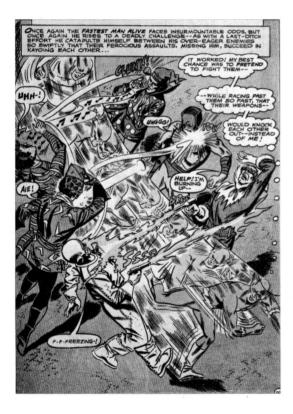

38 SAL BUSCEMA. Panel from *The Defenders*. © 1972, Magazine Management Co., Inc. Marvel Comics Group. All rights reserved

used to suggest speed. This is a conventional cartoonists' symbol and we all understand what it means. What would a photograph of something moving at high speed look like? Figure 40 gives us an example. The car is not moving as fast as The Flash, but it's not standing still either. We gather that the car is moving because the image is blurred. But this is also a conventional reaction. We know this kind of blur means movement because of our experience with photography. Without such experience one might imagine that what he is seeing is the dissolution of some vaporous object. Foreknowledge tells us that blur equals motion. But all we can be really sure of is that movement occurred when the picture was snapped. In this case it could have been the camera that moved rather than the car. In figure 41 it was the camera. The camera was also moving in figure 42, but, because the automobile is clear and the background fuzzy, it is understood by the viewer that the car is the moving object. In figure 43 we see the result of higher-speed film and a faster shutter; it is not possible to be sure whether the vehicle is moving or stationary.

Long before the invention of photography, a Spanish painter named Diego Velázquez (1599-1660) captured the same effects in his

39

CARMINE INFANTINO AND JOE GIELLA. Panel from *The Flash*. © 1972, National Periodical Publications, Inc.

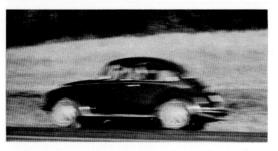

40

Photograph of a moving car with both car and background blurred

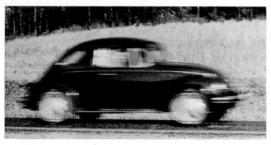

41 Out-of-focus photograph of moving car

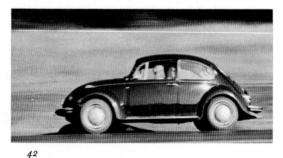

Photograph of moving car with car clear and background blurred

Photograph of moving car taken with fast shutter speed

large oil painting, The Spinners (fig. 44). In this picture he may be said to have devised a technique for representing motion. The spinning wheel, its spokes lost in motion, has a supporting strut whose vibration Velázquez suggested by means of an afterimage (fig. 45). This is the sort of thing the eye sees. You have only to riffle the pages of this book to observe that your eye retains briefly the image of a thing you have just seen if movement is sufficiently rapid. This characteristic of the eye is the ultimate source of the blurriness of fast-moving objects. But seeing the afterimage in the blur is one thing, and devising a way of representing it in a picture is quite another. The Spinners and the photographs symbolize actual visual phenomena in a way approximating ordinary vision. The cartoonists give us a schematic representation that is less like what one sees.

Sometimes the artist wishes to convey by visual means something that has never been seen and is not even presumed to exist as a visual phenomenon. Then the employment of convention is much more evident. As an example, let us take the Christian art of an age gone by.

Religious belief and artistic convention

During the Middle Ages—from, say, 400 to 1300—the civilization of the Western world was dominated by an ascetic ideal. We associate the term *ascetic* with monks, nuns, priests, and other people who have given up worldly pleasures for the joys of the spirit. Medieval man saw life as merely a passing moment in an eternity, most of which would be taken up by an afterlife. Worldly pleasures were seen as snares of Satan, and those who abstained from them were more highly regarded than those who did not. These people dwelt in a world where the trees growing in

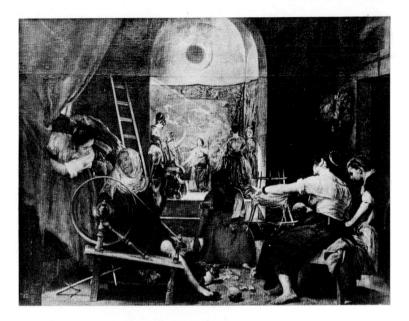

44 DIEGO VELÁZQUEZ. The Spinners. 1656. Oil on canvas, $7'3\frac{3}{8}'' \times 9'5\frac{3}{4}''$. The Prado, Madrid

45 DIEGO VELÁZQUEZ. Detail of The Spinners

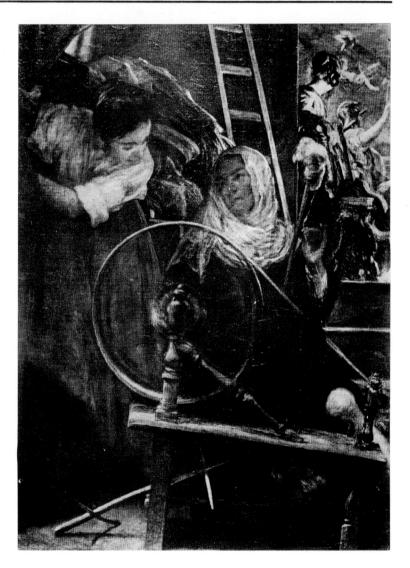

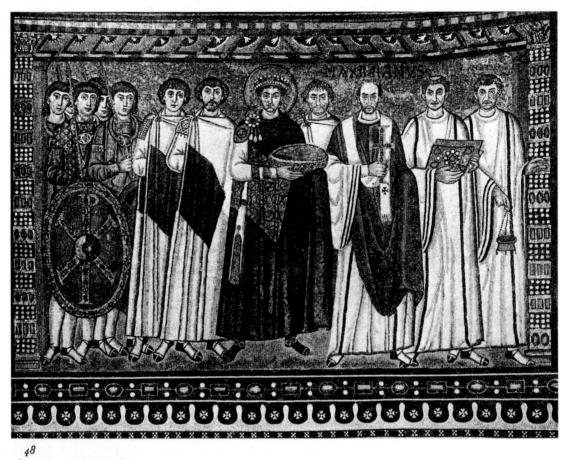

Justinian and Attendants. C. 547 A.D. Mosaic. S. Vitale, Ravenna

The administrative outpost of Byzantine power in Italy was Ravenna, and San Vitale owed its existence to imperial support. The gift Justinian holds in his hands, a golden paten, used for holding the communion bread, is symbolic of the munificence of the ruler in providing this house of worship.

The august figures portrayed in the mosaic look rather stiff and a bit choleric. One is apt to attribute much of this to the medium and overlook just how thoroughly conventionalized the work is. If, however, one examines many images from Byzantium, he will soon become aware of the predominance of very strict rules and firm guidelines. For instance, what is depicted here is not a group of people posing for their portraits. What we are supposed to understand is that this is a procession, part of the dedicatory ritual of the church. Now, did processionals in those days progress by side step? No, but there is a convention of representing important figures full face, no matter what the circumstances. This kind of frontality is frequently encountered in highly authoritarian, hierarchical societies; figures are routinely presented as imperious, indomitable, superior to the observer. Judas and Satan, however, are consistently shown in profile in Byzantine art because of the fear of the Evil Eye, a very old superstition pervading many different tribes and civilizations.

Strict convention also determines the arrangement of the personages. The positions of the figures express their precedence and rank. Justinian is on center and overlaps everyone else. That is, if the figures are conceived of as cards, the emperor is on top of the pile. Bishop Maximianus to Justinian's immediate left is labeled. He was of signal importance in the creation of the Byzantine ecclesiastical-civil structure and was also responsible for the completion and consecration of San Vitale. He overlaps the other clergymen. And so it goes. The honor guards are of no individual importance and are sort of crowded and heaped up over on the edge of things. They are overlapped by a shield bearing a monogram devised by Constantine the Great, the first Roman emperor to be converted to Christianity. This device is called the Chi-Rho (X-P) and represents the first two letters of the word Christ in Greek. But it means still more. An X is, literally, a cross and must be taken to refer to the Crucifixion. The P, especially when given an elongated form, is not unlike a shepherd's crook; it stands for the pastoral mission of the Church and harks back to the parable of the Good Shepherd.

Like many backgrounds in Christian art of the Middle Ages, this one is flat and gold. Golden things in a spiritual context recur constantly in Christian art, and it may seem odd that this should be so. After all, one might think, what could be more closely associated with worldly materialism than gold? Such a reaction is sponsored by innocence of the reasons for man's love of the yellow substance. Gold was and is valued not merely because of its rarity. It is unique among metals in that it does not corrode or oxidize. Even silver tarnishes. But gold remains unblemished. Therefore, ancient peoples considered it "immortal" and invested it with magical powers and supernatural meaning.

You may have noticed the circle ringing the head of the emperor. It is a halo. This

symbol was originally Persian and signified the descent of the Persian religious figure Zoroaster from the sun, so indicating his godlike origin and his holiness. The Greek Christians applied it to their emperor, in effect deifying him. There was a tradition in the ancient Roman world of deifying pagan emperors-both Julius Caesar and Augustus were considered demigods-and it was not difficult for early Christians to accept the idea. That would have been particularly true in Byzantium. Byzantium was a "caesaropapacy," that is, a system of rule in which the emperor is not only the secular ruler but also the final ecclesiastical authority, the pope. The laws of the Church and those of the state are one with the law of God, and it is the emperor who administers them.

The application of the Persian halo to secular authorities did not persist, but the motif itself became a convention of all Christian imagery. Throughout the Middle Ages the halo appears over and over again, designating spiritual radiance. It is used to indicate the sacredness of certain individuals—Jesus, His family, the disciples and apostles, various sainted prophets, martyrs, and so forth. It is interesting to observe what became of this symbol as it was subjected to the aesthetic conventions of various periods. For, while the halo remains even today a meaningful convention, the character of the halo has undergone radical transformations.

Economics and artistic convention

Although art underwent many changes during the medieval era, the really profound modifications of treatment and convention occurred as the Renaissance began to emerge during the 1300s. In the work of the Italian artist Cimabue (c. 1240–1302?) one already sees marginal changes that are tokens of a

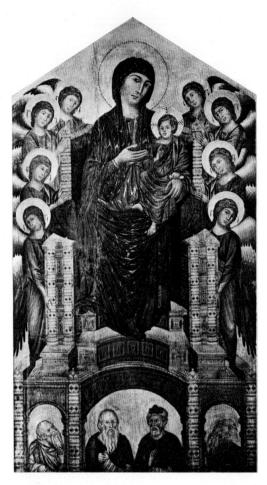

49

CIMABUE. Madonna Enthroned. c. 1280–90. Tempera on panel, 12'6"×7'4". Uffizi Gallery, Florence

new direction. In his *Madonna Enthroned* (fig. 49) the prophets in the lower region are treated much more realistically than the principals above. Still, the picture is very much like those of centuries past, with many of the medieval conventions. Mary and the infant Jesus are very large relative to the other figures, an indication of their importance; the work is quite flat in effect, and there is little feeling for these people as anything but emblems of worship. The halos are simply signs of holiness. They don't look like anything in particular; we know that they are not meant to have an objective referent in the real world.

Cimabue's pupil Giotto (c. 1266 or 1267– 1337) carried the realism hinted at in the lower part of the Cimabue far, far further in his own *Madonna Enthroned* (fig. 50). The advances are much more radical than the casual observer is likely to recognize, and we are going to deal with their importance later on. For now, it is enough to say that here, too, the halos are merely emblematic—flat golden circles behind the heads.

It is in the work of the short-lived Masaccio (1401-c.1428) that the seeds sown by Cimabue and Giotto come to flower in a style that can safely be called Renaissance. In his *Tribute Money* (fig. 51) the halo is no longer a mere emblem. Now it resembles an element of the visible world, like nothing so much as a golden plate hovering over the head of the holy being. The appearance of the halos is subsidiary to the effect of the whole painting, which, compared with the other works, is more substantial and real looking.

The sudden emergence of Masaccio's realism is connected with a more general modification of convention—the whole set of changes that are known, collectively, as the Renaissance. The emergence of this set of attitudes, social forms, and artistic conventions has never been completely accounted for. Certainly, it was the product of many things.

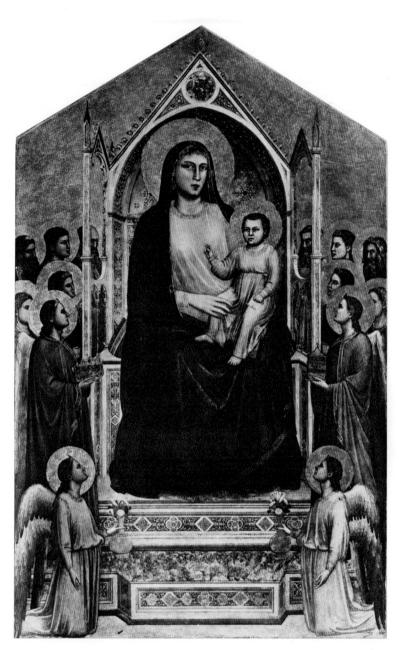

50 GIOTTO. Madonna Enthroned. C. 1310. Tempera on panel, 10'8"×6'8". Uffizi Gallery, Florence

One of the most profound influences was undoubtedly the creation of a middle class.

In the United States we tend to associate the term *middle class* with middle-income groups. But this is a peculiar usage. Historically speaking, the middle class is the one which stands between the lower classes and the aristocracy; it is made up of those who have either wealth or education but are untitled. For the most part its members are merchants, and their principal goal in life is the making of a profit.² During the Middle

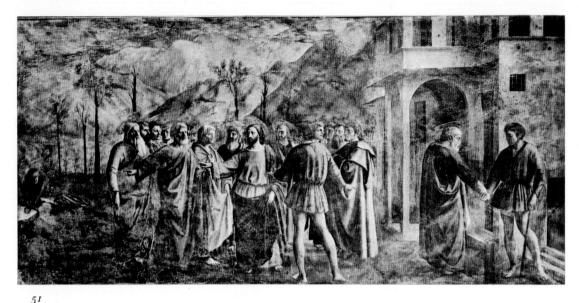

MASACCIO. The Tribute Money. c. 1427. Fresco. Brancacci Chapel, Sta. Maria del Carmine, Florence

Ages this group was too small and insignificant to constitute a social class. Indeed the whole idea of profitmaking was in eclipse from the fall of Rome until the beginning of the fourteenth century.

The idea of gain as a positive social good is a relatively modern one. Throughout most of recorded history it has been conspicuous by its absence. Even our Pilgrim forefathers considered the notion of "buying cheap and selling dear" nothing short of satanic doctrine. Nonetheless, a genuine middle class appeared as a social force in the Mediterranean region during the course of the fourteenth century. Its development coincided with an increase of trade occasioned by two related discoveries. The first was the invention of the technique of tacking against the wind, a procedure that made sailing much less subject to the whims of nature than it had been before. The other was the compass. Marco Polo had brought one of these magical instruments back from Cathay in 1295 (although it does seem to have been known in Europe a century earlier), and

general use of the device by mariners made navigation a good deal more certain than it would otherwise have been. Soon new trade routes opened up all over the world. Surplus capital came into existence and, with it, new ambitions. By the beginning of the fifteenth century a number of merchants had become wealthier than any king. The fortune established by one of these, Giovanni de' Medici (1360-1429), created what we know as the Florentine Renaissance. The history of the city of Florence was for centuries the history of the banking house of the Medici. For the Medici became the discreet dictators of the city-ostensibly a republic-without ever holding public office. The Medici were bankers to all of Europe. Their home base, Florence, became a cultural center to rank with the Athens of ancient Greece.

Although the Medici held social views that you and I might, loosely, call "aristocratic" and although they eventually became a line of dukes by marriage and through papal action, their fundamental attitude toward life was very different from that of the medieval nobility. In many respects their world view was distinctly middle class. The middle class is dynamic and businesslike; it distrusts class privilege when that privilege is based on nothing more than a birthright, and it at least gives lip service to the idea of an aristocracy of proven ability. This is the class which supported the republican revolutions in England, France, and America. As a class it tends to be highly opportunistic, hard-headed, and pragmatic.

It is hardly surprising that whenever the middle class makes its tastes felt in art the resulting art is apt to be rather down-toearth. But the effect is not unmixed. The art sponsored by the Medici was not just realistic. Not only did the weight of tradition influence everyone's taste in art; there was also the influence of the preferences of the genuine nobility, which maintained greater or lesser power into the nineteenth century. And there was the mitigating factor of abstract thought. Bankers and merchants, after all, do deal constantly with ephemeral abstractions such as market values, profit and loss, relative quality, interest rates, and so on. Even for their practical minds reality is not just what shows on the surface; beneath everything there is a sort of hidden substructure. Throughout its history the art of the Italian Renaissance exhibits a marriage of mimesis and formality; that is, realistic effects are packaged in unnatural form.

This excursus seems, perhaps, to have taken us far from anything to do with halos. Nothing could be further from the truth. Masaccio, whom we were discussing, is singular in the whole span of history. Within the short space of six years he moved from the late medieval style into a full-blown Renaissance manner. This genius, who died at twenty-seven, was the creative descendent of Giotto, and he revolutionized painting by incorporating into it a whole repertory of pictorial devices that constitute what, for most people, is "real art." Not only do his halos look like solid objects, the figures themselves are profoundly three-dimensional in appearance. And his picture contains cast shadows, scientific perspective, plausible drapery, and a high degree of anatomical exactitude. *Tribute Money* looks a good deal more like a segment of real space than does Giotto's *Madonna Enthroned*. Even the halos, purely symbolic things, look substantial. They express a middle-class preference for the straightforward and true to life over and above aristocratic acceptance of the purely emblematic.

Sandro Botticelli's Madonna of the Pomegranate (fig. 52), painted by a man born twenty years after Masaccio's Tribute Money was completed, takes advantage of all that the earlier painters had accomplished and contains halos that are far more illusionistic. Now they seem to be made of glass. They are not so obtrusive as the golden plates, but they seem even more like things that might be seen on earth.

Still later, Raphael (1483–1520), in his Madonna of the Beautiful Garden (fig. 53), uses the kind of halo that is the commonest symbol of holiness even today; above the Christ Child's head hovers a slender golden ring. Hardly noticeable, the ring halo is more of a concession to the demands of the middle class for what is palpable and easily accommodated into its matter-of-fact image of what is true.

By the sixteenth century, when the middle classes are burgeoning, buying titles and otherwise moving toward suzerainty, Tintoretto (1518-1594) has substituted for a disk or ring a nimbus of flame that blazes in the dark behind his figures' heads (fig. 54). But it remains for Rembrandt van Rijn (1606-1669) in that most middle-class of all nations, the Dutch Republic, to reduce the halo to ambiguity. In his *Christ at Emmaus* (fig. 55) is the halo radiated by Jesus, or is it a coincidental

52 SANDRO BOTTICELLI. Madonna of the Pomegranate. c. 1487. Tempera on panel, diameter 56¹/₄". Uffizi Gallery, Florence

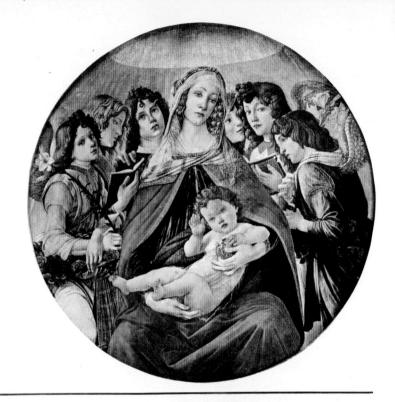

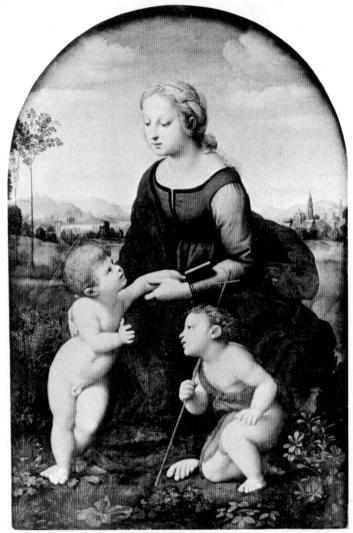

53

RAPHAEL. Madonna of the Beautiful Garden. 1507. Oil on panel, $48 \times 31\frac{1}{2}^{"}$. The Louvre, Paris

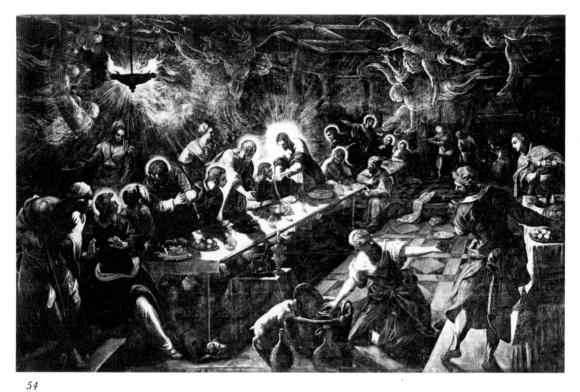

TINTORETTO. The Last Supper. 1592–94. Oil on canvas, $12' \times 18'8''$. S. Giorgio Maggiore, Venice

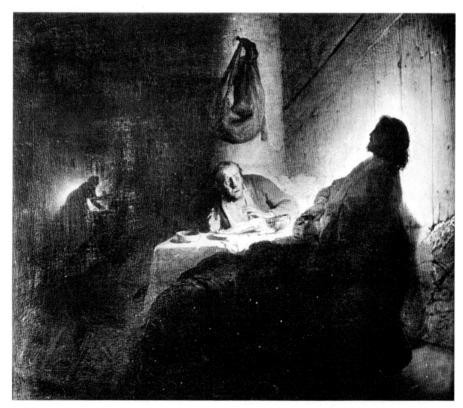

55

REMBRANDT VAN RIJN. Christ at Emmaus. 1628–30. Oil on paper, mounted on panel, $15\frac{3}{8} \times 16\frac{1}{2}$ ". Musée Jacquemart-André, Paris

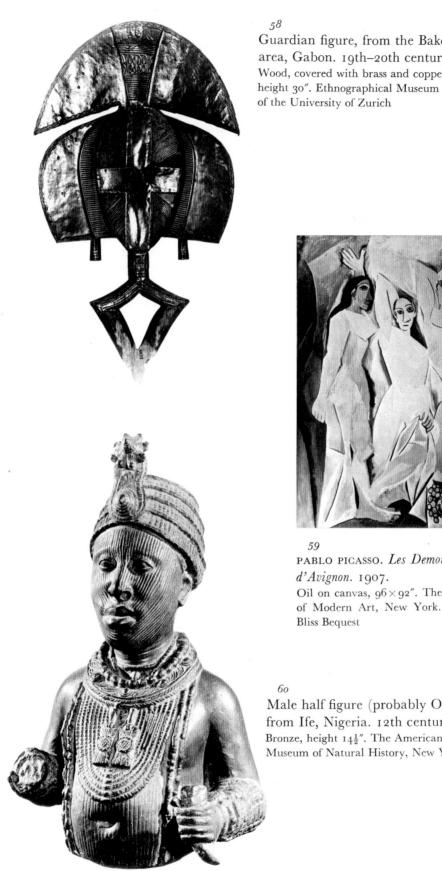

58 Guardian figure, from the Bakota area, Gabon. 19th-20th century. Wood, covered with brass and copper,

59 PABLO PICASSO. Les Demoiselles d'Avignon. 1907. Oil on canvas, $96 \times 92''$. The Museum of Modern Art, New York. Lillie P. **Bliss Bequest**

60 Male half figure (probably Oni), from Ife, Nigeria. 12th century. Bronze, height $14\frac{1}{2}$ ". The American Museum of Natural History, New York it is *your* way of looking at things. And it scarcely matters whether your ancestors were Europeans, Africans, Asiatics, Americans,³ or Oceanics.

All of us have learned to look at pictures through the eyes of Western man. Yet the world of art is not a provincial place to live. White artists have been influenced by the power of black insight (figs. 58 and 59) and, in Nigeria, there is sculpture from the 1100s (fig. 60) rivaling the harmonious realism of the far later Renaissance. The human adventure is a single adventure upon which all races and cultures have embarked together. If this primer helps the reader to a greater awareness of what art has to do with his own role in that adventure, it will have served its purpose well.

3 Line and form

All I have done so far is emphasize that art has many faces and make an issue of the fact that the relationship between art and reality is relatively obscure. We have given incidental attention to ways in which artists of various ages and places have translated reality into pictures, but we have not paid much attention to the things common to all visual art, to what are called its "elements." The visual elements are fundamental, basic. Without them no imagery could exist. Usually, they are identified as line, form, space, texture, light, and color. But to label them in this way is merely a convenience; in fact, the attributes described by these words merge into one another so that it is impossible to draw hard and fast distinctions among them. They are quite a lot like the interrelated components of music: melody, harmony, rhythm, meter, and timbre. Artists and composers don't very often think of such elements as separate entities. They use the words, however, to make it easier to talk about certain aspects of their works. To a layman they and their critics sometimes seem to be playing fast and loose with the English tongue, as when artists discuss the "line" in work like that of Mark

61 MARK ROTHKO. Orange and Yellow. 1956. Oil on canvas, 91×71". Albright-Knox Art Gallery, Buffalo, New York. Gift of Seymour H. Knox

62 Lines and forms

Rothko (fig. 61). Here again, however, a common-sense approach can help us understand precisely what is meant.

There are ten different black marks in figure 62. They are all the same height; the

widths vary. Which of them would you refer to as "lines" in casual conversation and which would you call "forms"? The most common reaction is to call "lines" those marks which are so thin that you don't really pay attention

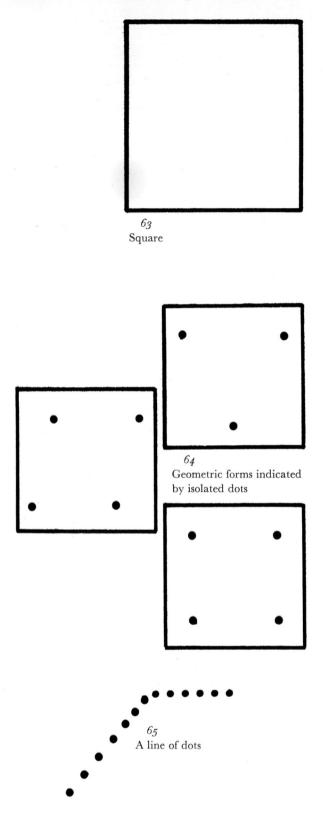

to their ends. They have a noticeable length -they terminate-but the look of the ends themselves is not an important feature of their appearance. With respect to the "forms," though, the character of the end is of sufficient thickness that we are apt to call it the "top" or "bottom" of the shape. Now in fact all the marks are forms; some are long and thin, some are not. We are aware that C is wider than A, but nonetheless it is true that what predominates in C is its length; our eye seems to run up and down A, B, and C whereas it seems to run around H, I, and J. We might go so far as to say-as some readers undoubtedly already have—that H, I, and J have lines around them, that their edges are the same as lines. And this is perfectly correct. A line can describe the edge of a form, or it can be a long thin mark enclosing an area (fig. 63). In both cases we could call them "boundaries" or outlines.

That is not the close of the matter. For we also have invisible lines. Thus, in figure 64 our tendency will be to link up the isolated dots into a square, a parallelogram, and a triangle. And with a few more units (fig. 65) we provide the viewer with a *line* of dots.

What is important to the concept of line is the impression of movement. When someone says, "Lines do not exist in nature," he simply means that your arm, say, is not bounded by long thin marks. But we commonly refer to such things as the *line* of the horizon, the treeline, and the receding hairlines of older men. And, in a sense rather close to that of the artist, we speak of the lines of a car. The line of an automobile design is not just the outline of the machine. It is also the general flow of the forms. Figure 66 is identical in silhouette to figure 67; but the "lines" are not the same, only the outlines are. Such language is very inexact, of course, but the meaning is quite clear.

When the artist or critic speaks of the lines in such a work as Raphael's Madonna of the 66 Automobile

67 Automobile

Beautiful Garden (fig. 68) or Orange and Yellow (fig. 61) by Mark Rothko (1903–1970) he is talking about movements. Most often such movements are along the edges of forms, that is, they are lines of boundary as in the Raphael. Sometimes, though, they are as diffuse and generalized as the movement around the hazy rectangles in the Rothko. My meaning is fairly obvious when I speak of lines existing in something like the Degas Self-Portrait (fig. 69). In this work there are actual drawn lines¹—that is, thin forms—and there are also the outlines of the larger forms or shapes which result from the accumulation of the thin black marks.

In a very real sense all drawn lines can be thought of as forms that serve to emphasize movement. For example, the lines in figure 70 indicate the directions the edges would take if Tarzan were treated in terms of bold masses (fig. 71) instead of in terms of thin black forms. All lines are pathways that connect up shapes and forms in a work of art. If we put Tarzan back into the original composition (fig. 72) by Burne Hogarth, we can see that he is at the crest of a general sweep of lines and forms beginning at the bottom of the picture and curving up and back to the assassinated chieftain. This is a very important use of line in pictorial composition. It is the result of an alignment of forms, in this case a lining up of shapes so insistent that one's eye is drawn through the illustration almost as if by a powerful magnetic force. Even the streaked sky contributes to Hogarth's little drama.

The same kind of movement occurs in the Raphael, although in a far more subtle way. Notice how the forms of Christ's body establish a curved movement that is carried on through the arm of the Virgin. There are a number of such linear developments throughout the work. I have diagrammed some of them in figure 73. Of course, a diagram is not the work itself; there are other alignments and pathways that I have overlooked or deliberately ignored. Indeed, one is wise to be suspicious of critics who engage PAPHAEL. Madonna of the Beautiful Garden. 1507. Oil on panel, $48 \times 31\frac{1}{2}^{"}$. The Louvre, Paris

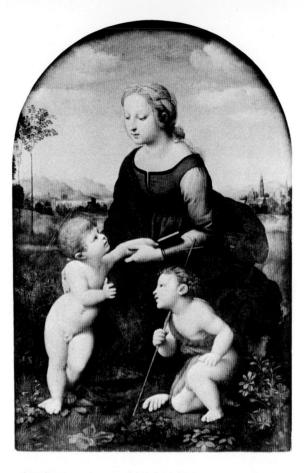

69

EDGAR DEGAS. Self-Portrait. 1855. Etching, $9 \times 5\frac{5}{8}$ ". National Gallery of Art, Washington, D.C. Lessing Rosenwald Collection

68

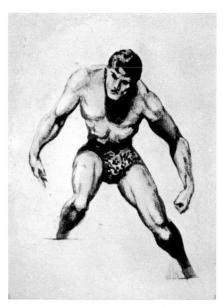

71 After Tarzan by Burne Hogarth

72 BURNE HOGARTH. Tarzan. © 1949, Edgar Rice Burroughs, Inc.

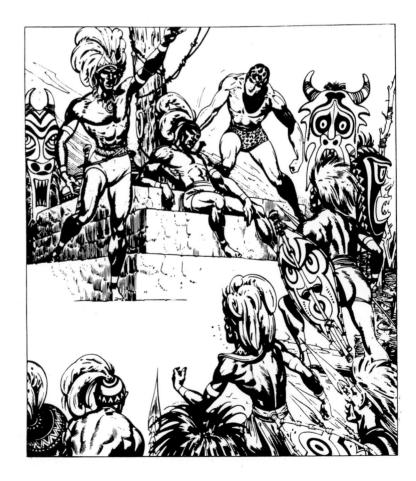

73 Diagram of movements in Raphael's Madonna of the Beautiful Garden

74 Three-legged arch

in very much of this kind of analysis; truth is apt to exist in inverse proportion to the number of schematic diagrams. But it is sometimes necessary to sacrifice a bit of truth to understanding. Which brings me to another caution.

I have had frequent recourse to such phrases as "the eye runs up and down," "the eye runs around," "our eye is drawn," and "pathways through the picture." While these phrases are commonly used among artists and critics, there is no real evidence that we comprehend pictures in this way. Certainly it is not true that the focus of our vision is actually along the lines in a picture. If it were so, the bizarre image in figure 74 would not disturb us in the least; we would accept it as a matter-of-fact array of long thin marks. But we see it in its totality, and the top half doesn't go with the bottom part. The notion of movement of line in art has more to do with a generalized sensation that it has to do with the actual mechanics of vision. Yet the feeling that one's eye moves along pathways is so pronounced in something like the Hogarth cartoon of Tarzan or the Raphael Madonna that it is both convenient and convincing to talk as if it were true that vision finds its way through pictures by using stepping stones and pathways.

A painter of the American West, Charles Russell (1864–1926), made very obvious use of such pathways in his oil painting *Loops and Swift Horses Are Surer than Lead* (fig. 75), which shows a couple of wranglers roping a bear. The lariats establish a bold, looping curve through the middle of the work. This same curve is repeated in the shapes of the valley beyond, carried through the slant of the horses' legs, and echoes in the posture and movement of the cowboys. Notice, too, that the sagebrush is not so random in disposition as one might at first suppose. The clumps are lined up in curves; some correspond to the line of the lariat, others lead up from the

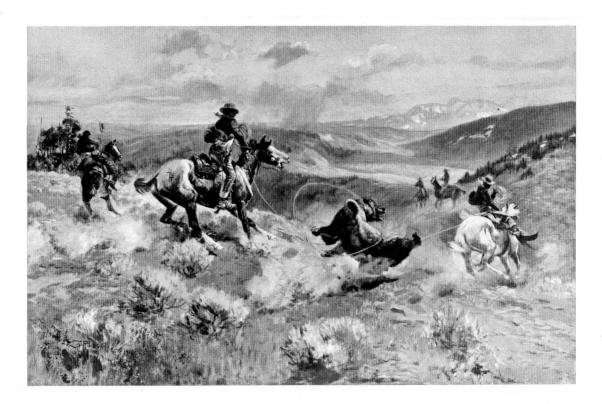

75

CHARLES RUSSELL. Loops and Swift Horses Are Surer than Lead. 1916. Oil on canvas, $29\frac{1}{2} \times 47\frac{1}{2}$ ". Amon Carter Museum of Western Art, Fort Worth, Texas

foreground into the center of the action. At first glance the painting looks perfectly natural. But a little analysis reveals the artist at work, arranging things in terms of movements.

It would be difficult to find a more contrasting painting than *Composition in White*, *Black and Red* (fig. 76) by Piet Mondrian (1872–1944). Here there is no action, not even a portrayal of any kind—nothing but black lines on a white panel with a thin rectangle of red at the base. What Mondrian was interested in, obviously, was outlining different size zones on his canvas. This looks simple, but it is a difficult sort of problem and Mondrian has handled it very sensitively. Because his style was associated with a certain development in architectural design, reflected in such structures as Mies van der Rohe's buildings (fig. 77), it is common to teach people to "appreciate" it by suggesting that they think of the black stripes in the work as steel members, the white spaces as glass, and the red strip as brick. Yes, it resembles a storefront of the sort one might see on a fashionable street. This approach demonstrates, perhaps, the relevance of Mondrian's ideas to our daily lives, but it misses what is most intriguing about the painting itself, namely, the relationships of the forms.

May I suggest that you try looking at the work not as if it were produced by placing 76 PIET MONDRIAN. Composition in White, Black and Red. 1936. Oil on canvas, $40\frac{1}{4} \times 41''$. The Museum of Modern Art, New York. Gift of the Advisory Committee

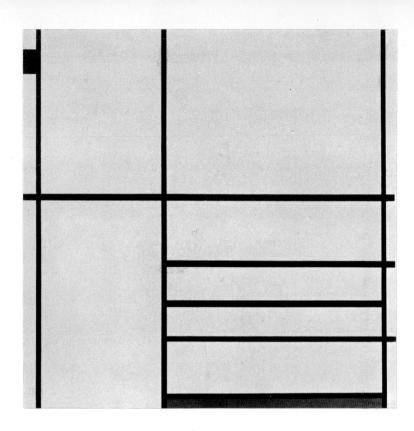

77

MIES VAN DER ROHE. Crown Hall, Illinois Institute of Technology, Chicago. 1952–56

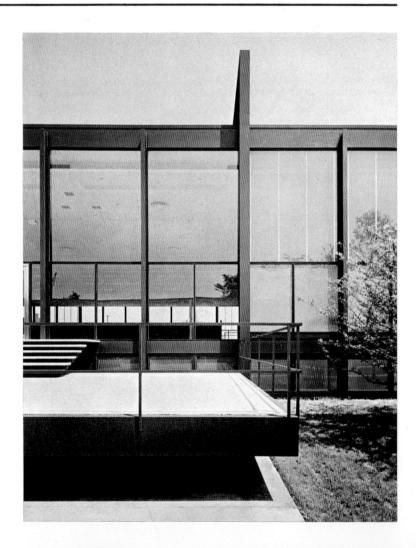

black stripes on a white background but, instead, as if Mondrian had placed large white units on a black background? The exquisite proportioning of the various elements may be more apparent when seen in this light than when looked at in the expected fashion. However, it might not; some people find this kind of thing dull no matter how expertly it's done. In any case, you may get some idea of Mondrian's seriousness of purpose. He was deeply in earnest about his art, feeling that it was a purified representation of the kind of harmony and equilibrium toward which all nature strives but never experiences in fact.

Charles Russell, like Burne Hogarth, was a popular illustrator who appealed directly to a mass audience. His audience was interested first and foremost in the anecdote, that is, in the story the picture told. They were somewhat less concerned with imagery, although the authenticity of details had a decisive bearing upon reception of the anecdote. As to the composition, the fans of Russell were indifferent. Russell organized his forms in order to present the anecdote effectively, not out of some noble, artistic motive. Mondrian was far more seriousminded and self-sufficient about his picture; he was devoted to an ideal and he wished to express it. He organized his composition for the sake of the composition itself. For him it had a value in and of itself. Russell was not indifferent to artistic form by any means, but he looked upon the forms as means to another end.

It would be misleading to say that the painters of the Italian Renaissance wanted to achieve the same ends as Mondrian. They did not. Yet they were somewhat more like

78

LEONARDO DA VINCI. The Last Supper. 1495–98. Mural. Sta. Maria delle Grazie, Milan

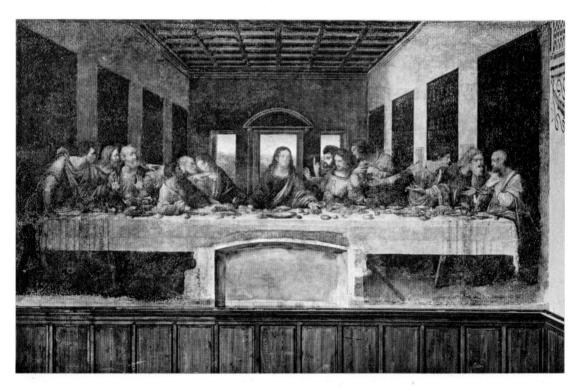

79 Some formal elements in Leonardo's The Last Supper

Mondrian than like Russell. They sought far above themselves for inspiration and turned their backs on the details of everyday existence. In its way the famous *Last Supper* (fig. 78) by Leonardo da Vinci (1452–1519) is as good an example of the Renaissance search for harmony as Mondrian's painting is of twentieth-century seriousness. Let us examine it in terms of line and form.

The work is remarkably symmetrical. Leonardo assembled the twelve apostles in four groups of three with two groups to the left of Christ and two groups to his right. Christ himself is posed and drawn so as to form a pyramid (fig. 79). He is the most stable shape in the entire work, and the most isolated and self-sufficient figure. The moment is immediately after He has spoken the words, "One of you shall betray me." The party is alive with speculation. Judas, whose head is fourth from the left, draws back in fear and hatred. His outline is as triangular as the Master's but is lopsided, scalene, and far less stable. Of the disciples only he has a face caught by darkness. His left arm is parallel

to the left arm of the disciple seated between him and Jesus, and the two disciples' arms are at an angle to the table which is precisely opposite to the angle struck by Jesus's right arm. This establishes between Christ and His neighbor a wide V that echoes His own silhouette inverted. At the point of the V He is in contact with the adjacent disciple. But the width of the \mathbf{v} and the repetition of its left side in Judas's arm bars Him from the traitor. By means of this geometry Leonardo conveys both the historical closeness and the moral distance between the Messiah and Judas. Their shared triangularity accents the fact that they are the principal actors in this historic event. Of course, Christ is the focus of the tale. And He is, quite literally, the focus of the picture. Not only is He on center stage, He is the spot on which the lines of the ceiling converge. Similarly, the tops of the tapestries on either wall are in line with His forehead. So are the edges of the table. He is seated before a rectangular window accented by a curved molding that resembles a halo. Too, there are linear developments through the disciple groups, leading us to the central figure. It is a very austere, harmonious, and thoughtful work.

Leonardo's Last Supper is the most famous of them all, but the subject has been treated by many other painters. Nearly a century later, the Venetian painter Tintoretto undertook the same theme on a similar scale (fig. 80). But how different from Leonardo's is his conception of the event! The main point of convergence is no longer Christ's face but is over on the far right. The whole thrust of the room is opposed to that of the viewer's eye, which is yanked across the picture toward Jesus. This effect is achieved partly by means of Christ's bright halo; all the halos are like shouts in the night in this dark and smoky inn, but His is largest. It is also the most radiant, and it casts a light so powerful that sharp shadows fall from it across the figures in the forefront of the picture. A very distinct pathway is created by the coincidence of the shadow beneath the foot of the nearest person in the right foreground, the folds in the garments of the kneeling maid, the shadow of the maid's head, Christ's plate, and the edge of His robe. The cherubim and seraphim boiling down from the oil lamps in the ceiling are coordinated with the figure of Christ. There are numerous other chains of this general type, such as the one leading from the basket up through the serving table and on to Christ.

The Tintoretto is far, far more dramatic than the Leonardo. It is theatrical. This has a good deal to do with the history of the Church. The Leonardo was painted before the beginnings of the Protestant Reformation. Leonardo was, personally, a skeptic in matters of the faith. But he was not self-conscious about depictions of gospel stories. He took them for granted. In fact, the stability of Rome, the permanence of the Church, and the patronage of the devout could all be taken very much for granted. After 1517, however, this was no longer true. Once Martin Luther had successfully challenged the authority of Rome, the Church was on the defensive. Tintoretto was a painter of the Counter Reformation, Rome's answer to the threat of Protestantism, an increasingly powerful influence in northern Europe. Tintoretto did not take the Last Supper for granted; he wished to thrill viewers with his portrayal, wished to move them to accept the continuity of the Roman Church from Christ through

80 TINTORETTO. The Last Supper. 1592–94. Oil on canvas, $12' \times 18'8''$. S. Giorgio Maggiore, Venice

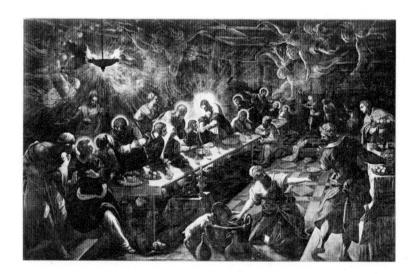

Peter all the way up to their own day. Notice that Leonardo keeps us down in the orchestra pit, as it were, while Tintoretto sets us upon the stage. Leonardo shows us a tableau; Tintoretto invites our participation. Tintoretto was a propagandist for the Catholic position, and his work is devoted to propagation of the true faith. He marshals every resource available to him to dramatize events from Christ's life, to invest mere paint with hints of the truly miraculous. Thus his use of line and form is charged with dynamic energy, full of grand sweeps, thrusts, and counterthrusts. He enlists the capacities of line and form to touch the viewer emotionally so as to simulate the effect of a mystical experience. Leonardo's pacific symmetry is an emblem of a time when the permanence and order of the Church were exempt from challenge. Tintoretto's style is a shout for attention.

The shapes of Venus

Line and form are characteristics of all images, not just those produced by artists with pencils, pens, and brushes. The photograph of a nude woman (fig. 81) is subject to the same kind of analysis as a painting or a

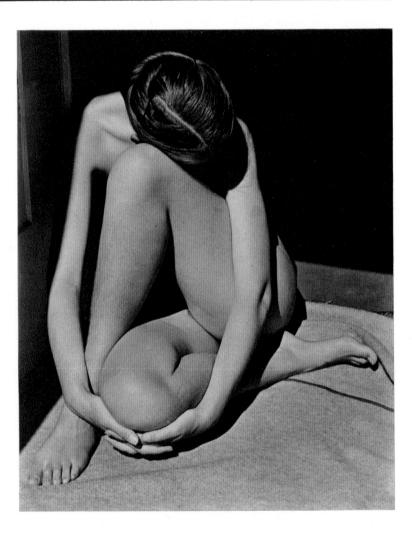

81 EDWARD WESTON. Nude. 1936. Photograph drawing. The photographer cannot control the line as decisively as a painter; but he can, by means of pose and lighting, articulate his images. The woman portrayed in figure 81 is composed. The photographer has studied her in terms of massings of anatomical forms and their outlines to produce a very cohesive work. And she is treated as a female human being, an animal having certain physical properties distinct from other beings. The commercial photographer who makes pictures for the enjoyment of readers of men's magazines such as Playboy approaches women with a quite different objective in mind. He does everything possible to make the figures resemble those depicted by pinup artists like Vargas. Such renderings have proved highly provocative to most males in Western culture. They don't look like real women, though, despite the tremendous stress on female secondary sexual characteristics. You've only got to study them dispassionately to see this. Vargas's young ladies are so drawn as to be quite impossible; their internal organs would be in disarray. One can't use that fact alone to put them down, however. Many of Michelangelo's nudes are equally unsound from a physiologist's point of view.

What is most striking about the treatment Vargas gives the female form is that he invests it with an overall tenseness. He and his colleagues treat womankind as if every bit of female flesh were made of erectile tissue and were utterly lacking in the softness more typical of the female body in repose.

A human breast is a gland surrounded by fatty tissue, a form on which gravity exercises some effect. In Vargas it looks like some sort of pneumatic pillow. This kind of rendering has the effect of making women look like male athletes with female appendages. The aggressive "femininity" of the pinups is barely skin-deep; a young man is hiding under there.

The popularity of such treatments insinuates something unsettling about our civilization. But the point I wish to make here is that the pinup photographer does everything he can to duplicate them. The *Playboy* model tends to be posed with her arms raised, her thorax inflated, her stomach held in, her legs tensed. The photographer cannot overcome the effect of gravity in fact; but he can choose a model with an unusually high bosom, tilt the set so that the forces of nature are cancelled out, and then tilt the camera so that the picture looks straight. And he can retouch the negatives and prints to erase certain blemishes, unwanted lumps, and other evidences of humanity—particularly female humanity.

In ages past, men were less nervous about the female form. This is particularly evidenced in the many statues and paintings of the goddess of love and beauty, Aphrodite (or, as the Romans called her, Venus). In the fourth century before Christ a great Greek sculptor named Praxiteles (active 375-330 B.C.) carved a statue of her (fig. 82) for the city of Kos. As it happened, that city was nervous about uncovering the beauties of Aphrodite and rejected Praxiteles' nude in favor of a draped figure. The people of another city, Knidos, were to profit by this piety, for they became the owners of the nude version of the goddess, possibly the most famous statue in all antiquity. The original work is lost, and only imperfect Roman copies remain. Still, it is easy enough to see the general approach chosen by the artist.

The Knidian Aphrodite is a bit heavy for modern tastes, but she is nonetheless of an extraordinary perfection of form. She is relaxed, unself-conscious, and posed with her hip swung out in the way the French call déhanchement. The arc of her right hip, sweeping up to the sphere of the breast, is balanced by the long graceful undulation of the left side. No one of the time questioned that the statue was intended as an embodiment of physical desire; for a Greek that would be connected with religious veneration of the goddess of love. Indeed, a Greek author of

LINE AND FORM | 69

SANDRO BOTTICEI T. The Birth of Venus. c. 1480. Tempera on canvas, $5'8\frac{2}{8}'' \times 9'1\frac{2}{8}''$. Uffizi Gallery, Florence

85

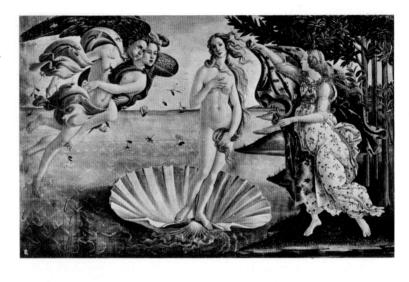

and even Picasso. Sir Kenneth Clark has said of the painting:

Her pose seems so calm and inevitable that we do not at once recognize its originality. Giorgione's *Venus* is not antique. The reclining figure of a nude woman does not seem to have been the subject of any famous work of art in antiquity . . . She lacks the weighty sagging rhythm, as of a laden branch, in which the antique world paid equal tribute to growth and to gravity.²

The treatment of the figure is such that she is, as Clark remarks, like a bud enfolded. Giorgione has given to the female form a compression of shape that brings about perfectly smooth transition from shape to shape. The lines flow insensibly from one place to another. The forms of the beautiful cloth on which Venus lies express the same kind of coherence and are a sort of reflection of the graceful outline of her body. She sleeps a gentle sleep, removed from immediate reality, in a landscape that is suffused with mellow golden light.

Titian's Venus of Urbino (fig. 87) is very like the Giorgione in pose, yet the mood is different. The Venus of Urbino is awake; she invites us to her side with her eyes. And Titian (c. 1487/90-1576) has turned the torso a bit more toward us. By intensifying certain darks he has produced stronger contrasts of form within an outline that is almost as cohesive as the silhouette of the Giorgione Venus.

The appeal of these Renaissance nudes is sensuous and direct, largely achieved through the manipulation of line and form. While it would be going too far to say that the artists have revealed the carnal nature of Venus, it is well within the bounds of truth to note that their treatment of female anatomy in terms of enclosed forms which have the solidity of spheres and cylinders points up woman's physical being. Only those who accept the human body in an open, straightforward manner have such a command of line and form.

By the middle of the nineteenth century the naturalness of Titian had been supplanted by a stuffy, high-minded attitude toward the female nude. The nineteenth century wor-

72 | ART: THE WAY IT IS

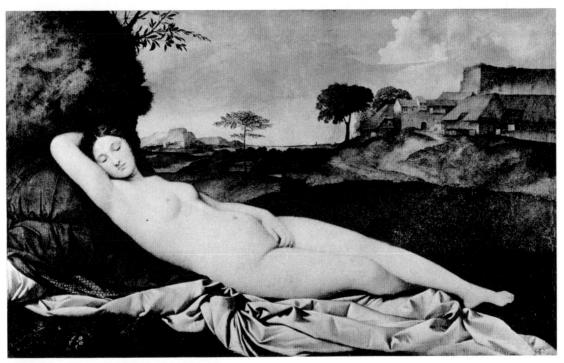

86

GIORGIONE. Sleeping Venus. c. 1508–10. Oil on canvas, $42\frac{3}{4}^{*} \times 69^{''}$. State Picture Gallery, Dresden

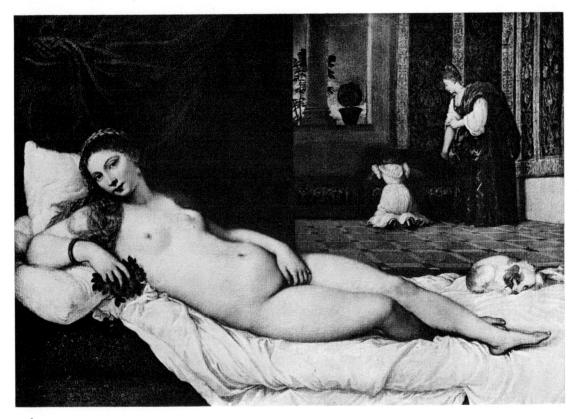

87 TITIAN. Venus of Urbino. 1538. Oil on canvas, $47 \times 65''$. Uffizi Gallery, Florence

88

ADOLPHE WILLIAM BOUGUEREAU.

Nymphs and Satyr. 1873. Oil on canvas, $8'6\frac{3}{6}" \times 5'10\frac{7}{6}"$. Sterling and Francine Clark Art Institute, Williamstown, Massachusetts

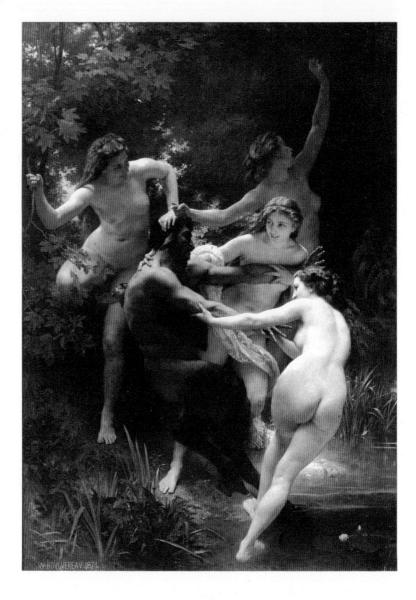

shiped women in the sense that Victorian men put their ladies on pedestals and idealized them. But the nineteenth-century view depended upon a rejection of women as human beings. The successful painters of the day—whose names are now known mostly by professionals only—had one thing in common: when it came to depicting naked women, they glossed over the facts. An artist like Adolphe William Bouguereau (1825– 1905) imitated the mannerisms of the Renaissance but had no feeling or interest in the substance of the women he depicted. He substituted for the articulate volumes and coherent lines of Giorgione and Titian a slick, waxy-looking surface and placed his women in a mythological fantasy (fig. 88). In 1863 Edouard Manet (1832–1883) challenged this popular acceptance of unreality with the exhibition of his *Olympia* (fig. 89).

The Olympia is based on Titian's Venus of Urbino. Manet was perfectly open as to that. But while the poses are similar, the women are quite different. This is not Titian's loving creature; this is a hard and cold professional —a high-class prostitute, a courtesan. Her stare is not inviting; it measures one. Moreover, the girl is very much an individual; her face and figure are rendered with an eye to their specific characteristics. We could probably recognize Manet's model on the street. And we encounter her here in probable surroundings. The picture is a fine example of the style art historians know as French Realism, a movement opposing the high-flown fancies of men like Bouguereau with the realities of the everyday world. Titian had been concerned with reality too, but it was a reality that went beyond the one that Manet represents. The Renaissance artists strove to reveal the substance that lay beneath superficial appearances. The Realists were obsessed with appearances only. That they were so concerned drew upon them the charge that their works were both shallow and ugly.

Still, Manet's Olympia is as significant for the painting to follow as its prototype, the Venus of Urbino, was for the art that succeeded it. Generally, the Olympia is considered the first example of truly "modern" art. This may

89

EDOUARD MANET. Olympia. 1863. Oil on canvas, $51\frac{1}{4} \times 74\frac{3}{4}$ ". The Louvre, Paris

go Titian's Venus of Urbino out of focus

91 Manet's Olympia out of focus

sound odd. The term *modern art* connotes to most of us a kind of art that doesn't resemble anything—the sort of thing Picasso, Kandinsky, Mondrian, and Rothko do—and the *Olympia* is very true to life. What makes Manet modern is the way he employs the elements of art.

Certainly, the Olympia doesn't look much like the Venus of Urbino; she is flat, pale, and the lines are crisp and rather cold. Compare figures 90 and 91, out-of-focus photographs of the Titian and Manet, respectively. The two photographs are blurry to the same degree, but the lines and forms in the Titian remain relatively clear while those in Manet's nude are nearly lost. The one line in the Manet that does remain clearer than any in the Titian is the outline of the pale silhouette containing the girl, the bed, and the maid's clothing. This large light area has some of the impact of a gigantic poster. Within it there are no deep shadows to produce an impression of deeply rounded forms. The outline of the nude Olympia is a faintly shaded edge as narrow as a drawn line. Thus, the form of the Olympia produces an entirely different effect from that of the Venus of Urbino.

The image of woman in the work of Richard Lindner (born 1901), a contemporary American artist, evokes still other thoughts. His work (see fig. 92) constitutes a statement on the kind of society in which men get their "kicks" from looking at women presented in the way the pinup artists show them-as non-women. Lindner's figures are armored, corseted, and otherwise constrained. They are grotesque caricatures of the painted, pampered American Woman, a woman who (Lindner seems to say) is about as yielding as a chunk of sidewalk. The lines of his figures are of an inhuman regularity; their forms are geometric to the extent that nothing animal is left. They are robots in the form of sex machines. They represent the pinup view of woman carried to its logical conclusion.

92 RICHARD LINDNER. 119th Division. 1965. Oil on canvas, $80\frac{1}{2} \times 50\frac{1}{2}''$. Walker Art Center, Minneapolis

Clearly, the image of Venus changes with the role of women in society, and artists convey their feelings about that role by the way they describe woman through the medium of art. It is also true that the moods peculiar to the individual pictures are produced in part by the varying character of the lines and forms.

Line, form, and feeling

There is a kind of folk-art knowledge embodied in the name of the weeping willow tree. Everyone knows that drooping lines are supposed to convey sorrow or fatigue. A calm sea is placid, and placidity is marked by horizontal lines. When you're "up" you are happy, and upcurving lines are often used to indicate joy. These associations of line direction with mood probably derive from somatic identifications; that is, with their occurrence in our own bodies. Figure 93 illustrates the presumed relationships. Actually, the inference that downturned lines are sad and upturned ones joyous is simple-minded. For instance, the face made up of only upturned lines is not as gleeful-looking as the top-left face in figure 32 because the latter corresponds

93 The supposed physiognomy of linear moods

more closely to actual configurations in a smiling face. But simplistic or not, it is obvious that there is *something* to the idea that line movement and mood are connected.

Leonardo's Last Supper (fig. 78) conveys a pacific feeling. It is a calm picture. The Tintoretto version (fig. 80) boils with energy; its line movements are highly charged. In viewing it one feels less at rest because it is not at rest. Its mood is intense and aims at provoking a feeling akin to ecstasy, religious fervor. In an analogous fashion, two famous works from the late nineteenth century, *The Starry Night* by Vincent van Gogh (1853– 1890) and *A Sunday Afternoon on the Island of La Grande Jatte* by Georges Seurat (1859–1891) evoke different moods because of the different ways the artists have used line and form.

The brushstrokes in the Van Gogh (fig. 94) are exceptionally linear, and their movement is torrential. Starry Night is emotional to the point of being vehement. The nebulae raging across the heavens of the night are not things seen but something felt. In A Sunday Afternoon on the Island of La Grande Jatte (fig. 95) the painter has employed little dots of color. His lines are regulated, predictable, serene. Everything is thought out. Even the forms between the figures are calculated; they resemble jigsaw cutouts. And the repetitions of line are very clear. Compare the back of the lady in the bustle on the far right with the line movement from the seated girl ahead of her up through her companion's parasol to the hip of the oncoming mother. Such similarities can be discerned throughout the painting. The mood? It is one of calm, appropriate to a quiet Sunday afternoon in Paris.

Line and form are but two of the elements of art. They are, as you have seen, so closely related as to be almost interchangeable. The other elements are similarly dependent upon each other. Without contrast between dark and light we could not perceive form, and

78 | ART: THE WAY IT IS

94 VINCENT VAN GOGH. The Starry Night. 1889. Oil on canvas, 28³/₄×36¹/''. The Museum of Modern Art, New York. Lillie P. Bliss Bequest

GEORGES SEURAT. A Sunday Afternoon on the Island of La Grande Jatte. 1884–86. Oil on canvas, $6'9\frac{1}{2}'' \times 10'1\frac{1}{4}''$. The Art Institute of Chicago. Helen Birch Bartlett Memorial Collection

95

without form we would not have line. Darkness or lightness is an aspect of color. In fact, the aspect of color summed up by the terms *dark* and *light* is perhaps the most important aspect of all. One can be colorblind and still see very well indeed. But without the contrast between lights and darks one would be unable to see at all.

4 Light and shade

In discussions of light and shade it must be ever borne in mind that the painter works with pigment and not with real light. He cannot make us squint into his painted sunsets, cannot actually blind us with the radiance of his desert skies. We need not shield our eyes from the glare on Turner's water (fig. 96). The artist creates his illusions within a very limited range. But he always has our help, our willingness to go along with the tricks.

A good example of just how tolerant we are when it comes to accepting deviations from reality in pictures can be had by studying a slide of Jan van Eyck's (c. 1390–1441) *Gio*vanni Arnolfini and His Bride (fig. 97) projected onto a screen in an appropriately darkened room. Pick out something in the picture that looks very dark, even black. It will not be as dark as any number of things in the room around it. The slide is, in other words, a very pale image of reality. Yet, until you make an effort to notice this effect, it is not apparent. Even when you are aware of it, the image on the screen continues to look "right." This is because the relationships among contrasts in 96 JOSEPH MALLORD WILLIAM TURNER. The Dogana, San Giorgio Maggiore, le Zitelle from the Steps of the Europa. 1842. Oil on canvas, $24\frac{1}{2} \times 36\frac{1}{2}$ ". The Tate Gallery, London

97 JAN VAN EYCK. Giovanni Arnolfini and His Bride. 1434. Oil on panel, 324×232". The National Gallery, London

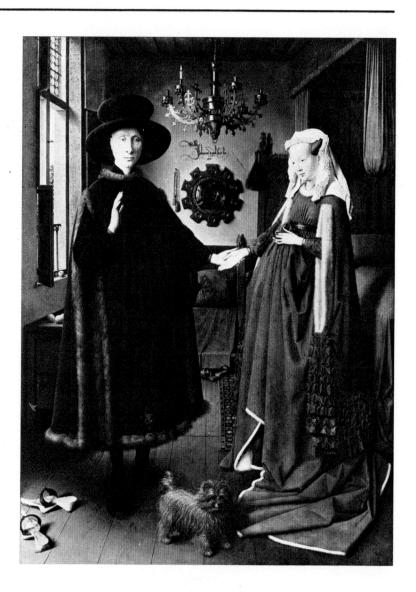

98 Gray strip in graduated background

99 Natural light

100 Artificial light

the original painting and its slide reproduction remain pretty constant. It's like playing an instruments at higher or lower pitch; the difference is obvious, but the relationship between tones doesn't change much.

One can see the importance of such relationships by glancing at figure 98. The background is graduated from black to faint gray, the central strip remains a constant gray; the strip only *seems* to change because its relationship to the background is inconstant.

Convincingly realistic pictures, such as photographs, preserve the principal relationships that obtain for vision. Thus, in figure 99 sunlight, falling in parallel rays, lights the sides of things in a consistent fashion. Everything to our left is light, and what is to the right is in shadow. Of course, the shadows are not utterly black, because air itself is reflective and holds light even in the shade. Artificial light, emanated by candles, lanterns, electric bulbs, and the like, radiates so that the things in figure 100 are lighted on the side toward the torch. The effect is obvious to everyone. Figure 101 diagrams it. What is toward a light is lighted; what is away from it is darker. Giovanni Arnolfini and His Bride is based on the assumption that light is entering the bedchamber from our left, and Giovanni Arnolfini's face is light on the left and dark on the right. Similarly, all the things in the room -the oranges on the sill, the folds in the bride's gown, even the individual hairs on the little dog-are light on the left and cast shade to the right.

Georges de La Tour (1593-1652) was fascinated by the effects of artificial light, and in his painting *Joseph the Carpenter* (fig. 102) he has used a flame to illuminate the figures. They are consistently light on the side of the light source and lost in deep, deep shadow elsewhere. It is not magic that makes it look so like a firelit scene; it is the artist's consistency.

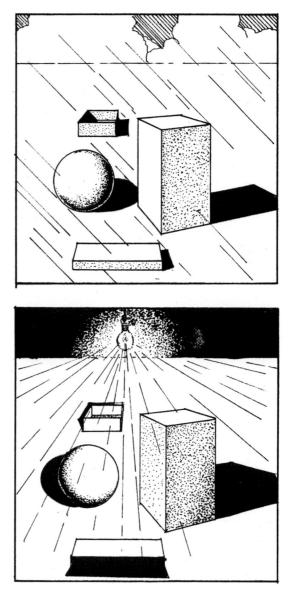

IOI

Diagram of light sources and effects. Slanting lines indicate parallel sunbeams and radiating artificial light rays 102 GEORGES DE LA TOUR. Joseph the Carpenter. c. 1645. Oil on canvas, $53\frac{7}{8} \times 40\frac{1}{8}''$. The Louvre, Paris

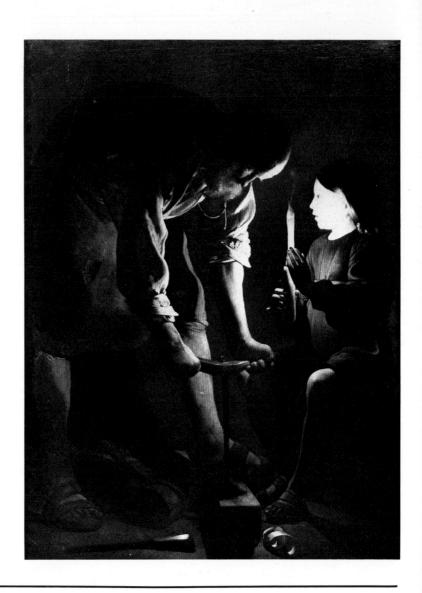

Chiaroscuro and modeling

The Italians have a word for the effect of light and shade in art. They call it *chiaroscuro*. This is the term artists apply to the general effect; the specific applications of it to noses, lips, eyes, drapery folds, and so forth is called *modeling*. Chiaroscuro always refers to light and dark, but there are some specialized uses of the term that you should know about. It is often applied to a kind of drawing (fig. 103) emphasizing light-and-shade effects. In such drawings the artists work on tinted paper, usually gray, indicating shadows with a dark crayon or ink and noting the lightest places with a white crayon or paint. There is a woodcut technique called chiaroscuro (fig. 104) in which light in the print is indicated by white paper, semishade by some medium tone, and dark shade by black or extremely dark gray. But these usages are just special applications of the term. Chiaroscuro is literally *chiaro*, meaning light, plus *scuro*, meaning dark. 103

PIERRE PAUL PRUD'HON. Study for

La Source. c. 1801. Black and white chalk, $21\frac{1}{4} \times 15\frac{1}{4}$ ". Sterling and Francine Clark Art Institute, Williamstown, Massachusetts

104

UGO DA CARPI. Detail of Raphael and His Mistress. 16th century. Woodcut, $7 \times 5\frac{1}{2}^{n}$. The Metropolitan Museum of Art, New York. Rogers Fund, 1922

Shadow lettering

106 Ribbons forming letters

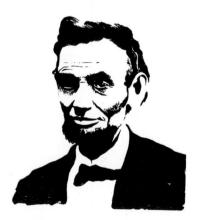

107 High contrast drawing

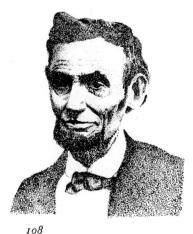

Stipple drawing

We can best understand how artists use light and shade to create an illusion of solidity if we ignore the subtleties of modeling. A very good example for our purposes is the kind of lettering in which the letter forms are indicated by what would be the shaded side if they were made of metal strips (fig. 105). Viewers perceive the letters as if they were as I have rendered them in figure 106. But of course there is no thin band along their thickness in figure 105: the viewer merely "fills in" with such a band; he pretends it is there.

You do the same thing when you look at an ink drawing such as the picture of Lincoln (fig. 107); you imagine the intermediate grays that are actually defined by tiny dots in figure 108. In both figure 103 and figure 105 you are projecting your expectations onto emptiness. The empty surface is as much a part of the image as the black forms are. A number of art styles are based on precisely this effect. Milton Caniff's cartoon style (fig. 109) derives its documentary appearance from it; and Jim Steranko (fig. 110), Jeff Jones (fig. 111), and others make constant use of it for dramatic impact and design. The Chinese created an entire aesthetic tradition based on the power of expressing things through the absence of ink. The whiteness of the silk in figure 112 is not just a void; it is as palpable a part of the depicted scene as are the brushstrokes that evoke hillocks, trees, and mounds of earth. It is also true that a number of media, such as wood engraving (fig. 113), rely on the willingness of viewers to fill in absent information.

That the contrast between the large masses of shade and the blankness of light is fundamental to the painter's illusions is borne out by the practice of the great masters of representational art. When Caravaggio (1573– 1610) painted *Christ at Emmaus* (fig. 114), he detailed every surface, and we luxuriate in the satiny perfection of his tones. In his preparatory studies, however, Caravaggio,

109 MILTON CANIFF. Steve Canyon. © 1948, King Features Syndicate, Inc.

JIM STERANKO. At the Stroke of Midnight. © 1968, Magazine Management Co., Inc., Marvel Comics Group. All rights reserved

JEFF JONES. Alien. © 1969, Jeff Jones and Witzend by the Wonderful Publishing Company

112

MA YUAN. Landscape with Bridge and Willows. Sung Dynasty, early 13th century. Ink and colors on silk, $9\frac{3}{8} \times 9\frac{5}{8}$ ". Museum of Fine Arts, Boston

113 CLARE LEIGHTON. Dawn in the Train. Wood engraving, $5\frac{3}{4} \times 7\frac{1}{2}^{n}$. Museum of Fine Arts, Boston. Horatio Greenough Curtis Fund like his followers (fig. 115), was brusque, searching not after subleties of light and shade but studying their larger disposition. Since it is known that Caravaggio worked directly on his paintings, without recourse to careful preparatory drawings, it is likely that the initial sketching onto the canvas was similarly bold, perhaps something quite like figure 115.

In learning to draw, it is important for art students to come to the understanding that the big relationships are primary. If the general effect is plain, precise detail is relatively easy to attain, but no amount of fussy detail will convey an impression of reality. Such itemizing may be charming (fig. 116), may even possess its own distinctive kind of genius; but it does not provide a convincing illusion. Many amateur works of art look naive because the painter has approached his subject "backwards."

The reduction of the complex world of light and shadow into simpler contrasts also has the effect of packaging the volumes more coherently than they come to us in ordinary life. For example, look at Vermeer's *Head of a Young Girl* (fig. 117). Jan Vermeer van Delft (1632–1675) may be the very greatest master of light and shade. He modeled his forms with such certainty that this girl seems extant in space as no real person could ever be. The volumes are so explicit that one knows almost exactly how this head would look if the girl were in profile or if she were looking up or looking down.

Whenever in painting a light meets a dark, an accent is obtained, just as a contrast in tone creates an accent in a musical sequence. When this accent is formed by the junction of two areas, one uniformly light relative to another that is uniformly dark, an apparent change of plane occurs. In other words, if nothing else opposes the illusion, such a contrast is read as though it were a corner carved

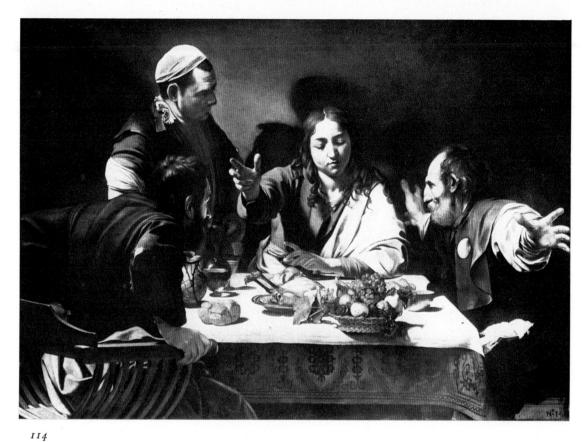

CARAVAGGIO. Christ at Emmaus. c. 1598. Oil on canvas, $55 \times 77\frac{1}{2}''$. The National Gallery, London

115 FOLLOWER OF CARAVAGGIO. A Feast. 17th century. Pen, brown ink and wash, $6\frac{1}{2} \times 7\frac{3}{4}''$. Achenbach Foundation for Graphic Arts. California Palace of the Legion of Honor, San Francisco

116

HENRI ROUSSEAU. The Dream. 1910. Oil on canvas, $6'8\frac{1}{2}'' \times 9'9\frac{1}{2}''$. The Museum of Modern Art, New York. Gift of Nelson A. Rockefeller

117

JAN VERMEER. Head of a Young Girl. c. 1665. Oil on canvas, $18\frac{1}{4} \times 15\frac{3}{4}^{"}$. Mauritshuis, The Hague

from space. Thus, in figure 118 we have a Y in a hexagon, but with one segment darkened we have a cube (figure 119). Whether such a corner seems carved into space or seems to project outward depends on its relation to the other contrasts. Thus, had Vermeer darkened the top of the young lady's nose instead of its side, the nose would appear to be a hideously deep scar. As this suggests, darkening the nose on its side-the side corresponding to the dark side of the face-made it stand away from the head. Likewise, placing a continuous series of accents over the turban, down the forehead, by the eye, down the neck, and across the shoulder creates the impression that the planes to either side are moving back into a dark void. The girl's head and body constitute one large volume containing smaller volumes (like noses and ears) and are not merely aggregations of little details.

Of course, it is not really possible to describe the Vermeer in terms of light versus dark. There are all sorts of in-between tones; some parts of the shadow are darker than others, some lighted surfaces are much lighter than others, and everywhere there are transitions. The technical term in physics for a space of partial illumination between perfect shadow and full light is *penumbra*. This is the term applied to the "twilight" area of the moon, to the hazy edge of an eclipse, and also to graduations from dark to light in pictures.

Figure 120 illustrates the traditional way of describing form as it is revealed by light and shade. The *highlight* represents a reflection of the light source; it is nearly pure white. On a dull surface the highlight will not be reflected in so clear a fashion; it is then merely part of the *light* area. The *penumbra* provides the transition to what is known as the *umbra* (or core of shadow). The *cast shadow* is, of course, the shade of the object on another surface and is usually the darkest of all these components. The final element is *reflected light*.

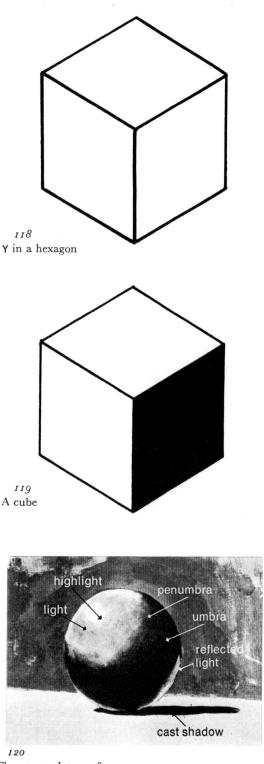

The nomenclature of chiaroscuro

Reflected light is perhaps less well understood by laymen than are the other components of chiaroscuro. So far as that is concerned, the paintings by Jan van Eyck and Vermeer at which we've been looking contain hardly any reflected lights. The Caravaggio (fig. 114) has some, but they are not treated in a very obvious fashion. The most familiar demonstration of reflected light is the child's game where a dandelion is held beneath the chin to see whether the subject "likes butter." Invariably, a yellow glow appears. It is sunlight reflected from the blossom. In sunlit atmosphere such reflections are all around. Most people aren't aware of their presence, but without them things on earth would look a good deal more stark than they do. In fact, the absence of an atmosphere on the moon decreases the chance for reflection with predictable consequences-the shade is black. The photographer, in his studio, often uses both a primary and a secondary light source in order to enhance his illusions, with the secondary source doing duty for reflected light. But the value to artists of representing reflected light goes beyond the duplication of sunlit reality.

Michelangelo's *Creation of Adam* (fig. 121) makes good use of reflected light on the upper arm of God the Father. Without the glossy light touching the curve of His triceps, the thrust of the entire arm would be less powerful. And a similar treatment of God's right leg brings the leg out from the mass of nudes supporting Him. In the same way, the glisten of a light under God's left wrist helps distinguish His arm from the background. These reflected lights also help continue certain linear patterns which compose the picture into a unified whole.

Ivan le Lorraine Albright of Chicago (born 1897) paints "uglies" (fig. 122). Even his paint surfaces look corrupt. And his shadows have the phosphorescent glow of utter putrefaction, a unique use of reflected light.

The Spaniard whose name is synonymous with the bizarre in art, Salvador Dali (born 1904), has turned chiaroscuro into a game in his *Apparition of a Face and Fruit Dish on a Beach* (fig. 123). What seems one thing is quickly

121 MICHELANGELO. The Creation of Adam. 1508–12. Fresco. Sistine Chapel, Vatican, Rome IVAN LE LORRAINE ALBRIGHT. Into the World Came a Soul Called Ida. 1929–30. Oil on canvas, $56\frac{1}{4} \times 47''$. The Art Institute of Chicago. On permanent loan from the Collection of Mr. and Mrs. Ivan Albright

122

123

SALVADOR DALI. Apparition of a Face and Fruit Dish on a Beach. 1938. Oil on canvas, $43\frac{1}{2} \times 57''$. Wadsworth Atheneum, Hartford, Connecticut. The Ella Sumner and Mary Catlin Sumner Collection

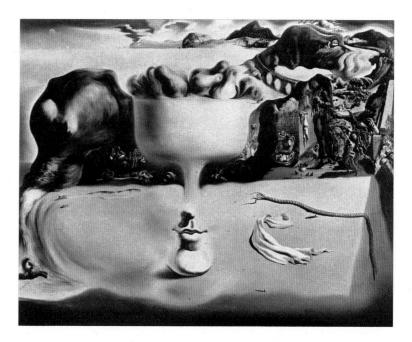

124 VIRGIL FINLAY. Untitled. Courtesy Mrs. Virgil Finlay

transmuted into another. Take the bridge over the river at the upper right. It is also a dog's collar! A little attention will reveal the entire animal. The hole through the hillside is the dog's eye. His hindquarters seem to be of a holocaust at sea. Dali accomplishes these shifts of meaning through a clever use of the principles of chiaroscuro, turning one set of lights into relative darks (in the sea scene, for instance), making the reflected light serve double duty, and so on. It is very ingenious, if rather tricky and superficial.

The mechanical procedures for producing chiaroscuro modeling are more easily observed in drawings than in paintings, simply because the procedures are more direct. Anyone can see how fantasy-science-fiction illustrator Virgil Finlay (1914–1971) did his ink drawing (fig. 124): very carefully.

Finlay's technique involves both cross-

hatching, in which lines are drawn over one another, and stippling, in which dots are made with the pen. His work is particularly useful in discussions of light and shade because he is a painstaking craftsman in love with simple artifice. With a kind of puritanical insistence his lines follow every curve of flesh; they are incredibly controlled as pen lines go. almost as precise as the engraved lines he imitates. The stippled dots are used to intensify a few darks and to moderate the lighter areas of the sea god's face. Notice that the illustration contains every facet of chiaroscuro. By bringing the umbra-the darkest part of a shadow-right up against the light on the girl's back, Finlay even obtains a highlight. This produces the illusion of increased whiteness nearest the dark. It is a well-known effect -Finlay is not at all imaginative in terms of artistic approaches-which can be observed in El Greco's Resurrection (fig. 19). It derives from the illusion we noted in figure 98.

The means of operation in the Finlay is the same as that in any pen-and-ink drawing, line etching, engraving, or similar image. The darkness or lightness of an area is the result of the relative density of units. Where there are more lines or dots per square inch, there is the deepest shade. Obvious? Of course. But it has some consequences. It is, for example, a good deal easier to control the relative concentration of lines or dots if a rather systematic procedure, like Finlay's, is used. In the work of professional artists you rarely see scratchy effects like those in figure 125. Normally, the artist will crosshatch by going from light to dark, building up the darks by adding new lines at different angles from the ones he puts down first (fig. 126).

In his *Self-Portrait* (fig. 127) Edgar Degas presents himself lighted from behind, his face and body in shadow faint enough to reveal his features and details of his clothing. The shading entails several levels of cross-hatching, each one growing progressively darker.

125 Pen scratches

126 Cross-hatching

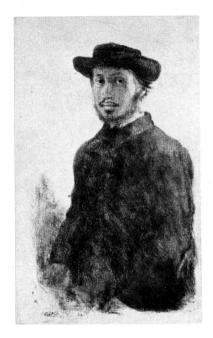

127 EDGAR DEGAS. Self-Portrait. 1855. Etching, $9 \times 5\frac{5}{8}^{"}$. National Gallery of Art, Washington, D.C. Lessing Rosenwald Collection

128

GEORGES SEURAT. Seated Boy with Straw Hat. 1882. Conté crayon, 9½×12¼″. Yale University Art Gallery, New Haven

129 EDOUARD MANET. Olympia. 1863. Oil on canvas, $51\frac{1}{4} \times 74\frac{3}{4}$ ". The Louvre, Paris First, there is the general half-light of the silhouette. It is rendered as a haze of very, very thin marks. Over this, Degas applied a layer of slightly heavier lines, following the contours of his flesh and his clothing. Finally, another set designates the darkest shadows, the eyes, mustache, beard, and so on.

A slightly later painter, Georges Seurat, did many drawings with black crayon on a very distinctively textured paper (fig. 128). One can see that he was very conscious of the crayon as a granular substance. Again, the relative density of units (in this case particles of crayon) determines relative darkness, and light and shade in Seurat's drawings take on a curiously crepuscular quality.

You may have noticed that most of the artists discussed in this chapter contrive to work with a light source that is above and to the left or right (usually to the left) of the subject. There are various advantages to proceeding in this fashion, but it is not essential to do so. Manet's Olympia (fig. 129) seems to be lighted from directly in front, as if by a flashgun; and the faint shadows curve around the edges of the model's torso, head, arms, and legs. This relationship of lights and darks can be turned to advantage by artists who wish to give an impression of the third dimension without making use of the full range of light and shade effects. Figure 130 contains some geometric solids treated in terms of a light source in panel A and, in B, on the assumption that light areas stand for advancing or protruding forms and dark ones for receding edges. B is not consistent with any real light source, not even one out front, but it is an effective way of representing the objects. Cimabue (fig. 131) and other late medieval painters attempted to convey solidity in this way, generally, but a certain timidity stood in the way of the kind of exaggeration I have employed in my drawing. That is not true of the modern painter Fernand Léger (1881-

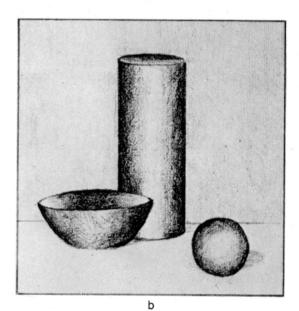

130 Shading techniques

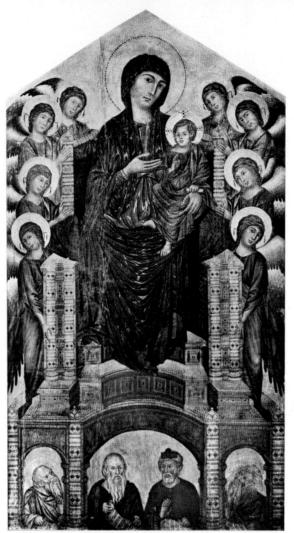

131 CIMABUE. Madonna Enthroned. C. 1280–90. Tempera on panel, 12'6"×7'4". Uffizi Gallery, Florence

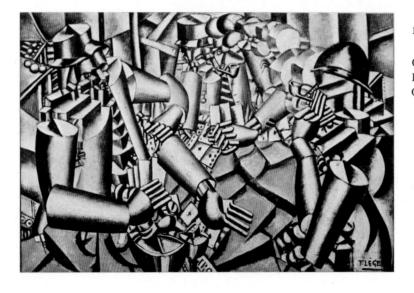

132 FERNAND LÉGER. *The Card Players*. 1917. Oil on canvas, 50[§]×76". Kröller-Müller Museum, Otterlo, The Netherlands

1955). In his *Card Players* (fig. 132) and in other works he turns everything into a series of mechanical forms by means of the same technique.

Léger also uses a related device whose basis is demonstrated in figure 133, where A is treated as if sunlit and B as the result of a simple alternation of dark-light contrasts.

What is important in every one of these images is that they depend upon contrast between light and dark. The impression can be of greater or lesser verisimilitude, depending on the degree to which the drawings or paintings approximate actual light effects; but the presence of dark-light contrast is essential. In figure 134 I have taken an exquisitely subtle still life (fig. 135) by the eighteenth-century Frenchman Jean-Baptiste-Siméon Chardin (1699–1779) and ruthlessly reduced it to gross relationships which derive from a theoretical light source and mechanical alternation of darks and lights. Despite some passages that would be inexplicable in nature-such as the darks on the wall behind the objects-the result is an image of solid objects occupying space.

The meaning of light and dark

Darkness means more to us than just the absence of light. It conjures up within our minds notions associated with the night concealment, mystery, danger, evil. In nearly every culture blackness has some identification with evil. It is not true that white racism is the sponsor of such associations;¹ they grow out of the long ages of mankind when night was filled with terrors, before artificial lighting had mitigated the hazards of darkness in the forest, on the prairie, and in the jungles. Even today the lightest streets are the safest ones.

Rembrandt's etching The Descent from the Cross: By Torchlight (fig. 136) uses light to

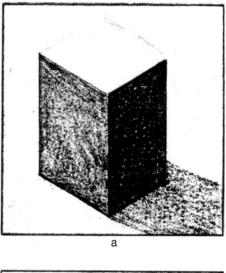

133 Treatments of a cube

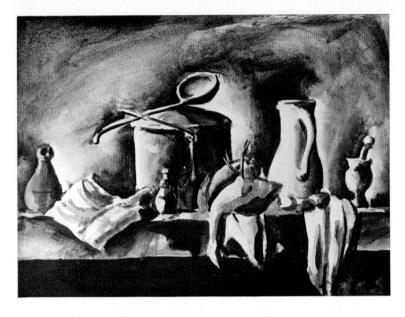

134 After Chardin's Still Life: The Kitchen Table

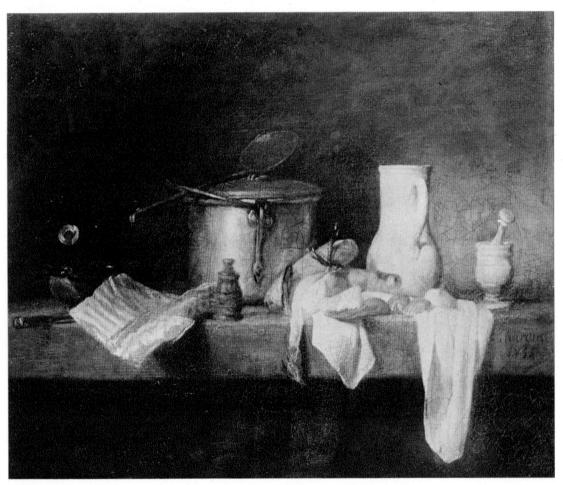

135

JEAN-BAPTISTE-SIMÉON CHARDIN. Still Life: The Kitchen Table. 1733. Oil on canvas, $15\frac{1}{2} \times 18\frac{5}{8}$ ". Museum of Fine Arts, Boston. Gift of Peter Chardin Brooks

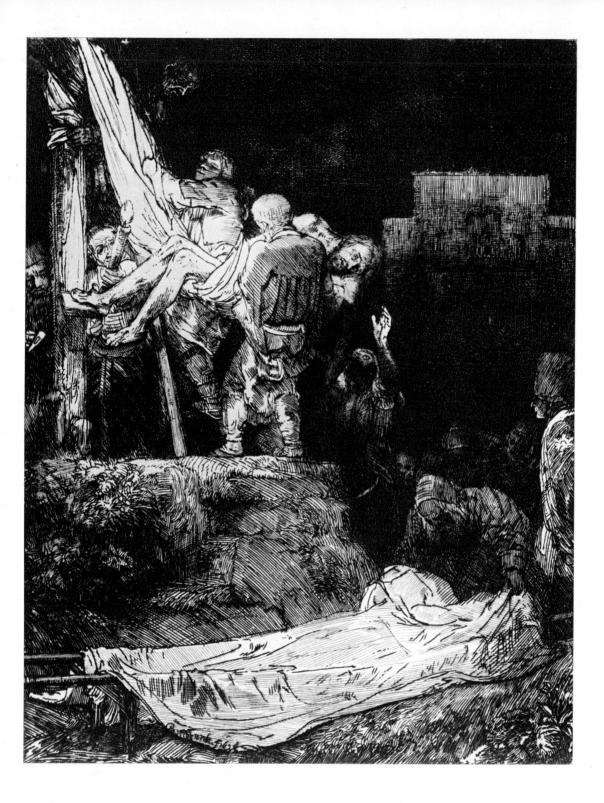

136

REMBRANDT VAN RIJN. The Descent from the Cross: By Torchlight. 1654. Etching, $8 \times 64^{"}$. Rijksmuseum, Amsterdam

dramatize the scene and also to heighten the symbolic meaning of the event. Whiteness is associated with Christ, the Light of the World, and darkness with the great sin of humanity. The hand raised to receive Christ's head is as eloquent as the ancient symbol of the drowning man; it reaches out of the gloom as if in hope of salvation.

The Spanish painter Francisco Goya (1746–1828) makes use of dramatic lighting in a rather similar fashion. In The Third of May, 1808 (fig. 137), representing French troops crushing a rebellion by the people of Madrid, the principal victim is in the center of a veritable explosion of light. The effect is all the more striking because his flesh is dark. He throws his arms out in a gesture of defiance and signifies that he, like Christ, is being "crucified." In the distance a tiny cross on a church building drives home the point. The firing squad is shadowy and featureless: the soldiers have no individual personalities; they are merely instruments of French imperialism, the tools of the oppressor.

Works of art that are highly dramatic, such

as the Goya, the Rembrandt etching, Tintoretto's Last Supper (fig. 80), or El Greco's Resurrection (fig. 19), frequently contain areas of extremely high contrast. Usually the drama is produced by bright light in dark surroundings. But once in a while the artist will do the opposite and show us a dark shape against the light, as Richard Corben does in his underground comic strip Rowlf (fig. 138), as Théodore Gericault (1791–1824) did in his famous Raft of the "Medusa" (fig. 139), and as Honoré Daumier (1808–1879) did in The Laundress (fig. 140). In any case, the extreme contrast between dark and light areas makes for a highly charged impact.

Not all painters wish to be so dramatic as Goya or Tintoretto, and not every subject lends itself to collisions between dark and light. The later works of the Englishman J.M.W. Turner (1775–1851) are so light as to approximate luminous phantoms on the canvas (see figure 141). The typical Rembrandt tends towards gloominess. An American painter, the late Ad Reinhardt (1913– 1967), did abstractions so dark that when you

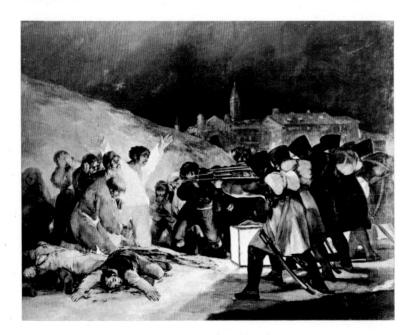

137 FRANCISCO GOYA. The Third of May, 1808. 1814-15. Oil on canvas, $8'8\frac{3}{4}'' \times 11'3\frac{7}{8}''$. The Prado, Madrid

138 RICHARD CORBEN. Rowlf. © 1971, Richard V. Corben

139 THÉODORE GÉRICAULT. The Raft of the "Medusa." 1818-19.Oil on canvas, $16'1'' \times 23'6''$. The Louvre, Paris

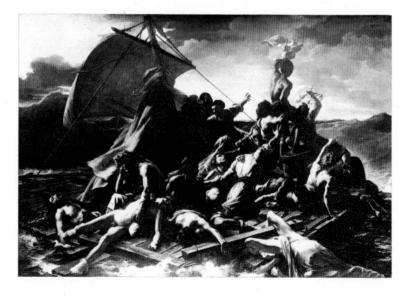

140 HONORÉ DAUMIER. The Laundress. c. 1861. Oil on panel, $19\frac{1}{4} \times 13''$. The Louvre, Paris

141

JOSEPH MALLORD WILLIAM TURNER. The Dogana, San Giorgio Maggiore, le Zitelle, from the Steps of the Europa. 1842. Oil on canvas, $24\frac{1}{2} \times 36\frac{1}{2}$ ". The Tate Gallery, London

142 AD REINHARDT. Abstract Painting, Blue. 1952. Oil on canvas, $75 \times 28''$. Museum of Art, Carnegie Institute, Pittsburgh

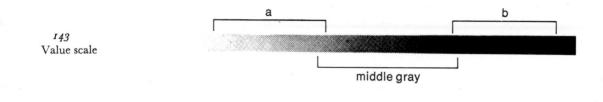

walk into a gallery full of them your first impression is that the place has been hung with dark brown and black rectangles (see fig. 142). His pictures contain very, very somber rectangles, and there is a kind of magic in their emergence out of sunless depths.

Paintings and photographs in which the majority of tones are, like Turner's, lighter than a middle gray (fig. 143A) are called high key. Those in which most of the tones fall below middle gray (fig. 143B) are referred to as low-key pictures. (These terms have nothing to do with tension and relaxation; they refer only to the comparative lightness or darkness of things.)

The key of a painting has an important bearing on its general character. It is not altogether true that dark paintings are sad and light ones joyous, although there is a kind of affinity between the mood and the key. It is true, though, that the representation of miniscule detail can be achieved only in the lower register. Notice that the two most detailed works we've so far examined, the Harnett (fig. 144) and the Van Eyck (fig. 145), are dark.

144

WILLIAM HARNETT. After the Hunt. 1885.

Oil on canvas, 11×48". California Palace of the Legion of Honor, San Francisco. Gift of H.K.S. Williams to the Mildred Anna Williams Collection

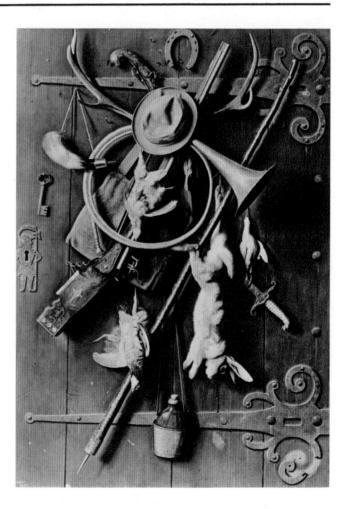

145 JAN VAN EYCK. Giovanni Arnolfini and His Bride. 1434. Oil on panel, $32\frac{1}{4} \times 23\frac{1}{2}''$. The National Gallery, London

The impression of complete and absolute fidelity to nature achieved in a work like After the Hunt derives from the artist's handling of the sparkle of reflections on the various surfaces. For it is in the treatment of the reflection of the light source that the variety of textures is revealed. The same thing is true of Giovanni Arnolfini and His Bride. But, since the highest possible highlight is nothing but white pigment, it is necessary that lightness not be approached too rapidly. The reason for this has to do with something we barely touched on earlier. I mentioned above that there would not be distinct highlights on a dull surface, that the highlight there would be merely a part of the lighted area. The art historian E. H. Gombrich once made use of an old-fashioned textbook example similar to figure 146 to make a point about the difference between light and luster. The way light falls on an object reveals its form. The way the object's surface reflects the light reveals 146 Light and luster

its texture. The matt-surfaced top hat exemplifies light's operation; the shiny silk top hat is filled with highlights that are reflections of the light source distorted by the curvature of the tissue of fabric.

It is a commonplace of art criticism that works like the Harnett and the Van Eyck are less secure in rendering forms in space than are works in which surfaces have not been treated with such miraculous precision. Thus, a Masaccio (fig. 147) is far more solid-looking than a Van Eyck, although not nearly so detailed. When Caravaggio, in his *Christ at* *Emmaus* (fig. 148), placed his objects on a table, moving back into space, he sacrificed some of the illusion Harnett retained. The Harnett is convincing partly because it is shallow, because the need to use dark and light to handle spatial relationships has been suppressed.

You will notice that in figure 146 the highlight of the matt-surfaced hat is no less white than the highlight on the shiny one. Consider then my treatment of a jewel (fig. 149). In AI have painted the jewel so as to reveal its form, without indicating anything of the tex-

147

MASACCIO. The Tribute Money. C. 1427. Fresco. Brancacci Chapel, Sta. Maria del Carmine, Florence

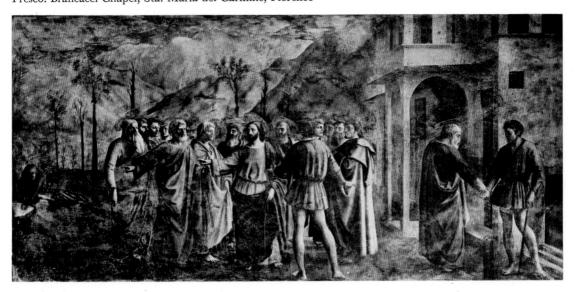

148 CARAVAGGIO. Christ at Emmaus. C. 1598. Oil on canvas, $55 \times 77\frac{1}{2}^{"}$. The National Gallery, London

149 Pale and dark underpainting

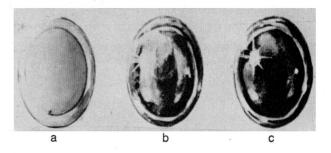

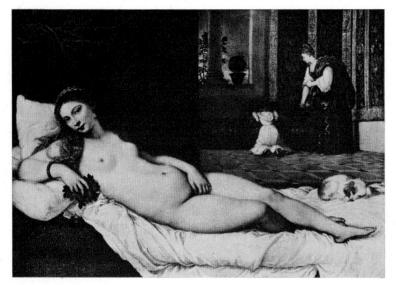

150 TITIAN. Venus of Urbino. 1538. Oil on canvas, 47×65". Uffizi Gallery, Florence 151 EDOUARD MANET. Olympia. 1863. Oil on canvas, $51\frac{1}{4} \times 74\frac{3}{4}$ ". The Louvre, Paris

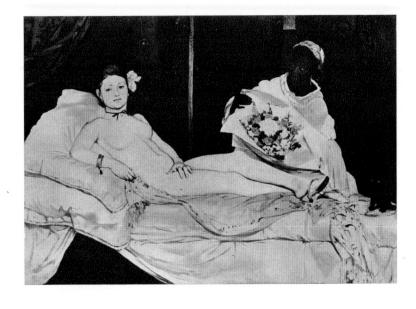

ture. In B I have tried to render the texture with A as my basis. But the highlights don't sparkle as they should; the gold setting has none of the sheen of real metal. The image in C is much more convincing simply because I began with a lower-key representation of the form and could, therefore, vary the lightness of the highlights, achieve different contrasts, and simulate the flashing variability of vision. This condition prevails for all renderings of meticulous detail. You can't have high-key pictures that are impressively detailed in the way that the Harnett and Van Eyck are.

The condition of relatively far-ranging

contrast between the highest light and the darkest dark holds for all powerful illusions of three-dimensionality too. This is the reason that the Masaccio looks more solid than the Van Eyck. Masaccio didn't expend his highest lights on detailing; he used them to model bold forms in space. It is also the reason that Titian's *Venus of Urbino* (fig. 150) gives an impression of roundness and fullness that the more photographic *Olympia* (fig. 151) does not.

Manet, however, was onto something else. But it is something that cannot be understood without an understanding of color theory, the subject of the next chapter.

5 Color

In our discussion of light and shade we were already dealing with color theory, for lightness and darkness are aspects of color. Everyone must be aware of that. Navy blue is dark and sky blue is light, and all that the two colors share is their common blueness. In every other respect they are different. Scarlet is different from crimson, but both are reds. If we want to be precise in our description of a color, we must refer to three specific attributes: (1) the value, (2) the hue, and (3) the intensity. I would describe a "passion pink" as having a high value (it is light) and being in the hue of red at full intensity.¹ Since we are going to be talking about some features of painting that depend upon hue and intensity as well as dark-light relationships, it will be necessary for you to understand exactly what the terms mean.

Before getting into a more elaborate discussion of the meaning of value, hue, and intensity, however, I wish to remind you once more that the painter is not working with light; he is using pigments. Of course, he sees only in terms of light rays, like everyone else, but he cannot imitate light effects in a direct way. What is true of the brightness

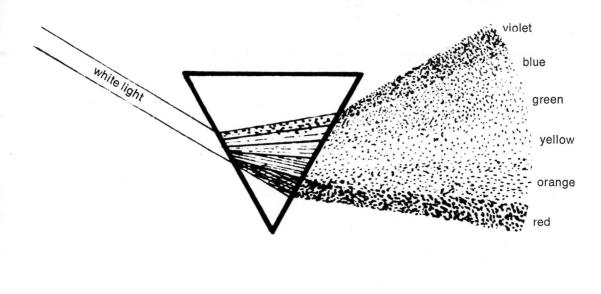

of sunlight as compared with the brightness of white pigment is true of everything else in painting. For instance, in light theory the presence of all colors equals white light, but if I were to mix all the colors on my palette together, I'd end up with a dark brown muddle. White light, when broken down into its components by a glass prism (fig. 152), produces a full range of spectrum colors: violet, blue, green, yellow, orange, red, and all the intermediate gradations. White light striking white pigment reflects back almost entirely, while nearly all of it is absorbed by dull black paint. Red paint absorbs all the white light except red; the red is reflected back to our eyes and therefore we see the paint as a red area. Of course, this doesn't apply just to paint. It applies to everything. Lemons absorb everything but yellow, the green felt on a billiard table reflects back nothing but green. (To ask what these substances "really" look like makes no sense. That is like wondering what a guitar sounds like apart from the sensations it produces in the ear, or asking what sugar tastes like apart from what it does to the taste buds in the mouth.)

We have already discussed value at some

length because it is the basis of chiaroscuro. There will be more to say about it, but color is most easily approached by beginning with the notion of *hue*.

Hue

Hue is what most people think of when they think of color. When you are arguing with a friend about whether a sports car you saw was blue or blue-green, you are arguing about the hue. A simple way of describing hue would be to say that it represents a segment of the spectrum. In discussing color, artists often make use of a color wheel (colorplate 1). This is nothing more than the hues of the spectrum bent into a wheel. (There is, however, one color in the wheel that does not appear in the rainbow of hues the prism gives us. Red violet is used to tie the ends of the spectrum together into a circle.) It would be possible to make the circle of hues continuously graduated into one another, but it is customary to divide color wheels into twelve units.

You will notice that three of the hues are

labeled with the numeral *I*, three with a 2, and six with a 3. The colors labeled with a *I* are called *primary hues*. You cannot mix these from any other hues; you must begin with them. Given these three primary colors, red, yellow, and blue, you can mix any of the other hues.

If you mix two primaries together in equal amounts, you will get one of the hues labeled 2, hence the name secondary hues. Red+ vellow=orange. Yellow+blue=green. Blue +red=violet. And, of course, the hues labeled 3 are the tertiary hues, the mixtures standing between the primaries and secondaries. Red+orange=red-orange. Orange+ yellow=yellow-orange, and so forth. By adding a little more red to the orange one gets a redder red-orange, a scarlet. By adding quite a lot of red to a red-violet you can produce a red red-violet, a crimson. All such intervening colors are referred to as *tertiary* hues even though the number of variations is infinite. All of them are the result of combining any two of the three primaries.

Hues that are very similar—adjacent to each other on the color wheel—are called analogous hues. Analogous relationships always involve a tertiary color, since these fall between primaries and secondaries. Analogous hues tend to be harmonious and restful when used together in a design. Orange and Yellow (colorplate 2) by Mark Rothko (1903 -1970) has an analogous color scheme involving oranges, red-oranges, yellows, and yellow-oranges. Those luminous rectangles float effortlessly, tensionlessly, in a cottony atmosphere.

The Last Supper (colorplate 3) by Emil Nolde (1867–1956) is different from the Rothko in many ways, but one of the most striking differences is in the color organization. Nolde's painting is the opposite of an analogous design; the hues are highly contrasting. Greens and reds, yellows and violets, contest for our attention in much the way that dark and light do in Tintoretto's *Last Supper*. Nolde's color scheme is a *complementary* one involving hues that are complements, that is, directly opposite each other on the wheel. The effect is one of excitement and intensity.

Rarely do artists work exclusively with analogous hues or complementary ones. More often they use complex arrangements in which analogous areas contrast with each other or in which zones of highly contrasting hues are played off against harmonious ones. In Picasso's *Girl Before a Mirror* (colorplate 4) the mirror image is made up of analogous hues, and the background and the girl herself are constituted of complementary and primary contrasts. *Girl Before a Mirror* is a particularly bold and well-orchestrated example of such balance, but you will find some hint of this kind of equilibrium of hues in most paintings.

Another feature of color is the relative warmth or coolness of hues. The identification of reds, yellows, and oranges as warm colors, and blues, blue-greens, and violets as cool colors, derives no doubt from our experience of nature. Extremely hot things are usually red or orange, and the ocean, the sky, distant mountains, and ice cubes are bluish. Artists have come to term hues lying toward the red-orange side of the color wheel "warm" and those lying toward the blue-violet end "cool." Within the various hues, too, there are different temperatures; a red-violet is a cooler red than a red-orange and a yellowgreen is warmer than a green. But the connection between hues and actual temperature is extremely vague-as observe "white heat" and "blue flames." For the moment it is best to consider "warmth" and "coolness" as descriptive of the placement of hues on a spectrum or color wheel and ignore the other implications.

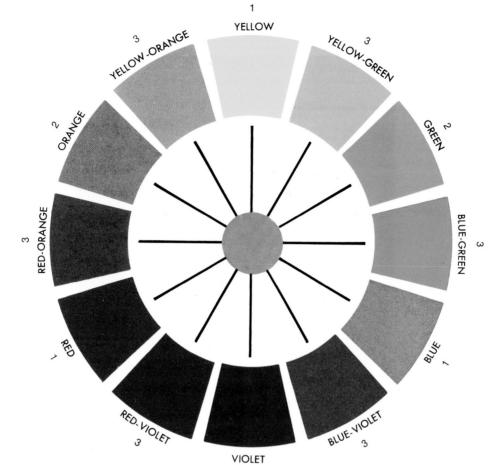

2

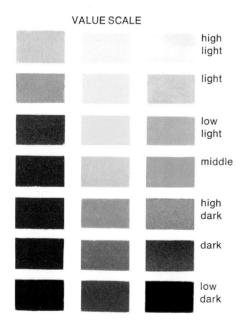

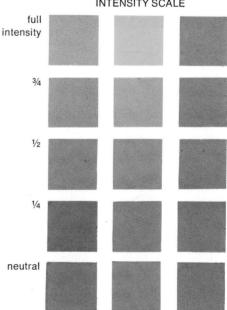

INTENSITY SCALE

Colorplate 1 Color wheel

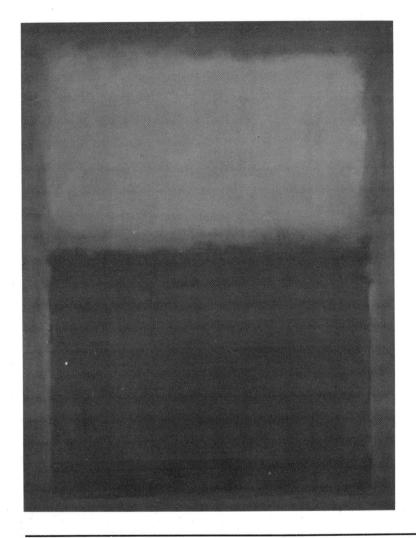

Colorplate 2 MARK ROTHKO. Orange and Yellow. 1956. Oil on canvas, $91 \times 71''$. Albright-Knox Art Gallery, Buffalo, New York. Gift of Seymour H. Knox

Value

Value refers to the lightness or darkness of a color. The hue of a color depends on the kinds of white light rays the color absorbs and which one or ones it reflects back. The value of a color depends on how *much* of the light is absorbed. Pure violet absorbs far more light than pure yellow. If we wish, however, we can lighten the violet to the point where it is as light as pure yellow by introducing white into it. When this is done, the resultant color, orchid, is a *tint* of violet. A tint of a hue is a lightened version of the hue. There are

various ways of darkening the yellow. We could add black to it, for instance. A yellow so darkened would be called, technically, a *shade* of yellow. (Yes, I know, paint salesmen and interior decorators, among others, use the terms *tint* and *shade* interchangeably. Color theorists don't.) Generally speaking, artists do not add black to hues to darken them, because it deadens them. All the same, the term for a color darkened by the addition of black is *shade*.

There is very little to be said about dark and light values in art that we have not already covered. In colorplate 1 a value scale gives an indication of possible comparisons and contrasts among hues. Needless to say, the lightest of all colors is white and the darkest is black. (These *are* considered colors even though they have no hues.)

Intensity

Of all the attributes of color the most difficult to explain is intensity. *Intensity* is the term used to describe the brightness or dullness of a color, and there is a tendency for people to confuse intensity with value. But if you look at the intensity scale that is shown in colorplate I, you will realize that intensity has to do with how much of the hue is present in a given color sample. Anything you do to a color that neither tints it nor changes its hue will vary its intensity. That is, if you mix white into a pure red, you tint it: it becomes a bright pink.² If you mix yellow into red, you modify the hue: the red turns into redorange or orange. If, however, you add black to the red, you change its shade and also its intensity (it becomes less bright), but you do not change its hue. And, as odd as it may seem, the introduction of green into the red also will make the red duller without changing the hue.

Look at colorplate 1 again. Notice that the colors at the top of the intensity scale are quite bright and that they decrease in bright-

- Colorplate 3

EMIL NOLDE. The Last Supper. 1909.

Oil on canvas, $33\frac{7}{8} \times 42\frac{1}{8}$ ". State Art Museum, Copenhagen

Colorplate 4

PABLO PICASSO. Girl Before a Mirror. 1932. Oil on canvas, $63\frac{3}{4} \times 51\frac{1}{4}$ ". The Museum of Modern Art, New York. Gift of Mrs. Simon R. Guggenheim

ness as they go down. The value of all the squares is the same; only the brightness has changed. And the bottom square in all three rows is a "neutral," a gray. The neutral in the left column is the dullest orange it is possible to have. Similarly, the last square in the second row is as dull a green as you can get. In the same way, the lower-right-hand square is the dullest of all violets. It is also the case that the gray squares are, respectively, the dullest blue, red, and yellow possible. In fact, the neutral in the left-hand column is the product of an equal mixture of orange and blue (tinted to maintain the value of the original orange). Likewise, the neutral in the next row is a mixture of green and red, and in the right hand row it is a mixture of violet and yellow. Those particular hues "neutralize" each other when they are mixed. It is no accident that they do or that these six hues predominate in our two scales. They are complements.

Complements are not merely what are across from each other on a color wheel. They can be defined in other ways. If you are in doubt as to what the complement of, say, yellow is, you have only to think of what hue would be produced by the two primaries not present. In this case the two left out are blue and red, which mixed make violet. Violet is the complement of yellow, and yellow the complement of violet. Red's complement is blue plus yellow, that is, green. Orange is a mixture of red and yellow; its complement is blue. Obviously, a neutral can also be produced in other ways than by mixing two complements: the three primaries can be combined, or black and white can be mixed. But one can obtain far richer grays-warm,

cool, soft, or clear—by mixing complements in equal amounts and adding white. Black tends to deaden colors as well as dull them, and painters use it very sparingly indeed.

An artist's usual means of dulling a color is to mix into that color its complement. And, since shadows on objects are not only darker than lighted areas but also duller, it is typical for a realistic painter to paint them by dulling the color of the object with a bit of the complement. In other words, the shadow on a green vase will be green with a good deal of red mixed into it. What this produces in layman's terms is frequently a "brown." If you study the intensity scale in colorplate 1, you can observe that brown is nothing but a step on the way to the neutral. In colorplate 5 I have used black to indicate shadows. In colorplate 6 I have used complements except on the white cloth, where dull bluish tones predominate. The latter rendering surely looks more realistic to you than the other one. At any rate, it more nearly resembles a color photograph of the objects. But this doesn't necessarily mean that the objects would look this way to you in fact. Eyesight is far more sensitive than color film.

Fugitive sensations

The eye perceives things no camera could ever see. Jasper Johns (born 1930) has painted many pictures of the American flag. Here (colorplate 7) he used peculiar colors. Stare at the dot on the flag for one minute. Then switch your gaze to the black dot below. Ah ha! There it is, Old Glory, rather

Colorplate 8 Simultaneous contrasts

shifty and pale but in its normal hues. Johns has made use of a so-called fugitive sensation, in this case an afterimage. If you look at the sun in the sky, you'll experience the same kind of thing, a black dot floating around in front of your eyes for a few moments afterward. The eye remembers strongly impressed images in terms of their opposites: for the brightness of the sun, darkness, for colors (as in the case of Johns' flag), their complements (blue for orange, red for green, white for black). The technical name for the experience of such a fugitive sensation is *successive contrast*.

A related phenomenon is simultaneous contrast, the tendency of a color to induce its opposite in hue, value, and intensity in an adjacent color. In colorplate 8 identical grav circles appear slightly different due to operation of this effect. The one set in violet surroundings seems slightly yellowish and lighter than it really is; the circle in the red field is identical to the one in violet but appears greenish and also darker. The red dot on the yellow seems cooler and darker than the red background of the second square, but it is in fact the same. The same color red dot in green surroundings seems the reddest of all because the complement of green is red, and the green, therefore, reinforces the brilliance of the dot.

Pigments

All artists' pigments are substances which have been ground up into powder and are then mixed with a vehicle such as linseed oil to make paint. It would even be possible to make pigments from plate glass, but as it happens, colored glass would not make very good paint. It is not nearly as intensely colored as commercial pigments and would not have much tinting strength. To have covering power, a pigment must have a higher

refraction index than the vehicle in which it is suspended. Refraction index is the technical term for the relative change in velocity of light caused by its deflection when passing through a substance. (In other words, how much does it slow down?) The refraction index of boiled linseed oil is in the neighborhood of 1.5. If the particles mixed into it have a similar or lower refraction index, the light will pass through them with little change in velocity and to the human eye it will be just as if the particles were absent, even though the viscosity and other properties of the oil have been altered. Plain window glass, finely ground, has a lower refraction index: it takes the form of a brilliant white powder, but when mixed with oil, this powder produces a paint with no more opacity than clear varnish. The refraction index of titanium dioxide, however, can be as high as 2.76. Titanium white oil pigment is one of the least transparent of all pigments and has extremely high covering power. Zinc white is a clearer white but has less covering power. Lead white is as opaque as titanium white but has the disadvantage of less permanence of color-over the years it yellows more than either titanium or zinc. But what is true of these white pigments also holds for pigments of other hues. Each substance has its own, peculiar attributes.

The oldest artists' pigments came from earths and other natural materials. The most permanent of all colors are the so-called earth colors. Two of these get their names from the areas in Italy where they were first dug from the soil. Tan *raw sienna* and brown *raw umber* are from the soil of Siena and Umbria. When these earths are calcined (heated to a high temperature but below the melting point), they darken into a reddish brown and dark brown respectively; then they are called *burnt sienna* and *burnt umber*. *Terre verte* (literally, "green earth") is of all greens the least brilliant and the most stable. Ochre is an earthy, impure iron ore that may be yellow, red, or orange. The best known of the ochres is *yellow ocher*, a brownish yellow about the color of butterscotch pudding.

The earth colors are cheap, but some of the pigments of the old masters were extremely valuable. Tyrian purple was ground from the glands of a snail found off the coast of Lebanon (ancient Tyre). To make even a tiny amount of the pigment so many animals were required that the color gained the name "royal purple." The original ultramarine blue was powdered lapis lazuli, a semiprecious stone worth its weight in gold. It had to be imported from the Orient, from ultra marine (beyond the sea). Today ultramarine blue is synthesized from calcined kaolin, soda ash, sulphur, and charcoal, strengthened with a little cobalt blue. Cobalt blue is cobalt aluminate. Cerulean blue is cobalt stannate. Alizarin crimson was once ground from the root of the madder plant; it is now manufactured synthetically from anthraquinone. A few colors are not pigments in the usual sense at all; the lake colors are dyes. A dye is without body; it is really only a soluble stain. Lake colors are transparent bases that have been dyed so that they can be used as paints. They have little covering power despite their brilliance, and they are frequently impermanent.

Few pigments are really permanent. Some are highly unreliable. The billiard table in Van Gogh's *Night Café* (fig. 153) was once a bright kelly green. It is now a greenish tan, possibly the result of the artist's use of a color newly invented in the nineteenth century, malachite green, made of unstable copper salts. The billiard table is an extreme example of the effects of aging on paint, but every picture changes over the years; colors darken or fade, oil vehicles grow brown and crack, watercolor papers become yellowed. Even pigments of proven permanence, such as the original ultramarine blue, will change in appearance. The degree of change will depend 153 VINCENT VAN GOGH. The Night Café. 1888. Oil on canvas, $28\frac{1}{2} \times 36\frac{1}{4}$ ". Yale University Art Gallery, New Haven. Bequest of Stephen C. Clark

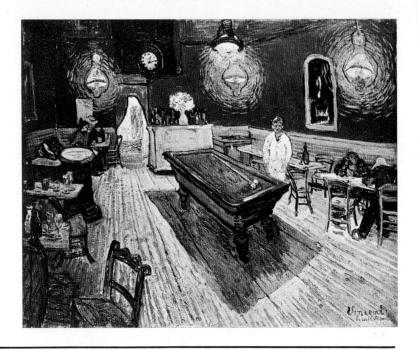

upon the vehicle the pigment is mixed with. Tempera paint changes less in appearance over the years than oil paint because the vehicle for the pigment is less subject to change. The only difference between ultramarine blue oil paint and ultramarine blue tempera paint is the substance with which the powdered lapis lazuli is mixed; the pigment remains the same, only the medium that binds the particles together differs. Over the centuries ultramarine ground in oil will *appear* to have changed color more than ultramarine ground in tempera.

Since the appearance of pigment color is dependent on so many variables other than the hue of the powder itself, it should not surprise you to learn that few paints actually correspond to theoretical color systems. It is easy enough to say that equal amounts of red and green will produce a neutral, but in fact an ounce of red paint and an ounce of green will not necessarily turn out to be an indeterminate neutral when mixed. Black introduced into yellow doesn't just darken it; it also turns it green. Contingent factors such as the refraction index of the pigment and its vehicle, the size of the pigment particles, and the chemical purity of the substances make the painter's art less dependent on theory than on craftsmanship. Painters don't speak of red paint or yellow, but of cadmium red, alizarin crimson, and of cadmium, zinc-, or Naples yellow. To secure a "true" red, you must mix a little alizarin into the cadmium red. Cadmium yellow is a golden hue, zinc a lemon yellow. Naples yellow is a beautiful creamy tone made of lead and antimony.

Historic combinations and consequences

Although the three main attributes of color hue, value, intensity—are all important to any painting, throughout most of history the fundamental character of painting has been governed by value relationships. After all, a person blind to hue can see the world. But without contrast between darks and lights vision cannot exist. Were it otherwise, we should have had to use color reproductions throughout this book, which would have raised its cost enormously. As it is, black and white adequately defines the works and so serves our purposes. Saying Grace (fig. 154) by Norman Rockwell (born 1894) involves skillful juggling of darks and lights. It is primarily through the value relationships that we understand the picture. The glare of light along the top of

154

NORMAN ROCKWELL. Saying Grace. 1951. Oil on canvas, 43×40". Courtesy Ken Stuart, New York, and Norman Rockwell

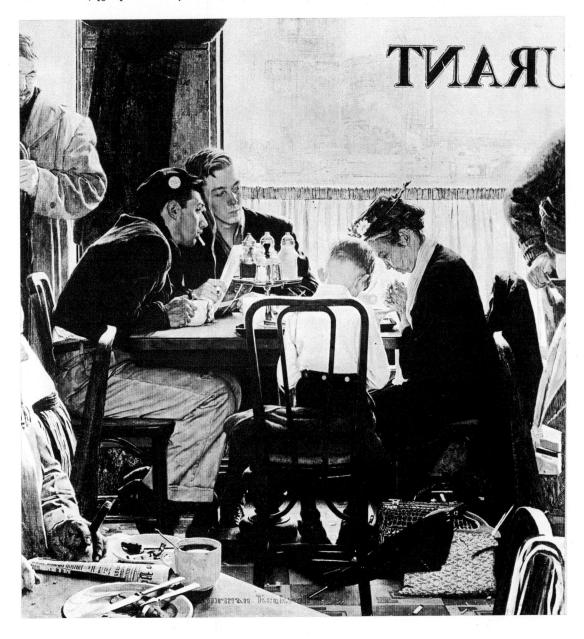

the little boy's bentwood chair back draws our attention to the center of interest in the illustration. Actually, that highlight is no lighter than the highlight along the café curtain at the window, but it seems lighter because the adjacent area is so dark. Simultaneous contrast is being used here to intensify the impression of brightness. Thanksgiving day beyond the window is overcast but still fairly bright. The high key of that area of the picture tells us everything we need to know. And it is kept in harmony with the interior contrasts by means of the last part of the word restaurant lettered on the glass. That the hue of things is rather unimportant is evidenced by the low intensity of the reds and greens which predominate in the color scheme.

We have already used Caravaggio's *Christ* at Emmaus (fig. 114) to exemplify chiaroscuro. It is a far more complicated work than Rockwell's magazine illustration, and hue and intensity play a larger role in the Caravaggio—in the handling of the still life objects on the table, the fabrics, and the flesh. But, still, hue and intensity of color are ancillary to the values. In black-and-white reproduction more of the qualities of the Caravaggio than of the Rockwell are lost, but not so many that one feels the reproduction is utterly false. The small painting of the Vatican from across the Tiber River (fig. 155) by Jean-Baptiste-Camille Corot (1796– 1875) loses something without the dull bluegray sky and melodious umbers and siennas of the original, but not enough to give art critics the shakes. It, too, is primarily a work of neutralities managed in terms of dark and light.

With Manet's Olympia of 1863 (fig. 156) a new thrust occurs. Good color reproductions of it are hard to come by and never adequate. This is because the hue of the colors is so important to the character of the painting. I remarked earlier on the absence of genuine chiaroscuro in the Olympia. The modeling of the nude is so delicate, the shading so lean and pale, that in contrast to Titian the forms are not at all solid-looking. But Manet turned what conservative critics of his day considered a weakness into what present-day critics consider a strength. He deliberately suppressed volumes by his method and virtually eliminated transitions from dark to light.

Chiaroscuro inevitably attenuates the brilliance and purity of colors—that is, it dulls them or otherwise weakens them. Surely,

155 JEAN-BAPTISTE-CAMILLE COROT. Bridge and Castle of St. Angelo with the Cupola of St. Peter's. 1826–27.

Oil on paper, mounted on canvas, $8\frac{5}{8} \times 15''$. California Palace of the Legion of Honor, San Francisco. Collis Potter Huntington Memorial Collection

EDOUARD MANET. Olympia. 1863. Oil on canvas, $51\frac{1}{4} \times 74\frac{3}{4}$. The Louvre, Paris

that is obvious. Just lowering the value of a flesh tone lowers its intensity. Adding white makes it less vibrant. And, in any case, what is most obvious about traditional painting techniques is their reliance on dark-light relationships. That is why black-and-white photographs do them some justice. In his Olympia Manet has virtually eliminated chiaroscuro. Its absence means that the color can be rich even when it is not particularly intense. The nude's body is not strongly modeled and gives little impression of threedimensionality, but, despite this, the color of the figure is powerful because of its consistency and its contrast to the dark surroundings. The clarity of the zones of color is achieved through lightness of values against

dark contours. The final impression is of clear tints spread over the canvas, with a few very bright notes in the flowers and bedspread accenting the purity of the other tones in the composition. The importance of this general effect to the history of art would be difficult to exaggerate. Within thirteen years young radicals considered Manet the spearhead of a new movement in painting. It is no exaggeration to say, as Lionello Venturi did, that Manet is the foundation of modern painting.

If we understand that *something* in the real world of light must always be sacrificed to the nature of pigment when painting a picture, it should be easy to see that the sacrifice is not exclusively relative darkness or light-

Colorplate 9 CLAUDE MONET. Haystack at Sunset Near Giverny. 1891. Oil on canvas, $29\frac{1}{2} \times 37''$. Museum of Fine Arts, Boston. Juliana Cheney Edwards Collection

ness. The hues of the rainbow, the intensity of reflected light, cannot be duplicated with paint any more than the radiance of the sun can be applied to canvas. It was absolutely necessary for the masters of chiaroscuro to give up all sorts of hues and many levels of intensity in order to paint their highly modeled surfaces. The same thing is true of color photography: it cannot capture the subtleties of the hues the eye takes in.³ Manet, to some extent, abandoned the modeled surface. He opened the way to a different sort of sacrifice: the giving up of extreme contrasts of value in favor of a play of varied hues and increased intensity of color.

The painting of a haystack at sunset (colorplate 9) by Claude Monet (1840–1926) may strike you as completely fantastic. The color may seem to you merely ornamental. It isn't; in fact, the picture is a kind of super color-realism. These hues actually do occur in one's visual field, but most of us are not accustomed to paying attention to their existence. Some of them are fugitive sensations; Monet rendered these as faithfully as older painters did solid objects. He once said in an interview: "Try to forget what objects you have before you.... Merely think, here is a little square of blue, here an oblong of pink, here a streak of yellow, and paint it just as it looks to you, the exact color and shape, until it gives your own naïve impression of the scene before you."

It would be difficult to exaggerate the revolutionary character of Monet's method. For, while it represented no more than a logical extension of traditional realism, it accepted things that every authority had said should not be countenanced by painters. The picture is full of optical effects that are usually considered illusory. For example, many of the color spots he indicates are the result of simultaneous contrast. Others are representations of mouches volantes. The latter are nothing more than particles floating in the vitreous humor (the fluid) of the eyeball. We normally don't notice them unless we are staring at a bright light field-a waste of snow, the sky, a sunset, something of that sort. A famous authority on optics contemporary with Monet, Dr. Hermann von Helmholtz, commented on the difficulty most people have in seeing these things.

Even the after-images of bright objects are not perceived by most persons at first except under particularly favourable external conditions. It takes much more practice to see the fainter kinds of after-images. A common experience, illustrative of this sort of thing, is for a person who has some ocular trouble that impairs his vision to become suddenly aware of the so-called mouches volantes in his visual field, although the causes of this phenomenon have been there in the vitreous humor all his life. Yet now he will be firmly persuaded that these corpuscles have developed as the result of his ocular ailment, although the truth simply is that, owing to his ailment, the patient has been paying more attention to visual phenomena.4

Helmholtz also noted that "not every il-

lumination is suitable for representing a landscape." His studies implied that painters should not light objects from behind, since that would cause them to appear flat. That this would be the consequence is quite right. In figure 157 there are two haystacks, one lighted from the side and the other from behind. The second seems less round because chiaroscuro does not indicate any relief, only silhouette; moreover, the stack appears continuous with its own shadow. Besides, Helmholtz pointed out, if the artist looks into the bright sun in this way, his vision will be impaired by mouches volantes and other fugitive sensations dancing within the field of vision. About this too the scientist was correct. Not only is Monet's haystack flat, but his picture is filled with all sorts of colors that existed only in his retina.

Monet did not discover such phenomena; they were well known. But when older painters had looked long and hard at a green vase and begun to see red or violet spots afloat on it, they took into account that this was the product of fatigue and simultaneous contrast. They left the spots out of the painting. They knew that the spots were not "real." That is, the vase was green, and the spots were only in the eye.

The traditional idea of the nature of that green vase derived from a fixed idea of color. The idea has a name, local color. Monet's approach utilized optical color. The following example will explain the difference. We may know that a mountain thirty miles away is covered with green trees. But because of additive mixing of colors and because of the intervening layer of atmosphere, which exercises a subtractive effect by scattering light rays in the air, the mountain looks blue. Green is the local color of the mountain; the blue that reaches one's eyes is the optical color. Another example would be a burning cigarette in a room lit by a red bulb. The coal of the cigarette appears bright white in such

157 Haystacks lighted from the side and from behind

circumstances, although we know that in white light it would be red orange. If the smoker is wearing a green shirt, the shirt will look black in the red light. Again, red orange is the local color of the cigarette tip, and white the optical color. Green is the local color of the shirt, black the optical color.

The example of the distant mountain shows that painters and laymen accept without qualm the substitution of optical color for local color when the effect is sufficiently obvious and universal. The example of the redlighted smoking room should demonstrate just how arbitrary the idea of a local color is. That is, in these special circumstances the cigarette tip *is* glowing white. And the green shirt *is* black. All that local color means is that an object seen under white light will have that particular hue.

But Monet wanted to show in his paintings that vision is not constant even in sunlight to depict such phenomena as the simultaneous contrasts on the green vase. The major difference between Monet and a traditional

painter is that he was willing to substitute optical color for local color at all times and without exception. So far as Monet was concerned, what he saw was what was. He painted the colors of the haystack just the way they looked to him, the exact color and shape, until he had, in his own words, a "naive impression of the scene." And by "naive" he meant to indicate a more honest and truthful rendition. Now Monet couldn't really portray the thing precisely as it appeared; that is impossible. What he did do was rely on visual sensation to the exclusion of intellectual knowledge about local color. And he eliminated chiaroscuro to retain the purity of the hues he saw.

Monet was the outstanding representative of *French Impressionism*, a movement about which I shall have more to say later. Its influence was not restricted to the acceptance of optical color in place of local color, but this was the most striking thing about it. When the public was first exposed to Impressionist painting, it reacted with incredible hostility. The reaction was due partly to the kind of brushwork the Impressionists used and to some extent to the kinds of subject matter typical of the style, but it was due more than anything else to the use of optical color. After all, the average person perceives optical color as differing from local color only under very unusual circumstances, as in a room lit by a red light. To him the Monet would look fantastic. A fellow Impressionist, examining the Monet, would see it as a refreshingly accurate recording of visual reality. The Impressionists had trained themselves to see such things. The cliché about the beholder's eye was never more true than it is in this case.

Georges Seurat invented a later style typified by *A Sunday Afternoon on the Island of La Grande Jatte* (fig. 158). He retained in this work the Impressionist interest in purity of hue and intensity of color, but he did something very radical: he looked at the whole matter from a reverse point of view. Monet had copied optical color sensations with little dabs of oil paint. Seurat attempted to *create* optical color sensations with little dots of oil paint.

Paint also has its local color. There is no difference, so far as optical receptivity is concerned, between light reflected from a green leaf on a living tree and light reflected from dead pigment of the same hue if both are

158 GEORGES SEURAT. A Sunday Afternoon on the Island of La Grande Jatte. 1884–86. Oil on canvas, $6'9\frac{1}{2}'' \times 10'1\frac{1}{4}''$. The Art Institute of Chicago. Helen Birch Bartlett Memorial Collection

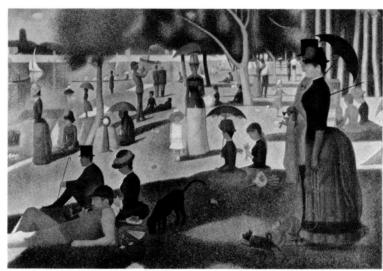

viewed under similar conditions. This is obvious, of course, but we don't often look at pictures from just this angle. Seurat did. He conceived of his paints not so much as colors that could imitate the hues of nature, but as colors that were themselves sensation-producing. He was thereby led to apply himself to the science of optics and devise a set of principles to guide his intuition. These principles were largely derived from the writings of the physicists Ogden Rood and Michel Chevreul and were later jotted down by another painter, Lucien Pissarro, for his own use. Among them is the following:

Two complementaries mixed in unequal portions destroy each other partially and produce a broken color which is a variety of grey, a tertiary color. The law of complementaries permits a color to be toned down or intensified without becoming dirty; while not touching the color itself one can fortify or neutralize it by changing the adjacent colors.⁵ This is a description of simultaneous contrast. Monet copied the effect. Seurat used it. Not content with Impressionism's copies of the world of visual phenomena, Seurat aimed at constructing a phenomenal image at first hand, an image that would possess all the brilliance and variability of the world of light itself because it was constructed according to the laws governing the mechanics of vision.

In order to accomplish his ends, he had to control the color relationships very precisely. This is one of the reasons for his use of thousands of separate dots of color instead of the usual brushstrokes. The technique of application is known as *pointillism*, the style itself either as *Neoimpressionism* or, by Seurat's own preference, *Divisionism*. Most critics and authors of art appreciation books assert that the way to view a Seurat is to stand far enough away so that the dots fuse and only the effect is plain, as if Seurat's style were a kind of handmade halftone reproduction like the one

RICHARD ANUSZKIEWICZ. All Things Do Live in the Three. 1963. Acrylic on canvas, $21\frac{7}{8} \times 35\frac{7}{8}$. Collection Mrs. Robert M. Benjamin, New York

in colorplate 10—so blue dots and green dots together give you blue-green. Nonsense! The optical mixtures and contrast effects will not occur at such a distance. To appreciate the picture you must be standing just close enough to comprehend the dots as separate areas of color.

There is a somewhat related set of experiments with color in art which has come in recent years to be called *Op Art*. Among the outstanding practitioners of the mode is the American Richard Anuszkiewicz (born 1930). His *All Things Do Live in the Three* (colorplate 11) is an example of Op Art and also a good illustration of what a small but distinct area of color can do to adjacent hues. The red background is continuous but appears to change according to the influence of the colored dots upon it. Notice, too, that the effect of the blue-green dots on the red is different from that of the blue dots going to the outer edges. If you have someone hold the book up far enough away for the dots to become invisible, the outer edge is indistinguishable in color from the internal form. This supports my point about not standing so far from the Seurat as to cause the dots to merge.

Emotional effects of color

This chapter has been almost exclusively concerned with the visual attributes of color. But color also has another side, revealed in the following dialogue between a pair of cliché-happy youths:

"Hey, man, cheer up! Ever since your girl took off with your buddy you've been in a black mood."

"Naw, it's just the blues."

"Yeah, 'cause you're green with envy!" "If you don't cool it with that jive I'll be seeing red!"

"So what? You'd be too yellow to do anything about it!"

For reasons not understood at all well, specific hues are associated with certain moods. Folk knowledge of this fact led the famous football coach Knute Rockne to have the team dressing rooms at Notre Dame painted red for the home team and blue for the visitors. The assumption was that red would maintain the emotional "heat" of his players during the half-time break while blue would cause the visitors to relax. Rockne won a lot of football games and was noted for his half-time pep talks that sometimes snatched victory from defeat. Whether the wall colors had the effect he hoped for is impossible to say, but he did recognize that cool colors are more restful than warm ones. Motivational psychologists have made considerable use of such recognitions in packaging products, marketing automobiles, and selling political ideologies.

Painting a locker room red would have at least one disadvantage, because warm colors tend to advance and cool ones to recede. A claustrophobic guarterback would concentrate much better in a blue room. When interior decorators wish to make a room look larger, they use cool colors and minimal contrast. If, conversely, they want to make a large room seem more intimate and cozy, psychologically smaller, they will tend to use warm hues and plenty of contrast. Hotel rooms are apt to be cool in hue and to use analogous color schemes. The lobby of a large ski lodge is likely to be full of browns, yellows, and reds, with a few highly contrasting hues and values to make the setting seem less institutional. These colors will also make the lobby seem literally warmer than it otherwise would.

The terms warm and cool are well chosen to

describe the effect of color on the inhabitants of a room. It has been discovered that personnel working in offices painted with warm tones, such as red-orange, are physically comfortable at lower temperatures than those working in offices painted blue, green, or violet.

Painters make use of the emotive content of color. In chapter four I discussed at some length the feelings evoked by darks and lights and their relationships. Van Gogh, speaking of The Night Café (fig. 153), said that his colors were not entirely true to life but were meant to "express the terrible passions of humanity by means of red and green." The café, he said, is a place where one might run mad, commit a crime. The violent contrasts of the complementaries are no longer so garish as they must have been when these words were written, but Van Gogh's understanding of the emotional function of color is made quite clear in a beautiful passage from a letter written to his brother Theo in September, 1888. "I am always between two currents of thought," he said, "first, the material difficulties . . . and second, the study of colour. I am always in hope of making a discovery there, to express the love of two lovers by a marriage of two complementary colours, their mingling and their opposition, the mysterious vibrations of kindred tones. To express the thought of a brow by the radiance of a light tone against a somber background. To express hope by some star, the eagerness of a soul by a sunset radiance."

I have one last statement to make about the psychology of color. For years I have heard psychologists, art theorists, and others make reference to studies which have shown women to be slightly superior to men in color discrimination. Usually, the relevant experiment was supposed to have involved equal numbers of males and females sorting strands of differently hued yarn into piles; the women tended to discern more kinds of blue, of green, and so on, and consequently ended up with more piles of yarn than the men. I say that the experiment is "supposed" to have been like this because no such experiment seems to be on record. It's a myth. There are, however, experiments *refuting* such claims. Women may be more expert in using color names because of tradition and social influences (just as men are more apt to know about machinery) but

there is no evidence that they are fundamentally better at judging color likenesses or differences.⁶ The only difference between men and women so far as color is concerned would appear to be the well-known fact that color blindness is vastly more common in the male, the proportion being 8 percent for men and 0.5 percent for women.

6 Space

You cannot help but notice that we have been talking about two different kinds of forms in the previous chapters. There are the kind that make up the Mondrian (fig. 159)—flat, twodimensional, areas—and the kind that seem three-dimensional (fig. 160). In actuality the Titian is no more three-dimensional than the Mondrian, of course; it's just that chiaroscuro provides an illusion of roundness and relief. Physically, the works are much the same. Psychologically there is a world of difference. And the difference is mostly spatial.

There are two primary alternatives a painter has when he creates a picture. He can treat the canvas as if it were a window or *picture plane* through which the world is seen, or he can treat the canvas as a window on which forms are placed. Psychologically, it is the same with paintings as with real windows. If you focus on the world beyond the window, you are not aware of the window (fig. 162); and if you focus on the window itself (fig. 161), the world beyond has little prominence. Thus, *The Marriage of Isaac and Rebekah* (fig. 163) by the French painter Claude Lorrain (1600–1682) really does somehow seem "in" the page, while Picasso's

159 PIET MONDRIAN. Composition in White, Black and Red. 1936. Oil on canvas, $40\frac{1}{4} \times 41''$. The Museum of Modern Art, New York. Gift of the Advisory Committee

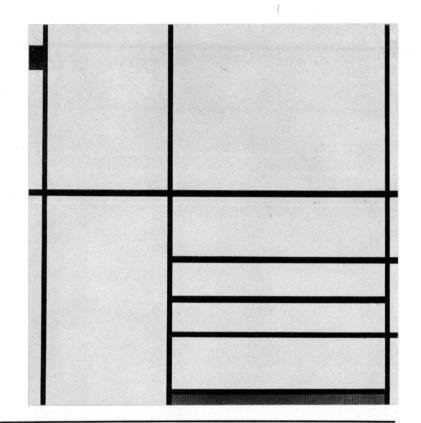

160 TITIAN. Venus of Urbino. 1538. Oil on canvas, $47 \times 65''$. Uffizi Gallery, Florence

161 Focused on the window

162 Focused beyond the window

Girl Before a Mirror (fig. 164) is more easily accepted as being printed on the page.

Since pictures are flat, not deep, laymen are usually more intrigued by the illusion of depth than they are by an arrangement of zones on a surface. And well they might be. The creation of spatial illusions is a major achievement of Renaissance art. In some respects, the deep space of the Claude Lorrain depends even more upon conventions than do chiaroscuro or line drawing. But these particular conventions have proved their effectiveness over and over again through the medium of photography, which incorporates them. Indeed, the impression these conventions make is so powerful that, once you've learned them, the illusion is apt to remain even when you are doing your damnedest to destroy it. The humorous engraving (fig. 165) by William Hogarth (1697-1764) is an attempt to defy the conventions. Yet the space of the picture is not flat or nonexistent; it's just that some of the things contained in the space look bizarre.

The primary clue to spatial order is overlapping. What blocks out something else is ahead of it. Basic to all spatial illusions is the fact that things distant from the viewer appear smaller than things close to him. If an artist wants something to look far away in a picture, he draws it small relative to something he wants to look near. While it is necessary to use this device to convey depth, it is not, as the Hogarth engraving proves, in itself sufficient. What is absolutely essential to the spatial illusion-apart from overlapping and relative size—is the one other thing Hogarth preserved (whether by design or inadvertence): a clear notion of the viewer's station relative to the scene. The artist and the viewer must both understand the vantage point from which a scene is viewed. That is, if the picture were reality, where would you have to be standing in order to see the objects as they appear in the picture? Hogarth's objects look

163 CLAUDE LORRAIN. The Marriage of Isaac and Rebekah (The Mill). 1640. Oil on canvas, $58\frac{3}{4} \times 77\frac{1}{2}$ ". The National Gallery, London

164
PABLO PICASSO.
Girl Before a Mirror.
1932.
Oil on canvas, 63³/₄ × 51¹/₄".
The Museum of Modern
Art, New York. Gift of
Mrs. Simon R. Guggenheim

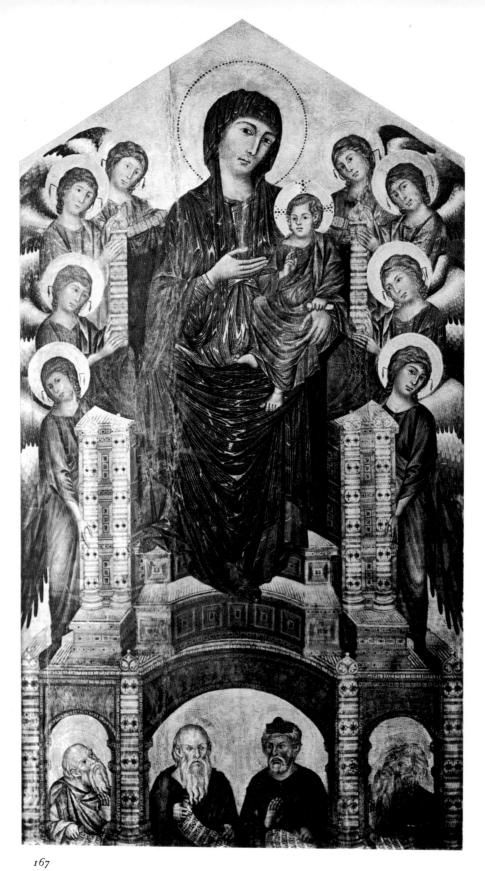

CIMABUE. Madonna Enthroned. c. 1280–90. Tempera on panel, 12'6"×7'4". Uffizi Gallery, Florence

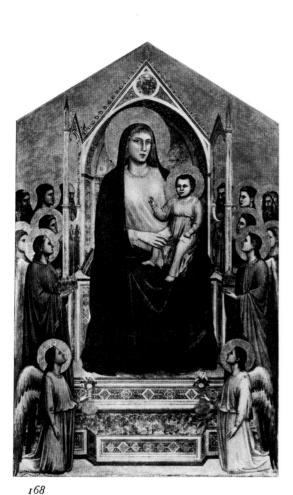

GIOTTO. Madonna Enthroned. c. 1310. Tempera on panel, 10'8"×6'8". Uffizi Gallery, Florence

Cimabue's Madonna Enthroned (fig. 167) reveals the artist fumbling after an illusionistic space in the lower part of the painting. The concave steps below Mary's feet are an indication of his attempt. He tried to carry the effect on down into the arch above the anonymous prophets' heads, but the marriage of arches and concavity gave birth to ambiguity. Is the arch an arch like the ones that flank it, or is it an indentation that happens to look like the flanking arches? No one can say.

About thirty years after Cimabue painted his Madonna Enthroned, Giotto, who was probably a student of Cimabue's, did a rather similar one (fig. 168). Both of them are displayed in the same room in the Uffizi Gallery in Florence, Italy, and thereby invite comparison. The Giotto is vastly more advanced in the direction of Renaissance realism, despite the retention of many medieval characteristics such as larger scale for the more important figures. Giotto didn't know scientific perspective-it wasn't invented until after his death-but he did establish a vantage point. The viewer is conceived of as standing slightly to the left of center and being approximately as tall as the two angels standing on either side of Mary's throne. Your position to center left is very certain; you can see slightly more of the left end of the step than the right end, and you see a little more of the inside of the throne on the side that is to your right. This explicitness is important. Cimabue gives you no good clues as to your position. You might say that you are meant to see the Cimabue as if from dead center but you'd be wrong. Yes, you would. Because you can see the inside of both sides of all three arches, and this would be impossible if you were viewing them from on center.

As for the relative height of the viewer, I must confess that this is somewhat uncertain in the Giotto. We can see the tops of the throne arms, which means that our eyes must

169 Photographic perspective

170 MASACCIO. The Tribute Money. c. 1427. Fresco. Bråncacci Chapel, Sta. Maria del Carmine, Florence

be above them. And we can see the underside of the throne's canopy, which means our eyes must be below that. So we feel that we are somewhere on the level of the standing angels. But the viewer cannot be sure which rank of angels is at his level. Even so, the Giotto is a considerable advance over the Cimabue.

In the Cimabue there is no sense whatever for the vertical position of the observer. When looking at a reproduction in a book, our first impulse is to identify with Mary's eye level, as if we were looking straight across at her. (Confronted with the actual work, which is over twelve feet tall, one is less likely to suppose this.) But there is nothing to prevent us from supposing that we are on the level of *any* of these painted figures. The only consistent pattern is of looking down onto elements of the throne. And we always see the throne from the same angle no matter how high or low its elements, unlike Giotto's throne, parts of which are obviously above our gaze, parts of which are obviously beneath our gaze.

Giotto does numerous things to make his

picture like a segment of real space. Cimabue drew Mary's halo in line with the collar of her blouse, a procedure that makes for flatness. Giotto gave the collar a different contour. He also drew the Virgin's cowl in such a way that you can see the outside of it on one side of her head and the inside on the other. This gives one a greater sense of looking at a threedimensional object. The light in Cimabue seems to come from up front, if anywhere. It is somewhat realistic. But Giotto shifted the light source to the right so that it is obviously a light *source*. His angels are shaded on the left side and lighted on the right.

Finally, there is a sense of gravity in Giotto's work. This is due partly to the greater roundness of his figures; they look solid and heavy compared to Cimabue's. But what really enhances the effect is the distribution of the figures. In Cimabue they are all over the place, from top to bottom. Giotto masses his figures toward the bottom of his picture, and this makes them seem like things tied to earth. It helps convey to us the notion that we are related to them as fellow creatures sharing a common gravity. The total effect is a feeling of being presented with an extension of our own space. The illusion is incomplete and unconvincing to us because we are surrounded by images like that in figure 169. But without Giotto or someone like him, photography might not have come to be.

Masaccio's *Tribute Money* (fig. 170) is by the next artist of Giotto's stature. It is in his work that we first encounter scientific perspective. Perspective was not invented by Masaccio; it seems to have been the invention of the architect Filippo Brunelleschi (1377– 1446).¹ But it is in Masaccio's work that it becomes part of the vocabulary of art.

Geometric projections

I am going to tell you enough about perspective to give you a pretty good notion of how it works. You should understand at the outset, however, that perspective drawings are not really realistic. Rather, they are mathematical approximations of the way you see with one eye closed and your head in a fixed position. Too, perspective is just one way of projecting objects in space.

Consider figure 171. It is not a projection; it is a plan with elevations. People speak of the different elevations as "views," but they are not. If the front elevation were a view of this object, the cabinet section would appear to be on a different plane from the bookcase section. Moreover, you would be able to see the undersides or the tops of at least some of the shelves in the bookcase. All an elevation does is give you a drawing of measurements: if something on the side is to be one inch wide, it is drawn to the same scale as anything else that is to be one inch wide whether it is on the nearest face, six inches back, or two hundred feet back. A plan drawing is made to be worked from rather than looked at. But even carpenters, machinists, and masons find it helpful to have pictures of the things they are constructing. For their purposes a method of drawing pictures that offers a high degree of accuracy and clarity is required. There are two techniques of mechanical drawing which provide this kind of clarity. Neither requires the slightest talent for freehand drawing.

Cabinet projection (fig. 172) simply combines the plan with the front and side elevations from the original diagram. It gives a fairly good approximation of how the object will appear when finished and also provides measurements in scale. It is not, however, a particularly popular method because it requires that the measurements of top and side undergo at least one translation—into halves even when the projection is exactly the size of the object itself. Usually it requires two translations. After all, if you want to make a drawing that is not too cumbersome for normal use, you usually want something

side elevations

smaller than the object you are going to build. In cabinet projections the ratios become annoying to deal with because what is a quarter of an inch on the front elevation has to be an eighth of an inch on the side. And what happens when something turns out to be seven thirty-seconds of an inch? A more popular method of projection avoids this sort of tiresome chore.

Isometric projections (fig. 173) are commonly used wherever exact conceptions of shape and scale are required. Tool- and diemakers use them, the aircraft industry relies on them, and industrial designers frequently present their ideas in this form. The word isometric means "of equal measure." All measurements in an isometric projection are to the same scale; but the front, side, and top of the object are at a thirty-degree angle to the vertical axis. The general impression is of looking down onto the object. And some of you will feel that it looks distorted, that the distant end of our piece of furniture is taller than the nearer end. If you measure them, you'll find that the ends are exactly the same height. The reason they don't seem to be is that in isometric drawings everything that will actually be parallel is drawn parallel. The edges of the top and bottom of the bookcase are parallel in the plan, and they are therefore parallel in the isometric projection. It looks peculiar to see the bookcase in an isometric projection because we expect the edges to appear to converge as they will when we look at the real object. In a photograph they would. In perspective drawings they do.

Scientific perspective

Perspective drawing is another form of projection. The technical name for scientific perspective is *central projection*. The center of this projective technique is the center of one eye or any point of focus. The German artist

Albrecht Dürer (1471-1528) once did a woodcut of an experiment to show, in one quick step, how the system works. His Demonstration of Perspective (fig. 174) depicts two men doing a drawing of a lute as it would look to us if we were standing so that our eye was at the spot on the wall marked by the hook, the center for a central projection. One man attaches the string (which represents a light ray) to the point on the lute to be noted. The other man drops a plumb down to where the string passes through the frame (representing a picture surface), then loosens the string and swings the drawing board around to mark the dot. Such a procedure will give you an accurate perspective drawing of the lute. Perspective theory accomplishes the same thing and doesn't require awkward apparatus. Photography does the same thing with a convenient mechanical device. I could describe the relationships between the Dürer illustration, the human eye, the camera, and scientific perspective. I'm not going to, because I don't believe these things have much relevance to the appreciation of artists' work. What I am going to do is give you a quickie course in perspective drawing . . . the sort of thing I give beginning drawing students as an introductory lecture.

Perspective theory depends upon the idea of a functional infinity. Ordinary perspective drawing depends upon two basic notions: (1) the horizon line or *eye level* and (2) vanishing points toward which the edges of things converge.

Figure 175 contains three pictures of a telephone pole. In A we are above the pole, as if in a helicopter. In B we are standing looking at the pole. In C the pole is higher than we are —it's floating. The drawing of the pole is the same in all three pictures; the only change is the position of the line of the horizon relative to the pole. When you are above the pole, the line is above it. When you are on the ground, the horizon line passes through the

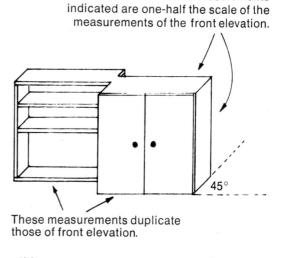

The measurements

Isometric projection

174

ALBRECHT DÜRER. Demonstration of Perspective, Draftsman Drawing a Lute.

From the artist's treatise on geometry. 1525. Woodcut, $5\frac{1}{4} \times 7\frac{1''}{3}$. Kupferstichkabinett, West Berlin

pole. When you are below the pole, the line is below the pole. The horizon line is *always* at the same level as your eyes. *Always*! (Okay, so if you're in outer space it isn't. But within the gravitational field of the earth it is.) Even if you are flying in an airplane, the horizon is level with your eyes. You can check me out by looking through a sash-hung window, a casement window, or any window with open venetian blinds. Stand looking at the horizon so that some other horizontal (sash, crossbar, blind slat) matches the line of the Earth against the sky. Squat. The horizon will descend with you. Stand on a chair. The horizon will ascend with you. If you happen to live in a mountainous region, in an urban apartment, or in densely wooded suburbia, this may not work, because "horizon line" as I am using it refers to the edge of the globe, and things like mountains, buildings, and trees get in the way if they are close enough. Figure 176 shows you what I mean by the horizon line or eye level. In perspective theory the two terms are identical.

Imagine that you are standing in the desert in the middle of a railroad track (fig. 177).

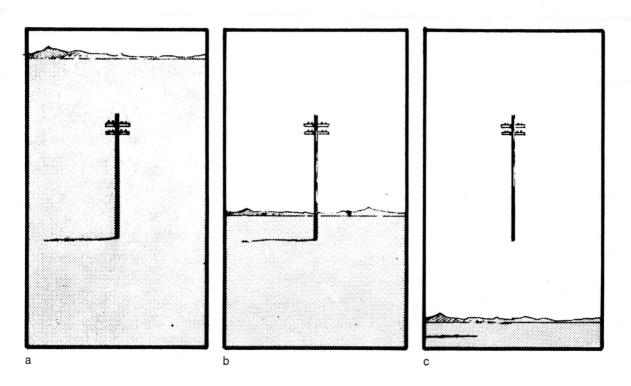

175 Horizon line and viewer's eye level

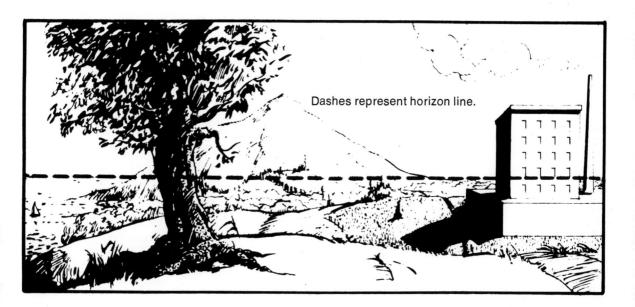

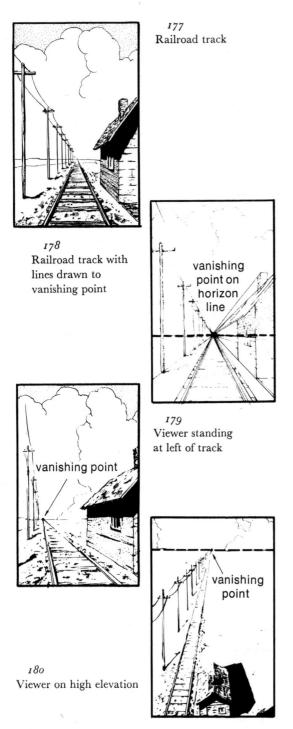

Of course, the rails converge at a single point. What you may not realize is that every edge or alignment parallel to the rails is directed to the same spot (fig. 178). This is a perspective drawing. The horizon line establishes the viewer's presumed eye level relative to the scene. The point at which all the diagonals converge is called a *vanishing point*. The vanishing point establishes the viewer's position. In figure 179 the viewer has moved just left of the tracks. In figure 180 he has climbed up onto a watertower. (By the way, so far as the artist is concerned, *he* is the viewer.) This kind of image involves one vanishing point.

What if the viewer is supposed to be standing way, way around to the side of the tracks —so they go off to the edge of the picture as in figure 181? Where do the ties go? How do you know how to draw the crossbars on the poles? In such a case the artist sets down a second vanishing point and directs anything that is at a right angle to the rails to the new point, as in figure 182. (Don't worry about how I knew where to put the second one. It's too complicated to explain in a nontechnical book. The main thing is not to get them too close together.) Actually, as you can see, I have established a third vanishing point for the nearby crate and two more for the box that is over by the tracks. So we have, altogether, five vanishing points on our horizon line. The system, however, is called two-point perspective because it never involves more than two vanishing points for any single object. In somewhat the same fashion an image like either figure 178 or 179 is called one-point perspective because most of the principal elements are directed to one point. There is also a three-point perspective system, used for drawing things like skyscrapers (fig. 183), but it is very uncommon in the fine arts. In drawing certain sorts of things-such as houses with pitch roofs-there are elevated vanishing points (fig. 184), but the system itself is included in two-point perspective.

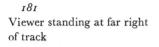

Regardless of the number of points, any circle drawn in correct perspective will appear as an ellipse (fig. 185)—unless, of course, it is parallel to the picture plane (as in the upper left) or exactly on eye level (as in the center of the cylinder). There are many, many special rules and exact procedures for doing scientifically correct perspective renderings; they have to do with the optimum angle of vision, the procedure for establishing relative distances among objects as they recede into the distance, techniques for doing things like roller coasters, spiral staircases, and so on. None of these need concern us here. But I do want to confirm the utterly mathematical and theoretical nature of central projections.

And one way to do this is to show you how an architectural draftsman would go about making a perspective drawing of our bookcase.

People who do technical illustration and architectural studies are not often required to have ability in freehand drawing. I have done both, and I know. When an architect shows you a perspective drawing of a building to be put up, he is not showing you an artist's sketch. He is showing you a drawing that was produced mechanically, by application of the techniques of projective geometry. The mechanical procedure for drawing the bookcase is described in figure 186: (1) The plan is put down at an angle to a line representing the picture plane, with one corner just touching

183 Three-vanishing-point perspective

it. (2) A point is fixed directly below that corner. This point represents the viewer's eye and will be nearer to or farther from the plan depending on how far from or near to the object the viewer is supposed to be. (3) From this point lines are run out parallel to the edges of the plan. (4) A second horizontal line is placed at some arbitrary, convenient distance below the picture-plane line. This line is going to be the eye level. (5) Below this line the draftsman will draw a third horizontal line known as the base line. (6) Two dots are drawn on the eye-level line directly beneath the spots where the diagonal lines intersect the picture-plane line. (7) Lines are drawn from important points on the plan to the viewpoint and marked off where they intersect the picture-plane line. Vertical lines are dropped from those points of intersection through the eye level. (8) An elevation is placed on the base line. (9) Measurements on the elevation are carried across to the line connecting the nearest corner of the plan and the viewpoint. Using these coordinates, the draftsman can make a perspective drawing (10) of any object from the blueprints alone. And he can vary the angle of the plan to produce whatever point of view is desired.

That photography's images closely correspond to drawings produced by the application of strict perspective (fig. 187) is not surprising, since most camera lenses are ground in accordance with the geometry of central

184
Sloping roof in perspective (center)
185
Circles in perspective

186 Perspective drawings of a bookcase derived mechanically from plan and elevations

projection. Both perspective and photography do, of course, have something in common with the way a single human eye functions. (An obvious difference is the matter of focus. If you hold your eye completely still, very little of what it sees will be in sharp focus. But a fixed camera lens or perspective rendering puts *everything* into clear focus.)

Renaissance painters, from the time of Masaccio on, made constant use of scientific perspective. It affected them powerfully because it seemed the ultimate example of an abstract, theoretical system that revealed a visual truth. Out of mathematical order illusion is produced. And the orderliness of perspective, with its completely unified space, appealed to them almost more than its realistic effects. In chapter three I remarked apropos of Leonardo's *Last Supper* (fig. 188) that the convergent lines of the ceiling, the tops of the tapestries, and the table edges all pointed to the face of Christ. It will now be

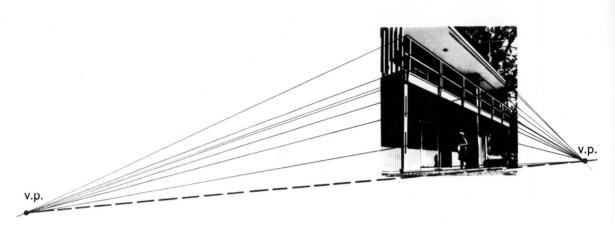

187

Photograph with lines superimposed to show perspective. Dotted line represents eye level of slightly tilted camera

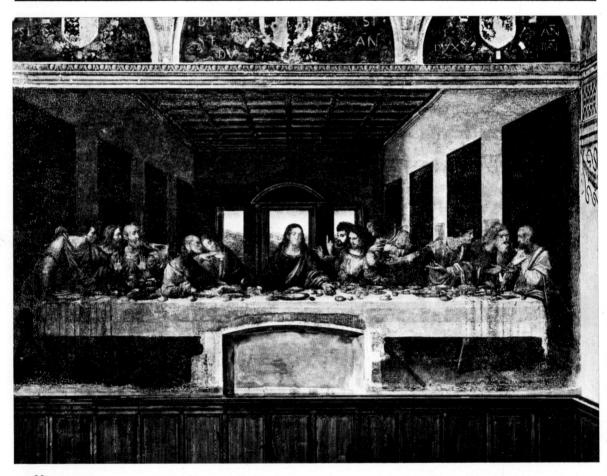

188

LEONARDO DA VINCI. The Last Supper. 1495–98. Mural. Sta. Maria delle Grazie, Milan

obvious that this is a consequence of one-point perspective. In Masaccio's Tribute Money the vanishing point for the architecture is on Christ's face. Tintoretto, in his Last Supper (fig. 189), has used a distorted one-point perspective to accomplish his ends. The viewer is conceived of as standing way over on the right, more or less in line with the nearby male figure. If the table were drawn in twopoint perspective (which, technically, this span of the room demands), the viewer might well imagine himself over to the left. Since the ends of the table are parallel to the eye level while its sides converge on the same vanishing point as other major elements of the room, we know the viewer is remote from the center of the room, in line with the vanishing point. For in one-point perspective the viewer is always directly ahead of the point of convergence. Tintoretto's aims are not scientific but emotional, and it is to his advantage to break the rules. His "error" is partially hidden by the glamorous chiaroscuro.

One of the most famous examples of deliberate deviation from the rules is a painting by an artist who was a contemporary of Leonardo, Andrea Mantegna (1431-1506). Mantegna's *The Dead Christ* (fig. 190) is a perspective study which is "wrong" from a technical point of view. Again, though, the artist knew what he was doing when he made his mistakes. If he had projected the body of Christ mechanically from this angle, the feet would have dwarfed the rest of the figure.

189

TINTORETTO. The Last Supper. 1592-94. Oil on canvas, $12' \times 18'8''$. S. Giorgio Maggiore, Venice

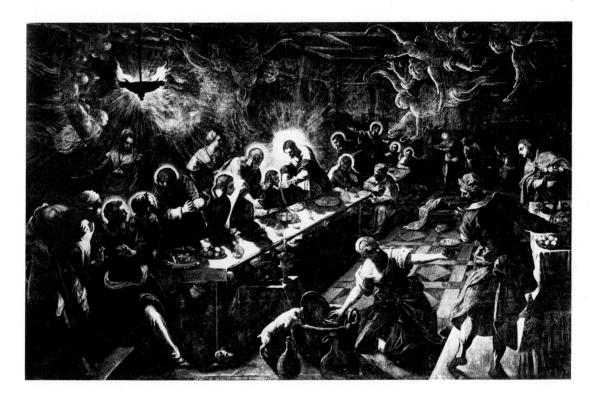

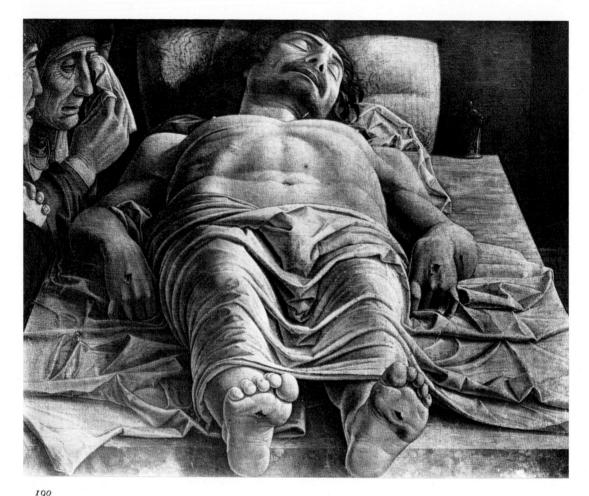

ANDREA MANTEGNA. The Dead Christ. c. 1501. Tempera on canvas, $26 \times 30''$. Brera Gallery, Milan

Given the nature of the subject matter, the result would not be humorous, but it would demean the sacred spirit of the work. So Mantegna has adjusted his projection in order to preserve the dignity and solemnity of Jesus. When you realize this, it becomes very obvious that the legs and feet are smaller than one would expect them to be. Until just now, however, you probably didn't notice it.

Usually, in the fine arts, the absence of scientifically correct perspective is neither deliberate nor the result of ineptitude. It is the consequence of an antipathy for mechanical exactitude. Edgar Degas was actively interested in perspective drawing, but his mature work (fig. 191) is full of inconsistencies. He's always doing things that would drive a mechanical-drawing teacher up the walls. He takes in too much of the floor; he paints things from slightly different points of view. His receding parallels don't have a common vanishing point. *Foyer of the Dance* proves him guilty on every count. Yet the painting doesn't look unreal; on the contrary, it gives an impression of considerable accuracy. Degas's perspective is not inaccurate so much as empirical. He knew the rules and they assisted his intuition. But it was an impression of the room he wished to project onto his canvas and not a geometric diagram. His perspective is sensed rather than constructed. Most artists' drawings are done freehand in the way Degas drew in his picture.

Even an artist like Canaletto (1697–1768), famed for his perspective vistas, did not do paintings with the precision theory would require. Still, it is obvious that when he painted Santa Maria della Salute, Venice, showing the Molo as seen from the Piazzetta (fig. 192) he began with a pretty systematic central projection. The figures are distributed in such a way as to measure off distance in the picture, and he used the lines in the pavement as well as the architectural components of the buildings to mark off the square with exceptional clarity.

Francesco Guardi (1712–1793) was another painter of eighteenth-century Venice, and he has given us a very similar view (fig. 193). But in his picture the perspective is empirical, felt, much as it is in the Degas. Guardi sacrificed a lot to atmospheric effect. His perspective is not exact. All the same, the space of the picture is deep and dramatic. And in his work we are conscious of the essentials of the perspective scheme. The eye level is firmly established, and the ideal of the vanishing point remains even though the actual points

191

EDGAR DEGAS. Foyer of the Dance. 1872. Oil on canvas, $12\frac{1}{2} \times 18''$. The Louvre, Paris

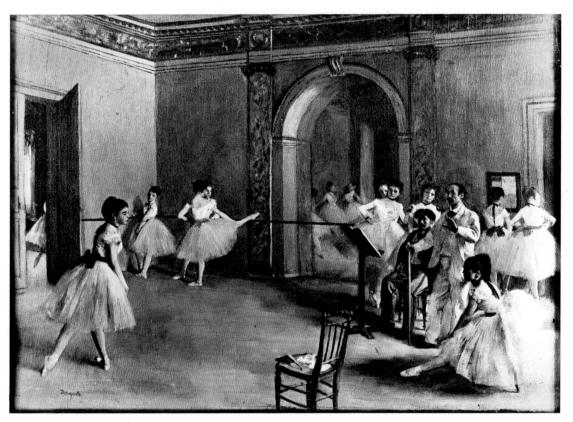

ANTONIO CANALETTO. Santa Maria della Salute, Venice. 18th century. Oil on canvas, $23\frac{1}{4} \times 36\frac{5}{8}''$. The Wallace Collection, London

193

FRANCESCO GUARDI. Santa Maria della Salute, Venice. 18th century. Oil on canvas, $17\frac{3}{4} \times 28''$. Galleria Giorgio Franchetti, Ca' d'Oro, Venice

at which edges of things converge stray far from the ideal. Fortunately for painters like Degas and Guardi, those of us who see their pictures are very tolerant of such positionings and are not disturbed by shifts away from geometric perfection. As a matter of fact, since buildings settle and human constructions are rarely so regular as drawn diagrams, the "sloppiness" of Degas and Guardi may actually make their scenes appear more true to life.

Atmospheric perspective

One reason for the effectiveness of both the Canaletto and the Guardi is that neither

relies entirely on central projection. Guardi, especially, achieves depth through so-called *atmospheric perspective*.

Everyone must be aware of the influence atmosphere has on the appearance of things that are far away. The layer of air between us and distant mountains is one of the causes of their appearing blue. They are also less clear; even relatively nearby things are somewhat blurred by atmospheric haze. Artists copy this effect to represent the near and far in their works. But in paintings it is not blurriness that is the deciding factor in creating the impression of depth. The lucid, transparent light in which Canaletto's scene is bathed is one of the most appealing things about it. We

feel that this is a clear day indeed, because distant buildings are almost as sharp as things nearby. Despite the universal clarity, those domes do look far away. And the illusion is due to more than scientific perspective.

The Return of the Hunters (fig. 194) by Pieter Bruegel the Elder (1525/30-1569) does not depend for its spatial illusion on scientific perspective, because the landscape contains few elements that are geometrically regular. The same can be said of the Claude Lorrain (fig. 195). Both pictures rely for their impression of depth upon atmospheric perspective, a perspective whose character is only incidentally related to air. What this system really has to do with is value contrast. Things high in contrast appear closer than things low in contrast. That is, the difference between lights and darks is greater close up than far off. Thus, in the Bruegel, the trunks and branches of the nearby trees are far darker than distant ones, and those in the middle distance are darker than the ones that are far, far away. At the same time, the foreground snow is whiter than that of the valley, and the snow in the

valley is not so dark as that on the mountainside. Everything gets grayer toward the horizon.

In Claude Lorrain, too, one is led back through passages of diminishing contrast. As you go back, the darks get lighter and the lights grow somewhat darker. What is important to the illusion, however, is the decrease of contrast between lights and darks. One could simply make all the lights grow darker, leaving an impression of the distance shrouded in gloom. Conversely, a painter might lighten darks and preserve the same lightness throughout. Because Claude Lorrain lightened his darks a bit more than he darkened lights, his picture suggests far-off things lost in a luminous haze. The isolated panels of my comic strip Maxor of Cirod (fig. 196) make use of the principle of atmospheric perspective by eliminating large black spots from the distance, by reducing the amount of unbroken white space in the end of the arena and the mountains, and by treating the outline of the clouds with a faint, broken line.

From the close of the Renaissance to the

194 PIETER BRUEGEL THE ELDER. The Return of the Hunters. 1565. Oil on panel, $46 \times 63\frac{3}{4}$ ". Kunsthistorisches Museum, Vienna

middle of the nineteenth century, painting underwent many stylistic changes without forsaking the spatial conception that gave birth to both scientific and atmospheric perspective. John Constable (1776-1837) was one of the great masters of English landscape painting. His *Hay Wain* (fig. 197) was really quite radical in its treatment of nature. It was painted straight onto the canvas from studies done at the scene, and Constable employed spontaneous, sketchy brushwork designed to capture the transitory aspects of nature—the flicker of light on water, the leaves fluttering in the breeze, the clouds crawling lazily across the sky. This painting made so profound an impression on the French painter Eugène Delacroix that he revised the background of his *Massacre at Scio* in imitation of Constable. The *Hay Wain* is not a timid work. It is anything but conservative. But the space of the picture is no different from the space in the Pieter Bruegel or Claude Lorrain.

A contemporary of Constable, J. M. W. Turner, became so fascinated with the corre-

CLAUDE LORRAIN. The Marriage of Isaac and Rebekah (The Mill). 1640. Oil on canvas, $58\frac{3}{4} \times 77\frac{1}{2}$ ". The National Gallery, London

196

JOHN ADKINS RICHARDSON. Maxor of Cirod. © 1971, John Adkins Richardson

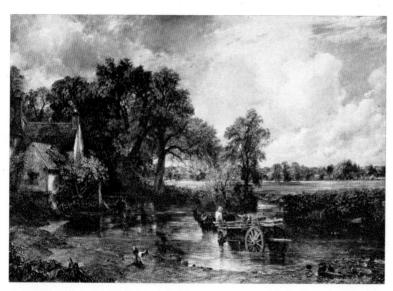

197 JOHN CONSTABLE. The Hay Wain. 1821. Oil on canvas, $51\frac{1}{4} \times 73''$. The National Gallery, London

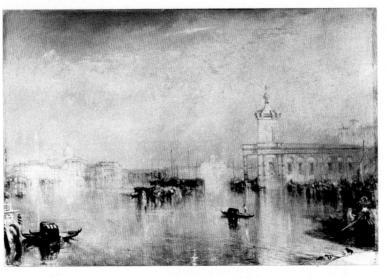

JOSEPH MALLORD WILLIAM TURN The Dogana, San Giorgio Maggior le Zitelle, from the Steps of the Europa. 1842. Oil on canvas, $24\frac{1}{2} \times 36\frac{1}{2}$ ". The Tate Gallery, London

199

JEAN-BAPTISTE-CAMILLE COROT. Bridge and Castle of St. Angelo with the Cupola of St. Peter's. 1826–27.

Oil on paper, mounted on canvas, $8\frac{5}{8} \times 15''$. California Palace of the Legion of Honor, San Francisco. Coll Potter Huntington Memorial Collecti

lation between light and color that his work foreshadows Impressionism. In essence, however, his paintings (see fig. 198) share the spatial effects of Claude Lorrain. Corot's (fig. 199) solidity exists within the same general scheme as that of his predecessors. It is with the French Impressionists that the concept began to change.

Space in French Impressionism

Actually, the modification of traditional space

was just a by-product of the Impressionists' concern with sensation. Monet's procedure of painting scenes in terms of color notations without regard for much except his "naive impression of the scene" (fig. 200) would have itself denied the deep space typical of his predecessors. The scientist Hermann von Helmholtz pointed out that if you look at the world from an unusual position it looks flat.

In the usual mode of observation all we try to do is judge correctly the objects as such. We know that at a certain distance green surfaces appear a little different in hue. We get in the habit of overlooking this difference, and learn to identify the altered green of distant meadows with the corresponding color of nearer objects. . . . But the instant we take an unusual position and look at the landscape with the head under one arm, let us say, or between the legs, it all appears like a flat picture. . . This whole difference seems to me to be due to the fact that the colours have ceased to be distinctive signs of objects for us, and are considered merely as being different sensations.²

Monet's haystack picture makes no distinction between the spots of color used to indicate farm buildings in the distance and those which indicate light on stubble just behind the stack. Because of this the houses are hard to identify. (They are strung out in line with the division between the hump and sides of the haystack.) Does the horizontal line between the houses and the top of the picture represent the edge of a hillside or the crest of a cloud bank? You'd have to know the locality to make a good guess, and even then

200

CLAUDE MONET. Haystack at Sunset Near Giverny. 1891. Oil on canvas, $29\frac{1}{2} \times 37''$. Museum of Fine Arts, Boston. Juliana Cheney Edwards Collection

you'd not be sure. Colors have ceased to be distinctive signs of objects and are treated merely as different sensations. It is just as Helmholtz said.

The kind of spatial ambiguity exhibited by the Monet is called frontality.3 The nude and bedclothing in Manet's Olympia have the same property. Most Impressionist paintings have it to some extent. It is not the result of a doctrinaire denial of the perspectives of the past; it is merely one consequence of the outlook of painters who wished to be true to their sensations. Our discussion of scientific perspective should have proved its abstract, impersonal character if nothing else. Monet would have considered the rules of central projection an imposition upon his sensations which was inconsistent with his purposes. And he would have been correct. The rules dictate certain proportions that are not in accord with sensational responses. They substitute measurement and magnitude for intuition. Atmospheric perspective is similar insofar as it presupposes an ideal range of value relationships.

Degas did not consider himself an Impressionist, although he exhibited with them. He did not concern himself with color sensation in and of itself until quite late in life. To cite him as an example of Impressionist divergence from abstract principle is to select the poorest example—for he was interested in perspective more than any other Impressionist. Yet, even in his work, the perspective is never scientifically correct; it is Impressionistic.

Two French Impressionists who were not particularly fascinated by perspective drawing were all the same disturbed by what seemed to them the superficial nature of the Impressionist method. Both Auguste Renoir (1841-1919) and Paul Cézanne (1839-1906) became disenchanted with the relative looseness of Impressionism. Renoir attempted to combine Renaissance form with Impressionist color. Cézanne is often said to have done the same, but his accomplishment goes far beyond Renoir's rather obvious synthesis of Titian's drawing with Monet's hues. He invented what the English critic Roger Fry called a *perspective of color*.

Cézanne's perspective of color

Cézanne's art is very complicated. It is rather like the music of Bach; solemn contemplation of each part and its relationship to the whole is necessary if one is to come to an appreciation of it. Perhaps the following remarks will not convey what I want them to. Roger Fry thought that the method Cézanne employed was inexplicable. Fry was a lyrical critic of art, and he didn't attempt to analyze the specific functions of line, form, and color. What a poet would not try, I perhaps should not attempt. But I am going to, anyhow. Maybe I can give you some notion of the majesty of Cézanne's accomplishment.

Let us examine the panoramic landscape entitled Mont Sainte-Victoire (fig. 201). At the base of the lone central tree there is a dark clump of brush. It is juxtaposed with the yellow-brown wall of a little house. The house is nearly hidden by foliage. It has a lavender roof. Notice, now, that the ridgepole along the middle of the roof and the eaves on its right-hand side form a single line, interrupted only by the tiny chimney. The house is virtually a continuous plane because of this line. Almost as if unbroken, it leads the eye back into the picture from the accent of the brush. But it is not unbroken. It is divided by hue into two parts, the yellow-brown of the wall and the pale violet of the roof. From this simple division emerge the many relationships that, together, identify a Cézanne.

When you place a cool color (blue-green) against a warm color (yellow-brown) and the

PAUL CÉZANNE. Mont Sainte-Victoire. 1885–87. Oil on canvas, $25\frac{5}{8} \times 31\frac{7}{8}$ ". The Metropolitan Museum of Art, New York. The H. O. Havemeyer Collection. Bequest of Mrs. H. O. Havemeyer, 1929

two hues are of different value, they tend to separate. Thus, the brown wall pulls away from the green shrub. And space, thereby, comes to exist *within* a receding plane. But the effect has another side. Put together, colors dissimilar in hue temperature but of approximately the same value suggest a "folding" of space; that is, they create the illusion of an angle. For this reason, the single segmented plane of the house can also be viewed as composed of a wall parallel to the viewer and a rooftop slanting away from him. Having such

a duality of recession, the form is doubly cogent. Moreover, the plane of the little house is but a section of a still larger plane which penetrates the house, the trees on the left, and drifts into the ground plane of the valley. Such planes, of which the entire work is composed, are like great slabs of light superimposed over the volumes of the landscape. And what is most intriguing about it all is that Cézanne managed to make the picture deep and frontal at the same time.

Frontality in Mont Sainte-Victoire stems from

the fact that elements of the foreground participate in the illusion of deep space. For example, the bit of foliage to the left of the lone pine tree belongs to the tree and also acts as an accent for a set of shifting planes that tip up and backward to become Mont Sainte-Victoire. We'd think the green was a clump of trees, except that they would have to be the largest trees in the world if they towered as they seem to over the ancient Roman aqueduct. A branch on the right of the pine projects a corresponding spot of green out over the landscape. This spot is the accent for a plane that passes along the branch to the aqueduct. Numerous elements of this kind predominate. The projecting branch aligns the two green spots and also lies parallel to the roof of the little house and to the general direction of the distant river. The meanderings of that river are almost exactly repeated in the line of the mountain range against the sky. The entire shape between the river and the mountaintops can be relished as an independent chunk of the picture. When you look at that segment of the picture, you can see just how frontal it can seem. The picture is an exquisite marriage of Classical structure and harmony with Impressionist sensitivity and frontality. It contains both and resembles neither.

The uncanny space of Cubism

Five years after Cézanne's death in 1906, two young artists invented a style that was to revolutionize painting in modern times. The artists were Pablo Picasso and Georges Braque (1882–1963), and the style came to be called *Cubism*, although it had nothing to do with cubes. It is the first truly nonrepresentational or "abstract" movement in modern art, and we shall have more to say about it later on. For now, I am interested in its curious spatial quality. The space of Cubism is so unusual that it has led to all kinds of speculations: that it is derived from multiple viewpoints of objects, that it is dependent on a mystical fourth dimension, and that it has something to do with Einstein's Theory of Relativity, which was enunciated about the same time. These speculations are almost always based on a misunderstanding of both the style itself and the scientific ideas.⁴ What we are presently concerned with is the space of painting.

Picasso's Ma Jolie (fig. 202) looks, at first glance, like a jumble of forms which doesn't make much sense at all. Select one of those forms and try to figure out whether it is ahead of or behind another one. Things do look as if they are ahead or behind; the picture doesn't look flat. Virtually any form you select can also be construed differently, however. If the one selected seemed to be on top of an adjacent one, imagine it beneath. You can shift assumptions this way with great ease. Picasso has taken to its ultimate conclusion Cézanne's method of rendering things so that they retain their volume as well as their frontality. The space doesn't depend on the color variations of Cézanne; it does derive from the ambiguities he used. It should be easy for anyone to see that in figure 203 plane P lies between O and Q. The illustration is typical of traditional overlappings. But what about the situation in figure 204? This schematic drawing takes a Cubist image as a point of departure. Where is P? Possibly it lies both ahead of and behind the other forms and lines. This ambiguity is not due to a transparency of the forms. It is due to the arrangement of masses and edges. The same is true of Ma Jolie.

The bizarre space of Cubism is of great interest because the whole character of a painting like *Ma Jolie* changes as you change assumptions about where in space the elements are. Take that one tiny form you took before. Look at the whole picture in terms of it. Then

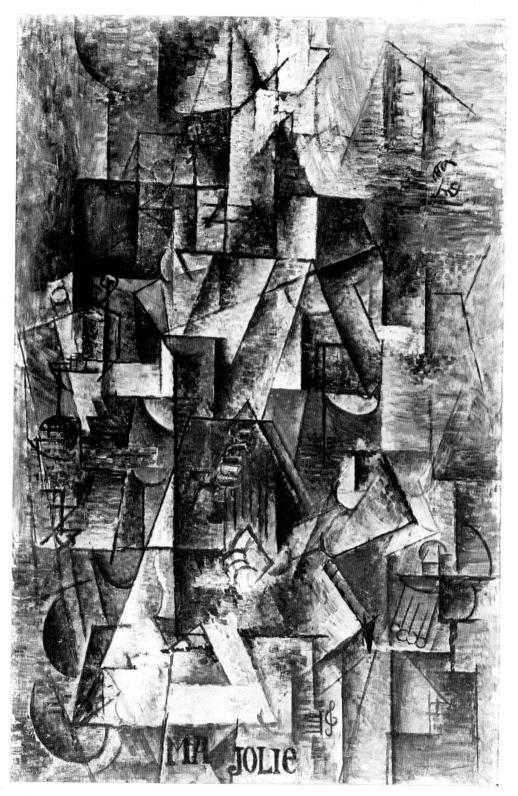

PABLO PICASSO. Ma Jolie. 1911–12. Oil on canvas, $39\frac{3}{8} \times 25\frac{3}{4}$ ". The Museum of Modern Art, New York. Lillie P. Bliss Bequest

203 Overlapping planes

204 Cubistic treatment of space

assume that the form is not where you at first supposed it was but is in the opposite relationship. The assumption makes the rest of the picture look different. Too, if you select another form and make alternative assumptions, similar changes will occur. This is the simplest version of what is most interesting about the painting: that it never "wears out." I have seen it many, many times, and it always shows me a somewhat different face. It is not a very decorative picture in terms of color (it is all browns and grays), but it is a work of art that one could live with forever.

Let me hasten to say that this is also true of Rembrandts, Caravaggios, and others. What is particularly intriguing about the Picasso is that its interest depends completely upon the way it was painted and not at all on what it represents. guish betwe of a picture i ter. The forr what kinds artist used. make as you it is hard to

Content

Jan van Eye (fig. 205) se ject—a you hind a dog in the subsidia to be the co has further ter has a me is part of the is a whole with conten raphy. A cle Giovanni Arr reveal what of the work

Your first be that here the bride w She is holdi her midsect protrudent figure of her greater imp his right ha of marriage Church did for a valid r tween man holy matrir pensed by th was a fides hands) and forearm) on of private its proper p

Formal composition

I have been using the word form interchangeably with shape. There is, however, another usage current in the fine arts. In writing about art, the terms form and content are frequently opposed. Like many terms in art, these have their counterparts in common speech. Suppose you are at a public forum dealing with the application of I.Q. tests to urban schools, a subject fraught with hazards. A speaker says: "White urban Jews do consistently better than white Protestants from rural Appalachia on I.Q. tests." You ask: "Are you saying that urban Jews are smarter than Appalachian whites?" He responds: "No, not at all. They just get higher scores on intelligence tests. Let me put it in a different form. The whole social structure and life-style of the typical Jewish child gives him the skills a normal I.Q. test measures. This is not true of the mountain people." Now, the speaker has said essentially the same thing in both cases. The amplification didn't really add anything that was not implicit in his previous remark. The form made all the difference. What he said was the content of his remarks. The way he made them was their form.

In discussing artworks critics often distin-

AGNOLO BRONZINO. Exposure of Luxury. c. 1546. Oil on panel, $57\frac{1}{2} \times 45\frac{3}{4}$ ". The National Gallery, London

20) JAN Oil o lone candle burns; a candle burning in a lighted room signifies the presence of God. Sunlight itself alludes to the purity of the bride, particularly since it bathes the fruit resting on the windowsill. The fruit harkens back to the story of Adam and Eve. Finally, the mirror is convex and takes in more than a flat glass would. It has been compared to the eye of God beholding the witnesses as well as the bride and groom.

A little over a century later the Italian artist Agnolo Bronzino (1502–1572) did a painting also having to do with sexual love, his Exposure of Luxury, formerly known as Venus, Cupid, Folly, and Time (fig. 206). It is characterized by a sort of cold lasciviousness. Venus was Cupid's mother, and here her adolescent son fondles her in a way that suggests anything but filial tenderness. She holds in her right hand an arrow taken from his quiver and in her left an apple. We take the word sinister from the Italian sinistra (left). Cupid can see the apple, but not the arrow. He is offered something that is delicious but dangerous. On the right a little figure (of a type called a putto in art) strews roses. He combines the ideas of pleasure and jest, something already hinted at in the apple and arrow. Venus's behavior also suggests deceit, and the picture is full of things relating to fraud. Beneath the putto there are masks, and behind him a curious creature sometimes referred to by critics of the painting as a Harpy. This being has the face of a precociously sensual little girl; the lower extremities are scaly, reptilian. In her right hand she is holding a honeycomb and in her left a poisonous lizard. But her right hand is formed like a left hand, and her left is like a right. Again, a sinister image, explicitly, the symbol of Deceit. Consider, too, the peculiar relationship of Cupid's head to his body; we have some question as to whether the head and body belong together. He kneels on a pillow, the standard symbol of idleness and luxury, just behind two billing doves signifying amorous caresses. Beneath his wing we observe an old woman tearing at her hair, a figure that has been identified as Jealousy. This highly suggestive group of weirdos is revealed to Truth by Father Time, who is shown drawing back a curtain. The subject is treacherous pleasure. It is a warning against luxury to the supersophisticated who would dismiss manifest evils as diverting pastimes.

Not all paintings are complicated in this way. *Giovanni Arnolfini and His Bride* was the result of a deliberate attempt to invest a dual portrait with religious significance. The Bronzino is an allegorical work; in fact, the title is sometimes given as *Allegory*. An allegory is a work (whether in the fine arts or in literature) in which symbolic figures and actions represent ideas about human conduct.

The majority of paintings and sculptures the vast majority—are about just what they seem to be. The portrait of the German merchant Georg Gisze (fig. 207) by Hans Holbein the Younger (c. 1497–1543) is exactly that, a picture of a man surrounded by the materials of his trade. One might, of course, be interested in knowing who Gisze was, precisely how he earned a living, and what purpose each of the objects depicted served, but one can gain a pretty fair idea of all this just from the objective representation Holbein has given us.

What these pictures are of and about is their content; the way the artists painted them is their form. What is of more than passing interest is the way in which form can modify the meaning of the subject matter, that is, the way form influences content.

The interdependence of form and content

Many of you are familiar with at least the general outline of the story of Othello, the

207 HANS HOLBEIN THE YOUNGER. Georg Gisze. I532. Oil and tempera on panel, $38 \times 33''$. Staatliche Museen, Berlin-Dahlem

Moor of Venice. It is famous because of William Shakespeare's play. Othello, a black man who is a gallant general in the service of Venice, is married to Desdemona, daughter of a white Venetian senator. He has offended a cunning fellow named Iago by promoting a younger soldier, Cassio, over his head. Iago arranges it to seem that Desdemona and Cassio are having an affair, and stirs Othello to such a frenzy of jealousy that he murders his wife in her bed. When it turns out that Desdemona had been faithful and his fury unjustified, Othello kills himself in remorse.

Even if you've not read or seen the play, you can probably imagine how it was handled by Shakespeare. Fine. Imagine how it might appear in the work of Sir Walter Scott. Mark Twain? Ernest Hemingway? James Baldwin? Mickey Spillane? LeRoi Jones? Obviously, the same plot would have entirely different implications in the hands of each of these authors. Indeed, the meaning of the events would take on different aspects because of the varying forms the writers would give to them. Quite the same is true of painting and sculpture.

The Annunciation is a very common subject in Christian art. The essentials are the Angel Gabriel and Mary. In terms of both form and content one of the most elaborate Annunciations ever painted is the Mérode altarpiece (fig. 208), done by a painter whose identity was for years uncertain. You will, for this reason, sometimes see it credited to the Master of Flémalle. Most scholars now identify the Master of Flémalle as Robert Campin (c. 1378–1444), who was the leading painter of Tournai.

The altarpiece is a *triptych* (three-paneled painting). The left panel depicts the couple who donated the picture to the church. They look toward the central panel through a garden door. The spring flowers denote the season of the Annunciation. Moreover, forgetme-nots stand for Mary's eyes, and the violets and daisies symbolize her humility. The rosebush is thorny (a reference to Christ's martyrdom) and full of beautiful blossoms (standing for Mary's love). The brick wall alludes to the Song of Songs in the Bible, where a virgin is described as "a garden enclosed." The man in the background is the broker who arranged the donors' marriage. The door is a symbol of hope. The lock symbolizes charity, and the key stands for the desire of God.

The central panel depicts the Annuncia-

tion itself, taking place in a fifteenth-century Flemish room. The room contains all sorts of references to purity: a basin, a lily, a white towel, white cloths, and white walls. The Infant Jesus, carrying a tiny cross, speeds through the window on a sunbeam. And the candle on the table has just gone out; its smoke trails up in a wisp. This signifies that God has assumed human form in Mary's womb.

The right-hand panel shows Joseph in his shop. The workbench is laden with sharp gouges and other tools, all of which summon up thoughts of torture and the Crucifixion. Joseph is boring holes in a board. There is uncertainty among scholars as to what he's supposed to be making. Erwin Panofsky, greatest of all iconographers, suggested a spike block. Another authority has said that it looks like a footwarmer. And Meyer

208

MASTER OF FLÉMALLE (ROBERT CAMPIN?). Mérode Altarpiece of the Annunciation. c. 1425–28. Oil on panel, center panel 25'' square, each wing $25 \times 10''$. The Cloisters,

The Metropolitan Museum of Art, New York

209 FRA ANGELICO. Annunciation. 1438–45. Fresco. S. Marco, Florence

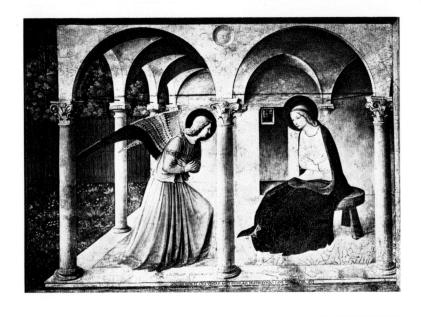

Schapiro, another great scholar, thinks it may be a fish trap. The latter suggestion is rather persuasive, because fish symbolize Christ¹ and because there is another kind of trap in Joseph's shop, a mousetrap. It is by his elbow on the table. St. Augustine had written that the crucifixion of Christ was the bait in a trap that caught the Devil just as a mousetrap catches a mouse.

The Mérode altarpiece is heavy with content. But when one has seen what Campin's younger contemporary Van Eyck made of a simple marriage portrait, one can appreciate the care with which Campin inventoried all symbols connected with an event of universal significance. It is consistent with the style of fifteenth-century Flemish painting.

In the South during the same period, a little Dominican monk named Fra Angelico (1400–1455) decorated the monastery of San Marco in Florence with fresco paintings. One of these is an Annunciation (fig. 209). Again, the flower-carpeted garden symbolic of virginity is used. But nearly everything else is different. The event takes on a tender charm quite unlike the hard objectivity of the Flemish painting. Fra Angelico has used perspective and other Renaissance inventions for drawing the architecture, anatomy, and drapery, but has used them primarily with an eye to decorative effect. Even the secondary content is kept to a minimum so that attention is not distracted from the shy Virgin and God's messenger. (The dark halos, incidentally, have no significance. Originally, the halos were painted in gold leaf. The gold has long since vanished, leaving in its place the adherent of dark gum.)

Tintoretto, whose *Last Supper* has received quite a lot of attention in these pages, also did an Annunciation (fig. 210). It is as flamboyant as Fra Angelico's is restrained. Gabriel swoops down through the door, startling Mary half out of her wits.

The essential subject matter of all these Annunciations is the same. But the form in which the scene was cast makes the content rather different from one to another. It is also the thing that gives the works their quality. It would be easy to imagine me telling *you*, for example, everything to put into a picture of the Annunciation, even giving you the precise positions of the figures. It might not be quite so easy for some of you to imagine undertaking a picture according to my description, but let's pretend that I'm going to pay several hundred dollars if you do regardless of how poorly finished the picture is. Obviously, you are not going to be able to produce anything of the quality of the Campin, the Fra Angelico, or the Tintoretto, even when the content is exactly the same.

Since, in the final analysis, it is the form of the work that determines whether the work is good, bad, or indifferent, it is the form with which we shall concern ourselves in the rest of this chapter.

Formal "rightness" and families of forms and colors

All of us have had the experience of being asked whether something—an arrangement of furniture in a room, or a combination of clothing—looks "right." Sometimes we say, "No, there's something a little bit wrong. I'm

not sure what. . . . Hmmmm. . . . Maybe if you changed-" and so on. You sort of play around with possibilities until everyone is happy with the situation or until it becomes obvious that it "just won't do." Of course, one person may be satisfied with what another cannot abide. There's no way of proving yourself right or wrong in such circumstances because there are no rules. It all depends on how the thing "feels." This is true even when you agree to decide taste by majority vote of a group; one set of feelings is being weighed against another. But let's face it, some people have feelings you can rely on and some don't; some of us have good sense about these things and some of us are stupefying clods. . . . whose opinion would you take on selecting draperies-the collective judgment of your father's bowling team or the suggestion of an interior designer?

Since ancient times men have tried to devise prescriptions for attaining beauty in art. None of the formulas have been confirmed by history. What seemed unquestionable in one age was overturned in the next.

210 TINTORETTO. Annunciation. 1583–87. Oil on canvas, $13'10'' \times 17'10\frac{1}{2}''$. Scuola di S. Rocco, Venice

Even an abstract, objective system like scientific perspective, which *does* have hard and fast rules, cannot be employed strictly, without exception. When it's technically wrong, as in Mantegna's *Dead Christ*, it's artistically right for the picture—because content affects form just as form affects content.

There exists a geometric proportion called the Golden Section. Since its discovery by Euclid, some time during the third century before Christ, it has been considered the key to formal beauty by any number of theorists in art. It is a ratio between the two dimensions of a plane figure or the two divisions of a line such that the smaller element is to the larger as the larger is to the whole (fig. 211). There is something peculiarly natural and appealing about the proportion. It occurs all through nature, even in seashells and microscopic cell structures. I have tested its appeal in art appreciation classes by giving students identical strips of paper and asking each to cut out one "perfect" rectangle. When I collect all the rectangles from a class of one hundred, there are always a few silly onesuncut long strips, tiny little bits, and so onbut the majority are so much alike that you can shuffle them like a deck of cards. And the rectangle in the deck is a Golden Rectangle; the short end is to the long edge as the long edge is to the end plus itself. Incredible! But true. The typical picture shape is a Golden Rectangle: most architectural forms subscribe to the proportion, painters employ it, and trees sometimes even grow in that proportion (fig. 212). There is no question that the ratio is common in nature and is appealing to human eyes.

As you might expect, many artists have attempted to paint perfectly composed pictures by applying the Golden Section to their designs. Unfortunately, the fact that this ratio is a persistent feature of great works does not mean that its presence will assure greatness. It does not even imply that a work con-

212 Golden Rectangles

taining it will be good. And, of course, it certainly doesn't mean that works from which the ratio is absent will be poor. True, there are some zealots who insist that the Golden Section and similar ratios can *inevitably* be found in all great works of art. Their demonstrations of this contention are frequently ingenious and even fascinating. Sometimes, too, they are a rarified form of mental torture. I am convinced that whenever the ratios are so well hidden as to require logarithmic functions to evoke them, they are not essentialthat in effect they do not exist. In any case, it is possible to use the same techniques to concoct similar justifications for paintings that are hideous. All too often the measurements "come out" if you begin halfway over on a fingernail but won't work if you measure from either of the two sides of the nail. That's altogether too "iffy" for this writer. Good composition in art is less the result of ideal proportions than it is a matter of consistency of line, form, and color.

Consistency alone won't make for quality; in fact, complete consistency would be monotonous. The trick, or so it seems to me, is to attain unity without monotony. To pull off the trick won't guarantee that a work of art will be great, but it seems a basic attribute of most fine painting and sculpture that it treads a line between chaos on one side and tedium on the other.

Confronted with a blank canvas, the artist can, in principle, do anything at all. Compare his situation with this: I hand you a piece of white cardboard and a thousand scraps of paper in a variety of colors. You are to create a design using no more than one hundred of those pieces. So you begin gluing them onto the cardboard. At first just any shape or color will be okay. But before long you will discover that certain things don't seem to fit in with the others. For instance, if you've used rounded forms in primary hues, a pentagon of chartreuse may look completely out of

213 STUART DAVIS. Colonial Cubism. 1954. Oil on canvas, $45 \times 60^{"}$. Walker Art Center, Minneapolis

place. By the time you've put in ninety-nine shapes, the character of the one-hundredth one is going to be pretty well determined.

The American artist Stuart Davis (1894– 1964) did paintings that might have been created by a method like the one just described. His *Colonial Cubism* (fig. 213) contains choppy forms resembling paper cutouts. The white spots on the right might not look as if they went with the star in the lower left if it were not for the intervening shapes. The star is very like some of those shapes, the spots resemble parts of others, and when you have them altogether they "fit." A perfect square of pale blue-green wouldn't belong. (Incidentally, this picture is quite Cubistic in its space. If these were cut paper shapes, what would be on top and what beneath?)

What Davis did in *Colonial Cubism* was create a *family of forms*. That's also what you would have done with your cardboard and scraps. We can presume that Davis, as a practiced professional painter, did a better job of it than you would have, but the principle involved in the attainment of unity would have been the same.

Families of forms exist outside art just as Golden Sections do. Trees constitute such a family of forms. So do leaves. So do people. And designers in professions entirely removed from art take formal consistencies into account. Among the man-made objects most people would not consider "artistic" are handguns. Still, the family of forms making up my 9 mm Luger is entirely different from the family that constitutes the Colt .44 (fig. 214). The harsh, knobby look of the Luger has made its silhouette immediately identifiable to generations of small boys. Those prominences are functional. The one on top is a hinge for the mechanism that ejects spent cartridge cases, the one on the bottom of the handle is a grip to remove the cartridge clip, and the one by the trigger is a button which releases the clip. The smooth contours of the Colt had some obvious advantages for a working cowboy in the 1880s. The weapon is easy to wipe clean, it comes out of a holster smoothly, and it isn't apt to get hung up on anything.

In figure 215 I have drawn a hybrid pistol made up of incompatible families of forms. You might like it because of its exotic, bizarre look. Science-fiction illustrators sometimes mix up things in this way to make an object look alien by making it look implausible. But only in special circumstances will one actually encounter such an odd amalgam of forms. It is not absolutely necessary that the Luger's grip be of that particular contour; nothing requires the butt to have a knob pull. It would work just as well if it were formed the way other semiautomatic pistols are. The knob is consistent with the general character of the weapon, that's all.

The comic strip *Peanuts* (fig. 216) exhibits the same kind of formal consistency. The figures and backgrounds are sort of geometric in an irregular, carefree way that matches the mood of the strip. The "peanuts" are always striving for absolute order and facing frustration. The balloons in which the speeches appear have, generally, the same

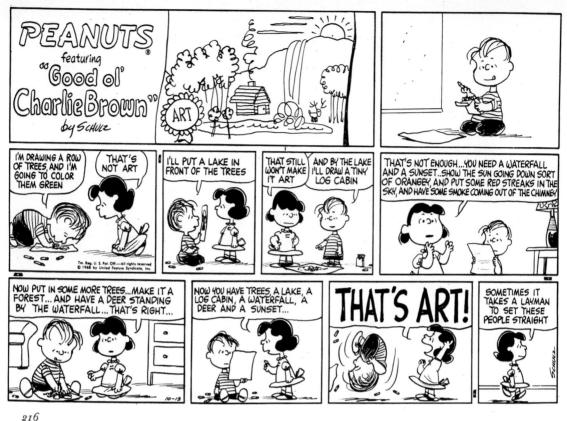

CHARLES SCHULZ. Peanuts. © 1968, United Feature Syndicate, Inc.

217 BURNE HOGARTH. Tarzan. © 1949, Edgar Rice Burroughs, Inc. 218 WALT KELLY. Pogo. © 1963, Publishers-Hall Syndicate

characteristics as the rest of the strip. In Hogarth's *Tarzan* (fig. 217) the musculature of every figure defines itself with unreal clarity. The same kinds of curves, even the same rhythms of darks and lights, are repeated in the masks, shields, spear tips, plumes, and knife hilts. The sweep of the figures itself echoes the same abrupt curvature of the individual bodies.

Walt Kelly (born 1911) does the panel borders in *Pogo* (fig. 218) with a brush instead of a ruling pen and achieves a special kind of harmony within the daily strips.

Krazy Kat (fig. 219) by George Herriman (1881-1944) is perhaps the most poetic comic strip of them all. The dramatis personae are a black cat whose sex is never made clear, a

white mouse named Ignatz, a white dog called Offissa Pup, and a brick. Black cat loves white mouse. Mouse has one goal in life: to hit the cat in the head with the brick. Cat considers these plasterings an ensign of Ignatz's affection. The Kop, Offissa Pup, strives to protect "that dear Kat" from Ignatz's sadism and Krazy's masochism. Herriman's scratchy drawing is well suited to the happenings and to the fantasy land in which Krazy and his/her companions live. It is a place where a distant house will turn into a more distant mesa and then into a tree-a metamorphosis that is taken for granted by the characters and never mentioned by any of them.

Prince Valiant (fig. 220), as drawn by its

219 GEORGE HERRIMAN. Krazy Kat. © 1938, King Features Syndicate, Inc.

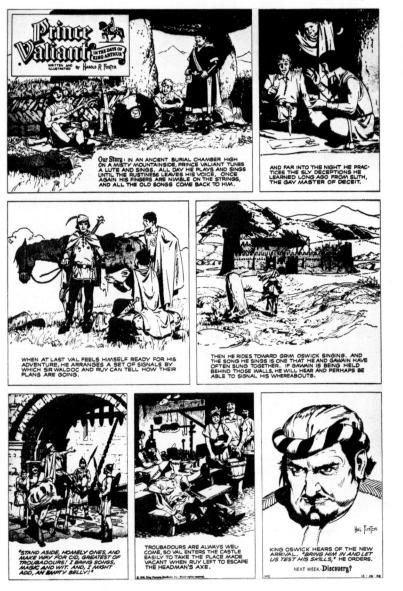

HAROLD FOSTER. Prince Valiant. © 1958, King Features Syndicate, Inc. 221 Figure combining forms from Burne Hogarth and Harold Foster

inventor, Harold Foster, was the cream of the adventure comics. Thoroughly researched (though full of anachronisms) and beautifully drawn, it established a standard that has never been surpassed. Foster's drawings are much more pretentious than those of the other cartoonists. The individual panels are really fairly elaborate illustrations of the text. and the family of forms they contain is discernible but too complicated for a quick definition. In figure 221 I've drawn Prince Valiant partly as Foster would have and partly with Hogarth's forms. It's easy to see that the things don't match. My conglomeration of Schulz, Kelly, and Herriman in figure 222 is similarly uneasy.

Harold Foster picked up much of his style from the so-called Dean of American Illustration, Howard Pyle (1853-1911), particularly from Pyle's illustrations for his own books, published in the early 1900s (fig. 223). In this drawing Pyle used a specific kind of drawn line over and over and over, varying it only a little whether it described chain mail, tree bark, horsehair, or the masonry of the background turret. Contemporary illustrator Bernard Fuchs (born 1932), in his magazine portrait of John F. Kennedy (fig. 224), used blocky forms throughout, repeating a characteristic pose of the young president in the angles of the White House exterior. And when the illustrator par excellence of swashbuckling tales of derring-do, Frank Frazetta (born 1928), did a paperback cover for E. R.

222

Drawing combining elements from Charles Schulz, Walt Kelly, and George Herriman

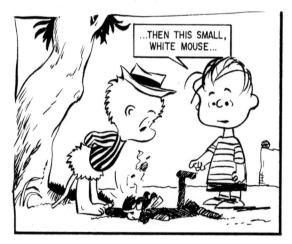

HOWARD PYLE. Illustration from The Story of the Champions of the Round Table. © 1905, Charles Scribner's Sons

224 BERNARD FUCHS. Illustration for part one, "Kennedy," by Theodore C. Sorenson, Look, 1965. Copyright 1965 by Cowles Communications, Inc.

225 FRANK FRAZETTA. Cover illustration for *Conan*, by E. R. Howard. 1967. Courtesy the artist

Howard's *Conan* (fig. 225), he did with paint something like what Hogarth did with ink in the *Tarzan* panel. The grotesquely prominent muscle groups of his figures are matched by lumps in the environment. And the movements match the massed lumpiness of the bodies.

Let us now consider a serious work of art that is not much more complicated in its formal structure than the commercial illustrations. *American Gothic* (fig. 226) by Grant Wood (1892–1942) is unusually clear in the kinds of forms the painter has used as a basis for the composition. One of the most obvious forms is the pitchfork. Actually, it is somewhat unusual for a fork to have three tines; four or five are far more common. However, the trident shape is particularly well suited to Wood's purposes. It is repeated in the stitching of the man's bib overalls, in the stripes on his shirt, in the symmetry of his face, in the first-floor windows behind him, and in the pseudo-Gothic window of the upper story. The curve of the fork recurs in the rickrack border on the woman's apron and in the trees behind the house.

Cézanne's *The Basket of Apples* (fig. 227) is far more complex in its structure, although it may seem at first to be ineptly drawn. It is full of rather queer distortions. The bottle is asymmetrical and tilted. The plate is not elliptical as it would be seen from this angle. And that table is really strange; the near edge loses its identity as it passes beneath the cloth. We might suppose that there were two tables placed together underneath the tablecloth if it weren't for two things. In the first place, Cézanne does this all the time. Secondly, the

GRANT WOOD. American Gothic. 1930. Oil on beaverboard, $29\frac{3}{8} \times 24\frac{7}{8}''$. The Art Institute of Chicago. Friends of American Art Collection

table edge doesn't match up on the backside either; a line drawn along the right side through the plate won't meet the side on the left of the plate. And there are other strange things. Why is the basket of apples propped up so that fruit spills out on the table? And how about those cookies? Now, I ask you, who would stack cookies that way?

You can probably guess that I wouldn't point out these things if I didn't want to say something about them. And, after the analysis of Cézanne's *Mont Sainte-Victoire*, you most likely realize that the artist knew what he was up to.

The queer-looking bottle is a good place

to begin. Notice how similar it is to the shape between itself and the basket; that space looks a little like the bottle inverted, flipped over, and painted a lighter color. The highlight on the bottle makes its left side resemble the dark shadow at the very bottom of the picture. And it is possible to draw a continuous line from the left edge of the bottle down under the basket through the cloth all the way to that dark spot. Also, notice how the lower half of the basket has its curve mirrored in the line from the apple on the far right along the edge of the folded cloth through the next apple and up to the apple adjacent to the basket. Not easily seen in a black-and-white reproduction is an echo of that movement in a depression beneath the lowest apple of the three directly below the basket. There are many such familial relationships. These are but a few.

A comparison of the two schematics in figure 228 should serve to illustrate the magnitude and meaning of Cézanne's departure from traditional drawing. One thing is apparent at a glance; of the two the "Cézanne" (A) is by far the most stable. It is more like the space it fills; its lines and forms are reminiscent of the outline of the rectangle containing them. B, a shabby composition, drawn in accordance with the rules of geometric perspective, has no comparable suitability to its particular space. It does, however, have a highly dramatic and effective space. By contrast A is "standoffish," like a wall. Its space is not dramatic at all. But the relationships within the space are dramatic. One must be aware that the table in Cézanne's drawing

227

PAUL CÉZANNE. The Basket of Apples. 1890–94. Oil on canvas, $25\frac{3}{4} \times 32''$. The Art Institute of Chicago. Helen Birch Bartlett Memorial Collection

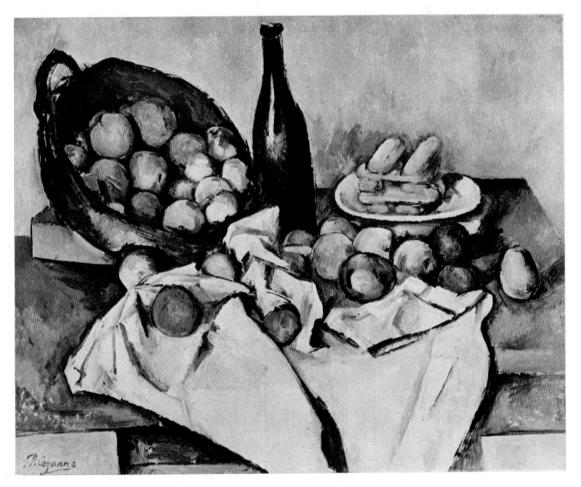

228 Scheme of Cézanne still life contrasted with scheme of traditional still life

had no prior existence. This isn't true of the table in B because it is a projection, and projections have an existence in the rules according to which you draw them. Cézanne's table is unique. Yet it is not drawn in this odd way just to be perverse. It belongs, like everything else in his picture, to a whole series of relationships. Meyer Schapiro has said of this still life that "deviations make the final equilibrium of the picture seem more evidently an achievement of the artist rather than an imitation of an already existing stability in nature."² Turn back for a moment to colorplate 4, Picasso's *Girl Before a Mirror*. Obviously, the forms are of a related family. Study for a while the way one shape fits into another and the way these join together to make still larger shapes. Look, for example, at all the shapes under the extended arm. Pick out the ones that contain black or touch a black zone of color. Do you see how they connect up into their own independent group and grow over into other areas of the painting? Try the same thing with the white shapes, with cool ones, with those that curve, and so on. You will

В

discover that new aspects of the work constantly emerge and that they awake new attitudes toward the painting.

Some comparisons and contrasts

In these pages such a point has been made of the fact that painters must depart from reality in order to portray it that you may suppose the same isn't true of sculptors. They are, after all, dealing with three-dimensional forms, and it is possible to model figures of wax that are so like living beings that they can be mistaken for humans at rest. Still, we do not consider Madame Tussaud's amazing craft an art of much importance. So close a copy of a human being or a piece of fruit is fascinating precisely because considerations of formal composition do not enter in. The moment you become aware of the artifice involved in creating them, the manikins in a wax museum look horribly stiff and dead.

Michelangelo's *David* (fig. 229) is clearly not a person—it is thirteen feet tall and made

MICHELANGELO. David. 1501-4. Marble, height of figure, 13'5". Academy, Florence of solid rock—but it bursts with a vitality more potent than that of living creatures. The *David* is not shaped the way real men are, not even the way highly developed men are. Look at one of those magazines devoted to male "body-building." It does not take much study of figure 229 to disclose the modifications of the male torso Michelangelo made in creating his statue. The forms of the chest, thorax, abdomen, and pubic region are much more harmonious in their relationships than the similarly defined muscles of any weightlifter. They constitute a more coherent family.

Within recent years there has been a movement towards waxworks-like realism among certain American sculptors. The works of Duane Hanson (born 1927) are made by taking plaster casts of people, making plastic molds from the casts, and finally adding real clothing and other paraphernalia (see fig. 230). The content is rather amusing as a comment on the vacuity of certain social values. The form is startling in its verisimilitude. But it hasn't the power of continuous interest of something like the David. Quite probably we in art would pay no attention to Fiberglas copies of people if it weren't for the fact that serious art has been dominated by nonrepresentationalism for the last three decades. It's kind of refreshing to see guys like Hanson flying in the face of all that art critics and professors have been saying is good for thirty years. But we must not forget that even during the days when abstract art was "it" no one doubted that Michelangelo's David was a masterpiece. Even Hanson is defended by his dealer, Ivan Karp, on the grounds that his work is interesting "because the volumes are right."

It may be of interest, at this point, to reexamine some of the masterpieces we've touched on before.

That Cimabue was aware of the necessity to maintain a pattern of similar forms is made clear in his *Madonna Enthroned* (fig. 231). There is so much repetition that the work

DUANE HANSON. Tourists. 1970. Fiberglas and polychromed polyester, $64 \times 65 \times 47''$. Collection Saul Steinberg, Hewlitt Bay Park, New York group into an articulated whole by means of smooth, graceful curves. The line of Christ's hip continues up through his mother's arm and proceeds in an S turn back over her shoulders. Her shoulders are themselves abnormally smooth and circular. The top of her dress matches them. The hills, the clouds in the sky, and even the arc of the frame relate to the gentle swelling curves prevailing in the figures.

Monet's Haystack at Sunset Near Giverny (fig. 235) and Van Gogh's The Starry Night (fig.

236) were painted only two years apart (1891 and 1889) by modern artists of unquestioned genius. In some ways they are very much alike. Both are landscapes, both are frontal, both are concerned with private visions. The private vision of Monet was based on his attempt to render with complete objectivity the color sensations he perceived in a given time and place. That of Van Gogh was a blend of the objective condition of reality with his subjective feelings about it. Monet broke everything down into little spots of color,

235

CLAUDE MONET. Haystack at Sunset Near Giverny. 1891. Oil on canvas, $29\frac{1}{2} \times 37''$. Museum of Fine Arts, Boston. Juliana Cheney Edwards Collection

236 VINCENT VAN GOGH. The Starry Night. 1889. Oil on canvas, $28\frac{3}{4} \times 36\frac{1}{4}$ ". The Museum of Modern Art, New York. Lillie P. Bliss Bequest

weaving a fabric of interlaced hues. His technique reduced the world down into brushstrokes, and they produced a cohesive pattern because of their similarity in scale and weight. The relative massings of strokes of various hues coalesced into shapes from which the larger composition grew. The brushstrokes in *The Starry Night* are more like drawn lines than spots. They are filled with energy and drive that reveal the painter's feelings about the world. Nebulae rage across the heavens of the night, and cypresses spring up like dark flames against the sky. It is easy to see why Vincent van Gogh has come to represent in the popular mind the example of a genius who created in the throes of maddened frenzy. He was mentally ill: he had delusions, once during a seizure he cut off the lobe of his own ear, and he finally committed suicide. But he was a great artist in spite of, not because of, his affliction. His study for *The Starry Night* (fig. 237) is excessive in its fervor; everything is sinuous, intertwined, overwrought. In the final painting such violence has been curtailed. The painting has been ordered, resolved, and made

VINCENT VAN GOGH. Cypresses and Stars, study for The Starry Night. 1889. Reed pen, pen, and ink, $18\frac{1}{2} \times 24\frac{5}{2}''$. Formerly Kunsthalle, Bremen (destroyed in World War II)

richer by pitting stable lines against wavy ones. The sketch is typical of sophomoric "Expressionistic" paintings, the oil an example of excellence.

One of the most famous paintings in the entire history of art is Leonardo's Mona Lisa (fig. 238). Her strange smile is so haunting that it has become a part of the folklore of our civilization. The subject was Lisa,3 wife of Francesco del Giocondo, but she never got the portrait; Leonardo liked it so much that he kept it for himself. A great deal has been written about why she looks at us in this way, about the circumstances under which the picture was painted, and so on. Most of it is nonsense. When you hear someone explain the smile, you must take into account something that most speakers don't-this is an oil painting done in a technique that is timeconsuming. Such an expression occurs in this kind of oil portrait because the painter chooses to put it there.

In his *Mona Lisa* Leonardo is playing games with us. The ambiguity of the famous "gioconda smile" is the result of two things. One is the artist's skill in handling chiaroscuro so as to blur our perception of the second thing. The second thing is the radical asymmetry of the face. Cover up the left half and you will see that she is smirking rather superciliously. Cover up the right half and you will observe that she is cool and reserved. All faces are asymmetrical, and all good portrait painters make use of this fact. But Leonardo has made La Gioconda's face do what a real face couldn't-maintain two expressions simultaneously without a hint of strain or unnaturalness. Also, the face has been harmonized by bringing the arc of the brows, the cheeks, the lips, and the chin into parallel. The same curve is repeated in the top of her dress, the slope of her shoulders, the shape of the top of her head, and in details of clothing. It is a masterful and ingenious work, in which form and content are so completely tied together as to be inseparable.

Leonardo did not much care for women, at least not as men usually do. Willem De Kooning (born 1904) does. But about 1950 De Kooning started painting gigantic pictures of women in a way that would make you think he hates the sex. His *Woman and Bicycle* (fig. 239) evokes the female as a crazed, maniacal, vampirish sex symbol. The forms are born of violent, smeary brushwork played off against flat zones of color. Yet all kinds of artistry are working here, revolting though their consequences may seem. To take a simple example, the feet of the figure merge with the immediate background so as to produce

a whole area of sienna. An adjacent yellow area above (a skirt?) has a similar configuration. Seek out such comparisons and you will be able to see why critics speak of De Kooning's talents as a painter. I myself cannot abide the man's work; in my opinion it is vastly overrated. I can see, however, that it is not empty of value. Some of you may be as enthusiastic as most critics. You don't have to agree with my judgment, obviously. Nei-

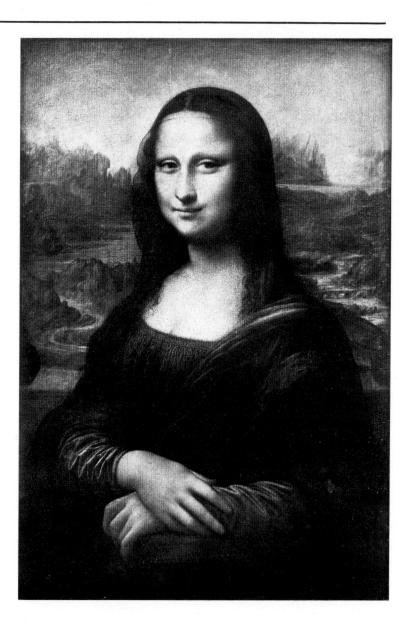

238 LEONARDO DA VINCI. Mona Lisa. 1503–5. Oil on panel, $30\frac{1}{4} \times 21''$. The Louvre, Paris

WILLEM DE KOONING. Woman and Bicycle.

1952–53. Oil on canvas, $76\frac{1}{2} \times 49''$. Whitney Museum of American Art, New York

ther do you have to go along with fashionable opinion. Who knows? I may change my mind about De Kooning. I have modified my opinion of Roy Lichtenstein.

Lichtenstein is what has come to be called a *Pop artist*. His early work was very delicate and sensitive. In the 1960s he developed a new manner. It involved turning comic-strip panels into huge paintings. Figure 240 is from a comic strip; figure 241 is a Lichtenstein painting. At first they look quite a lot alike, although perhaps the looseness of the cartoonist's rendering is more appealing than the tight, almost mechanical drawing in the oil 240 Anonymous comic-strip panel

THAT WAS THEIR MISTAKE -- BECAUSE IT GAVE ME MORE TARGETS THAN I COULD SHOOT AT...

241 ROY LICHTENSTEIN. Brattata. 1962. Oil on canvas, 42×42". Collection Gail and Milton Fischmann, St. Louis

painting. Art historian Albert Boime did a formal comparison of the panel with the painting, and it is worth quoting here:

In the *Brattata* the balloon is modified from the original to correspond more closely to the shape of the pilot's visor... the balloon stem is carefully brought into compositional play with regularly recurring features in the picture. Departing from the straight stem of the original panel Lichtenstein repeats his own crescent shape in

the speed lines of the falling plane, in the highlights of the visor and around the knob on the control panel. Its arc parallels the curve of the helmet and recurs in the contours of the pilot's profile. An even more significant change is Lichtenstein's formal emphasis of the cartoonist's visual "sound effect" of machine-gun fire (*Brattata*) not only in size and color but in the increased tilt which counterbalances the mass of the falling plane. A comparison with the original also reveals how Lichtenstein uses the balloon in

242 LARRY RIVERS. Dutch Masters and Cigars III. 1963. Oil and collage on canvas, $96 \times 67\frac{3}{2}^{m}$. Harry N. Abrams Family Collection, New York

his correction from two to four as the number of downed planes required "to make Ace."⁴

The paintings of Larry Rivers (born 1923), like those of De Kooning, marry Expressionistic brushstroking to representational drawing. And, like Lichtenstein, Rivers sometimes paints pictures of pictures. His Dutch Masters and Cigars III (fig. 242) proves just how complicated this can get. First off, the Dutch Masters trademark is an old master, Rembrandt's The Syndics, and so while Rivers is using popular art as a point of departure, he is also closely tied to fine art. Using The Syndics for a trademark is a case of honoring greatness with levity, especially when the painting is animated for TV. Rivers reversed this by memorializing the trivial and making a cigar box into a cultural monument. The coupling of his drawing style with Rembrandt's figure composition produced an extraordinary effect of renewed vitality. And there is a kind of fascinating interchange of forms occurring between the top and bottom versions in Rivers's painting. The rhythmic play of the angular blotches that move through the pictures, seeming to erase them at one point, helping to articulate them at another, is almost like counterpoint in music. The cigars are handled with similar delicacy. The two at the base suggest the traffic lanes and divider strips of the Long Island Expressway, where the billboard that inspired this painting stood.

It would be misleading to say that formal composition comes down to nothing more than developing unmonotonous similarities of shape, line and color. Obviously, there is a good deal more to it than that. Proportions, painting and drawing techniques, spatial illusions, the nature of the content—all have a role in giving any work its unique form. In one way or another we've been dealing with formal composition all along, in discussing the elements of space, line, chiaroscuro, and form. What this chapter has tried to do is summarize the relationships critics refer to as "form." The next chapter will amplify the understanding.

8 Styles of vision

The word style has so many different meanings as to be unwieldy. "She's not my style." "I don't care for the new styles in clothing." "His style evolved from folk music to hard rock." "When this Brother talks, he comes on with style." "The life style of young people during the 1950s was very different from that of young people today." At the root of all of these applications of the word style is the recognition that objects and individuals and groups of objects and individuals have certain things peculiarly characteristic of them, things which distinguish them from other objects, individuals, or groups. A man with hair to his shoulders, who customarily wears tie-dyed shirts and flared trousers of blue denim, has a different style from someone with a crew cut, a Botany 500 suit, and a "colorcoordinated" shirt and tie. The grooming style of the first person identifies him with a completely different group than the one the second belongs to. But someone who shaves all his hair except for a short, four-inch triangle on top, who never wears anything but jump suits and slippers with pointed toes, and who affects a platinum ring through his lower lip could be said to have a unique style. Unless it should catch on, in which case he'd be the founder of a style.

The kinds of forms and lines in *Peanuts* (fig. 243) distinguish it from *Pogo* (fig. 244) at a glance. And one would not be likely to mistake a comic strip by Milton Caniff (fig. 245) for one by Alex Raymond (fig. 246), simply because the forms Caniff uses are consistently different from those employed by Raymond.

In art, *style* refers to the customary series of forms, colors, and techniques used by an artist. Sometimes these can be identified as characteristics of whole groups of artists; thus, we can speak of a fifteenth-century Flemish style in painting, of the French Impressionist style, or of the Cubist style. It is easy to see that Robert Campin (fig. 247) and Van Eyck (fig. 248) have many things in common when compared with Monet (fig. 249) and Degas (fig. 250). The Cubist work of Pablo Picasso (fig. 251) and Georges Braque (fig. 252) is even more alike than the work of the two Flemish painters or the two Impressionists.

But there is another side to style. There are always specific traits in any artist's work which will differentiate him from everyone else. Van Eyck is like Campin, but there are also things about his drawing and painting that are as individual as his fingerprints. That is obviously true of the two Impressionists. Even the Picasso and the Braque have certain distinctive features that will set them apart for the expert eye. If any of these artists had wished to completely submerge his identity in another's style, he would have been unable to do so. No imitation, no forgery, is ever perfect. For in every individual there are parts of the personality that remain invincibly insulated from external influence or conscious will. This truth is one we must not overlook. But no matter how you view it, the style of a period or group is easier to identify than the style of an individual within a period or group. That is, it's a pretty good bet that you wouldn't mistake a Degas for a Monet

244 WALT KELLY. Panel from Pogo. © 1963, Publishers-Hall Syndicate

243 CHARLES SCHULZ. Panel from *Peanuts*. © 1968, United Feature Syndicate, Inc.

245 MILTON CANIFF. Panel from Steve Canyon. © 1948, King Features Syndicate, Inc.

246 ALEX RAYMOND. Panel from Flash Gordon. © 1938, King Features Syndicate, Inc.

MASTER OF FLÉMALLE (ROBERT CAMPIN?). Mèrode Altarpiece of the Annunciation.

c. 1425–28.

Oil on panel, center panel 25'' square, each wing $25 \times 10''$. The Cloisters, The Metropolitan Museum of Art, New York

248

JAN VAN EYCK. Giovanni Arnolfini and His Bride. 1434. Oil on panel, $32\frac{1}{4} \times 23\frac{1}{2}''$. The National Gallery, London

250 EDGAR DEGAS. The Tub. 1886. Pastel, $23\frac{1}{2} \times 32\frac{1}{3}''$. The Louvre, Paris

249

CLAUDE MONET. Haystack at Sunset Near Giverny.

1891.

Oil on canvas, $29\frac{1}{2} \times 37''$. Museum of Fine Arts, Boston. Juliana Cheney Edwards Collection

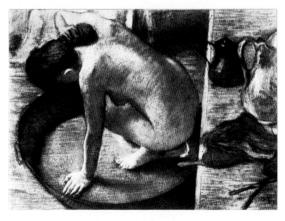

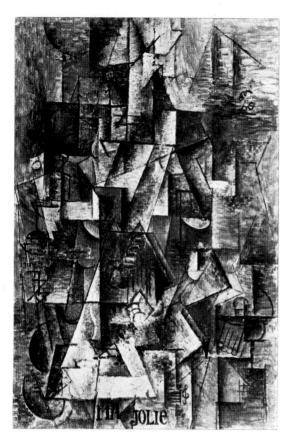

25 I

PABLO PICASSO. Ma Jolie. 1911–12. Oil on canvas, $39\frac{3}{8} \times 25\frac{3}{4}$ ". The Museum of Modern Art, New York. Lillie P. Bliss Bequest

the way you might the Braque for the Picasso. But there's *no* chance that you'd mistake either the Monet or the Degas for any of the others.

Just as there is a branch of art history (iconography) which deals with subject matter, there is a branch concerned with form. Its concern is with historical problems, not with art criticism; it hasn't much to do with quality, it focuses on objective description. It is called *theory of style*. And its principal objective is to explain the evolution of styles throughout history. There are a number of theories of stylistic development, all open to serious question and none without the kinds of flaws that would cause any scientific theory to be discarded. One of the most interesting is Heinrich Wölfflin's.

Wölfflin's theory of style and "instant" connoisseurship

Before we get into this thing, let me make it clear that Wölfflin's theory is applicable only to a specific period, although he himself at first supposed it applied to most historical epochs. Later he admitted that modern art was not accessible to his theory and also confessed that various factors might influence

252 GEORGES BRAQUE. Man with a Guitar. 1911. Oil on canvas, $45\frac{3}{4} \times 31\frac{7}{8}''$. The Museum of Modern Art, New York. Lillie P. Bliss Bequest artistic developments so markedly that they would not appear to correspond to his description. But he was unable to modify the theory to take account of the variables. If I wished to do so, I could give many examples that would dispute Wölfflin's procedures. Anyone seriously interested in art could do the same.¹ I am *not* presenting his theory here with a view to defending it; I use it merely to reveal the ways in which a general view can overcome individual differences among artists.

Wölfflin devised his system in a brilliant analysis of the art of the sixteenth and seventeenth centuries. His contention was that art during this time span tended to move from one set of characteristics to another, specifically from:

1. the linear to the painterly

2. the parallel surface form to the diagonal depth form

3. closed to open compositional form

4. multiplicity to unity

5. the clear to the relatively unclear

He was at pains to point out that he used the terms sixteenth century and seventeenth century for the sake of simplicity but that the characteristics of the latter had actually appeared before 1600 and lasted on into the eighteenth century. Probably the terms *High Renaissance* and *Baroque* should be substituted for his centuries. In any case, what he was trying to do was map out a sort of topography of historical developments. He did not argue that all artists in every nation modified their styles in a synchronized fashion. Obviously, some artists are ahead of the times and some behind. His favorite example of High Renaissance paint-

253

SANDRO BOTTICELLI. The Birth of Venus. c. 1480, Tempera on canvas, $5'8\frac{7}{8}'' \times 9'1\frac{7}{8}''$. Uffizi Gallery, Florence

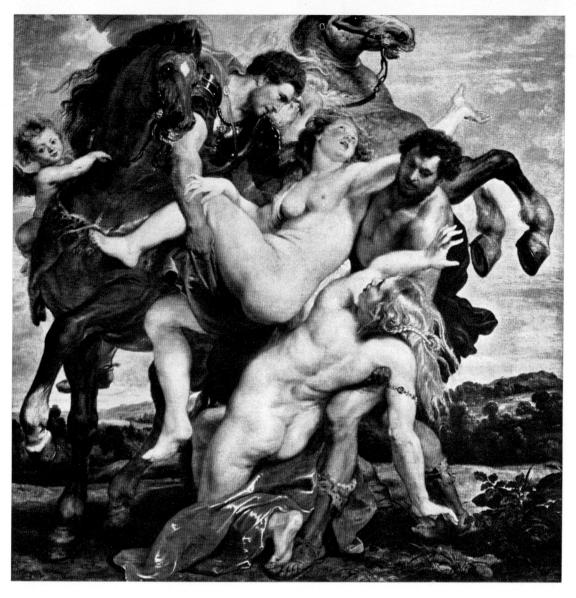

PETER PAUL RUBENS. The Rape of the Daughters of Leucippus. c. 1616-17. Oil on canvas, $7'3\frac{1}{2}'' \times 6'10\frac{1}{4}''$. Alte Pinakothek, Munich

ing is Leonardo's *Last Supper*, painted before 1500; and he often uses Tintoretto as an example of seventeenth-century form, although Tintoretto died in 1594. We are dealing here with generalities. But they are generalities with a good deal of substance.

In order to give a very clear picture of what Wölfflin's polarities mean, I shall make an exaggerated comparison between an Early Renaissance masterpiece and one from the full-blown Baroque. Let Botticelli's *The Birth of Venus* (fig. 253) of about 1480 represent the first set of terms and Peter Paul Rubens's *The Rape of the Daughters of Leucippus* (fig. 254), done about 1619, represent the second. The linear to the painterly: By "linear" Wölfflin means that outlines are relatively clear and that stress is laid on limits of things. By "painterly" he means depreciating the emphasis on outline and emphasizing the larger zones of dark and light. In the Botticelli the limits of things are clear. It would be wrong to say of the Rubens that edges do not exist; but it is certainly true that they are not nearly so clear as in the Botticelli. Rubens gives more power to the large spots of light and dark. Darks merge into darks and lights flow into lights.

The parallel surface form to the diagonal depth form: Obviously, the spatial arrangement in the Botticelli is of objects parallel to the canvas surface. Of course, there are diagonal elements-such as the lines in the shell-but they are not preeminent. What is most striking about the forms is that they are lined up more or less parallel to the front of the work. Rubens's picture contains elements that are parallel to the canvas, surely; but there are major forms that move back into space on diagonals. Consider, for instance, the recession from the nearest daughter's right hand to the head of the man lifting her sister. This movement is diagonal across the canvas and also travels progressively deeper into the picture. In more general terms, the effect of the Botticelli is of a very limited space, quite shallow and flat, whereas the space of the Rubens is correspondingly more three-dimensional. This is true despite the fact that the background in the Botticelli portrays things (such as sky) that we know are as far away in fact as any in the Rubens.

Closed to open compositional form: Venus forms a strong vertical axis for the Botticelli. Even though she is posed in a sinuous manner, she has been oriented to the sides of the picture. In fact, everything in the picture has. Verticals and horizontals dominate despite the presence of a few diagonals. This becomes obvious when we contrast *The Birth of Venus* with The Rape of the Daughters of Leucippus. Open is, perhaps, not a very good term (a-tectonic would be better), but it refers to the fact that in seventeenth-century works the horizontal and vertical elements of the picture edge do not dictate the internal arrangement of forms to the same extent that they do in sixteenth-century works. What is most evident in the Rubens is the diagonal, circular arrangement of things. Briefly put, the Botticelli looks deliberate and studied; the Rubens has a more open, casual look. We might think of the terms closed and open here as we do in describing personalities as closed or open. By the former we mean constrained, tense, uptight; by the latter we mean free and expansive. Too, closed compositions tend towards symmetrical balance, and open ones are often quite unsymmetrical.

Multiplicity to unity: The Botticelli is constituted of a collection of distinctly separate forms. We can separate out the nude or the two figures representing the Zephyrs and comprehend them as individual items very easily. We might even look at Venus's long hair apart from Venus as a whole. Venus is a composite of separate pieces; the picture is the result of multiple parts, each worked out as a separate entity. In Rubens it is possible, of course, to speak of a given head or hand or person separately from the others, but no individual figure or part of a figure has the kind of independence one experiences in Botticelli. This can be quickly demonstrated by vignetting Venus and one of the daughters (fig. 255). Venus can exist outside her original context; the daughter is dependent on her surroundings. This is what Wölfflin meant by unity in seventeenth-century art-the greater dependence of one part upon the others so that the picture as a whole is a unit.

The clear to the relatively unclear: This development is, like the others, closely connected with the difference between linearity and painterliness. But here Wölfflin was trying

²⁵⁵ Vignettes of a daughter of Leucippus (above) and Venus (below)

to tie together some loose ends. And from his point of view Botticelli wouldn't fit, really: Botticelli would be distinguished from the High Renaissance because he was not striving for the absolute clarity of form that later painters such as Leonardo and Raphael sought. Wölfflin's example of absolute clarity is Leonardo's Last Supper (fig. 256), in which human beings have been reduced to geometric forms, in which the perspective scheme focuses on Christ's head, in which all twentysix of the people's hands are shown. In Rubens's The Rape of the Daughters of Leucippus things are not absolutely clear in this way. Things are loose and swinging, the eye moves freely through the picture, and although five figures appear there are only seven hands.

Leonardo's Last Supper might seem too "painterly" for the High Renaissance as Wölfflin defines it. This is due in some measure to its physical deterioration and piecemeal repair, but any Leonardo is less obviously linear than any Botticelli. What Wölfflin points out is that in looking at the Last Supper we are conscious of the limits of things despite the haziness of the work. Much High Renaissance painting from Italy has a dark hazy effect (called sfumato) that obscures the clarity of edges. Still, the impression is that the edges exist firmly and tangibly beneath the shadows. Remember, this is a matter of relative clarity.

Contrast Leonardo with Tintoretto (fig. 257) in terms of Wölfflin's theory. The limits may be somewhat uncertain in Leonardo, but they are buried in Tintoretto. Furthermore, in Leonardo the parallel form is very evident: the table parallel to the picture plane, the figures in a row behind the table, the wall behind them, the landscape beyond the windows. As we have noted previously, Tintoretto drives the tables and figures deep into the picture, and the diagonal depth form is strikingly evident. Of course, the relationship of

259 REMBRANDT VAN RIJN. Adam and Eve. 1638. Etching, $6\frac{3}{8} \times 4\frac{5}{8}^{n'}$. Rijksmuseum, Amsterdam

is linear, has a parallel surface form, is closed rather than open, multiplicity rules (even the figures are made of separate muscle groups), and the individual forms are absolutely clear.

Rembrandt handled the same theme in an etching (fig. 259). It is made up of drawn lines, but it is not linear; indeed, there are places where the edges of things are not indicated at all. Notice the lighted side of Eve's right leg or the way shade merges with shadow under the serpent's foot. What strikes one in looking at the etching is not the outline of the forms but the dark and light spots in the work. Also one is much more conscious of diagonal spatial properties in the Rembrandt. The coordination between vertical and horizontal elements within the picture and the edges of the plane is not critical to the composition. As for clarity, the forms in Rembrandt's work are coherent rather than crisp and clear because of the way he uses light and shadow.

There were also Dutch artists of the seventeenth century who painted very neat, highly detailed pictures. So let us contrast one such picture with a sixteenth-century painting by Holbein. *Georg Gisze* (fig. 260) has a more parallel surface form than Vermeer's *Young Woman with a Water Jug* (fig. 261). It is more linear. It is pretty symmetrical and not so fluid and open-looking; HANS HOLBEIN THE YOUNGER. Georg Gisze. 1532. Oil and tempera on panel, 38×33". Staatliche Museen, Berlin-Dahlem

Gisze is a good deal more fixed in his space than the maid is in hers. He is obviously more a sum of individual parts than she, and so it goes throughout the two pictures. Finally, for all of the sparkling clarity of Vermeer's light effects, the objects are not so definite in their appearance as the sharply detailed things in the Holbein.

Now, then, having looked at a few examples of the application of Wölfflin's categories, you should be able to apply them to pictures you know nothing else about. Your "instant connoisseurship" depends on the fact that I am not going out of my way to trick you by including things that don't fit the system. But you may be surprised at how accomplished you are at dating works. Included in figures 262 to 271 are five sixteenth-century works and five seventeenth-century works. Which are which? The answers are on page 317.²

I suspect you got most of them right. Granted, if you had not known how many were in each category, you might have picked figure 263 as sixteenth because it is possible to read the figure groupings as parallel to the picture plane and because there are a lot of closed compositional relations to the canvas. But you'll have gotten at least eight out of ten right, which is better than you could have done without the Wölfflin formula. Right? Quite so.

261

JAN VERMEER VAN DELFT. Young Woman with a Water Jug. c. 1665. Oil on canvas, $18 \times 17''$. The Metropolitan Museum of Art, New York. Gift of Henry G. Marquand, 1889

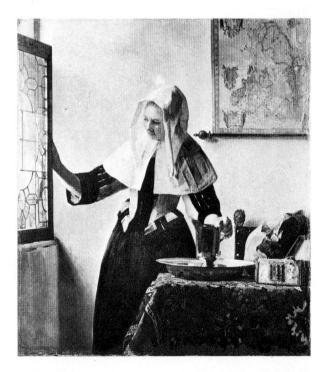

260

PIETER BRUEGEL THE ELDER. Peasant Wedding. c. 1565. Oil on panel, $44\frac{7}{8} \times 64''$. Kunsthistorisches Museum, Vienna

It would have been easy to stymie you. To which century would you assign figure 272? It has a definite linearity, yet the diagonal depth form predominates. There are elements of both the closed and open compositional form. Still, it is made up of individually distinct elements and is clear in the foreground but less so in the distance. It was done in the sixteenth century, as you can see by the caption. Wölfflin called the painter, Pieter Bruegel the Elder, a "transitional painter." He says that Bruegel paved the way for Vermeer but was not yet a Vermeer.

What I am trying to show you is that there are stylistic differences between vast groups of painters that are obvious to anyone who wishes to spend even a little time taking notice of them. In Wölfflin's theory they occur across the centuries regardless of the personal or national differences among the painters. His theory doesn't always work out, but it is true that it describes most High Renaissance art in the sixteenth century and most Baroque art during the seventeenth. The High Renaissance style of vision is different from the Baroque style of vision. The reason for the emergence of the two modes interests those of us with some concern for the history of ideas, but the point is that you don't have to know anything at all about history to observe the differences in the art; they are revealed in the distinctive forms the pictures take.

273 REMBRANDT VAN RIJN. Christ at Emmaus. 1648. Oil on panel, $26\frac{3}{4} \times 25\frac{1}{2}^{"}$. The Louvre, Paris

Individual styles within a style of vision

It would not do to neglect the profound differences that exist within a given style of vision. Rembrandt's *Christ at Emmaus* (fig. 273) and Vermeer's *Young Woman with a Water Jug* (fig. 274) were painted only four years apart, and both conform to Wölfflin's description of seventeenth-century art. But within that general Baroque style of vision these Dutchmen's styles of vision are vastly different. The differences, though, are apparent to anyone. The similarities take a bit of looking for.

Once in awhile we encounter paintings so much alike that a qualitative difference between them seems unlikely. But a little attention to particulars can enlighten us about the way in which individual genius overcomes an imposed style. In the works of Raphael and his teacher Perugino (c. 1450–1523) we have the perfect example. In 1500 Perugino portrayed the marriage of Mary and Joseph (fig. 275). In 1504 Raphael painted his *Marriage* of the Virgin (fig. 276), following the pattern established by his teacher.

At a glance the two works are almost identical. There is a row of figures in the immediate foreground, a courtyard behind them, and a temple beyond the court. A brief study will show that, while the content is the same

274

JAN VERMEER VAN DELFT. Young Woman with a Water Jug. c. 1665. Oil on canvas, $18 \times 17''$. The Metropolitan Museum of Art, New York. Gift of Henry G. Marquand, 1889

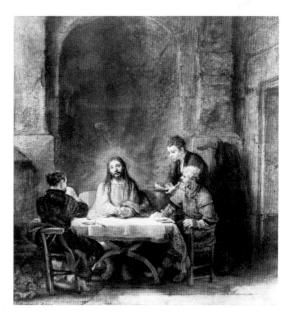

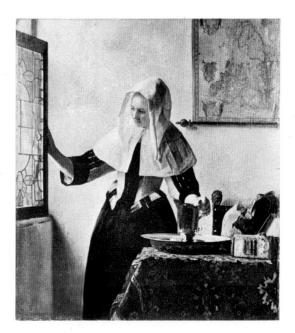

275 PERUGINO. The Marriage of the Virgin. 1500. Oil on panel, $92\frac{2}{8} \times 73\frac{1}{4}$ ". Museum of Fine Arts, Caen, France

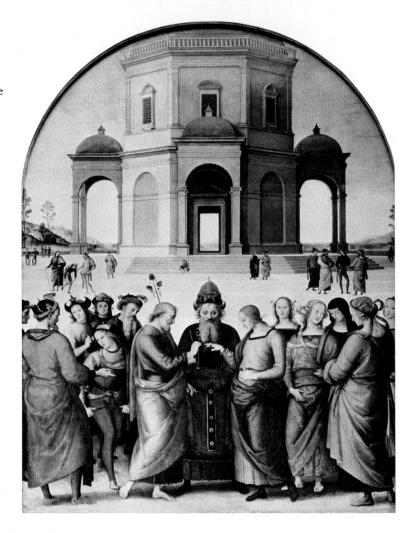

and the style of vision sixteenth century, the individual styles are really quite different.

The Perugino figures form a much more solid row; they are like a wall. We observe them with the same detachment with which we look upon the temple. The principle of horizontality is ruthlessly carried through by Perugino. The figure arrangement, the long panels in the courtyard, the extremely broad temple steps—all stress the horizontal. The temple is a distracting element. It has two porticoes out to the sides. An identical one projects toward us, but we don't realize it's a porch at first. What captures our attention is the doorway in the center of the shaded archway. That door is the most arresting single element in the whole work. The perspective is wrong too. There is one eye level for the temple, another for the figures.

Raphael has overcome most of his teacher's weaknesses. His row of figures is not so absolutely parallel to the picture plane. The young woman on the left stands closer to us than Mary, helping to lead the eye into the picture. Too, the fellow breaking a stick over his knee—symbolic of leaving one family for

RAPHAEL. The Marriage of the Virgin. 1504. Oil on panel, $67 \times 46\frac{1}{2}$ ". Brera Gallery, Milan

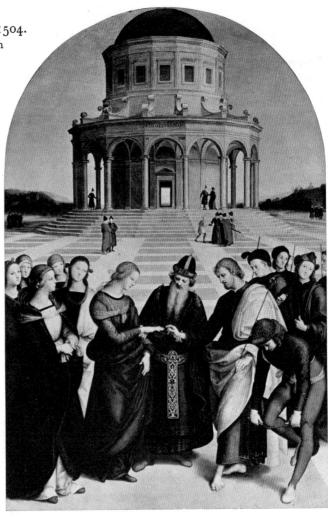

a new one—matches the girl's diagonal. In the Perugino the same ritual figure is lost among the other members of the foreground group. Raphael's courtyard is calculated to convey depth, and his temple has a coherence Perugino's lacks. Raphael has absorbed the porches into a continuous arcade, and he has decreased the depth of shadow around the door. Moreover, he has given the priest a brocaded belt with a strong vertical accent; it helps connect the temple door to the foreground figures. Too, the doorway is smaller than the one in Perugino. The courtyard panels are shorter, producing a series of brief diagonals that lead from the figures to the temple steps.

Perugino organized his painting in terms of a family of forms that tend to separate things into horizontal bands. It is a unified composition insofar as the visual pattern is concerned. But Perugino's pattern gets in the way of psychological coherence. Raphael's system of forms is as unified as his teacher's; but it contributes to the representation, it doesn't disrupt it. The different emotional tone of the two works is revealed in small by

SALVADOR DALI. Apparition of a Face and Fruit Dish on a Beach. 1938. Oil on canvas, $43\frac{1}{2} \times 57''$. Wadsworth Atheneum, Hartford, Connecticut. The Ella Sumner and Mary Catlin Sumner Collection

282

JOAN MIRÓ. Person Throwing a Stone at a Bird. 1926. Oil on canvas, $29 \times 36\frac{1}{4}$ ". The Museum of Modern Art, New York (born 1893) identified himself with the same trend in modern painting. His *Person Throwing a Stone at a Bird* (fig. 282) appears, however, to have nothing in common with Dali's style.

The apparent contradictions in modern art have been dealt with by an art theoretician, Wilhelm Worringer, who published his doctoral dissertation, Abstraktion und Einfühlung (Abstraction and Empathy), in 1908. An early apologist for modern art, particularly the Expressionistic movements, he attempted to demonstrate the existence of two polarities throughout the history of art. According to Worringer, abstract or geometric art occurs in cultures oppressed by nature and therefore obsessed with spiritualism. Realistic, organic, or empathetic art (according to his terms) flourishes among peoples who have an affinity for nature and find satisfaction in contemplation of it. Later, in 1912, he argued that the two styles of vision (abstract and empathetic) had generally a geographic identity, with the north of Europe leaning to the spiritualistic form and the south having a predilection for sensualism. In other words northern art is apt to be abstract and/or geometric, while southern art is realistic and organic.

Worringer's system accounts for both Renaissance humanism and Gothic architecture as well as for Mondrian, Kandinsky, and Marc. One can even force it to accommodate the Spaniard Miró, whose shapes are organic and sensual. But others don't seem to fit. Oh, you can make them fit the system, but any system that requires such strain is open to serious doubt.

There are later, rather more complicated explanations of the evolution of art styles throughout history. None of these seem altogether adequate. Certainly, an account of them is unnecessary in an art appreciation text.

9 Modern art, its variety and unities

If the word *modern* suggests what is up-todate, then modern art is misnamed. Most authorities date its beginnings with Manet's Olympia, and she is now over one hundred years old. Modern art is really just a catchall term for the many movements and individual styles that have succeeded Manet's early works. With rare exceptions these styles have been extremely unpopular even when celebrated by umpires of taste-museums, art critics, art collectors, and professors. Modern styles are, by nature, esoteric; that is, understanding of them is limited to a relatively small circle. In one sense all art is esoteric. Were that not so, there would be no need to study it and its meanings. But modern art is more puzzling to laymen than traditional forms have been. After all, you can appreciate Raphael's Madonna of the Beautiful Garden (fig. 53) or Harnett's After the Hunt (fig. 5) for what they represent, while remaining ignorant of the artistry that created them. Doubtless there are a few people who fall in love with Mondrian and Kandinsky at first sight, but they are very rare.

One of the things that makes modern

painting and sculpture hard to grasp is the sheer variety of its styles. The mortality rate of the movements is the most obvious thing about them. Some "ism" emerges, flourishes for a few years, and then drops out of fashion to be replaced by another mode. Sometimes the history of these "isms" seems like nothing so much as a spectator sport played for a special group of bored sophisticates; the champion of today is old-hat tomorrow. It really isn't that simple, but it sometimes seems to be. All those names: Realism, Impressionism, Postimpressionism, Neoimpressionism, Fauvism, Cubism, Expressionism, Surrealism, Futurism, Neoplasticism, Minimalism, and so on. The mind boggles!

In an earlier book of mine it took almost two hundred pages to cover a rather narrow topic-the relation of certain modern artists and movements to developments in scientific theory-even assuming a slight familiarity with the history of modern art on the part of the reader. Obviously, in one chapter of a book designed to introduce people to all art there is no way in the world to explain much about modern art. At the same time, we have already dealt with some major modern works in the earlier chapters, so we can make good use of previous analyses in an overview. Bear in mind, though, that this treatment is very superficial and that distortion of the truth is inevitable in such a survey. All I can hope to do is minimize its effects by warning you beforehand. For those interested in a more complete history of modernity (or, for that matter, of any other period) there are suggested readings at the end of this book.

Neoclassicism

To talk of the art of the nineteenth century, one must begin in the eighteenth. For modern art is a middle-class phenomenon, and it was at the end of the eighteenth century that the middle class finally came into political power. This class had had a decisive influence on taste in art from the time it emerged during the late medieval period. But all through the Renaissance political authority had been in aristocratic hands. And when those of middle-class origin became truly powerful—as the Medici did—they soon gained titles and entered into the line of nobles. There were exceptions to this pattern, the most notable being the Dutch Republic, ruled by an elected group of businessmen; but for the most part feudal rule lingered on in politics even as capitalism was driving it from the economic scene.

After the Treaty of Paris (1763), concluding the Seven Years' War,¹ such centers of aristocratic power as the estates, assemblies, and parliaments were under constant pressure from middle-class and popular radicalism. In 1789 the middle-class and radical elements of France combined to overthrow the government in the name of Liberty, Equality, and Fraternity. Out of the French Revolution was born the First Republic of France.

The First Republic turned out to be a thoroughly middle-class affair. One evidence of this is that not once during the famous Reign of Terror did its leader, Robespierre, challenge the right of private property, the thing which gives any middle class its security and its political clout. One might, then, expect the art of the Revolution to resemble that of the Dutch. After all, the Dutch had the first middle-class republic. Moreover, Dutchlike trends in France (represented by people like Chardin) had persisted throughout the eighteenth century alongside such aristocratic styles as those of Claude Lorrain and Antoine Watteau (1684-1721; see fig. 283). It must seem curious that the Revolution chose for its style a "purified" version of old-fashioned Classicism. But it isn't really odd when you consider the alternatives that were available.

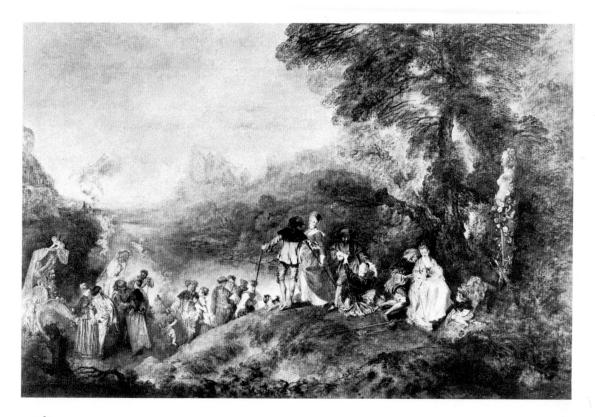

283 ANTOINE WATTEAU. A Pilgrimage to Cythera. 1717. Oil on canvas, $51 \times 76\frac{1}{2}$ ". The Louvre, Paris

Vermeer's scenes of domestic life, Chardin's still lifes, and the hundreds and hundreds of similar works by lesser artists all represented the private interests of the middleclass individual. There was no reason for an official style to represent that individual's class until the abolition of all feudal privileges occurred. The moment that occasion arose, with the success of the French Revolution, it became obvious that unheroic attitudes could not convey the patriotism and courage of the revolutionaries. Chardin was no more serious or heroic than Watteau. And the revolutionary situation required themes of tremendous gravity. Of the seventeenth- and eighteenthcentury styles then current, only Classicism had seriousness to offer.

Were it necessary for us to make up a style that would be in accord with the mood of the Revolution and the propaganda purposes of the First Republic, we could do so quite easily. Seriousness of theme would be a main requirement. The most suitable subjects would surely be drawn from the histories of ancient Greece and Rome. France was surrounded on all sides by hostile monarchies whose rulers argued that Divinity stood on the side of kings. But France could find in democratic Athens and Republican Rome models of civic virtue even older than the royal houses of Europe. As for form, the circumstances required an art distinguished by dignity and solemnity.

As it happens, we do not have to be con-

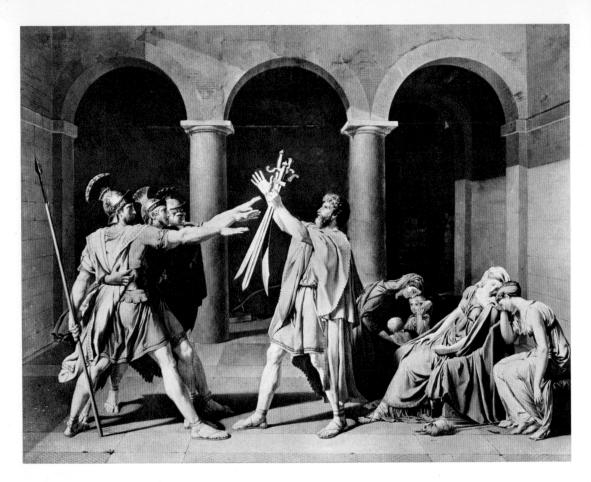

JACQUES-LOUIS DAVID. Oath of the Horatii. 1786 (small version). Oil on canvas, $51\frac{1}{4} \times 65\frac{5}{8}$ ". Toledo Museum of Art. Gift of Edward Drummond Libbey, 1950

tent with a description of what the art of the Revolution would have been like. It still exists. And the prescription laid out above is patterned on the canon of Jacques-Louis David (1748–1825), artistic dictator of both the First Republic and the Empire under Napoleon Bonaparte.

In 1785, four years before the Revolution, David had exhibited his Oath of the Horatii (fig. 284), the first triumph of his special style. Here the content is serious indeed; three brothers swear to win or die for Rome against Alba. But what set off David's Neoclassicism from previous Classical styles was the strict economy of means which characterized its form. His technique is abstemious even when compared to that of seventeenthcentury Classicists like Nicolas Poussin (1594–1665; see fig. 263). Everything is broken down into modalities of three. There are three archways, three figure groups, three brothers, three swords, three spatial levels. And any concession to Watteau-like luxuriance has been ruthlessly suppressed. Even his brushwork is flat, in itself uninteresting. Clarity is the supreme objective of the form, and moral seriousness plus sacrifice the content that it holds. Even before the Revolution the insurgents identified this picture with the goals and ideals of 1789. David was not the only Neoclassicist. Not by any means. Naturally, there were a few other great painters among the hundreds trained by official schools of art. But he is the foremost, and the purest of them all. He was high in the councils of government, and his ideas virtually dominated the education of artists all the way into the early twentieth century.

I am not the first person to note that David's was a curiously bloodless and dispassionate art, considering the kinds of things with which it was associated. These were the times of the tumbril and the guillotine; public executions and violent death formed an important item of the citizens' diet. David himself consigned lifelong friends to the chopping block with no more reluctance than he'd have thrown away a wornout brush. And what did he paint all the while? Pictures that are unemotional, spare, and neat. Impersonal Neoclassicism was, perhaps, the perfect art to "front" for such mass insanity. Even today the major polluters of the environment have the cleanest and most antiseptic-looking homes and offices. But David's times cried out for artistic

expressions of deeper feeling. And creative imaginations were not slow to answer.

Romanticism

Romanticism is often defended as a movement that opposed logic and rationality to Pascal's "reasons of the heart," and many people have fallen into the habit of accepting this description as if it were the thing. Just how far most of us have fallen was estimated a number of years ago by Jacques Barzun, who listed eighty separate uses of the term romantic.² Most of them derive from the idea that Romanticism is irrational. Professor Barzun, however, is of the opinion-an opinion I share-that the Romantics differed from the Classicists mostly in being more comprehensive. Instead of sticking to ancient subject matter of great nobility of purpose, the Romantics took in the whole world, both the tangible and the supernatural. They dealt with the present as well as the past and with exotic places as much as with familiar myths.

The first painting of real importance in the direction of Romanticism was Théodore Géricault's *The Raft of the "Medusa*"(fig. 285).

285 THÉODORE GÉRICAULT. The Raft of the "Medusa." 1818–19. Oil on canvas, $16'1'' \times 23'6''$. The Louvre, Paris

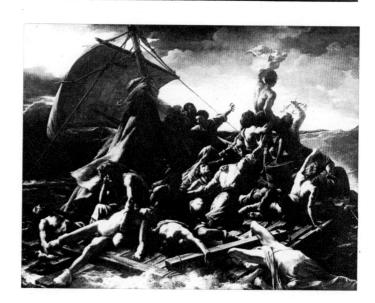

What it portrays is not something from the Classical past but a contemporary event. On July 2, 1816, the French ship *Medusa* wrecked off the west coast of Africa. One hundred and forty-nine passengers and crewmen were cast adrift on a makeshift raft. By the time they were rescued only fifteen still lived. The tragedy produced a maritime scandal, and Géricault's picture aftracted large numbers of people both in Paris, where, by taking advantage of a loophole, it was slipped into the annual exhibition of official art, and in England, where it was exhibited as a sort of sideshow novelty. The Classicists hated it, but the general public was introduced to a kind of modern painting that took as its models Rubens and Michelangelo instead of Poussin.

The picture was filled with innovations. Surrounded by the waves of the sea, the figures rise in a great wave of humanity at the top of which is a black man. That Géricault used a Negro was no accident; one was among the survivors. That he should be the pinnacle of the group relates to the very origins of Romanticism in the writings of the

286

EUGÈNE DELACROIX. The Death of Sardanapalus. 1827. Oil on canvas, $12'11\frac{1}{2}'' \times 16'3''$. The Louvre, Paris

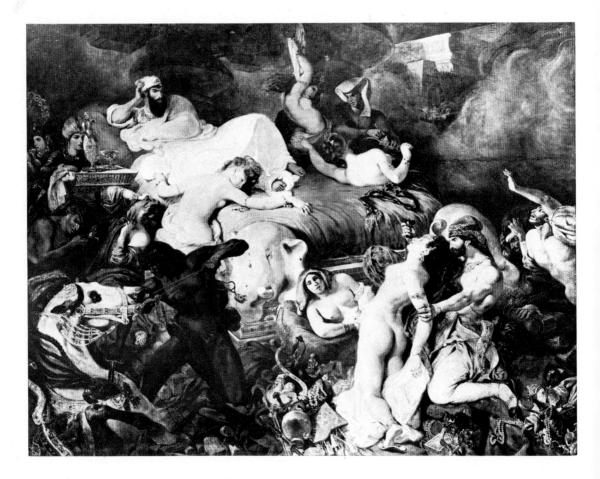

philosopher Jean-Jacques Rousseau, who contrasted the "noble savage" with corrupt Western civilization, who felt that the European culture of his day thwarted the humanity of man. This notion-that the civilized and reasoned-out is an assassin of the natural, the spiritual, and the human-is a recurrent theme that occurs in different guises throughout recorded history. (We are encountering it again today in "black consciousness," in "organic" food, in the hip subcultures, in all back-to-nature movements, and in the popularity of oriental mysticism.) Romanticism is founded on the assumption that the object of life and art is to grasp all directly, spontaneously, and freely.

Romanticism abandoned nothing; it simply incorporated far, far more. It wasn't just a style; it was a genuine intellectual movement, comprising all sorts of styles and many different art forms. The most famous Romantics are the writers Lord Byron, Sir Walter Scott, and Johann Wolfgang von Goethe. The Death of Sardanapalus (fig. 286) by the greatest of all Romantic painters, Eugène Delacroix (1798–1863), was based on one of Byron's poems. It concerns an Assyrian potentate who is determined that conquering invaders already at the palace gates shall not enjoy anything he himself prizes. As he is about to immolate himself, he has all his treasures-including his concubinesheaped upon the luxurious funeral pyre. He and all he values are to go up in flames together. Nothing could be less Neoclassical than this subject. It is violent, it is exotic, it is based on contemporary literature rather than the writings of antiquity, and it is painted in a manner altogether different from David's.

Where David sought precision, Delacroix sought power. David's edges are definite and predictable; Delacroix's are more obscure than the Baroque. Where color, for the Neoclassicist, was just added to the drawing as decoration, in Delacroix's painting the color is rich. David's brughwork is as dry and flat as that of the house painter; Delacroix's is lush and textured—it has what painters call a "juicy" look.

The Romantics rediscovered the Middle Ages and the Renaissance. Frequently their subjects were remote in space as well as time. Delacroix visited the Near East to paint Morocco's blazing shores and clamorous marketplaces. Others came to the New World, and still others traveled to Asia, that most ancient world of all. The Romantics tried to capture in paint and poetry the whole of man's experience. Part of that experience is, of course, not dramatic or bizarre in any way at all but simply ordinary day-to-day living.

Realism and Impressionism

Of all the many offshoots of Romanticism, the one that produced the most revulsion was a movement which has come to be known as Realism. Its principal exponent was Gustave Courbet (1819-1877), whose Stone Breakers (fig. 287) gives you some sense of the style. Courbet was sympathetic to these rough working men in their rude clothing, but, compared to the prettified characters of Neoclassicism or Delacroix's people with their grand passions, Courbet's peasants are vulgar. It was obvious to the middle-class viewers of the day that the painter of such ignoble men must be a socialist. Now political philosophy and compassion for the downtrodden don't have to be connected. But Courbet himself confirmed the opinion, saying that he was "not only a socialist, but also a democrat and a republican, in short a partisan of the entire revolution, and above all a realist, that is a sincere friend of the real truth." Need I add that the socialists soon began defending Realism as the true art of the age?

Left-wing cartoonist Honoré Daumier shows us, in his serious pictures (fig. 288),

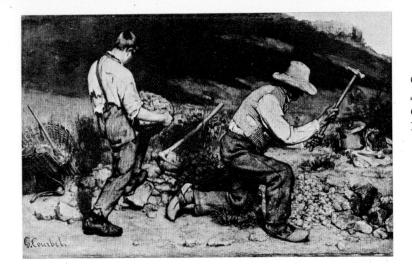

287 GUSTAVE COURBET. The Stone Breakers. 1849.

Stone Breakers. 1849. Oil on canvas, $5'3'' \times 8'6''$. State Picture Gallery, Dresden

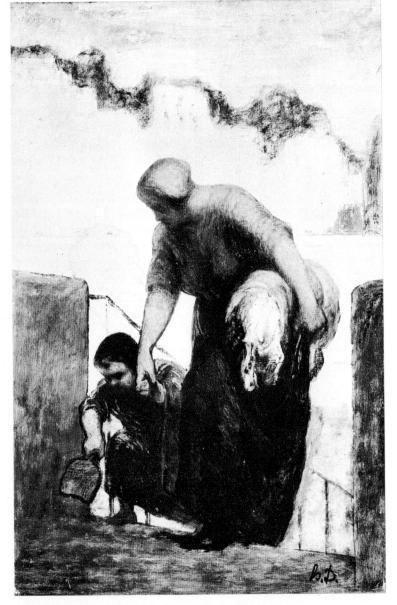

288 HONORÉ DAUMIER. The Laundress. c. 1861. Oil on panel, $19\frac{1}{4} \times 13''$. The Louvre, Paris 289 EDOUARD MANET. Olympia. 1863. Oil on canvas, $51\frac{1}{4} \times 74\frac{3}{4}$ ". The Louvre, Paris

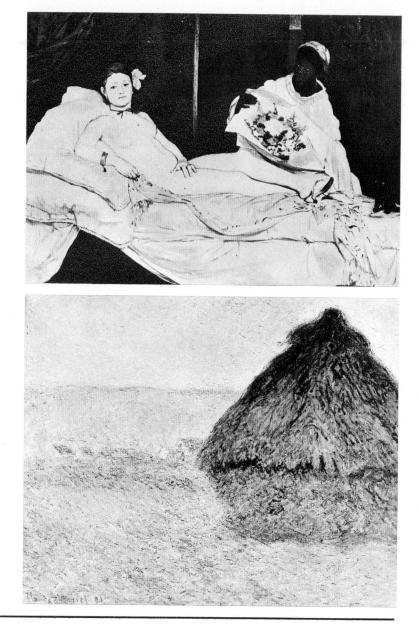

290 CLAUDE MONET. Haystack at Sunset Near Giverny. 1891. Oil on canvas, 29½×37". Museum of Fine Arts, Boston. Juliana Cheney Edwards Collection

the side of Realism that is dependent more on subject matter than on technique. He frequently portrays people of the city who are cut off from the benefits of middle-class urban existence. He is realistic in his willingness to face unpleasant social facts of inequality rather than in his manner of portrayal. Daumier, Courbet, and Naturalist writers like Emile Zola stood on the side of the radicals. From the very outset Realism and the movements it sponsored set themselves in opposition to the official representations of middle-class taste.

Manet's Olympia (fig. 289) was as shocking as any Courbet peasant because of the artist's characterization of Titian's Venus as a Parisian whore. Of course, Manet went beyond Courbet's Realism when he diminished chiaroscuro and intensified the role of hue. His painting opened the way for the truly radical realism of the French *Impressionists*, who, typified by their leader Claude Monet (fig. 290), turned the matter-of-fact technique of the Realists into a registering of exquisite color sensations. Too, Impressionist subjects reveal a quite different sort of taste;

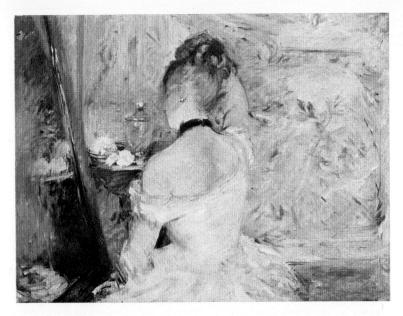

291 BERTHE MORISOT. Woman at Her Toilet. c. 1875. Oil on canvas, 23³/₄×31³/₄". The Art Institute of Chicago. Stickney Fund

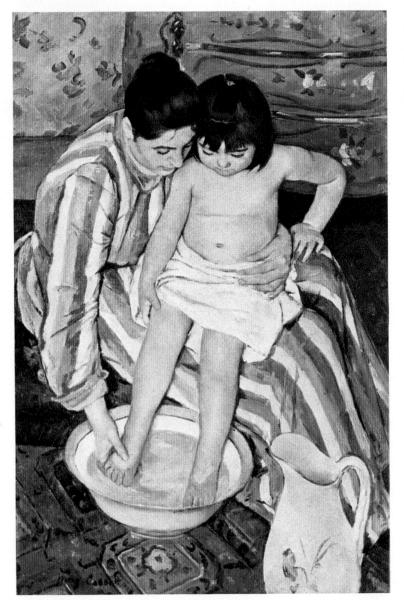

292 MARY CASSATT. La Toilette. c. 1891. Oil on canvas, $39 \times 26''$. The Art Institute of Chicago. Robert Alexander Waller Memorial Collection they are usually attractive things: landscapes, boulevards, café scenes, ballets, pretty women, picnics, horse races, boating parties, dances, and so on. The colors are pretty and the things portrayed pleasurable or pleasant. Such subjects seem far removed from the vision of Courbet or Daumier. Yet the Impressionists felt that they were rejecting the values of the middle classes. They weren't, really. What they were doing, without knowing it, was opposing the values of the philistine middle class with the more sophisticated tastes of the cultivated elements of that class. In other words, they rejected the kind of "blah" ordinary pictures and ideas that respectable bourgeois society equated with responsible behavior and the good family life. Instead they created pictures that tied in with the more liberal tastes of the fashionable ladies and gentlemen of nineteenthcentury Paris. In contemporary slang terms the comparison is rather like this: David's followers represented "straight" middle-class society, while the Impressionists painted for the well-to-do swingers of the late 1800s.

At the outset Impressionism was extremely

unpopular with all classes of people, but before the end of the century its practitioners were famous and successful. This is not surprising; their viewpoint was the same as that of the cultivated man-about-town. Except that they weren't all men.

French Impressionism produced two outstanding women painters in Manet's sisterin-law, Berthe Morisot (1841–1895), and the American Mary Cassatt (1845–1926). The former patterned her style after that of Manet's later work (see fig. 291). Cassatt began with a style modeled on that of Degas. She went on to produce a distinctively feminine version of Impressionism—feminine because of the subject matter: nearly always women and little girls (see fig. 292).

Most of its practitioners were not really dedicated to a thing called "Impressionism." Degas (fig. 293) did not consider himself an Impressionist. He looked upon his own work as a kind of modern Classicism despite the tendency of the color in his pastels to resemble more and more that of Monet and Monet's followers. One genuine Impressionist, Renoir (fig. 294), grew impatient with the

293 EDGAR DEGAS. The Tub. 1886. Pastel, $23\frac{1}{2} \times 32\frac{1}{3}^{"}$. The Louvre, Paris

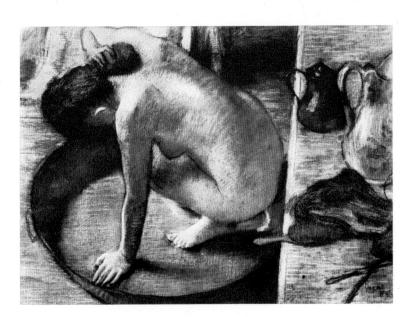

casual easiness of the style and combined Neo-Renaissance drawing with contemporary color. He is not usually grouped with the Impressionists; usually he is called a Postimpressionist. So is Cézanne.

The term Postimpressionism is a clumsy one. It wasn't invented until after 1900. It was first used as the title for an exhibition of recent French paintings being shown in London. All its inventor, the English critic Roger Fry, meant to accomplish with it was to indicate that all the paintings included in the exhibit came after Impressionism and owed something to it. The term confuses people because it contains artists as diverse as Van Gogh, Cézanne, and Gauguin. The sole value of the label lies in indicating that these men shared the same voyage from nineteenth-century Impressionism to the more extreme movements of the twentieth century.

A more useful way of looking at the history of modern art is to conceive of it as a set of related but contrasting elements, like complementary colors or odd and even numbers.

This conception sees everywhere an antecedent contest between Classical precision and Romantic power. There are paired opposites all along the way: David versus Delacroix, Seurat versus Van Gogh, Mondrian versus Kandinsky, Anuszkiewicz versus Pollock. Alongside a tendency towards pure formalism there flows a strong current tending to absolute subjectivity. If one thinks of these tendencies as streams analogous to actual rivers, one must think of them as meandering alongside each other in a common voyage from Impressionism to the present. Sometimes they are parallel. Sometimes they link and pool. Sometimes they are so far apart as to seem entirely unrelated.

The rationalist-formalist current

Of all the followers of the Impressionist method, Paul Cézanne is the most prominent. Although he shared the Impressionists' sentiments about the value of modernity and free-

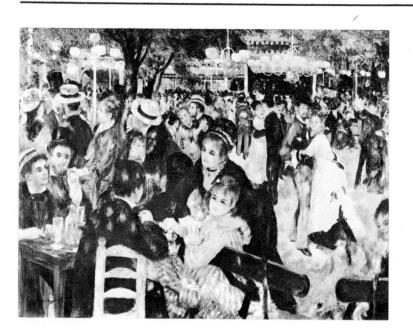

294

PIERRE AUGUSTE RENOIR. Le Moulin de la Galette. 1876. Oil on canvas, $51\frac{1}{2} \times 69''$. The Louvre, Paris 295 PAUL CÉZANNE. Mont Sainte-Victoire. 1885–87. Oil on canvas, $25\frac{5}{8} \times 31\frac{7}{8}''$. The Metropolitan Museum of Art, New York. The H. O. Havemeyer Collection. Bequest of Mrs. H. O. Havemeyer, 1929

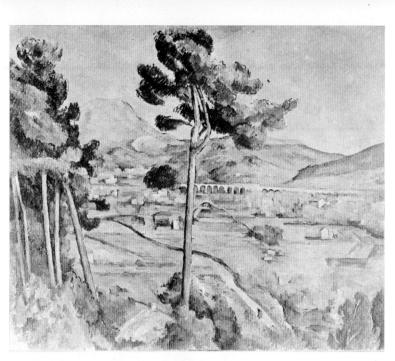

296 PAUL CÉZANNE. The Basket of Apples. 1890–94. Oil on canvas, $25\frac{3}{4} \times 32''$. The Art Institute of Chicago. Helen Birch Bartlett Memorial Collection

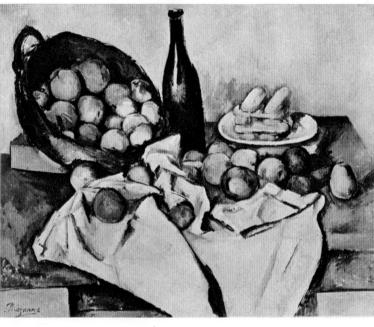

dom, he soon became disenchanted with the relative formlessness of their art. His transformation of that art into a personal style which included works as intricate and majestic as *Mont Sainte-Victoire* (fig. 295) and *The Basket of Apples* (fig. 296) is one of the most astonishing occurrences in the history of art. His emphasis on formal structure set him apart from all the others.

Georges Seurat, too, sought to rationalize Impressionism. And his work (fig. 297) is even more concerned with the constructive aspects of art than Cézanne's. But its peculiarity is such that its influence has been somewhat

GEORGES SEURAT. A Sunday Afternoon on the Island of La Grande Jatte. 1884–86. Oil on canvas, $6'9\frac{1}{2}'' \times 10'1\frac{1}{4}''$. The Art Institute of Chicago. Helen Birch Bartlett Memorial Collection

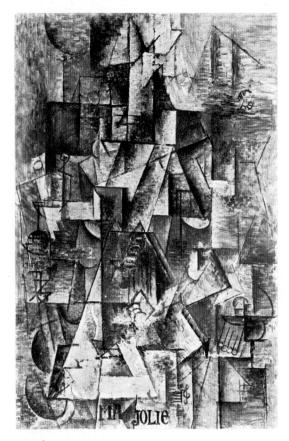

298

PABLO PICASSO. Ma Jolie. 1911–12. Oil on canvas, $39\frac{3}{8} \times 25\frac{3}{4}$ ". The Museum of Modern Art, New York. Lillie P. Bliss Bequest limited, whereas Cézanne's has been widespread.

The most obvious consequence of Cézanne's example is *Cubism*. Many stages intervened between *Mont Sainte-Victoire* and *Ma Jolie* (fig. 298), but Picasso's picture is a direct descendant of the Cézanne. The obsession with structure for its own sake, the concern with overlapping planes, the spatial ambiguity—all these things were derived from Cézanne. Of course, Cézanne was not the only influence on Cubism; African art was another.

In 1907 Picasso painted the most important of the works from his so-called Negro Period, *Les Demoiselles d'Avignon* (fig. 299). The derivation of the masklike forms on the right is obvious. But notice, too, that those forms are repeated throughout the composition.

Before World War I, African art was extremely popular in Europe, particularly in France. There was, however, no interest to speak of in the cultural sources of the works. What interested Frenchmen was the extraordinary perfection of formal composition exhibited by "uncivilized" tribesmen from Africa. From Picasso's point of view the Bakota sculptor of the guardian figure (fig. 300) was already a modern artist. Some of this sentiment is Romantic identification of the savage with all that is basic to human life. British novelist D. H. Lawrence, writing of an African statue in *Women in Love*, expresses this strongly:

Her body was long and elegant, her face was crushed tiny like a beetle's, she had rows of round heavy collars, like a column of quoits, on her neck.... She knew what he himself did not know. She had thousands of years of purely sensual, purely unspiritual knowledge behind her.... Thousands of years ago, that which was imminent in himself must have taken place in these Africans: the goodness, the holiness, the desire for creation and productive happiness must have lapsed, leaving the single impulse for 299 PABLO PICASSO. Les Demoiselles d'Avignon. 1907. Oil on canvas, 96×92". The Museum of Modern Art, New York. Lillie P. Bliss Bequest

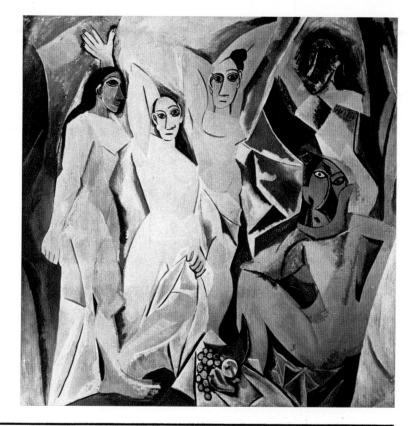

300

Guardian figure, from the Bakota area, Gabon. 19th-20th century. Wood, covered with brass and copper, height 30". Ethnographical Museum of the University of Zurich

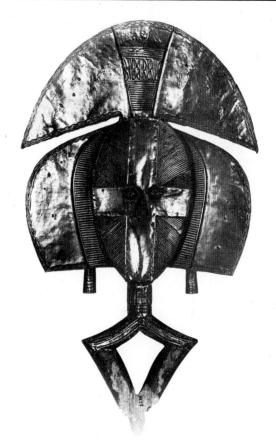

301 PIET MONDRIAN. Composition in White, Black and Red. 1936. Oil on canvas, $40\frac{1}{4} \times 41^{"}$. The Museum of Modern Art, New York. Gift of the Advisory Committee

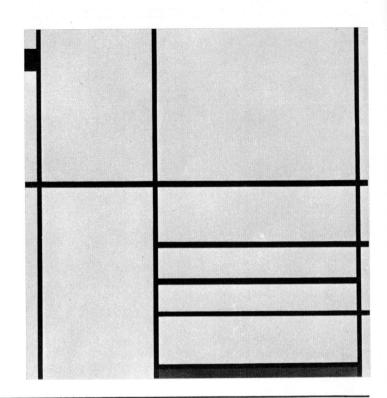

knowledge in one sort, mindless progressive knowledge through the senses.

More important is Picasso's recognition of the genius of black artists whose work he saw in Paris. There is neither time nor space in this little book to go into the continuous influence of African forms on the development of early Cubism. Suffice it to say that the importance of black culture is, in this instance at least, universally recognized and generally accepted.

Ma Jolie is the consequence of many different things. Yet the movement that produced it, Cubism, is the most unique and revolutionary of all modern styles. Nothing before or after it can approach its radicalism. To say so probably sounds odd, even narrowminded. It isn't, actually.

The Cubist position was that a painting is only a painting just as a building is a building, and that a picture ought to look no more like a house, tree, or person than a house ought to resemble a baker's roll. Once Cubism had come to that, once it had broken with the manufacture of illusions, it freed the painter from what had seemed self-evident boundaries. After that it didn't much matter what a painter did. If his work didn't have to look *like* anything else, the barriers were down, and anything went so far as technique and general approach were concerned. This is one reason for Picasso's incredible variety of styles. *Ma Jolie* was painted in 1911–12, his *Girl Before the Mirror* (colorplate 4) in 1932. They are very different at first sight, but the emphasis on pure form is common to both.

Piet Mondrian went further still in the hope of attaining what he called "concrete universal expression." His *Neoplasticism* (see fig. 301) eliminated from painting everything that was not absolutely fundamental: contrast, opposition of directions, variations of scale. The *Suprematist* Kasimir Malevich (1878–1935) went beyond even Mondrian. His notorious *White on White* (fig. 302) reduces painting to the ultimate simplicity of a

302

KASIMIR MALEVICH. Suprematist Composition: White on White. c. 1918. Oil on canvas, $31\frac{1}{4} \times 31\frac{1}{4}''$. The Museum of Modern Art, New York

white square in a white square at an angle. Malevich recognized that the next logical steps would be a blank canvas and then pure space. At various times since 1918 isolated avant-garde artists *have* exhibited plain white canvases, and exhibitions of empty rooms have been offered to a dismayed public. But, since unpainted pictures and vacant space are not very marketable as art, the trend has never become an important one.

In the field of sculpture the mood of the Neoplasticists and Suprematists was matched by *Constructivism*. The works of Naum Gabo (born 1890) are of a precision appropriate to mathematical models and entail the use of then newly invented materials such as nylon and plastic (fig. 303). Like the paintings of Mondrian, they appeal to our sense of exactitude and clarity. Resembling nothing in the natural world, they seem to represent its underlying laws.

Today also there are artists who find this realm of form and logic congenial to their expressive aims. The Op Art movement illustrated by colorplate 11 is one example. And there is a form of sculpture that has come to be called Minimal or Primary which is clearly related to the example of Malevich. The works tend, like The X (fig. 304) by Ronald Bladen (born 1918), to be massive in scale and unadorned.

The subjective-Expressionist current

It is possible to demonstrate that the apparent objectivity of Renoir, Cézanne, and Seurat

308 ERNST LUDWIG KIRCHNER. The Street. 1907. Oil on canvas, $59\frac{1}{4} \times 78\frac{1}{8}$ ". The Museum of Modern Art, New York

Another member of Der Blaue Reiter who is of great importance to the history of art was the Swiss painter Paul Klee (1879–1940). His works are very mystical, and often the mysticism is combined with satire. For example, his *The Twittering Machine* (fig. 310) is a symbolic comment on the arrogance of applied science. He is saying that, yes, it is possible to create a machine for duplicating birdsong—here you crank the handle, a sine curve rotates, and the birds jerk up and down, chirping—but see how silly and grotesque the machine would be. Klee employs in works of this kind a drawing method calculated to translate his images from the real into the fantastic. They do not resemble things of this world. For instance, it is impossible to tell whether we are looking at the base of the machine from above or below.

The third important member of Der Blaue Reiter was Franz Marc, who died in World War I and never reached the limits of his potential. As *Deer in the Forest II* (fig. 311) shows, this artist was influenced by the faceted forms of Cubist art; he used them, however, to very different ends than the Cubists. His was an attempt to, as he said, "animalize" art, to give painting the vitality of nature's throb. His work indicates the degree to which the various kinds of modernisms overlap and coalesce. Here Fauvist color plus Cubistic forms equals Marc's Expressionism. Sometimes the merging of existing forms

into another style is less a matter of artistic

309

WASSILY KANDINSKY. Improvisation Number 30. 1913. Oil on canvas, $43\frac{1}{4} \times 43\frac{3}{4}$ ". The Art Institute of Chicago. Arthur Jerome Eddy Memorial Collection

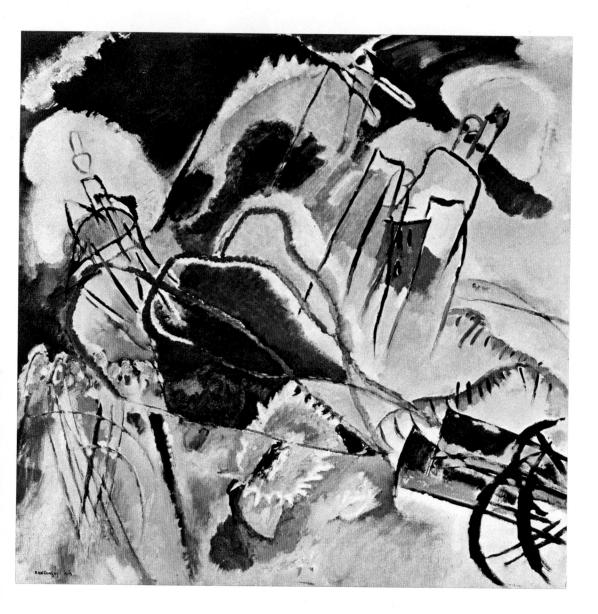

310

PAUL KLEE. The Twittering Machine. 1922. Watercolor, pen and ink, $164 \times 12''$. The Museum of Modern Art, New York

form than of attitude. Dadaism, founded in Zurich, Switzerland, in 1916, was such a movement. It was nihilistic, that is, it held that all traditional values and beliefs were unfounded, and life without sense or purpose. The poets and artists who participated in the movement were reacting to World War I. They resemble some of the more extreme factions of the counter-culture of the 1960s except that they went far beyond any of these underground groups in ridiculing the hallowed values of Western civilization. Louis Aragon's poem "Suicide" is nothing but the alphabet in its normal order. Other Dadaists created "poems" by cutting words from newspapers, putting them into a hat, and gluing the words to paper as they were drawn at

random from the hat. The poetry was, naturally, nonsensical.³

Man Ray's Indestructible Object (fig. 312) is an example of a Dadaist "ready-made," ordinary objects put in incongruous combinations or circumstances and treated as art. More famous is the urinal that Marcel Duchamp (1887–1968) signed "R. Mutt" and exhibited as Fountain. When Duchamp's The Bride Stripped Bare by Her Bachelors, Even (fig. 313) was being shipped to an art show in 1923, the glass on which it was painted cracked in transit. Duchamp was pleased! He said that the cracks "completed" the painting. His behaviour was perfectly consistent with the idea that all rational activity is absurd.

311 FRANZ MARC. Deer in a Forest, II. 1913–14. Oil on canvas, $43\frac{1}{2} \times 39\frac{1}{2}''$. Staatliche Kunsthalle, Karlsruhe, West Germany

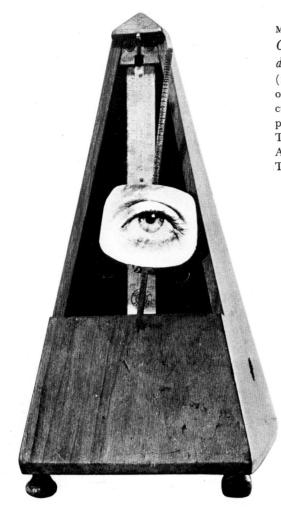

312

MAN RAY. Indestructible Object (Object to be destroyed) (1923 replica of destroyed original). Metronome with cutout photograph of eye on pendulum. $8\frac{7}{8} \times 4\frac{3}{8} \times 4\frac{5}{8}$ ". The Museum of Modern Art, New York. James Thrall Soby Fund

313

MARCEL DUCHAMP. The Bride Stripped Bare by Her Bachelors, Even (The Large Glass). 1915–23.

Oil and lead wire on glass, $9'1\frac{1}{4}'' \times 5'9\frac{1}{8}''$. Philadelphia Museum of Art. Bequest of Katherine S. Dreier Dadaism couldn't last. In the first place, the Dadaists were so clever and talented a group that quality and wit distinguished their work even when they were aiming at the ridiculous, Secondly, when anyone decides to contemplate the futility of it all, he's bound to see that it's useless. In 1924, to generate a new kind of order out of the chaos Dada had created, a Dada poet named André Breton (1896–1966) founded *Surrealism*. This movement drew upon Sigmund Freud's psychoanalytic theories, which attribute the greater part of human activity to the motives of the subconscious mind.

Salvador Dali is not the best example of a Surrealist, but he is *the* Surrealist in the public's mind. His *Apparition of a Face and Fruit Dish on a Beach* (fig. 314) can tell us a good deal about Surrealism. The first thing to understand is that the picture does not have a specific, concrete meaning. Like a dream it is subject to a variety of interpretations.

314

SALVADOR DALI. Apparition of a Face and Fruit Dish on a Beach. 1938. Oil on canvas, $43\frac{1}{2} \times 57''$. Wadsworth Atheneum, Hartford, Connecticut. The Ella Sumner and Mary Catlin Sumner Collection

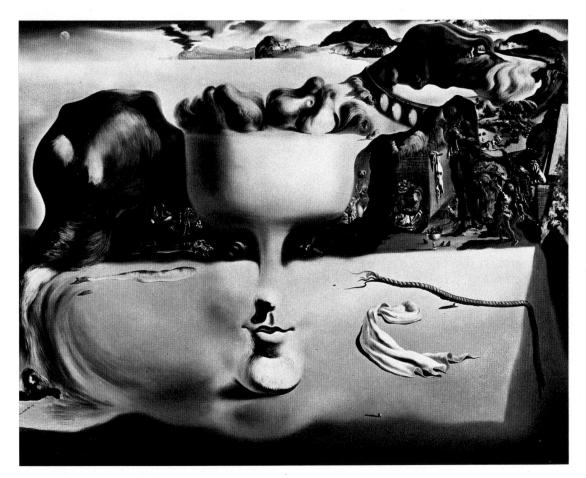

(In fact, Dali claims that he is reproducing his dreams and hallucinations with photographic clarity.) For Freud the dreams of men throw open windows on their souls. So do our responses to ambiguous stimuli. You may not be able to say exactly what this picture means to you, but it means *something*, because, in Freudian terms, you "project" your unconscious feelings onto it just as Dali has projected his into it. Dali's art has had much more popular appeal than that of any other modern painter because of the slick rendering it entails. Those techniques of his aren't particularly impressive to art historians and critics because they have all been cribbed from Baroque artists like Caravaggio and Vermeer. What is most remarkable about Dali is his subject matter. It is truly inventive. Who else would come up with a limp watch, the perfect symbol for subjective time, which sometimes crawls and other times races by too fast?

Dali represents a branch of Surrealism that might be called "literalist" because it attempts to mimic dreams and the like in a literal way. Yves Tanguy (1900–1955), René Magritte (1898–1967), and Max Ernst (born 1891) are others in this group.⁴

There is another major type of Surrealist art which, for lack of a better term, we can call "abstract Surrealism." Paul Klee has

315

JOAN MIRÓ. Person Throwing a Stone at a Bird. 1926. Oil on canvas, $29 \times 36\frac{1}{4}$ ". The Museum of Modern Art, New York

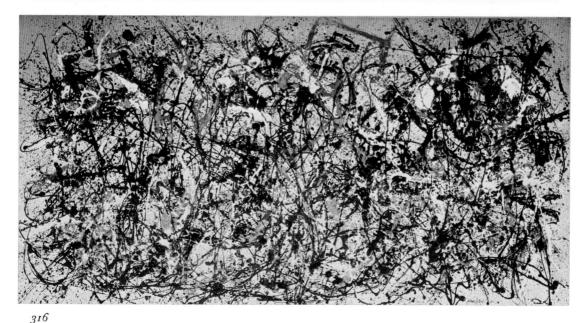

JACKSON POLLOCK. Autumn Rhythm. 1950. Oil on canvas, $8'9'' \times 17'3''$. The Metropolitan Museum of Art, New York. George A. Hearn Fund, 1957

sometimes been associated with it, but the best example is the Spaniard Joan Miró.

Miró's Person Throwing a Stone at a Bird (fig. 315) is not an accurate reproduction of a mental image, surely. Rather, it is a memory recalled in ideographic form, that is, by way of symbols that stand for ideas and experiences. It has been suggested that what we see here is a record of the occasion described in the title, with only the most impressive elements retained. The stone and its trajectory and the fulcrum of the thrower's arm are extremely evident. The eye, aiming at the bird's bright plume, and the foot to which the thrower has shifted all his weight are stressed. What is not essential has been eliminated. This interpretation may err in its simplicity. Whatever the case, Miró does insist that his work is not formal in intention. It looks as though it might be, true enough. The shapes have certainly been adjusted with an eye to their compatibility. Miró would say that the arrangement of shapes is just a means to an end and that the picture really has to do with explicit life experiences. The only "abstract Surrealist" whose work resembles Miró's very closely was Hans Arp (1887–1966). Others in this branch include André Masson (born 1896), Arshile Gorky (1904–1948), and Matta Echaurren (born 1912).

The 1950s, particularly in the United States, saw a synthesis of Expressionist and Surrealist trends in a kind of art called *Ab*stract Expressionism. Willem de Kooning is one representative. Jackson Pollock (1912–1956) is another. In one sense everything that Pollock did was already contained in the works of Kandinsky. His immense painting *Autumn Rhythm* (fig. 316) is on a far grander scale than anything Kandinsky ever did; but the impulsiveness, the complete nonrepresentationalism, the evocation of mood through color harmonies, all that is similar. The technique is what's different. Pollock created his pictures by pouring paint from cans onto a horizontal canvas. To paint a picture in this way strikes many people as completely ridiculous. After all, anyone can pour paint from a can. True. But anyone can make marks with an artist's brush too. It's what you do with the marks that counts. And poured liquids can be controlled, as anyone who has ever poured chocolate syrup over ice cream should know. If you move the stream of syrup slowly, you get a fatter line than if you move it fast. If you move it very fast, you get dotted lines from the broken drips. Move it too fast, and it spatters chocolate all over the table.

Neatness is not a factor in Pollock's art, but control was an important aspect of its creation. His method was not nearly so haphazard and arbitrary as it must seem at first sight. He followed a very deliberate procedure that can be discerned in the final work. He usually began by laying in a background color or colors. Then, on top of this background, he poured paint in a trail that established large, dominant movements that more or less decided the composition of the picture. Next, with another color, a series of subordinate movements were created, usually more intricate ones. From this point on it was a matter of embellishing and articulating the maze of lines and forms growing on the surface.

Autumn Rhythm is not simply a flat picture. Its vortex of thready lines and enmeshed strands of pigment gives one the sense of looking at a tremendously complicated structure existing on a vast, unbounded scale some-

317 GEORGE GROSZ. Fit for Active Service. 1916–17. Pen, brush, and India ink, 145 × 133". The Museum of Modern Art, New York. A. Conger Goodyear Fund

where outside nature. If you think of the works as they originally appeared, lying flat, so that you are looking down into them, they assume new power and force. The space they contain approaches the conditions of an aerial view shot with vapor trails. The maze is more fascinating than anyone might at first imagine.

Some synthetic styles

There are a great many modern styles that do not fall into either of the two mainstreams mapped out so sketchily above. Some of them are the result of a pooling of the two currents. In Germany, following World War I, a movement called Die Neue Sachlichkeit (The New Objectivity) combined Expressionist distortion and Realist attitudes into a style that expressed some of the most horrifying visions art has yet seen. George Grosz (1893-1959) indicted the military-industrial bloc in a series of works of which Fit for Active Service (fig. 317) is a good example. Such intensely bitter images typify the movement, whose main artists were Grosz, Otto Dix (born 1891), and Max Beckmann (1884-1950).

French artist Fernand Léger, discharged

from the service after he was injured in a gas attack at Verdun, took a curiously positive attitude toward the then-new machinery of war. In *The Card Players* (fig. 318) he has reduced a famous Cézanne into mechanical parts assembled in turn into the forms of soldiers taking their leisure in the trenches. Everything is metallic-looking; even the smoke from the pipe of the player on the right has been turned into a row of shiny plates. Léger said of his war experience: "I was dazzled by the breech of a 75 millimeter gun . . the magic of light on white metal. This was enough to make me forget the abstract art of 1912–13."

Similar in attitude to Léger were the Italian *Futurists*, whose devotion to the beauty of pistons, power, and motion let them proclaim, as Filippo Marinetti (1876–1944) did, that "a roaring motor-car, which looks as though running on shrapnel, is more beautiful than the *Victory of Samothrace.*" Or, in Umberto Boccioni's words: "The opening and closing of a valve creates a rhythm just as beautiful but infinitely newer than the blinking of an animal eyelid." Boccioni (1882–1916) said that modern sculpture must "give life to objects by making their

318 FERNAND LÉGER. *The Card Players*. 1917. Oil on canvas, 50[§]×76". Kröller-Müller Museum, Otterlo, The Netherlands

319 UMBERTO BOCCIONI. Unique Forms of Continuity in Space. 1913. Bronze, height 43¹/₂". The Museum of Modern Art, New York. Lillie P. Bliss Bequest

extension in space palpable, systematic, and plastic." His Unique Forms of Continuity in Space (fig. 319) attempts to fix in a frozen pattern all the positions of the various elements of a human form in motion. It has a kind of terrifying power, this heavy, striding monster. It is probably the greatest of all Futurist works.

There are also, of course, myriad individual painters and sculptors whose mannerisms and preferences do not really fit well into any single movement or composite of movements. Ivan le Lorraine Albright's pictures (fig. 122) resemble Realism in some ways, Surrealism in others, and The New Objectivity in still others. Pop artists like Roy Lichtenstein (fig. 241) and their associated workers—for instance, Larry Rivers (fig. 242), Jasper Johns (colorplate 7), and Edward Kienholz (fig. 6) —have derived a great deal from both the rationalistic and Expressionistic currents. Richard Lindner (fig. 92) stands somewhere between the Pop artists and the Surrealists. Mark Rothko (colorplate 2) incorporated into his style both Abstract Expressionism and the superrational directions signalized by Mondrian and Malevich.

Lest this brief survey give you the impression that only the names here listed are of importance, I should mention that I have not even scratched the surface. In the realm of fantasy the painter Marc Chagall is at least as important as Klee or Miró. Without Giorgio de Chirico's paintings for a prototype, the kind of Surrealism practiced by Dali and Tanguy would not exist. Rouault is as outstanding as Matisse. A list of important modern artists not mentioned elsewhere in this book would include the painters Bonnard, Modigliani, Kokoschka, Soutine, Schwitters, Tchelitchew, Gris, and Feininger. It would contain such sculptors as Brancusi, Giacometti, Nicholson, Moore, Calder, Pevsner, Duchamp-Villon, David Smith, and many, many others. (Even as I type these lists, I think of artists I have omitted who are more important than some included: for example, the painters Dubuffet and Bacon and sculptors Lipchitz and Paolozzi. And—oh well.) All I have tried to do in this chapter is give you a chronological, historical outline in which to place the artists we have already discussed.

10 Media and methods

Some media in two dimensions

Many of the words used in discussions of art are vague because they were drawn from common language. Form, style, color, and line are all in very general use and so have meanings other than the special ones we have given them in the vocabulary of art. This was not formerly true of the word media, but in recent years it has come to be the case. Nowadays, everyone speaks of "the media." What they refer to are the media of mass communication: radio, television, newspapers, magazines, motion pictures, and so forth. Media is the plural form of medium. We have the medium of radio, the television medium, and broadcasting media. In the fine arts we are concerned with painting media, sculptural media, printing media, and, within painting, sculpture, and printmaking, the oil medium, the medium of cast bronze, and the medium of the block print.

The medium an artist chooses for a given work has an important bearing on how the work is going to look, and not all media lend themselves to the same expressive ends. Monet's haystack pictures would not be effective cast in bronze, that's obvious. But neither would they be as effective in tempera or watercolor as they are in oil. To understand this is to go a long way toward an appreciation of an artist's work and, therefore, some discussion of media is in order. Again, the size of this book will not permit more than a cursory look at a few of the more prominent two- and three-dimensional media. But one can get a notion of how material considerations affect artistic decisions from examining just a few media and works. Additional information can be obtained from the books listed in the bibliography at the end of this book.

PAINTING MEDIA

In the discussion of pigments in chapter five I mentioned that paints differ according to the medium or vehicle¹ into which the pigment is mixed. It would be possible to add water to the pigment powders and paint a picture with them. But the pigment would not adhere to the paper or canvas; as soon as the water evaporated, the pigments would dust off. To have a painting it is necessary that the pigments stick to the surface, and this, in its simplest terms, is what a medium causes to happen. A medium binds the pigment particles together and to the picture surface.

Tempera One of the best media for binding pigment is egg yolk. Yes, just plain egg yolk. If you've ever tried to clean breakfast dishes which have been left sitting for a couple of days, you know how hard dried egg can be. The pigments that Botticelli used to paint *The Birth of Venus* (fig. 320) were ground in whole egg, and the name for that medium is egg tempera. The term means simply that the pigment has been "tempered" by egg. (What they call "tempera" in grade schools is not real tempera; it's a cheap distemper in which the binder is a glue.) Normally, we speak of egg tempera as "tempera."

Tempera paint has some very desirable characteristics for an art material. The major one is that it is highly permanent; colors ground in it don't change appearance much over a long period of time. But there are also problems connected with its use. It is very viscous—sticky—and it dries instantly. This

320 SANDRO BOTTICELLI. The Birth of Venus. C. 1480. Tempera on canvas, $5'8\frac{7}{8}'' \times 9'1\frac{7}{8}''$. Uffizi Gallery, Florence

means that the artist cannot blend tones together smoothly; his picture must be made up of short little strokes, all of which are separate. The Botticelli doesn't look this way in the reproduction because the painting is large and reproductions are small. But if you look at the original from up close, you can observe that it is built of very, very tiny individual brushstrokes.

Another factor tempera painters must take into account is a slight transparency of the medium. It is in the nature of the relation between the pigment and the egg that a completely opaque color cannot be achieved. This means that correction of errors is pretty much out of the question. Consequently, tempera paintings are carefully planned and executed according to a prescribed routine:

1. Tempera paintings are usually done on wooden panels. *The Birth of Venus* was done on linen, but it is an exception. Most of Botticelli's works were done on wood. For a large painting such as his *Madonna of the Pomegranate* (fig. 52) several planks of Italian poplar or German limewood were joined together virtually without a seam. The wood used for the panel must be completely dry, and it will have been seasoned for a year or more. It is then sanded to a perfect smoothness.

2. The panel is prepared to receive the picture by covering it with several coats of a mixture of plaster of Paris and glue called *gesso*. The successive layers are sanded alternately rough and smooth so that each layer is bonded to the one before and after it. When sufficient thickness has been applied, the surface is sanded to a degree of smoothness such that the finished product looks like a sheet of ivory.

3. The next step is to make on paper a fine, detailed drawing the exact size the final work is to be. Such a drawing is called a *cartoon* (the source of our term for frivolous drawings) and is made up from various preparatory sketches and diagrams the artist has created in the course of conceiving the picture. The cartoon is trans-

ferred to the panel in the following manner: Tiny holes are pricked through the outlines of the shapes. Then the cartoon is placed on the panel, and the artist shakes charcoal dust through the holes onto the gesso. The resulting tiny dots can be connected up with a line.

4. The entire work is painted in one color normally earth green, a dull but highly permanent green made from earth. The shadows will be dark green, the umbra pale green, and the lights clear white. This *underpainting* is exact but is monochromatic (all of one hue).

5. The artist then builds his picture up in a series of layers. Initially they are very light and transparent, and they grow stronger as the final outside layer is approached. Highlights are most opaque, shadows most transparent. Certain colors are excluded from the palette because eggs contain albumen and albumen contains sulfur, which tends to darken certain pigments.

The effect of the completed tempera painting is one of neatness and delicacy. Because of the semitransparency of the medium and because the gesso base is white, tempera paintings have a certain kind of luminosity and glow denied other media. Still, it is a tedious medium in which to work, and it is rarely used today. Among Americans, though, one of the best known of all modern works is a tempera painting, *Christina's World* (fig. 321) by Andrew Wyeth (born 1914).

At first *Christina's World* resembles a Surrealistic work, but the image is based on fact, not fancy. Christina Olsen was a crippled neighbor of Wyeth's in Chadd's Ford, Pennsylvania, and crawled about her property in just this way. The poignance of his friend's circumstance touched Wyeth, and in the painting he has turned it into a symbol of each person's solitude. In order to do so, he eliminated a few critical items from the landscape. For instance, there is a grove of trees up to the left of the house, rising against the crest of the hill. Vast emptiness suited the theme of the work, so he left out the trees.

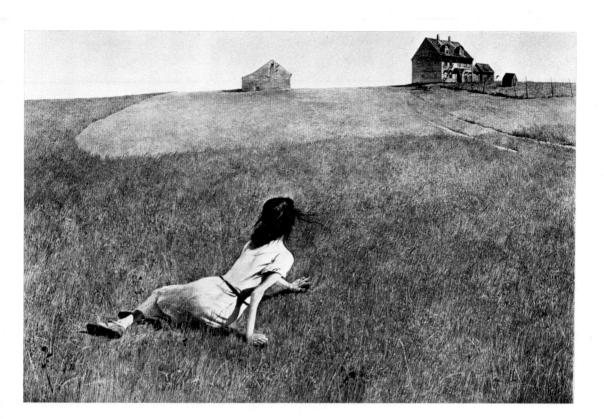

321 ANDREW WYETH. Christina's World. 1948. Tempera on gesso panel, $32\frac{1}{4} \times 47\frac{3}{4}''$. The Museum of Modern Art, New York

Oil paints Robert Campin, painter of the Mérode altarpiece (fig. 208), seems to have been the first person to add vegetable oil to his egg yolk and pigment. Since oil dries very slowly, this had the advantage of making the paint somewhat easier to handle. Jan van Eyck and Hubert van Eyck developed Campin's gimmick into an elaborate painting technique which substituted a clear, quick-drying varnish-oil mixture for the eggoil medium.

Jan van Eyck's Giovanni Arnolfini and His

Bride (fig. 322) was done in almost exactly the way that tempera paintings are. The principal difference was the vehicle for the pigment. But what a difference! Even quick-drying varnishes take many hours to harden, and it is possible to manipulate the layers of transparent pigment (called *glazes*) so that brushstrokes are practically nonexistent. Precise degrees of transparency or opacity can be secured. It is relatively simple to make corrections when painting with oils. The range from dark to light is much greater than with 322 JAN VAN EYCK. Giovanni Arnolfini and His Bride. 1434. Oil on panel, 32¹/₄ × 23¹/₂". The National Gallery, London

tempera. Since the oil does not affect the color of the pigments, no hues have to be omitted. Moreover, the range of technical effects that can be obtained is far, far greater with oil than with tempera.

Most of the paintings in this book were done in oil. Van Eyck, Titian, Vermeer, Monet, Mondrian, Kandinsky, et al., all worked with oils. Yet how dissimilar were the effects they obtained. Oil paint can be transparent or opaque, can be applied thinly or thickly, can be used to secure precise edges or bold splashes, depending on the preference of the painter. Small wonder that of all painting media oil has been the most popular among artists.

Nothing is without its handicaps, however. Oil color is not quite so permanent as tempera, even though the range of hues and values is far greater. And, while it is relatively easy to correct errors because oil as typically used is opaque and light colors will cover darks, there is at least one factor which limits the painter's freedom. In painting with oils you must always put fat over lean, never lean over fat. This is workshop jargon for indicating that it is not possible to paint a less oily pigment over an oily one. Oh, it's possible to apply it, but the paint will craze and peel off. Oil painters take care to proceed in such a manner that all the paint is of the same oiliness throughout or that successive layers are progressively oilier.

At first, oil paintings were done on wooden panels covered with gesso, just like tempera paintings. But in the early sixteenth century in Italy panels were replaced by canvas stretched over wooden frames. The use of canvas has continued down to the present day. Canvas is lighter than wood, and it is easier to weave large canvases than it is to build immense panels.

Titian's Venus of Urbino (fig. 323) is a fine example of oil on canvas. The technique Titian followed was essentially as outlined below:

1. Linen canvas is stretched taut over a frame of wood. Then the canvas is rendered impervious

to oil (which eventually rots fabrics) by coating it with a hide glue of some sort.

2. Various kinds of grounds other than brittle gesso may be applied. The simplest is white lead with enough oil (10 or 15 percent) to make it plastic. Applied to the canvas with a trowel or thinned with something "lean" (such as spirits of turpentine) so it can be painted on, the white lead forms the base for the picture. Since it is much leaner than any usable oil pigment, it will pose no problems for the artist.

3. The entire surface is stained gray, brown, or dull green with an *imprimatura* of earth color thinned in spirits of turpentine or some other nonoily solvent.

4. Monochromatic underpainting is worked out onto the imprimatura according to the method the artist prefers. It might be as detailed as a tempera cartoon, or it might be sketched onto the canvas rather loosely and then worked up by trial and error. In any case, Titian would have painted the major elements of his *Venus of Urbino* in a monochrome.

5. Hues of varying intensity and value are then glazed over the underpainting. The oilvarnish glazes let the values show through but add the richness of color to the work.

JOHN CONSTABLE. The Hay Wain. 1821. Oil on canvas, $51\frac{1}{4} \times 73''$. The National Gallery, London

6. Finally, various details and highlights are added to complete the work. Some of the paint is applied opaquely, some of it is *scumbled*. To scumble means to drag the brush lightly across previous brushstrokes or canvas to produce a broken, speckled effect.

The technique described here (but using varying formulas for grounds, underpainting, and glazes) constituted the technical procedure in oil painting from the High Renaissance all the way up to the middle of the nineteenth century. Some artists—I am one still make use of the same methods today. They provide the painter with well-established and time-tested means of control without rigidity.

Whatever one can say in favor of the Venetian oil technique, it too has strict limitations. Constable's Hay Wain (fig. 324), Monet's haystacks, or Van Gogh's The Starry Night could not have been created using Titian's system. All these paintings are done in what we call alla prima. In this technique the final colors and relationships are already present in the first attack on the canvas. This is the way most laymen think most pictures are painted, and it is the way amateurs always try to paint. But it was only after 1800 that many oils were done in this way. The Hay Wain had a seminal role in the change from the traditional working up of a painting from monochrome through successive layers of color to the more direct way of painting a picture.

Constable, more than any previous artist, was intrigued by the transitory effects of nature. A close friend of William Wordsworth, he attempted to capture in his paintings all that is spontaneous and naturally poetic in the British landscape. No classical technique could have given us all those flickering reflections on the water or hinted at the flutter of leaves in a summer breeze as successfully as Constable's scumbled color over scumbled pigment. Delacroix recognized the merit of the method when he first saw the Hay Wain and incorporated some of its technique into his own work. Realists and Impressionists followed suit. But the Impressionists had the advantage of materials which were not at Constable's disposal.

Today oil paints are sold in tubes. The first year that they were so dispensed was 1841. Prior to that the colors were sold in flat tins or, more commonly, in powders which the artist ground into his medium. Commercially produced oil pigments sold in tubes have some special properties. For one thing, they are far more transportable packed in tubes than in the other forms. This portability made it possible for Monet to go out and paint directly from nature rather than from sketches and memory. The haystack series, among others, is contingent on such direct observation of nature. A second feature of tube colors is that they tend to be thicker than pigments mixed by hand. Tube color is about the consistency of toothpaste; a ribbon of it laid on straight from the tube will stick to the canvas and not run off. Also, brushstrokes can have an extremely high impasto. Van Gogh used his oils in both these ways.

Another factor that had an important bearing on the work of the Impressionists and so-called Postimpressionists was the invention of new chemical pigments. Some of these, like the malachite green that turned Van Gogh's billiard table brown, were disastrous for painting. But many of the new colors were tremendously important for artists like Monet who wished to capture every nuance of nature's hues. Between 1826 and 1861 artificial ultramarine blue, cadmium yellow, mauve, cobalt yellow, and magenta all appeared.

Polymer paints Contemporary artists are beginning to move away from oil paint and to favor synthetic media, of which the most common is polyvinyl acetate. Polymer pigments look much like oils but have tremendous advantages for many artists. They are similar in many ways to their house-paint brethren, the so-called latex paints. They are watercompatible, that is, they can be thinned with water and the brushes can be cleaned with water. But once they have dried, water will not dissolve them. Neither will anything else except special solvents designed to remove house paint and furniture varnish. You can, therefore, paint layer upon layer of polymer pigments without fear of dissolving the lower layers or worrying about them bleeding through. The paints can be applied as thickly as oil paint, or as thinly, but the painter can ignore any consideration of fatness or leanness. The consequent range of effects is incredible, but the medium lends itself particularly to clean, hard-edge abstractions such as Yellow Arc (fig. 325) by Michael Smith.

Whereas it may take days or weeks for oil paint to dry enough to overpaint, with polymer-tempered pigments it is a matter of minutes or, at most, two hours. Most writers on art consider the quick-drying quality of the polymers to be an advantage, and for most modern styles it is. However, for anyone who works in a style that requires a good deal of blending and carefully articulated modeling, the polymers dry too quickly. The producers of the various brands have marketed agents which slow the drying time of their paints, but I have not yet found one that works really well—at least not as of this writing. 3^{25} MICHAEL SMITH. Yellow Arc. 1968. Synthetic polymer paint on canvas, $30 \times 28''$. Collection Robert Kutak, Omaha, Nebraska

Acrylic paints Another group of synthetics use acrylic resins as a binder. These paints are oil-compatible and can be thinned with water, linseed oil, or turpentine. The use of oil will slightly slow the drying time. Without the addition of oil these paints behave much like the polymers. Too, the acrylics can be dissolved with turpentine long after they have dried. This means it is possible to "erase" portions of a painting and rework it.

The artist Paul Jenkins (born 1923) has done a number of extraordinary works with acrylic-resin pigments in a way that takes advantage of the relative quickness with which they dry, their clarity, and their range of opacities. In his beautiful *Phenomena Point Swing and Flank* (fig. 326) the delicate zones of color were not painted on but floated and poured on before the canvas was stretched. His ability to control the effects thus achieved is nothing short of uncanny.

Both polymers and acrylics have been tested for durability by exposure to every possible factor except unlimited time. They are far more resistant to climatic conditions, light, and heat than oils or egg tempera. They do not darken as much as oils. And they are generally tougher, more flexible, and less easily damaged.

Watercolor There are several kinds of water-compatible paints—tempera, polymer, acrylic, gouache—but the best-known is transparent watercolor. Transparent watercolor pigment is available to artists either in tubes or in dried cakes which are soluble in water. The binder in this medium is gum arabic, a water-soluble gum which comes from the acacia tree. The painting surface is ordinarily a handmade paper with a prominent texture.

Two of the world's greatest watercolorists, Winslow Homer (1836–1910) and John Marin (1870–1953), happened to have been Americans. Homer's *Hurricane*, *The Bahamas* (fig. 327) exploits every characteristic of the medium. The palm fronds bending in a high wind are captured in a few swift brushstrokes, the buildings noted in a sketchy way that helps convey an impression that the air itself is blurred by the speed of the wind. The sky is overcast and glaring. No white paint has been employed—the latticework behind the red flag was produced by scraping with a knife.

326 PAUL JENKINS. Phenomena Point Swing and Flank. 1964. Acrylic on canvas, $5'11\frac{3}{4}'' \times 9'7\frac{1}{2}''$. Krannert Art Museum, University of Illinois, Champaign

327

WINSLOW HOMER. Hurricane, The Bahamas. 1898. Watercolor, $14\frac{1}{2} \times 21''$. The Metropolitan Museum of Art, New York

Since the major aims of the watercolorist are the attainment of transparency and spontaneity, white paint is almost never used. Traditionalists would consider it cheating. Light value is achieved by letting paper show through. This means that Homer always had to start with lights and work toward darks; in working with watercolor this is even more essential than with tempera.

People whose only experience with water-

color was in childhood are always amazed that watercolorists can control the paint. Laymen expect that the paper will lump up and the colors all run together and get muddy. It does require skill to prevent those things, but professional artists' materials help. Good watercolor paper is very heavy and is taped onto a drawing board or tacked to a canvas stretcher while dripping wet. When it shrinks, it stretches as flat and firm as a drumhead.

328

JOHN MARIN. Marin Island, Maine. 1915. Watercolor, $15\frac{3}{4} \times 19''$. Philadelphia Museum of Fine Arts. A. E. Gallatin Collection

Watercolorists use quite expensive sable brushes which can produce either bold strokes or extremely fine ones, depending on how they're handled. And, of course, professional artists' pigments are much more intense than children's play sets.

John Marin was an "original." Back in the 1930s he was wearing his hair to his shoulders. No one hassled him about it, though. He was too great an artist, an Expressionist in a peculiarly American way. Some consider him the greatest twentieth-century American artist, largely because he used the watercolor medium with unprecedented strength and vigor. Marin Island, Maine (fig. 328) speaks to the viewer in a kind of shorthand signifying trees, rocks, and rills-a shorthand that does not depart from the realities that inspired the picture. Marin's watercolors are abstract in the ordinary sense that he has left out a lot of nonessentials. They are also abstract in the sense that they are concerned with the play of formal elements in and of themselves. Note the way in which the great sweep in the sky is mirrored in the island and the water. The rough texture of the paper and the transparency of the paint contribute to an extremely effective image of Marin's private island.

Fresco painting All the paintings we have discussed thus far fall under the general heading of panel pictures. This term applies even though most of them are on canvas and two on paper. The point is that they are not *murals* —paintings done on walls.

Most of the great mural paintings which have been done throughout history are either mosaics, formed of bits of glass and stone, or are frescoes. Because fresco is a bit more difficult to understand without knowing something of the process, I have chosen to deal with it here.

Fresco is an Italian word which means "fresh." There are two kinds of fresco, fresco

secco (dry fresco) and buon fresco (good fresco). The former is done on a dry wall with a medium closely resembling egg tempera.² The latter is what normally goes by the name fresco; it involves painting into wet lime plaster with pigment mixed into limewater. The layer of calcium carbonate formed by the limewater binds the pigment to the plaster wall, and the mutual wetness of the pigment and the surface causes the color to dye the wall. This makes for a highly permanent decoration, as long-lived as the building itself. Permanence is the main advantage of fresco and is, of course, its own recommendation.

Michelangelo's *Creation of Adam* (fig. 329), like all the other works on the ceiling of the Sistine Chapel in the Vatican, is an example of fresco painting. Since plaster cannot be rewet, once it is dry, the fresco artist never applies more plaster to his surface than he knows he can finish in a single day. Consequently, we can find places in this fresco where plaster joints occur. There is a seam where Adam's neck fits onto his body and another at the line between the torso and the legs. Adam is about twelve feet long, and it took Michelangelo three sessions to complete him.

Because of the bleaching effect of the plaster, fresco color is never very intense. Some pigments are excluded because of the chemical incompatibility between them and lime. Too, in fresco even more than in tempera, correction is impossible. To have effected a change in Adam's nose, Michelangelo would have had to remove all the plaster containing the head and begin anew. Here, too, elaborate cartoons and precise preparatory studies were necessary before the artist undertook the actual painting.

Frescoes are still done for large buildings, but the method has not changed in hundreds of years except for the introduction of colors that Michelangelo did not possess.

329 MICHELANGELO. The Creation of Adam. 1508–12. Fresco. Sistine Chapel, Vatican, Rome

PRINTMAKING

No matter how well-to-do you happen to be, an original Rembrandt oil painting is probably beyond your means. Today such a work would cost you at least a million dollars, most likely. But if you wish to save up for awhile, you might be able to pick up a good etching from the hand of the same master for only a few hundred dollars. At an auction in St. Louis a few years ago I bought one from the Pulitzer estate for \$200 that is superior in quality to the impression owned by the Rijksmuseum in Amsterdam. My etching is just as much an "original Rembrandt" as an oil painting but not nearly so precious because it is but one of a number of copies. It has the qualities of great art but isn't as rare a thing as a one-of-a-kind painting. That is the main purpose of printmaking—to produce multiple originals of genuine quality.

In order to make what I'm talking about perfectly clear, it is wise to distinguish between *prints* and *reproductions*. Artistically speaking, a print has the following characteristics: The printing surface was made by the artist himself. It is printed by him or under his direct supervision. The processes involved are done by hand. In modern times a specified, limited number of individual pictures are made from a given plate or block which is then defaced or destroyed so that more cannot be printed.

A reproduction is produced by photomechanical methods, not by hand, and the relations between the artist and the printer are incidental or nonexistent. A so-called print of Andrew Wyeth's Christina's World is not a genuine artist's print; it is a color reproduction. Wyeth had nothing to do with it. Some reproductions are of very high quality; some are poor. Some reproductions of artists' prints are so fine that they can be palmed off on the inexpert as original etchings, woodcuts, and lithographs; in that case the reproduction is a mechanically produced facsimile-a counterfeit. Sometimes one sees ads for a "limited edition of color prints of" what is clearly a reproduction of a painting. The limits of such an edition will, as likely as not be a thousand or more. Legally it is "limited," and narrowly defined it is a print (after all, a press prints it); but from a printmaker's point of view anything over a hundred is a very large edition. And the reproduction of a painting is worth no more than any other gift shop item. Of course, it may be worth every penny to you as a decor item; a good reproduction of the Wyeth is higher on the scale of aesthetic value than the tenth-rate original oil paintings turned out by hacks for department stores.³ All I wish to make clear here is that a reproduction and a print are not in the same category.

Degas's *Self-Portrait* (fig. 330) is an etching. What we are looking at here is a black-andwhite reproduction of the print. The reproduction was made from a photograph of an impression of the print owned by the National Gallery of Art in Washington, D.C. There are other impressions of the same print in other 330 EDGAR DEGAS. Self-Portrait. 1855. Etching, $9 \times 5\frac{5}{8}$ ". National Gallery of Art, Washington, D.C. Lessing Rosenwald Collection

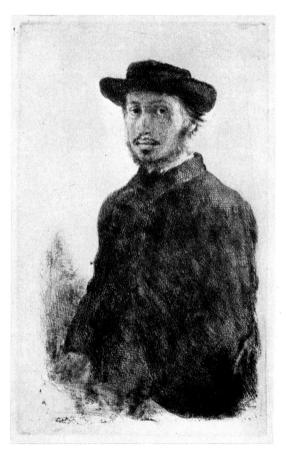

collections here and abroad. The print is the picture Degas's etched copperplate produced. An impression is any individual picture made from the etched plate. An edition is the total number of impressions Degas printed from the plate. If you buy a print from a contemporary artist, it should have the following information in pencil on the lower margin: title, edition number, artist's signature, and year.

The edition number is important. It will read "16-100" or "24-50" or "34-34" or something. This means that you are examining the sixteenth of one hundred impressions or the twenty-fourth of fifty impressions or the last of thirty-four. The artist will also have "pulled" (that is, printed) a few impressions for himself which are not in the numbered edition. Normally these will be labeled "artist's proof" and will be marked with a Roman numeral to identify the order in which they fall. Early impressions and artist's proofs are supposed to be worth more than later impressions, but in an edition of less than one hundred there are not apt to be any real qualitative differences.

Prints fall into four general categories: relief, intaglio, planographic, and stencil.

Relief prints The principle of relief printing is easy to grasp because it is so familiar. You have made thousands of them. When you leave a wet footprint on a poolside, you are relief-printing your sole in water onto concrete or tile. Unless you have abnormally flat feet, only the toes, ball, heel, and a tiny part of the outside edge of the foot come into contact with the surface. These are the parts of the sole that are in relief. The arch, the spaces between the toes, and the area between the toes and ball of the foot are recessed; they don't touch the surface, so they don't print. That's all the term relief printing means: that the image is printed by carrying ink to the paper from a raised surface. Fingerprinting is another commonplace example. Stamp pads

plank grain for woodcut

331 Woodgrain and relief prints

end grain for wood engraving

ink the relief surface of the rubber stamp. Typewriter keys strike the ribbon with the relief part of the key and make the mark. Printers' type is another example.

Relief prints can be made from so many substances that it is useless to enumerate them. In grade school halves of potatoes are sometimes used to make relief-print designs. Linoleum is used by children and artists as well. There are many, many possibilities.

Among artists the most common forms of relief printing are woodcut and wood engraving. The basic difference between the two is that woodcuts are carved into the plank grain of the wood and wood engravings into the end grain (See figure 331). Since it is difficult to secure smooth, unchecked end grain of any size, wood engravings are seldom over a few inches wide. At the same time, because end grain does not pose problems of cutting with, against, or across the grain, it permits much more intricate designs than plank grain. Not that woodcuts are necessarily crude. The Anatomist (fig. 332) by Leonard Baskin (born 1922), is anything but that. The same thing. however, could be done on a far smaller scale as wood engraving.

Figure 333 is a graphic demonstration of the relief process as it is carried out in woodcut. (A) This is the image the artist wishes to print. Notice that the rectangle is to the left of the circle. When the printmaker draws the design onto the plank (B), he will reverse the image because all relief prints come out backward. (C) He then chisels away all the areas he wants to come out as white when the block is printed. All the relief forms are carved wider at their bases to prevent chipping. (D) With a soft rubber or gelatin roller called a brayer the artist inks the block with oil-base printers' ink. (E) A soft thin rice paper is best for printing. Placed on top of the block, it is rubbed with a wooden spoon or similar implement so that the moist ink is transmitted from the relief surface to the paper. (F) An

332 LEONARD BASKIN. The Anatomist. 1952. Woodcut, $18\frac{3}{4} \times 11''$. The Museum of Modern Art, New York. Gift of the Junior Council

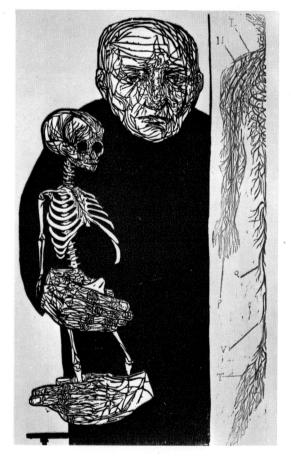

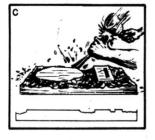

333 The relief-printing process

impression is pulled. The block is reinked for the next impression, the rubbing repeated, and so on, until an edition is complete.

Blocks can also be printed mechanically on presses, but hand rubbing is preferred by most artists for a number of reasons. Although tiresome, hand rubbing offers more control, since the printer can see just enough through the rice paper to tell what is properly printed and what is not. Also, in order to be printed on a press properly, a wood block should be absolutely true, which is not necessary with rubbing. Finally, it is possible to print woodcuts of much larger dimensions by rubbing because the size of block is not limited by the size of the press.

In Baskin's print whatever is white was carved out, and whatever is black was left standing. The areas that appear to be gray in our reproduction are red in the original print. They could have been blue or green or yellow or any color, since they depend for their hue upon the ink the printer chooses. I do not know whether the anatomist's chart was cut into the same block as the anatomist and inked a different color or cut into a different block and printed separately in red on the same sheet of paper. But most color woodcuts involve separate blocks. By combining several blocks so that their successive impressions overlap on the same piece of paper, it is possible to secure secondary and tertiary hues, as shown in figure 334. Such effects can be obtained because the inks can be made transparent by the addition of a clear base. Of course, relationships far more subtle and complex than the diagram suggests can be obtained by a practiced printer. But this is the idea. And it is the procedure followed in the other kinds of printmaking too; normally, a separate color means another block, plate, stone, or screen.

One kind of relief printing deserves special mention. Since 1960 *collagraphy*, originated by Glen Alps, has become extremely popular

334 Color printing

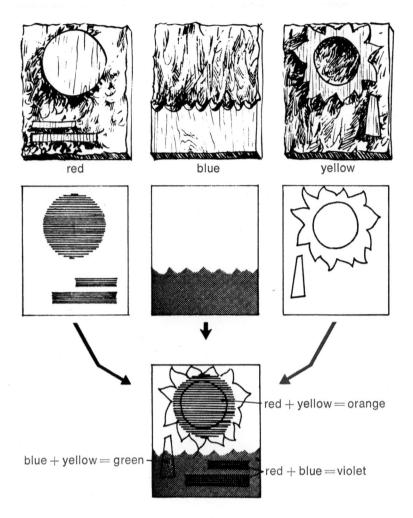

among printmakers. In this technique, pieces of cardboard and of materials such as lace and cloth are glued to a rigid surface (masonite, hardboard, or metal). The resulting collage (which sometimes includes "found objects") is then inked and printed on an etching or lithography press. Delicate and striking textural effects can be obtained by lacquering the materials; indeed, the design is sometimes created with lacquer brushstrokes alone. Advantages of collagraphy are that it permits the artist to achieve large-scale relationships with relative ease, it produces color fields that are very flat and powerful in their impact, and it lends itself to combination with intaglio and lithographic printing.

Intaglio prints Intaglio printmaking is exactly the opposite of relief printmaking. Rather than printing from a raised surface, the intaglio method prints from recessions. Line engraving, etching, and drypoint are the most common forms of intaglio. Ordinarily they are done on plates of metal, but it is possible to use other materials, for example Plexiglas or Formica. American currency is printed from steel-plate line engravings by an intaglio process called gravure. Most finearts prints are done on copper.

A line engraving entails incising grooves directly into the metal with sharp steel tools called *burins*. Burins are of various shapes and sizes, but the kind shown in figure 335 is typi*335* Burin

cal; it is a lozenge-shaped steel rod bent at an angle of about 30° so that the worker's hand clears the plate. To cut through metal with this instrument requires considerable muscular control, since continuous pressure must be exerted and the burin cannot be tilted or rocked during cutting. Line engraving is a difficult and demanding medium, but the resulting line has a vigor, clarity, and intensity no other kind of mark can match. Dürer's *Adam and Eve* (fig. 336) is a splendid example.

Figure 337 shows the process in serial form. (A) One begins with a polished copperplate about one-sixteenth of an inch thick (that is,

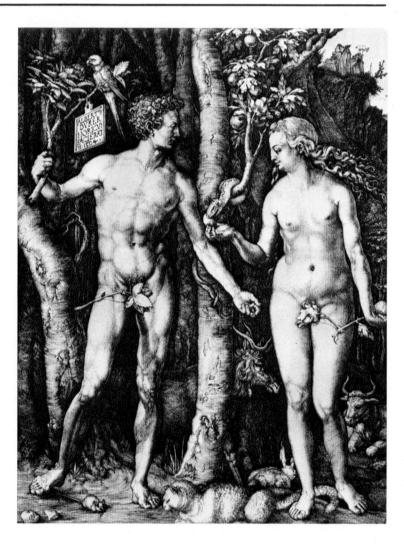

336

ALBRECHT DÜRER. Adam and Eve. 1504. Engraving, $9\frac{7}{8} \times 7\frac{5}{8}''$. Museum of Fine Arts, Boston. Centennial Gift of London Clay

16 gauge), completely flat and beveled on all four edges. (B) Sitting facing the direction of the cutting motion, the engraver pushes the burin through the metal. The burin is never turned; all curved lines are made by pivoting the plate. Burin grooves are clean, clear, sharp V-shaped troughs. The deeper they are, the heavier and darker the line they will print. No mark is too fine to print; the merest scratch will show. One of the characteristics of an engraved line is that it can be made to fatten and taper. Cross-hatching can suggest powerful volumes by taking advantage of this capacity. Very broad lines in engraving are really the consequence of many smaller cuts made right against one another. This effect can easily be seen in my engraving Archetype I: "The Great Gatsby" (fig. 338). As one cuts, a spiral of metal shaped like a watch spring curls up ahead of the burin. These burrs are razor sharp and must be removed as the engraver proceeds.

As you can see, line engraving is a mode of expression that requires a good deal of practice and tremendous patience. Many artists do not care for the effects it produces, preferring a more spontaneous medium. Others simply have neither the time nor the will to master the peculiar skills required. For these another method of intaglio is available.

Etchings are far, far easier to produce than engravings. That is why so many painters of the past have chosen this medium instead of some other graphic-arts technique. The Degas (fig. 330) is an etching. We have seen two Rembrandt etchings thus far, his *The* Descent from the Cross by Torchlight (fig. 136) and Adam and Eve (fig. 259). Picasso's The Frugal Repast (fig. 339) is also an etching. What these artists have done, in effect, is substitute acid for pressure to create the intaglio recesses in their plates.

Figure 340 shows you in part A the kind of design the artist wishes to produce in an etching. (Notice that both the circles and the

337 Engraving

338 JOHN ADKINS RICHARDSON. Archetype I: "The Great Gatsby." 1965. Engraving, $17\frac{1}{2} \times 21''$. Architectural Arts Collection, Southern Illinois University, Edwardsville

339 PABLO PICASSO. The Frugal Repast. 1904. Etching, $18\frac{1}{4} \times 14\frac{1}{4}$ ". The Museum of Modern Art, New York. Gift of Abby Aldrich Rockefeller

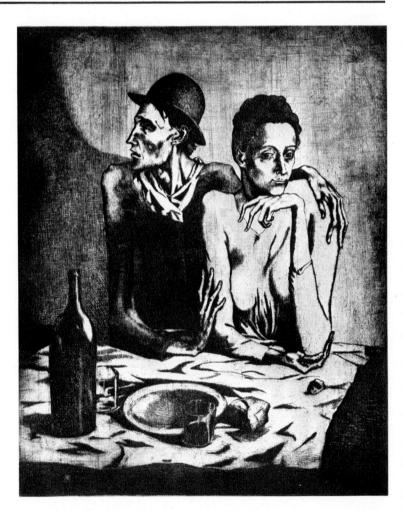

lines are partly thin and partly thick and that in one place thick lines cross thinner ones.) As in engraving, the deeper the recess, the darker the line. (B) A copperplate identical to the kind used in engraving is covered with a waxy substance called etching ground which is impervious to acid. (C) The lines are scratched through the wax with a sharp needle so as to lay the metal bare. (D) The artist immerses the plate in a solution containing a mordant, for instance, nitric acid. The acid eats the exposed copper away-it "etches" the plate. The longer the plate stays in the solution, the deeper the acid eats. (E) To produce the contrast between thin lines and thick ones the etcher removes the plate from the etching solution and paints over the parts he wishes to remain lighter. This is called *stopping out*. Usually one uses an acid-resistant varnish for this purpose because it is easier to control than ground. (Varnish is no good to use for ground because it is too brittle for the needle to cut cleanly.) (F) When the plate is reimmersed in the etching solution, the parts covered by the varnish remain as they were, but the acid continues to eat away at the exposed areas. To achieve the thin lines crossed by heavy ones, the etcher cleans the plate with solvents, regrounds the surface, and draws through the new ground over the old lines. Then he simply reetches the plate for as long as he needs to produce the effect. This is easy enough to do because etching ground is applied in a very, very thin layer and the existing troughs are readily visible. Rembrandt was a master of the technique. Some of his shaded areas contain five or six different line weights.

It is also possible to secure black and gray tonal areas in etching by using *aquatint*, a technique that involves dusting the plate with rosin powder, fixing it to the surface by heating the plate, and etching areas of the plate so that the surface becomes sandpapery in texture. There is a method of securing exact duplications of the textures of finger-

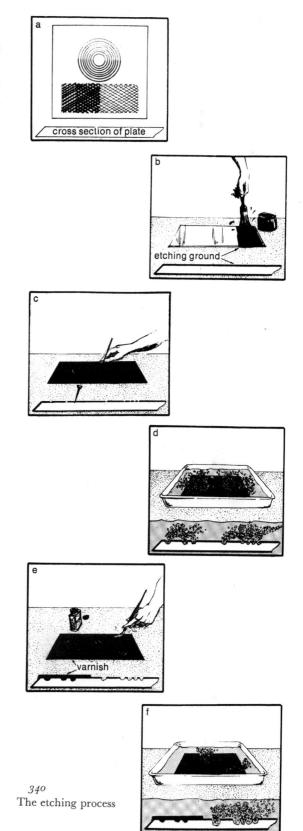

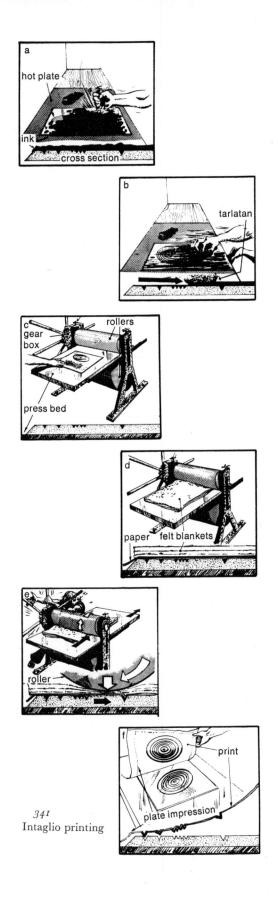

prints, lace, feathers, and other similarly delicate substances by putting petroleum jelly or tallow into etching ground so that it remains soft. The texture is pressed into this soft ground. When it is removed, some of the ground pulls away, leaving an impression. Then the plate is etched as it would be in line etching. There is also a primitive form of engraving called drypoint. Here, an etching needle is used to scratch the surface of the metal. The scratching causes furrows of metal to rise up on either side of the groove, and their roughness produces a furry-looking line when printed. All the methods-engraving, etching, aquatint, soft ground, and drypoint

What puzzles most people about intaglio printmaking is the printing itself. How do you get an image from the recesses? You do it by the process shown in figure 341. (A) The plate is completely covered with sticky printers' ink. The ink is driven into the grooves with a felt-covered tool called a *dauber*. (B)The printer wipes the ink from the surface while leaving the ink in the recesses. He begins wiping with coarse, open-weave material such as mosquito netting or tarlatan (starched cheesecloth) and then moves to muslin and/or the edge of his hand. Wiping requires a certain amount of skill, and different people do it in different ways. The idea is to clean the surface and not the lines. (C) The plate, then, rests face up on an etching press, which is essentially a steel bed between geardriven steel rollers. (D) The artist places on top of the plate a sheet of heavy printing paper, moistened to the point where it is limp, blotted so that no truly wet spots remain. On the paper he places three soft felt blankets. (E) The press bed rides between the rollers as the artist turns the star-wheel spokes. The top roller squeezes the blankets onto the paper and the paper onto the plate under tremendous pressure. Because the dampened paper is pliable and the felt is soft, the pressure drives the paper down into the grooves. (F) The paper has been *embossed*. If it had been run through the press on top of an uninked plate, it would be white on white embossing; since the grooves were filled with black ink, they are now black. Sepia ink produces sepia lines; green, green lines; and so forth. This same printing technique is used in engraving, etching, and all other intaglio processes. Unfortunately for indolent artists, the complete process of inking must be repeated for each impression.

Embossing and intaglio go together. You don't get one without the other. An original intaglio print will also reveal the impression of the plate itself as an indentation in the paper. (The reason we bevel the plate is to prevent the sharp edge from slicing through the paper and also cutting the felt blankets.) Today intaglio prints are framed with a cardboard mat so that a margin of paper shows between the plate impression and the mat. On the bottom margin the artist's signature, the date, the edition number, and the title will appear in pencil. The same procedure is also used when matting other kinds of prints, but with intaglio the relation of the mat to the edge of the impression is much more evident.

Planographic prints There is only one kind of planographic printing in the fine arts, lithography. Planographic means that the print results from an image that is neither above nor below the surface but on it. The surface involved was originally, and usually still is, the smooth face of a block of Bavarian limestone, hence the name litho (stone)graphy (drawing or writing). Plates of zinc and aluminum can also be used. Unlike other printmaking media, which are mechanical in nature, lithography is chemical. It depends upon the fact that oil and water will not mix.

Lithographs are easily mistaken for ink or crayon drawings because they are drawn with *tusche*, a water-soluble grease that comes in both liquid and crayon form. Honoré Daumier's lithograph *Les Témoins* (fig. 342)

342

HONORÉ DAUMIER. Les Témoins (The Witnesses at the Door of the Council of War). 19th century. Lithograph, $10 \times 8\frac{3}{4}$ ". The Metropolitan Museum of Art, New York. Schiff Fund, 1922

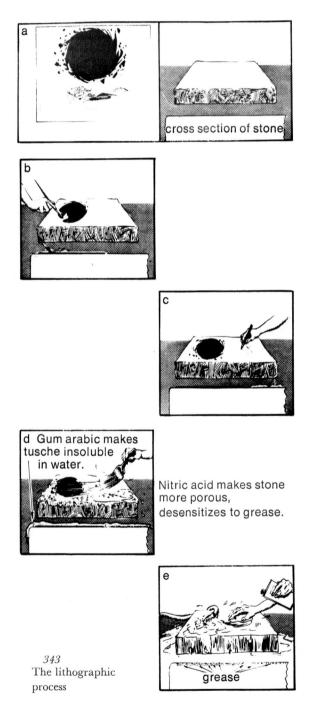

exemplifies the power of the medium. Compared with relief or intaglio, it is a relatively swift process and far more direct. Neither a wood block nor an engraved plate look much like the black-and-white thing printed from them. They are indirect. A woodcut is a carving. When you draw lines to be etched, they appear as bright copper trails against the dark brownish hue of the ground. But in lithography the drawing you make on the stone closely resembles the image it will print, except that it is reversed.

The lithographic process (fig. 343) begins with a perfectly flat slab of limestone (A) which has been given a slight tooth by grinding with carborundum powder. We are going to produce an image like the one at upper left.⁴ (B) For solid areas tusche in liquid form can be painted on or drawn on with a pen. The material is a grease, but it behaves more or less like ink. It can be thinned with water to give watercolor-like effects. (C) For graduated areas tusche in the form of a solid crayon is used. There are different grades of crayons, each producing a progressively darker mark. (D) Etching the stone is a complicated process involving rosin and whiting (talc) as well as acid, but the basic substance used is the etch itself. This is much milder than anything used in intaglio etching. It is a syrupy mixture of water, gum arabic, and nitric acid. To one and a half ounces of gum arabic solution the artist will add somewhere between fifteen and fifty drops of acid. The exact amount is impossible to say, because stones vary and because temperature, humidity, and the age of the acid all affect the outcome. The lithographer tests his etch on the margin of the stone, and when it foams in a certain way he knows he has what he needs. Delicate crayon work or tusche watercolor variations require a stronger etch than solid spots of tusche. The gum solution is painted onto the stone and left overnight. What happens is complicated, but the upshot of it is this: When the gum arabic comes into contact with the tusche areas, it makes them insoluble in water. The acid bites the limestone just enough to make it slightly more porous than before and, therefore, more capable of absorbing water. (E) The next step is apt to terrify the novice, especially if he has spent days and days slaving over an intricate drawing on his stone. With water and turpentine the artist *washes out* the image. It vanishes! (Well, if you look closely, you can see a kind of yellowish stain where the drawing was, but that's all.) At this point the stone is ready to be printed.

The black color of tusche ink and cravons has nothing to do with the darkness of the print; it is nothing but lampblack put into the tusche so that the artist can see what he's doing. The real difference between a dark lithographic crayon and a light one is that the dark one contains more grease. Similarly, when you add water to tusche ink to make a pale gray, what you actually have done is reduced the amount of grease. Grease is all that counts. And one dares not touch the stone with his hand as he is working because even the cleanest hand exudes a bit of natural oil. This oil, though invisible, will show up as a gray dirty spot when the stone is printed. Any grease that gets onto the stone before it is etched will eventually print.

Printing the stone (fig. 344) depends upon the antipathy of greasy areas for water and of wet areas for grease. (A) The limestone is wet down with water. The open stone areas absorb the water, but it beads up on the areas where tusche had been applied. (B) A previously inked roller the size of an extremely large rolling pin but covered with soft leather or rubber is passed over the wet stone. Since the bare stone areas are wet, the ink, which is greasy, will not adhere to them. But in greasy areas the roller pushes the drops of water out of the way, and the oily ink is attracted to the oily surface. As if by magic, the original drawing reappears on the stone. (C) A litho-

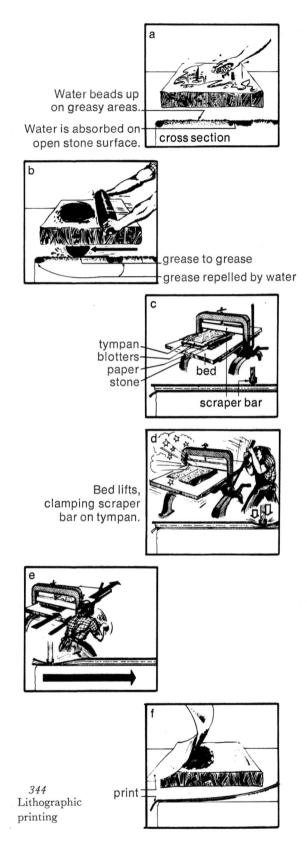

ROBERT NELSON. "Wagner". 1971. Lithograph and relief printing, $41 \times 27\frac{1}{2}$ ". Southern Illinois University, Edwardsville

graphic press has a movable bed like an etching press but has a scraper bar instead of a roller. The stone, which is kept moist all through printing, rests on the bed. As in intaglio printing, the paper is damp. The paper goes onto the stone, a blotter or two on top of that, and a piece of red fiberboard called a tympan on top of that. (D) The scraper bar, which has been lubricated with mutton tallow, clamps down onto the similarly wellgreased tympan, pressing the paper down hard onto the stone. (E) The printer cranks the press handle, driving the bed along under the scraper bar. The bed, of course, carries the stone along with it, and the pressure of the bar squeezes the image onto the paper. (F)Then the stone is rewet, reinked, another sheet of paper applied, and the whole business run back through in the other direction. This is continued until the edition is completed.

Lithographic stones may be used over and over because the tusche and etch affect only the uppermost surface of the stone. When an edition has been run, the stone is ground down with carborundum sufficiently to remove the inked image entirely, and another lithograph can be drawn on the same stone.

Some printmakers, for example Robert Nelson, combine intaglio, relief, and lithographic methods in the same design (see fig. 345).

Stencil prints (serigraphs) A stencil is anything that blocks out areas so they will not be touched by something else. The most common kinds are those used to do lettering. Serigraphy (literally, silk-writing), or silk-screen, is the most sophisticated of the stencil processes known to the fine arts. It is an extremely flexible medium, capable of hard-edge effects of high impact (fig. 346) or of an extremely subtle and delicate imagery rivaling painting (fig. 347). For those who do not like to work in reverse, serigraphy is ideal because stencil 346 MICHAEL SMITH. Arc I. 1967. Serigraph, $14\frac{7}{8} \ge 14\frac{3}{4}$ ". Private collection

347 OHN ADKINS RICHARDSON. load to Xanadu. 1963. erigraph, $11\frac{3}{4} \times 14\frac{3}{4}$ ". rivate collection

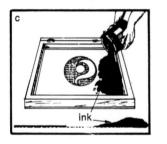

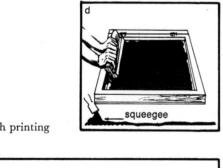

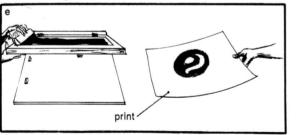

processes do not require you to reverse your conception.

The technique, as you can see from figure 348, is a simple one. (A) One begins with a wooden frame over which silk has been very tightly stretched. Silk comes in two weightsstandard (x) and heavy (xx)—and is available in coarse (6) to extremely fine (20), that is, from six strands per square inch to twenty per square inch. In my opinion the best silk for average screen-printing use is 14xx. Once the silk is on the frame, any area which contacts wood is taped with brown wrapping tape and waterproofed with shellac. (B) All parts of the screen that are not to print are blocked out. There are a number of ways of doing this. Some involve materials that stick to the silk, some entail painting in with glues or lacquers, and some involve "resist" techniques which permit you to put in thin lines or brushstrokes and to use crayon textures. The main point is that because the stencil is being prepared on a silk surface it is possible to block out areas in the center of an open space. (C) The printmaker pours into his screen ink containing materials which slow the drying of the pigment and make it flow smoothly. Silk-screen ink comes in a fantastic range of colors (including Day-Glos) and can be oil base, water base, or lacquer. In serigraphy, fast-drying oil inks are customary. (D) A squeegee (a hard rubber blade inserted in a wooden handle) is used to draw the ink across the screen. As the artist pulls it toward him, he presses it down and squeezes the ink through the mesh of the silk onto the paper beneath the frame. (E) The ink goes through the openings in the silk where the stencil is vacant but not where it is solid. When the paper is removed, the texture of the silk will not be visible because the ink is fluid enough to flow around the tiny threads. The printed area is very flat and solid. The printer inserts another sheet of paper, pulls the squeegee in the other direction to produce another print,

and so on and on until the run is finished. Once a color has been used up, the screen is cleaned and the stencil removed with solvent, which will either completely dissolve the block-out material or will loosen it but will not affect the silk or the shellacked tape. Successive colors are run on the paper by repeating the process described above. By strategic overlapping with the use of transparent bases in the ink, and through controlled printing techniques, it is possible to obtain very elaborate relationships.

PHOTOMECHANICAL REPRODUCTION

All the pictures in this book were reproduced by photomechanical printing processes. That is, the works of art were photographed onto photosensitive plates which were then chemically prepared for printing by machinery. The processes correspond to those in the fine arts and, indeed, derive from the hand processes of the artist. There are relief, planographic, intaglio, and stencil forms.

Relief (letterpress) Letterpress is the kind of printing with which most people are familiar. Raised type, having been inked, imparts the image to a sheet of paper. Most newspapers are printed by this process. Pictures reproduced for letterpress are of two types: linecut and halftone.

Linecuts are made from drawings that are of one value only—like the diagrams I have drawn to illustrate the printing processes. Sometimes my diagrams contain what appear to be grays, but if you look closely at the reproductions, you will see that the grays are really made up of tiny black dots very close together. Such a dot pattern is called *benday tint* and is available in many patterns and forms. In linecut the drawing is photographed onto a glass plate to produce a negative. Normally, the negative will be smaller than the original drawing; most comic strips, for instance, are drawn three or four times the size you see them. The negative is placed on a sheet of zinc that has been coated with a photosensitive solution and is exposed to a very strong arc light. The black of the negative (white in the drawing) blocks out the light; the clear area on the negative (black in the drawing) permits light to pass through. The light hardens the coating on the zinc so that it is insoluble in water. Careful washing removes the unexposed areas. The plate is then inked and dusted with a fine ground called dragon's blood which is very similar to etching ground. It clings only to the hardened areas and not to the remainder of the plate. The piece of zinc is immersed in an acid bath, and the parts not covered with ground are etched away. The plate is then mounted on a wooden block to bring it up to the same height as type and is printed exactly like type. What it prints, of course, is a small duplicate of the original drawing.⁵

The same procedure is used for the reproduction of continuous-tone photographs, that is, for things like the pictures of paintings and prints in this book. All photographs are reproduced by this process, called halftone. The difference between halftone and linecut is that in halftone two sheets of plate glass covered with lines are involved. The lines are engraved diagonally and are filled in with black pigment. When the two plates are placed face to face with the lines at right angles, a grid or screen is formed. The negative is photographed onto the zinc plate through the screen. Because the plate is able to "see" only in terms of the highest possible contrast, it. reads light areas as made of large dots and dark ones as small dots. (Remember, all this is in negative.) The ultimate consequence is that when the zinc has been prepared as it is for a linecut a lot of little dots stand up in relief; there are many dots close together where the image is to be black and very few where it is to be light. If you look at a newspaper, you

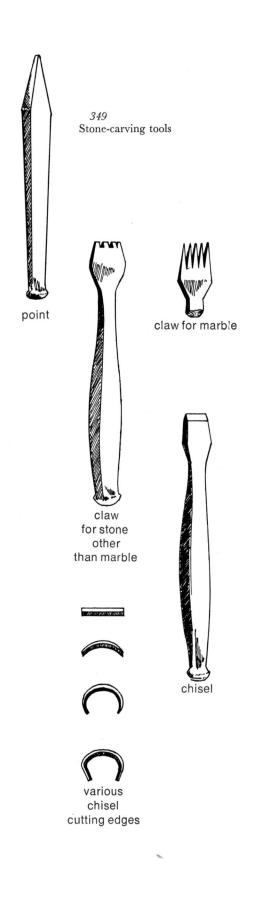

to a level corresponding to a predetermined height on the stone and revealed the exact section to be carved.

The removal of waste material from the block is accomplished by hammering a steel tool into the stone with a mallet of wood or iron. All the differently shaped tools (fig. 349) come in various sizes. The "roughing out" of the block is done with a tool called a point. The point is just what its name suggests, a sharp-tipped rod. Its purpose is to explode away the stone. Usually the sculptor carves with points to within about half an inch of the final surface. He then switches to the claw, so-called because of its teeth. Claws used for marble have longer teeth of a harder temper than those used on other kinds of stones. At this stage the sculptor carves his image more precisely into the stone, achieving a kind of three-dimensional cross-hatching. Chisels are used in diminishing sizes to make the final statement. The surface of the work is then refined with rasps, files, and abrasives.

Different kinds of stones dictate special procedures. Granite, for example, is too hard to be modeled with a claw, and so an instrument called a granite ax is used. A tool called a *boucharde*—a hammer with teeth not unlike those of a meat mallet—can be used to bruise stone away; it is used on marble and limestone as well as granite. Before the invention of steel, sculptors approached the stone by abrading it with other stones, iron hammers, and chisels. This is the way Praxiteles and other ancient sculptors worked. Indeed, the technique dates back to prehistoric ages when Paleolithic men pounded stone against stone to fashion spearheads and axes. It is a very slow process, pounding the surface of stone to dust, but it has the effect of stroking and smoothing the forms into their final state and lends a sensuousness to the carving that other methods do not attain. Michelangelo gains power and clarity denied Praxiteles but sacrifices some of the Greek's surface appeal.

288 | ART: THE WAY IT IS

You perhaps have noticed that David's leg rests against a stump. This sort of leg rest usually a stump but sometimes an animal, child, kneeling figure, stone, or other object is found in nearly any stone statue of a standing figure with legs that are not attached to a background. It is not an aesthetic device; it is a structural one. Stone is strong but it is brittle. Marble has so little tensile strength that the thin ankles of the *David* could not possibly carry his massive weight without assistance. The stump was introduced to increase the diameter of the support. In *Hermes and Dionysus* the same function is performed by the falling drapery.

Built (additive) sculpture Carving takes away material, building adds it on. Naum Gabo's Linear Construction, Variation (fig. 303) is an accumulation of plastic forms and nylon thread; it is a construction, and a construction entails addition of part to part. Similarly, the Bakota guardian figure (fig. 300) was constructed of elements which had themselves to undergo subtraction in order to fit together but which find their final form only in combination. Ronald Bladen's The X (fig. 304) is made of pieces of wood joined and painted black. Later it was fabricated in aluminum by welding, another form of building. These are very obvious forms of built sculpture because they involve putting separate components together to form a whole. The most common type of built sculpture, however, is terra-cotta sculpture (the kind shown in figure 350). It is of earthenware, a rather soft and porous clay fired at relatively low temperatures (1740-2130°F.) in an oven called a kiln.

Clay is the residue of decomposed granite. A sticky substance, it clings to itself because of the peculiar shape of the particles: they are not granular, like particles of sand, but flakelike, which is why they tend to adhere to each other. This makes clay malleable when wet and indurate when dry, an ideal

350 DAN ANDERSON. The Better Idea Cup. 1972. Terra cotta, $13 \times 12 \times 8''$. Private collection

352 .OUIS Painte Fift of

353

AUGUSTE RODIN. The Walking Man. 1905. Bronze, height $8_{3\frac{3}{4}}$ ". The B. Gerald Cantor Collection, Beverly Hills, California that is, a negative form from which a positive cast may be taken. If you fill a bowl with fruit gelatin (Jello) in liquid form and let it harden, then tip the bowl over to release the jellied dessert, you have made a casting. The bowl was the negative mold and the molded dessert the positive form, the casting. The same kind of thing can be done with plaster of Paris in place of gelatin or (given a silica bowl) with molten bronze.

A small thing made of solid bronze poses no problems, but a moderately large bronze statue does. For a work as large as or larger than Boccioni's Unique Forms of Continuity in Space (fig. 319) it is normal to cast the piece so that its inside is hollow. To do so is more economical, since less metal is used. It also produces a lighter sculpture. And hollow structures are actually stronger than solid ones. Since bronze castings shrink when they cool, solid ones run a greater chance of cracking than hollow ones.

The most flexible method for producing hollow castings of metal is the *cire-perdue*, or *lost-wax*, method. The Boccioni was done by this process, and so was the twelfth-century head by an Ife tribesman in Nigeria (fig. 60). One of the great masters of lost-wax bronzes was Auguste Rodin (1840–1917), whose *Walking Man* is reproduced here (fig. 353).

Close examination of the *Walking Man* would reveal many marks and impressions that suggest direct modeling as if in clay. This is because a bronze casting is made from a sculptural model of wax or clay that is exactly the size and precise character the artist wants the finished work to be.

The lost wax process is depicted in figure 354. The lower diagrams are of the cross section indicated by the dotted line. (A) The clay model is (B) completely covered with flexible gelatin, which can be cut apart and removed without losing any of the details. It is supported by a plaster jacket. (C) The gelatin mold is taken off and then coated on

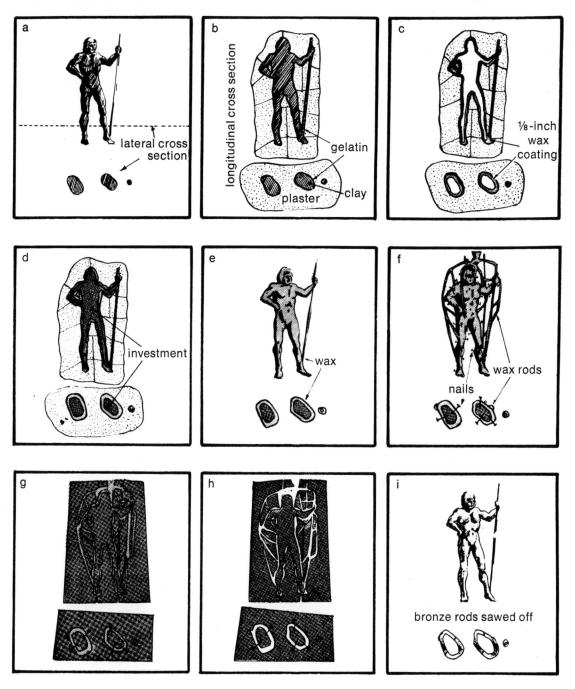

354 Lost-wax process

the inside with wax to the normal thickness of a bronze statue-about an eighth of an inch. (D) The mold is filled with an investment material made of plaster of Paris and silica. (E) Having removed the mold, we are left with a perfect wax casting identical in size and contour to the clay model and filled with a core of investment material. (F) Rods of wax are applied to the casting. These rods will carry off melted wax during baking and eventually will provide channels for molten bronze to enter and for air to escape. Iron nails, driven through the wax into the investment core, protrude from the cast. (G) In preparation for baking, the cast is covered with an outer mold of plaster-silica material. It surrounds the rods and nails. (H) The whole thing is put into a kiln and heated to 1500°F. This melts and burns out all the wax in the form. What is left is the core, separated from the mold by a space an eighth of an inch wide and held in place by the nails. This is the space formerly filled by the wax, hence the term lost wax. (I) Molten bronze is poured into the *casting gate*, a large opening at the top of the mold, and fills the cavity. When the bronze has cooled and hardened, the outer mold and inner core are removed, leaving a bronze replica of the wax form complete with the rods and gates. (Accomplishing this in such a way that a number of casts can be made from the same mold and core becomes complicated, but the problems of the foundryman need not concern us here.) The gating structure of rods is cut from the cast with a hacksaw, and then the surface of the work is finished: the holes left by the anchor nails are plugged, the rough edges are reworked, and some areas are accented by the use of files and punches (this last is called *chasing*). If it has been necessary to saw parts of the cast apart in order to remove the core, these parts will be joined together. Today, with modern electronic equipment, it is possible to weld and braze bronze joints. But it is simpler to follow the procedure of antiquity-joining by pounding with a hammer. Bronze is sufficiently malleable to do this without betraying the seam.

After a bronze is finished, the sculptor may wish to enhance it with color. If left alone, the metal will in time acquire the *patina*, or thin layer of corrosion, that gives it its characteristic green or dark brown color, but the natural process of oxidation can be hastened by brazing and the application of organic acids. Obviously, there are many other possibilities. The sculpture can be painted with enamels, materials can be applied to its surface, colored lights can be set to play on it. But sculptors have usually preferred the natural effect over the artificial.

Found sculpture Sometimes, in a junkyard, attic, or at the beach, one discovers things never intended to be artistic which nonetheless have all the characteristics of a work of art when seen with artistry in mind. For example, figure 355 is an iron object I call Miss America because of the long legs, absurdly high torso, and tiny head. It might very well be a welded-steel statue by a modern artist with a satirical turn of mind. But it isn't; it's a nineteenth-century tennis-net tightener. An artist I know had it welded onto a metal plate and gave it to me as a tasteful jest. It is an example of found art. One of the simplest and most exquisite of these "works" I've ever seen was a chrome-plated camshaft set vertically on an ebony base.

Duchamp's urinal called *Fountain* and Man Ray's *Indestructible Object* (fig. 12) are found art with an ideological purpose. Kienholz's tableau (fig. 6) is not really found art so much as a *combine*, a combination of common items presented to us as artistically meaningful.

ARCHITECTURE

Of all the fine arts, architecture is the most complicated, the most comprehensive, and the most expensive. It reveals the values of

355 MARTHA HOLDEN. Miss America. 1963. Found object welded to base. Private collection different periods and places to a far greater degree than any other art because it usually represents the major artistic investment of a society. Consider the contrast between a fourteenth-century European town and contemporary Manhattan.

In the Middle Ages the cathedral was the most prominent building in a town. It loomed more than a hundred feet above the marketplace. From almost any point its spires, its buttresses, its walls dominated the scene. It rose up among small buildings like a great island of power, a carnate symbol of the authority of the Church as a worldly institution, an institution to which all men looked for spiritual succor in times of fear and on whose charity they sometimes could rely in times of famine. The cathedral commanded the town in a quite literal way, too. Its spires served as lookout posts in time of war. In peace the music of its bells filled the air throughout the day. (The word belfry is derived from the Middle English word berfray, a watchtower used in warfare to gain a higher lookout. Since the church towers were used for the same purpose, they were sometimes called berfrys. Over the years the pronunciation of the word changed to belfry. The change from r to l is common, and the association with bells made it all the more likely in this case.) The cathedral made it quite obvious that in the year of our Lord (anno Domini) 1325 the Church was the most powerful institution on earth.

In the vicinity of Rockefeller Center in Manhattan are a couple of cathedrals built in imitation of the Gothic and every bit as large. Poor little things; they look tiny and forlorn against the backdrop of gigantic towers of commerce and pleasure. A twohundred-foot church spire is a mere trifle compared with one of those skyscrapers. The RCA Building is 850 feet tall. And it is merely the ninth largest building in New York City. Obviously, the society that builds such architecture is not terribly devout; at any rate,

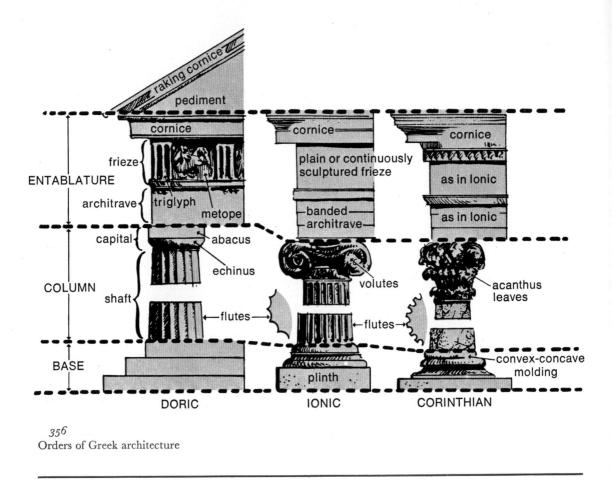

religion does not play anything like the role it did in fourteenth-century Europe. Now the Church looks to the State for protection, and men stake their hopes on economics and technology, not on the will of God. This is clearly evidenced in the scale of the buildings themselves. It is a gross contrast, but a very real one.

Classical architecture In surveys of the history of architecture one normally begins with the Egyptians. But few of their motifs have real currency today. This is not true of the architecture of the ancient Greeks and Romans. Their building styles and elements were revived during the Renaissance, and many of the forms you see in American and European public buildings are imitations of ancient Classical prototypes.

Early in Greek history the three orders (fig. 356) of Greek architecture emerged. An order is a specific type of base, column, and entablature forming the unit of a style. The diagram describes the principal elements and subelements that constitute the orders.

The Greeks considered the *Doric* order a masculine form and the lighter *Ionic* a feminine style. The *Corinthian* was not popular among Greeks even though it was their invention; a Classical building containing Corinthian columns is almost surely Roman.

The finest example of the Doric order occurs in a building constructed about 2500 years ago on a hill in Athens called the Acropolis. The Parthenon (fig. 357) has been a noble ruin only since 1687. At that time the Turks, who ruled Greece, were warring with the Republic of Venice. A Venetian bomb set off gunpowder stored in the ancient temple, and the resulting explosion destroyed the central portion of the building. Later, between 1801 and 1803, the British ambassador to Turkey, Lord Elgin, arranged to have most of the sculpture removed and taken to England where it now resides in the British Museum. (At the time, and in some quarters still, Lord Elgin's actions were considered criminal despite the fact that he sold the statues to the British government at a great financial loss to himself. In his day the statues were being ignored and would probably have fallen to ruin. He seems to have acted out of highly civilized motives and, in fact, we probably owe their existence to him.) The fragments are now popularly known as the Elgin Marbles. Despite these subtractions, the building remains one of the great edifices of the world.

The Parthenon is an example of *post-and-lintel* construction. That is, posts hold up horizontal beams (lintels), and the roof is laid over and across the support system. The engineering system is a simple one, and it has severe limitations, the most obvious of which is that posts cannot be far apart because stone has so little tensile strength that a long stone beam will break.

357 ICTINUS AND CALLICRATES. The Parthenon, Acropolis, Athens. 448–432 B.C.

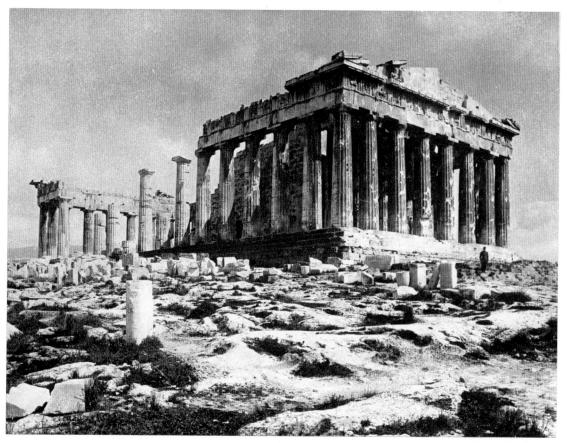

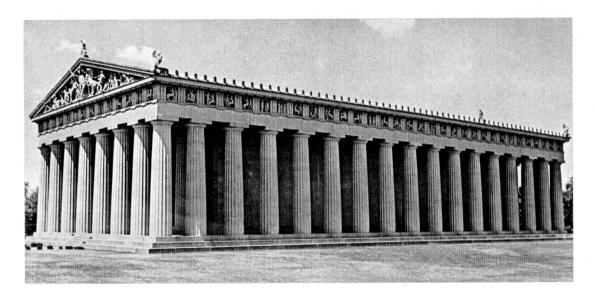

358 HART AND HART. The Nashville Parthenon, Nashville, Tennessee (second replica). 1920

What is impressive about the Parthenon is not the engineering but the refinements its architects introduced. Because long horizontal lines in buildings give an impression of drooping, Ictinus and Callicrates contrived to put a faint upward curve in all the steps, cornices, and other prolonged horizontals. Since a completely straight column appears to be concave, the Parthenon's columns were carved with a convex bulge. Such a curve is called entasis. Too, a structure which is perpendicular to the ground often looks as though it is leaning forward. This illusion was neutralized in the Parthenon by tilting its front slightly backward. Because a column which is silhouetted against a bright background seems smaller than one which is not, the four corner columns-the ones most often seen against the sky-were made a little larger than the others. Finally, the architects have overcome a problem common to long colonnades, namely, that when all the spaces between columns actually are equal they do not appear equal. That is an effect of perspective distortion. It is negated in the Parthenon by making the spaces widest in the center and progressively smaller toward the ends of the colonnade. The deviations involved in the use of entasis, bowing, tilting, and varied intercolumnation are about two and a half inches at most. This isn't enough to disturb an onlooker, but the prestige of the temple shows that these devices were effective. In the earlier part of the twentieth century the Parthenon was reconstructed as accurately as possible in the city of Nashville, Tennessee (fig. 358). The reconstruction gives us a good notion of what the original building looked like.

Where the Greeks strove for perfection and refinement in their buildings, the Romans preferred majesty. One of the best techniques for achieving scale in building is a device called the *arch*. Arches are based on the fact that if two things of equal weight lean against each other, both will stand. In a structure 359 Roman aqueduct. Segovia, Spain

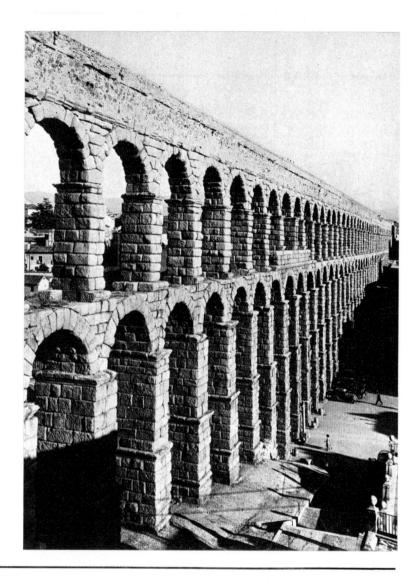

like a Roman aqueduct (fig. 359) the stones that make any single arch are literally falling toward the center of the arch. The keystone at the center of the top of the curve forms the resting place where all the stones lean together. The stones on the bottom don't pop out because of the equal counterthrust of the arches on either side or (at the ends of the arcade) by the sheer mass of stone. One of the advantages of the system is that no more stone is needed to support an arch at the end of a million arches than is needed to support one arch alone. If you could build an arcade like the Segovia aqueduct clear around the globe so that it met itself, it would be selfsupporting.

Roman aqueducts are a perfect example of what the term *imperialism* really means. These structures transported water from distant points into the centers of the cities of the Roman Empire. In a day when water was really precious and was jealously guarded, the peoples conquered by Rome's legions had as much water as they could possibly use. Some of the aqueducts are over thirty miles long. They are artificial streams, carrying water by gravity downgrade from the source to the urban terminus. If you think seriously about this kind of project for a moment, you will see what an impressive feat of engineering, surveying, and masonry construction an aqueduct is. Building an aqueduct is far more difficult than building a pyramid (really just a regularized pile of rock) or a Greek temple. It is not surprising that the Romans were able to Latinize most of the known world. Not only were they courageous warriors and masterful strategists, they were also superb administrators, great public relations men, and beneficent rulers. Their conquered subjects came to be dependent on them. Rome, of course, had markets for its goods and resources to exploit for its industry.

In the capital city itself the Romans built a palace to all the gods, the Pantheon (fig. 360). It involves a different kind of arch, the dome, and a material the Romans used magnificently, concrete. (Many people think concrete is a recent invention, but it is not. What *is* fairly new is steel-reinforced concrete.) The Romans accomplished a good deal with their variety, which used pieces of cut stone for reinforcement. Many of the great buildings of Rome—the Colosseum, the Basilica of Constantine, the Baths of Caracalla—are built of it.

360 The Pantheon, Rome. 118–125 A.D.

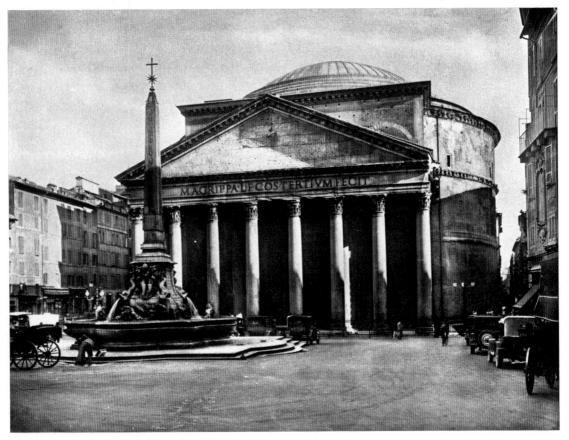

368 Notre Dame, Paris. 1163–1200. West facade

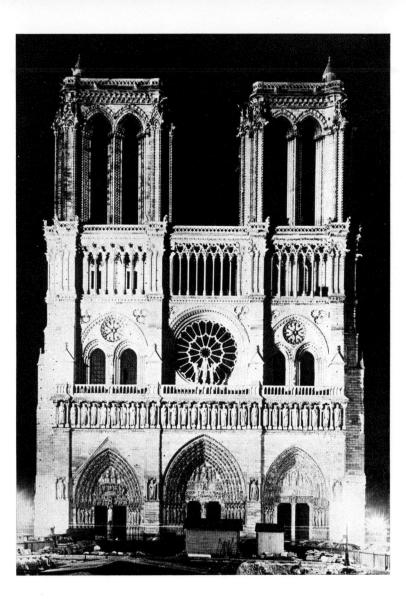

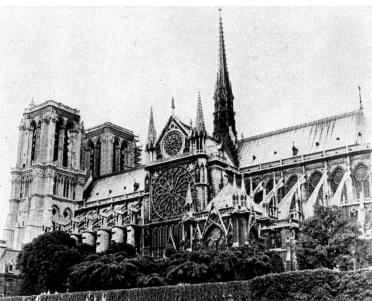

369 Notre Dame, Paris. View from the southeast

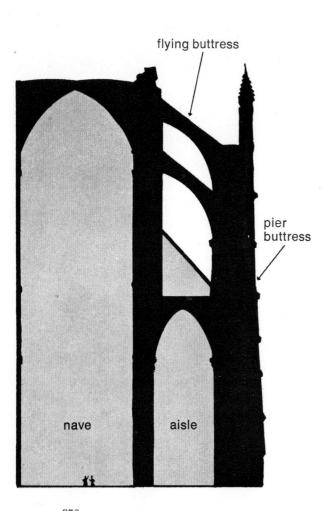

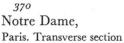

which conveys lateral thrust over to the pier.

Notre Dame's interior (fig. 371) is loftier and lighter than Romanesque interiors. The vaulting of the nave is similar to the vaulting in St.-Etienne; but the pointed arches that divide the bays permit the crown of the vaults to be level rather than domical, and they free more space for clerestory windows. In fact, the exterior walls of Gothic buildings are practically nothing but windows. Romanesque walls had to be thick to support the weight of the vaults. Notre Dame's buttressing would provide support even if the walls were all pulled away. This fact enabled Gothic masons to incorporate vast amounts of stained glass into their churches. Stained glass has a tendency to absorb light, and the buildings are actually rather dark despite the stupendous amount of window surface. But the windows themselves are like magic jewels, and the shafts of rainbow light that fall onto the stone columns and paint bare floors with radiance transform cold buildings into holy places.

Modern architecture The Gothic period was succeeded by the Renaissance, the Renaissance by the Mannerist, the Mannerist by the Baroque, the Baroque by the Rococo, the Rococo by the Neoclassic, and the Neoclassic by the Modern. But no major technical advances beyond Gothic engineering were made until modern times, when it became possible to build with steel. Without steel beams the construction of a skyscraper would be unthinkable. Forged steel has higher compressive strength than stone and vastly more tensile strength than wood or iron. Considering its toughness, it is startlingly light. Mies van der Rohe (1886–1969) was the outstanding spokesman for the International Style, an architectural movement that emphasized these properties and strove to make buildings reveal them. His Seagram Building (fig. 372) is essentially a steel cage supporting floors and partitions to make rooms and corridors. The

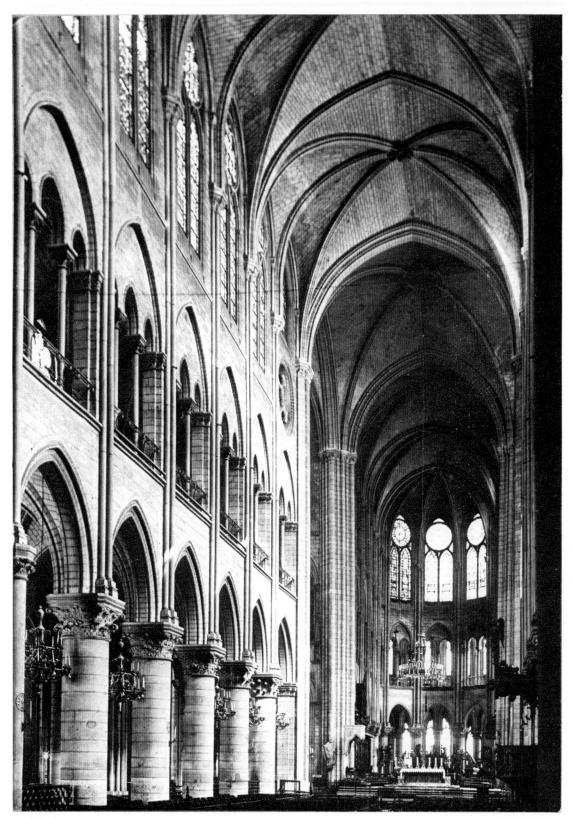

³⁷¹ Notre Dame, Paris. Nave

372 MIES VAN DER ROHE AND PHILIP JOHNSON. Seagram Building, New York. Designed 1958 exterior is a light skin of bronze and ambercolored glass.

Skyscrapers worthy of the name did not appear first in New York City but were built initially in Chicago during the enormous building boom that followed the fire of 1871. One of the great architects of modern times, Frank Lloyd Wright (1869–1959), was a product of that boom. In 1936 he built a private home, the Kaufmann House (fig. 373), called *Falling Water* because it straddles a waterfall. One of the great home designs of all time, it is of interest here because it involves the use of steel-reinforced concrete and a structured system called *cantilever*. A cantilever is a horizontal beam extending out from a supporting post and carrying a load. Here the terraces are cantilevered. A central block of building houses utilities and chimneys and acts to anchor the horizontal extensions. Many skyscrapers and apartment houses utilize this system, which was first employed in steel bridges, cranes, and railway terminals.

Another towering figure of modern archi-

373

FRANK LLOYD WRIGHT. Falling Water, Bear Run, Pennsylvania. 1936

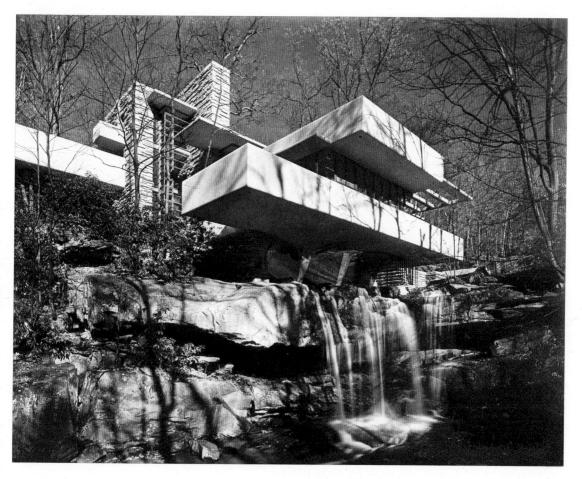

tecture was inspired by a European exhibition of Wright plans. This creator, a Swiss named Charles-Edouard Jeanneret (1887– 1965), adopted the pseudonym Le Corbusier (the name of his maternal grandmother). Le Corbusier built his first masterpiece of domestic architecture in France several years before Wright built Falling Water. The Villa Savoye (fig. 374) is as urbanely detached from Nature as Wright's house is integrated with her. Le Corbusier conceived of the home as a shelter from which nature could be viewed and taken advantage of. The interior of the dwelling is far more complicated than it appears. The upper level is a box containing the living area. But part of it is open to the sky. Rooms lead onto a terrace that is sheltered by walls. These walls are penetrated by openings that extend the window lines. What you see in the photograph is the box that surrounds the irregular and beautifully articulated interior, an interior of several levels tied together and attached to the terraces by a series of ramps. The cylinders rising above the box form a tower housing the staircase and act as a windbreak for the roof garden. Set well back beneath the overhang are the garage and the service functions.

Both Wright and Le Corbusier have designed major projects known to all the world

374

LE CORBUSIER. Villa Savoye, Poissy, France. 1928–30

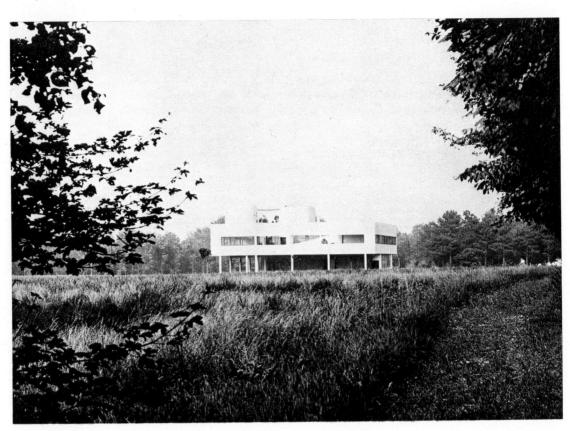

—to cite only two, Wright's Guggenheim Museum and Le Corbusier's plan for the new capital of the Punjab at Chandigarh, India. In Chandigarh Le Corbusier got a chance to undertake an entire architectural environment—something both he and Wright had always wanted to do. Both had distinctive theories of how the vast populations of the world should be housed. Their differences in attitude are interesting to consider.

Wright, a son of the wide-open Midwest at the turn of the century, had the point of view of an American Romantic; he disliked cities and believed in the dispersal of the population through an open landscape of farms and unblemished nature. It is an appealing dream, one that the suburbanites seek and never find. Wright felt that by clever use of land and strategic placement of service centers and commercial complexes modern man could have the best of the rural and the industrial. This antagonism to population density is just what one would expect from the naturist who designed Falling Water.

Le Corbusier was a sophisticated European intellectual. His ideal was to house people in tremendous buildings separated by parks and boulevards, canals and thoroughfares. He once proposed a solution to the traffic-population density problem which involved highways that would run on top of continuous apartment buildings of typically Le Corbusieran scale.

Whether cities are going to disappear or whether they will survive in some new form is still controversial. One thing is clear; the present form of the city is incapable of supporting life in a humane fashion. Even the wealthiest apartment dwellers are assailed by poisoned air, horrendous noise, and unsafe streets. Most thinkers today tend to incline in the direction Le Corbusier indicated—dense concentrations of people and unspoiled intervals between them.

One thinker and designer who has devoted

considerable attention to the problems of survival on the planet Earth is R. Buckminster Fuller (born 1895). Fuller feels that all architecture of the past is obsolete; he would say that every building we have so far discussed is inappropriate for man's future existence on the Spaceship Earth. He was trained not as an architect but as an engineer, and his ideal structures from the past are not buildings, but plant stalks, crystals, tension bridges, sailing ships, and airplanes. Strength, efficiency, and lightness dominate his designs, the most famous of which is the geodesic dome. A geodesic is the shortest distance between two points on a mathematically derived surface such as a plane (where the geodesic is a straight line) or sphere (where the geodesic is the arc of a great circle, that is, a circle that is the intersection of the surface of a sphere with a plane passing through the center of the sphere). The largest of Fuller's domes is the one used in the United States Pavilion at Montreal's EXPO 67 (fig. 375). The dome is constructed of steel pipe and transparent acrylic panels. It is 200 feet tall and 250 feet across. Altogether, the metal pipes weigh 720 tons. Yet, in terms of total space contained, this averages out to four ounces per cubic foot, an absolutely astonishing figure. No other man-made shelter comes close to the efficiency of the geodesic dome. These domes, built of triangular sections, can be constructed of anything from cardboard to steel and are being appropriated by all kinds of counter-culturists in both communes and private hideaways. They are tremendously strong-the tetrahedron, a pyramid composed of equilateral triangles, is the strongest structure known-and there seems no limit to the size that can be attained. Considering their advantages and spaciousness, the domes are dirt cheap. Fuller has proposed a two-mile-wide dome for New York City and is now designing a floating, two-hundredstory, tetrahedron-shaped city near Tokyo.

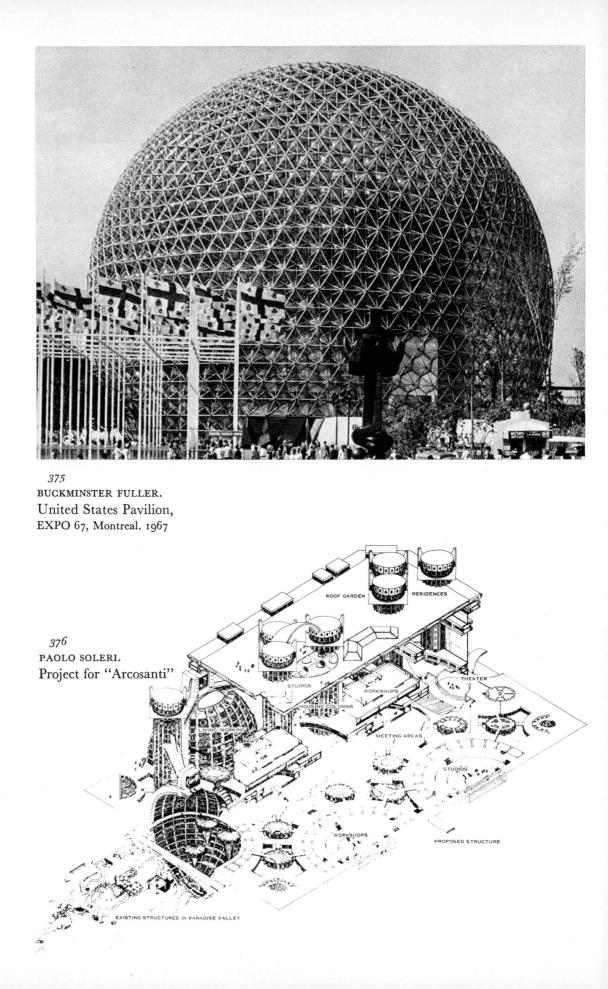

Another person who thinks on a grandiose scale is Paolo Soleri (born 1920), whose design for "Arcosanti" (fig. 376), a complete livingwork environment in Arizona, locks three thousand souls into a commune that is really a vast building of interlocking concrete modules. It is with preservation of the surrounding wilderness in mind that Soleri proposes such dense concentrations of people; the landscape would be left as it has been for centuries. Soleri recognizes that people need privacy as well as a habitable natural environment beyond the walls. Presumably this is designed into the hivelike complex.

Similar concentrations of people have been living in Habitat (fig. 377), the massive experimental housing project built for EXPO 67. It looks weird, but its inhabitants like it. This pileup of one- and two-story apartments consists of precast modular boxes which were fitted together by an assembly-line technique. What is particularly intriguing about Habitat is that this machine-made stack of blocks makes buildings with hand-laid brick seem mechanistic. For Habitat is more like a Mediterranean seacoast village than an apartment house. The ingenious Israeli architect Moshe Safdie (born 1938) designed the cubicles so that they can be coupled together in a number of ways, then opened up and partitioned off to make individual interiors more distinctive than is customary in ordinary apart-

377

SAFDIE, DAVID, BAROTT, AND BOULVA. Habitat, EXPO 67, Montreal. 1967

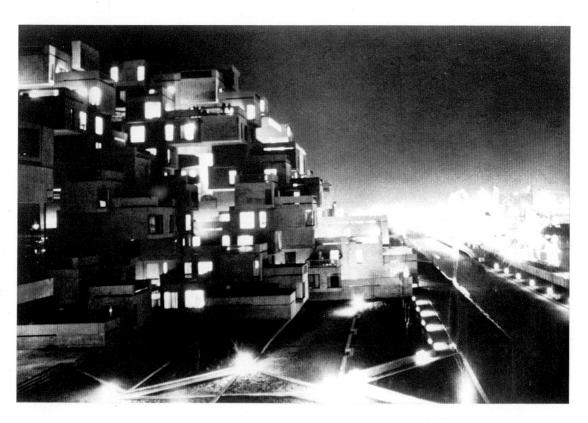

ments. Moreover, each apartment is sealed off from the others, having its own entrance from "sidewalks" that form a network of streets through the cluster. And each apartment has its own private terrace.

As an experiment in low-cost, high-density housing, Habitat was expensive—even more so than anticipated, because the special crane designed to position the cubicles turned out to be inadequate, and a second had to be built. The complex cost fifteen million dollars to construct. But now that the crane exists and the other bugs are out, it could be duplicated for about five million dollars. In fact, the duplicate would be of higher quality; interior finish in the original was skimped in the interest of keeping down ever-rising costs. Too, the more units such a complex contains, the less cost there is per unit. The idea of using prefabricated apartment units that can be "plugged" into larger matrices had occurred to Le Corbusier too. He had, in point of fact, experimented with them, inserting identical apartments into a concrete grid. Buckminster Fuller's Tokyo project also conceives of the living units as segmental indeed, he envisions each unit and any stable collection of them as portable.

Which of these ideas will dominate the city of the future is impossible to say. Quite likely all of them will be synthesized and used by lesser men. Their hope will be to house the masses of the world humanely while avoiding the desecration of land produced by the suburban sprawl with its commuter highways and dreary shopping plazas. To do so is within the technological reach of mankind; what is needed is the will.

Notes to the text

1. Who's putting on whom?

- Erwin Panofsky, *Meaning in the Visual Arts* (Garden City, N.Y.: Anchor Books, 1955), p. 19.
- 2. René Huyghe, *Ideas and Images in World Art*, trans. Norbert Guterman (New York: Abrams, 1959), p. 9.
- 3. Somewhere Vladimir Nabokov, a celebrated lepidopterist and the author of significant novels in three languages, mentions that he has never been able to master the art of refolding a road map.
- 4. It is not trashy in the sense of being obscene, however, although this charge has been brought against it. The figures in the rear seat are as incomplete as the automobile body; if we did not associate motor vehicles with instruments of illicit pleasure, the tableau would not be suggestive.
- 5. For those who haven't read this tale, it concerns a pompous ruler who is "conned" by two characters who claim that they weave a beauteous fabric which is invisible to anyone who does not deserve his position. In fact, they weave nothing, but only pretend to—the sovereign's garment is purely imaginary. But since no one—least

ropolitan Museum of Art, New York. Harris Brisbane Dick Fund, 1946. Fig. 264: Peter Paul Rubens. The Raising of the Cross. Triptych. 1610-11. Oil on panel, $15'2'' \times 11'2''$. Cathedral, Antwerp. Fig. 265: Giorgione. Enthroned Madonna with St. Liberalis and St. Francis. c. 1500-1505. Oil on panel, 78 $3/4 \times 60''$. Cathedral, Castelfranco Veneto, Italy. Fig. 266: Pieter de Hooch. A Woman and Her Maid in a Courtyard. c. 1672. Oil on canvas, 29×24 5/8". The National Gallery, London. Fig. 267: Michelangelo. The Fall of Man and the Expulsion from the Garden of Eden. 1508–12. Fresco. Sistine Chapel, The Vatican, Rome. Fig. 268: Quentin Metsys. The Money Changer and His Wife. 1514. Oil on panel, 28×26 3/4''. The Louvre, Paris. Fig. 269: Francisco de Zurbarán. Funeral of St. Bonaventure. 1629. Oil on canvas, 98 3/4×86 5/8". The Louvre, Paris. Fig. 270: Albrecht Dürer. Self-Portrait. 1500. Oil on panel, 26 $1/4 \times 19 1/4''$. Alte Pinakothek, Munich. Fig. 271: Jan Steen. The Lovesick Maiden. c. 1665. Oil on canvas, $34 \times 39''$. The Metropolitan Museum of Art, New York. Bequest of Helen B. Neilson, 1945.

9. Modern art, its variety and unities

- The Seven Years' War (1756–63) was a conflict between France, Austria, Russia, Saxony, Sweden, and Spain on the one side and Prussia, England, and Hanover on the other. There were two issues: (1) French-English colonial rivalry in America and India and (2) the struggle between Austria and Prussia for supremacy in Germany. The war proved Prussia's rank as a leading power and made England the world's chief colonial power at France's expense.
- See Jacques Barzun, Classic, Romantic, and Modern (Boston: Atlantic Monthly Press, 1961), pp. 155–68.

- 3. No one agrees on who appropriated the word *dada* as a trademark for the group, but it is supposed to have been discovered by accident in a German-French dictionary. Hugo Ball wrote: "In Rumanian, *dada* means yes, yes, in French a rocking horse or hobby horse. To Germans it is an indication of idiot naivety and of a preoccupation with procreation and the babycarriage." Quoted in Hans Richter, *Dada*: *Art and Anti-Art* (New York: Abrams, 1970), p. 32.
- 4. Max Ernst is really the Surrealist painter. He invented most of the mannerisms commonly identified with a Surrealist style in sculpture, in painting, and in both "literalist" and "abstract" Surrealism.

10. Media and methods

- 1. Some writers differentiate between the *medium* and the *vehicle*, with the vehicle in oil paint being the binder (oil) and the medium being whatever is used to thin it (turpentine). Such a distinction is useful in technical discussions with studio craftsmen but would serve only to complicate a text intended for laymen.
- 2. Leonardo's *The Last Supper* was done in a version of *fresco secco*. The *buon fresco* method was too restrictive for his restless, inquisitive temperament. Always an experimenter, he decided to try out a mixture of tempera and varnish on a dry plaster wall sealed with a varnish. The paint began to flake away as soon as the work was completed. Before World War II, the method of repair had been a piecemeal one, with restorers replacing the missing pigments fleck by fleck. After the war, however, deterioration was arrested by fixing the pigment to the wall with synthetic resins.
- 3. Those original oil paintings sold in furniture departments are indeed "original" in the sense that they are handmade. But buyers should beware of what they are getting. The people who turn out this

stuff paint the same pictures over and over, sending similar ones to different outlets in different locations. Every once in a long while something of quality sneaks in. But it's rare.

- 4. I have imitated the crayon texture the same way political cartoonists imitate it today: by use of a black lithographic crayon on a pebble-grained paper called *coquille board*.
- 5. It is possible, of course, to make any num-

ber of identical plates from the same negative. Since these would be expensive to ship through the mails to all the thousands of newspapers using syndicated comic strips, national advertising, and the like, another method is used. Asbestos molds, or *matrices* (plural of matrix), taken from the zinc plate are mailed to the newspapers, which then cast their own plates with molten metal.

Glossary

The following list contains many terms not used elsewhere in this book. Although one may expect to encounter these terms in connection with art, I have not always had occasion or space to touch upon them. Cross references are indicated by words in small capitals.

ABACUS. In architecture, a flat block used as the uppermost part of the capital of a COLUMN.

- ABSTRACT EXPRESSIONISM. A style of painting in which the artist expresses his feelings spontaneously and without reference to any representation of physical reality. Normally the term signifies a movement that originated in America during the late 1940s, but Wassily Kandinsky had pioneered the essentials of the manner before World War I.
- ABSTRACTION. Art dependent on the idea that artistic values reside in forms and colors independent of subject matter. An abstract work may resemble something else (apples, nude women, etc.), but the stress will be on form and color. Any work of art can be looked upon as an abstraction, but some styles (CUBISM, ABSTRACT EXPRESSIONISM, NEOPLASTICISM) intentionally emphasize the formal over any symbolic value.

ACTION PAINTING. A type of Abstract Expres-SIONISM incorporating impulsive gestures.

- AESTHETIC. Having to do with art and beauty. Often used synonymously with a theory of art or to refer to the characteristics of a given style, as, for example, "the IMPRES-SIONIST aesthetic." (Sometimes spelled ES-THETIC.)
- AMPHORA. A jar with two handles used by the ancient Greeks and Romans for storing grain, oil, condiments, etc.
- APSE. The exedra, normally semicircular, at the end of a Christian church. It occurs also in the Roman public buildings known as BA-SILICAS.
- AQUEDUCT. A watercourse, often supported in places by an ARCADE.

ARCADE. A series of ARCHES carried by pillars.

- ARCH. An engineering device used to span an open area. Arches are curved and made of wedge-shaped blocks called voussoirs. The central voussoir is known as the keystone. In arch construction no mortar is required; gravity operates to pull the blocks together in such a way that they lean on one another.
- ARCHAIC ART. A term having various meanings depending on its context. (1) In reference to the field of art, generally, it suggests the very beginnings of art and is applied to all prehistoric art and, by extension, (2) to the artifacts of tribal cultures of later eras. (3) When applied to the art of ancient Greece, it refers specifically to objects created prior to 600 B.C.
- ARCHAEOLOGY. The scientific investigation of ancient cultures and civilizations by means of their artifacts.

ARCHITRAVE, see ENTABLATURE.

ARMORY SHOW. The first large, public exhibition of modern art in the United States. Organized by THE EIGHT and some sympathizers, it was held in the 69th Regiment Armory building in New York City in 1913. The show outraged the average viewer and the press, but it was the most influential ever presented in America, for the European works in it opened a vast range of possibilities to domestic artists.

Art Nouveau. A decorative style of the 1890s

which attempted to break with past traditions. It is characterized by interlacing plant forms and similar organic elements along with relatively flat color treatments.

Ash Can School, see The Eight.

- ATMOSPHERIC PERSPECTIVE. The illusion of depth in painting created by reduction of contrast between lights and darks, cooling of colors, and blurring of outlines as things represented recede from the picture plane.
- AVANT-GARDE. French word for vanguard. Artists who are unorthodox in their approach. The connotation is that such people are "ahead of their time," but it sometimes happens that they are merely eccentric. Still, REALISM, EXPRESSIONISM, DADAISM, CUBISM, and the others are all examples of avant-garde movements.
- BAROQUE. Generally, the seventeenth century. The term connotes grandiose elaboration in architecture and decoration, since that is typical of the period. Dutch art of the period, however, is quite different and is distinguished by the name Protestant Baroque.

BARREL VAULT, see VAULT.

- BASILICA. In ancient Rome, a public building used for various assemblies, particularly tribunals. It is rectangular in plan and is entered on the longer side. See also CHRIS-TIAN BASILICA.
- BATIK. A process of dyeing cloth by painting designs on in wax so that only exposed areas are impregnated with the dye. The wax is removed after dyeing.
- BAUHAUS. A school of industrial design founded in Weimar, Germany, in 1919 by architect Walter Gropius. Known for its attempts to integrate art and technology.
- BENDAY PATTERN. In commercial printing, the technique invented by Benjamin Day (1838–1916) which adds tints to the linecuts by means of dots, lines, and other regular patterns.
- DER BLAUE REITER. "The Blue Rider." A branch of German Expressionism centered in Munich. Tends to be far more abstract than DIE BRÜCKE.

- BROKEN COLOR. The technique of applying paint in brief, rather heavy strokes on top of a background color. Typical of IMPRESSION-ISM.
- DIE BRÜCKE. "The Bridge." A branch of German Expressionism centered in Dresden. Very similar in appearance to FAUVISM but more pessimistic about things in general.
- BUTTRESS. In masonry, a support to take up the THRUST of an ARCH or VAULT. A pier buttress is a solid mass of stone that rises above the outer wall of a Gothic or Romanesque church. A flying buttress is an arch or series of arches carrying the thrust of the nave vaults across open space to a pier buttress.
- BYZANTINE. Pertaining to the BYZANTINE EM-PIRE. Byzantine painting is characterized by a religious ICONOGRAPHY, rich use of color, highly formal design, and frontal, stylized presentation of figures. Byzantine architecture is characterized by domes, spires and minarets, and the widespread use of MOSAICS.
- BYZANTINE EMPIRE. The Eastern Roman Empire. It lasted from A.D. 395 to 1453. Its capital was Constantinople, built on the site of the ancient Greek city of Byzantium by Constantine the Great.
- CAMPANILE. A bell tower.
- CANTILEVER. An engineering form which projects into space at one end and is firmly anchored at the other.

CAPITAL, see COLUMN.

- CARTOON. A full-size preliminary DRAWING for a painting. Also, a frivolous or satirical drawing. (The former is the original meaning but is retained today only within art circles.)
- CERAMICS. Pottery making. More specifically, objects made of clay and fired at high temperatures to render them stronger and/ or waterproof.
- CHARCOAL. A drawing medium produced by charring organic substances (wood or bone) until they are reduced to carbon. A drawing made with charcoal.

CHASE. To ornament metal by indenting it with

a hammer and tools that do not cut it. See also REPOUSSÉ.

- CHIAROSCURO. Light-dark relationships in a work of art.
- CHOIR. The space in a Christian church reserved for singers and clergy.
- CHRISTIAN BASILICA. An early church form resembling a Roman BASILICA in plan, but entered from one end and having an APSE at the other.
- CIRE-PERDUE PROCESS (or lost-wax process). A process of metal casting that consists of building up a refractory mold around a wax model, baking it until the wax melts and drains off through small holes in the mold, and then pouring metal into the empty space.
- CLERESTORY (or clearstory). In architecture, a part of a building raised above an adjoining roof and containing windows in its walls.
- CLOISONNÉ. From the French word *cloison* (partition). A metalsmithing process in which strips of metal are soldered to a base, thus forming cells to contain enamel or other decorative materials.
- CLOISTER. A covered walk on the side of a court. Common in MEDIEVAL monasteries in western Europe.
- COLLAGE. A picture made up in whole or in part by gluing various materials (newspaper, wallpaper, cloth, photographs, bits of wood, etc.) to a piece of canvas or other GROUND.
- COLLAGRAPHY. A relief-printing method which uses as the printing surface cardboard shapes and pieces of materials glued onto a base. It is often used in conjunction with INTAGLIO OF LITHOGRAPHIC techniques.
- COLLOTYPE. A photoreproduction method for making prints from photosensitive gelatin spread on sheets of glass or metal.
- COLOR-FIELD PAINTING. A kind of painting emphasizing large, usually unbroken, zones of color. Normally the term is applied only to paintings done by artists active after 1950.
- COLUMN. A vertical, cylindrical architectural member used to bear weight. Columns consist of a base at the bottom, a SHAFT,

322 | ART: THE WAY IT IS

and a capital. Sometimes, as in DORIC columns, the base is nothing more than whatever the shaft rests on. The capital is the upper member of the column, and serves as a transitional unit from the vertical SHAFT to the horizontal LINTEL.

- COMPLEMENTARY COLORS. Colors which are opposite each other on a color wheel. When mixed together in proper proportions, they form a neutral gray.
- CONCEPTUAL ART. A form of art whose "product" is not a physical object but a mental conception of some sort. The work may entail the use of pictures, documents, recordings, and other data, but the work itself is a mental synthesis of the material. Similar to and related to HAPPENINGS.
- CONNOISSEUR. Technically, an expert on art whose profession is identifying the specific artist who created a specific work. Generally, a person of highly developed artistic sensibilities.
- CONSTRUCTIVISM. A twentieth-century movement in sculpture which emphasizes precision, technology, and NONREPRESENTA-TIONAL form.
- CONVENTION. A practice established by custom and performance and widely recognized and understood.
- COOL COLORS. Blue and such hues as approach blue.
- CORBELED ARCH. A primitive sort of ARCH which spans an opening by means of masonry walls built progressively farther inward until they meet.
- CORINTHIAN ORDER. The least consistent of the three principal ORDERS of Classical architecture. Frequently it resembles the IoNIC except for the capital (*the* distinguishing feature of Corinthian), which is treated as a vase of acanthus leaves. Invented by the Greeks, it was never popular among them but found favor with the Romans, who admired its grandiose character.

CORNICE, SEE ENTABLATURE.

COUNTER REFORMATION. The reform of the Catholic Church during the sixteenth century. (The term is objected to by Catholics because, in fact, the reforms had begun before the rise of Protestantism.) The founding of the Society of Jesus (the Jesuit order), the convening of the Council of Trent, and the establishment of the papal Inquisition are among the notable consequences of Catholic reform.

- CROSS-HATCHING. The production of relative VALUE relationships in drawing by placing sets of more or less parallel lines on top of one another at varying angles.
- CROSSING. The space in a cruciform church where the NAVE and TRANSEPT cross.
- DADAISM. A MOVEMENT begun in Zurich during World War I. It reacted to the war by expressing the absurdity of all CONVENTIONS and the futility of all acts. It soon became international in scope.
- DIPTYCH. A two-panel altarpiece or devotional picture, normally hinged so that it can be closed like a book.
- DISTEMPER. Any of a number of water-base paints using a simple glue or casein as the binder. Calcimine, show-card, and poster colors are examples. (The "TEMPERA" of the primary grades is a distemper.) The term is more common in Great Britain than in the United States.
- DORIC ORDER. The most consistent of the three major ORDERS of Classical architecture. It is characterized by a COLUMN resting directly on the floor and a shaft with continuous fluting. The capital has a round, bulging element called an ECHINUS and is topped by an ABACUS. The ENTABLATURE has a plain architrave and a FRIEZE made up of alternating TRIGLYPHS and METOPES.
- DRAWING. The projection of an image on a surface by some instrument capable of making a mark. Drawings may be done with pencils, pens, brushes, PASTELS, crayons, CHAR-COAL, ETCHING tools, and numerous other implements. Most often, drawings serve as studies or sketches for a work in some other medium, but they are frequently done as completed works in themselves.
- DRYPOINT. The simplest form of metal ENGRAV-ING. Done by scratching a soft metal such as copper with a sharp steel needle.

EARTHWORKS. In art, a form of sculpture in

which the artist designs a pattern that is carved, dug, or built into the landscape itself.

- ECHINUS. In the DORIC ORDER, the bulging cushion-like member between the ABACUS and the NECKING.
- THE EIGHT. A group of painters active in New York City at the beginning of the twentieth century. For the most part, they were REALISTS with strong social convictions, and they took as their subjects the streets and back alleys, the tenements and their immigrant inhabitants. Critics disturbed by the raw candor of their pictures called them the Ash Can School, and that name is now better known than The Eight.

EMBOSS. To raise up from a surface.

- ENCAUSTIC. A painting MEDIUM using hot colored waxes. It is extremely permanent.
- ENGAGED COLUMN. A COLUMN forming part of a wall and more or less projecting from it.
- ENGRAVING. The process of cutting a design into a substance, usually metal, with a sharp tool. Also refers to a print made from an engraved plate.
- ENTABLATURE. The horizontal portion of a building between the capitals of the COLUMNS and the roof or upper story. In Classical architecture the entablature consists of a horizontal beam called an architrave (which may be plain or banded), a FRIEZE (in the DORIC ORDER made up of TRIGLYPHS and METOPES and in the IONIC and CORINTHIAN either unadorned or covered with a continuous relief decoration), and a cornice. The latter is a projecting molding that runs along the top of the entablature.
- ENTASIS. A slight, almost imperceptible curve in architectural elements, particularly in the shafts of Classical COLUMNS.

ESTHETIC, see AESTHETIC.

- ETCHING. The process of producing a design on a metal plate by use of acid or similar mordants. Also refers to a print made from an etched metal plate.
- EXPRESSIONISM. Strictly, German Expressionism. A MOVEMENT in the arts that originated in Germany just prior to World War I, em-

phasizing the subjective aspects of the artist and his subjects. By extension, any art of this type.

- FAUVISM. A turn-of-the-century MOVEMENT in France characterized by bright, flat zones of color. Similar to German Expression-ISM of the more representational sort (e.g., DIE BRÜCKE), except that it took a far more optimistic view of man and his circumstances.
- FENESTRATION. The arrangement of windows in a building. Sometimes the term is applied to the arrangement of all the openings windows, doors, and so on.
- FERROCONCRETE. Steel-reinforced concrete. That is, concrete reinforced by embedding steel mesh, nets, rods, or bars in the cement while it is wet.
- FLORENTINE RENAISSANCE. The period from the fourteenth to the sixteenth century in the city of Florence, the cradle and the jewel of the Italian RENAISSANCE.

FLYING BUTTRESS, see BUTTRESS.

- FOLK ART. Art and craft objects produced by untrained people as an expression of community life. Usually the craftsmen are anonymous and the objects relatively utilitarian.
- FRESCO. The term *fresco*, used alone, refers to what is known, strictly, as *buon fresco*—a painting made on wet plaster so that the pigments become incorporated into the plaster. *Fresco secco* is painting done on dry plaster so that the wall surface serves as a GROUND.
- FRONTALITY. In sculpture and figurative painting the term refers to deemphasis of the lateral aspects of things. In painting, generally, it refers to the arrangement of planes parallel to the canvas surface. With respect to modern art it has a less precise meaning, but suggests that the tangible, two-dimensional surface of the picture is emphasized.
- FRIEZE. The band between the cornice and the architrave in an ENTABLATURE. By extension, any richly ornamented band and,

further, any arrangement suggesting such a frieze.

- FUTURISM. An Italian MOVEMENT originating prior to World War I which hoped to glorify the dynamism of the machine age.
- GENRE. Normally the word is used to refer to pictures in which the subject matter is drawn from everyday life. It is also used in a more general sense to describe whole categories of subject matter. Thus, one may speak of "the landscape genre," "the stilllife genre," "the genre of figure painting," and so on.
- GEODESIC DOME. A building form, constructed of small, triangular MODULES, devised by Buckminster Fuller.
- GERMAN EXPRESSIONISM, SEE EXPRESSIONISM.
- GESSO. A mixture of plaster of Paris and glue used as a GROUND for painting.
- GLAZE. In painting, a PIGMENT (usually oil) applied in transparent layers. In CERAMICS, a vitreous coating applied before firing to seal the surface or used as decoration.
- GOLDEN AGE. Any age of high culture in a civilization. Most commonly, the term is applied to Athens under Pericles (495-429 B.C.) and to the BYZANTINE EMPIRE under Justinian (A.D. 527-565).
- GOLDEN SECTION OF GOLDEN MEAN. A ratio between the two dimensions of a plane figure or the two divisions of a line such that the shorter element is to the longer as the longer is to the whole.
- GOUACHE. Opaque rather than transparent WATERCOLOR. The medium is essentially the same as in transparent watercolor, except that the proportion of binder to PIG-MENT is greater and an inert pigment such as precipitated chalk has been added to increase the opacity of the paint.
- GRAPHIC. Literally, written, drawn, or engraved. In the arts the term refers, in a narrow sense, to drawing and printmaking. But it is also used in the more commonplace sense to describe something that is striking in its clarity.

GROIN VAULT, see VAULT.

GROUND. Usually, the surface to which paints are

applied. In ETCHING the term refers to the waxy coating used to cover the plate and prevent mordants from acting upon it.

- HAPPENING. A satiric act which takes place in a specially constructed or devised environment. Has both sculptural and theatrical aspects, but no permanent form is established. The "put-on" side of such an event is considered a vital part of its seriousness.
- HARD-EDGE PAINTING. Any painting style employing very clean, sharp edges and flat areas of color. Normally restricted in application to work done by artists active after 1950.
- HUE. The name of a color, such as red, blue, yellow (primaries); orange, green, violet (secondaries); and the intermediate (tertiary) colors.
- ICON. Literally, an image. Specifically, an image of a sacred person regarded as an object of veneration in the Eastern Church.
- ICONOCLAST. Image breaker. Originally the term was applied to the BYZANTINE ruler Leo III (680–740), who opposed the religious use of images. It has been extended to apply to anyone who actively questions generally accepted intellectual, ethical, or moral attitudes.
- ICONOGRAPHY. The study of images primarily in terms of their symbolic intentions. (The study of the deeper significance of content and its general importance is sometimes referred to as iconology.)
- ILLUMINATED MANUSCRIPT. A manuscript whose pages (and especially the initial letters) are decorated with silver, gold, and bright colors. Sometimes such manuscripts contain MINIATURES.
- ILLUSTRATION. Imagery that relates explicitly to something else—that serves to clarify or adorn an anecdote, literary work, description, event, etc.
- IMPASTO. The texture of paint applied in a thick, pasty form.
- IMPRESSIONISM. Specifically, French Impressionism. A MOVEMENT in painting that originated during the last third of the nineteenth century. It attempted to attain a sort of

ultimate NATURALISM by extending REAL-ISM beyond value relationships to an exact analysis of color. A typical Impressionist work is painted with short, brightly colored dabs of paint. The subject matter tends to be unproblematical and undramatic.

- INTAGLIO. A design sunk into a surface so that the impression it makes is in RELIEF. Signet rings are common examples, as are engraved plates.
- INTENSITY. The dullness or brightness of a color. (Not to be confused with VALUE, meaning the color's darkness or lightness.) Often referred to as chroma.
- INTERCOLUMNIATION. The space between COL-UMNS in a row of them.
- IONIC ORDER. The second major ORDER of Classical architecture. It is lighter than the DORIC and is distinguished by the scrolllike volute decoration of the capital. The shaft has separated flutes and a concaveconvex molding at its base. With the exception of those in Athenian buildings, Ionic COLUMNS usually rest on PLINTHS. The ENTABLATURE contains a banded architrave and a FRIEZE that is either plain or ornamented with a continuous RELIEF decoration.
- JUGENDSTIL. A German decorative style that parallels ART NOUVEAU.

KEYSTONE, see ARCH.

- KINETIC ART. Works of art that are designed to move, either in response to human presence (because of touch, electric-eye beams, etc.) or because they are mechanized.
- LITHOGRAPHY. A printing technique in which the image to be printed is drawn on a flat surface, as on Bavarian limestone or a sheet of zinc or aluminum. The process takes advantage of the antipathy of oil for water.
- LOCAL COLOR. The natural color of an object as seen under normal daylight.

LINTEL. A horizontal beam spanning an opening.

MAGIC REALISM. A style of painting that often overlaps with SURREALISM but is distinctive in that it involves a sharp, precisely detailed rendering of real things. There are actually two types: (1) that which brings prosaic things into unusual and disturbing juxtaposition, (2) a variety that depicts ordinary things with such abnormal clarity as to lend them extraordinary overtones.

- MANDORLA. An almond-shaped aureole or nimbus (sometimes called a glory) surrounding the figure of God, Christ, the Virgin Mary, or sometimes a saint.
- MANNERISM. A style in Italian art that developed between about 1520 and 1600.
- MEDIEVAL PERIOD, see MIDDLE AGES.
- MEDIUM. The vehicle or liquid with which PIG-MENT is mixed. In a more general sense, the material through which an artist expresses himself (e.g., paint, metal, wood, printmaking). In technical usage the term refers to the substance used to thin or otherwise modify the PIGMENT and its vehicle.
- METAPHYSICAL PAINTING. An Italian MOVEMENT in painting during the earlier part of the twentieth century. The strangely evocative pictures by Giorgio de Chirico formed the basis of the movement; his paintings also had a profound influence on SURREALIST imagery.
- METOPE. One of the panels between the TRI-GLYPHS in a DORIC FRIEZE. Often these are decorated with RELIEF sculpture.
- MIDDLE AGES. The period in Western history between, generally, A.D. 400 and 1300.
- MIMESIS. Literally, to imitate. Thus, the representation by illusion of the properties of the external world.
- MINIATURE. Any small image, but particularly a little picture illustrating an ILLUMINATED MANUSCRIPT.
- MINIMAL ART. Painting and sculpture that stresses the simplest color relationships and/ or most clearly geometric forms.
- MODELING. The forming of three-dimensional surfaces. Thus, the creation of the illusion of such surfaces within the two-dimensional confines of painting or drawing.
- MODULE. A given magnitude or unit in the measurements of a work of art or building. Thus, if one used a sixteen-inch module in designing a house, all dimensions would be some multiple of sixteen inches.

- MONOCHROMATIC. Consisting of variations of a single HUE.
- MOSAIC. The decoration of a surface by setting small pieces of stone or glass (called *tesserae*) into cement.
- MOVEMENT. A general cultural tendency, sometimes carried out by people known to one another but frequently a more diverse response to given stimuli. Thus, one can speak of "the IMPRESSIONIST movement," of a "Black Nationalist movement," or of a "youth movement."
- MULLION. A vertical bar used to section off the panes of a window.
- NABIS. A group of French painters active between 1889 and 1899. The most outstanding members were Pierre Bonnard and Edouard Vuillard.
- NAIVE ART. Works of art created by those without professional training in which a lack of sophistication is preserved as a positive value.
- NARTHEX. A porch adjacent to the front of a church and forming a vestibule. Usually it is colonnaded or ARCADED.
- NATURALISM. In literature the term corresponds to French REALISM in painting. In art, however, it usually signifies accuracy of transcription of nature. Harnett, Courbet, Manet, and Norman Rockwell are all naturalistic to some degree.
- NAVE. The major, central part of a church. It leads from the main entrance to the altar and is separated from the side aisles (if any) by piers and COLUMNS.
- NECKING. An indentation between the ECHINUS and shaft of a COLUMN.
- NEOCLASSICISM. The attempt in the eighteenth and nineteenth centuries to revive the ideals of the Greeks and Romans in French painting. By extension, any style based on the principles of Neoclassicism. The style attempts to attain perfection and harmony through prescribed limits.
- NEOIMPRESSIONISM. The style of painting devised by French painter Georges Seurat at the end of the nineteenth century. It involved a quasi-scientific method of applying color and a highly controlled system of drawing

and composition. Called Divisionism by its inventor. Other prominent Neoimpressionists were Charles Angrand, Henri Edmond Cross, and Paul Signac.

- NEOPLASTICISM. A type of NONOBJECTIVE painting that reduced form to horizontal and vertical movements and used only black, white, and the primary colors. Its principal practitioner was Piet Mondrian.
- NEOROMANTICISM. A painting style associated with and resembling the representational form of SURREALISM, but distinguished by its evocation of lyrical and nostalgic sentiment. The main artists are the brothers Eugene Berman and Leonid Berman (who signs his work "Leonid"), Christian Bérard, and Pavel Tchelitchew.
- NEUE SACHLICHKEIT. "The New Objectivity." A reaction against Expressionism which occurred in Germany during the post– World War I period. It is "objective" only in that it took a more realistic view of the physical world. Marked by a concern with social problems.

New Objectivity, see Neue Sachlichkeit.

- NONOBJECTIVE ART. NONREPRESENTATIONAL art.
- NONREPRESENTATIONAL ART. Works of art that make no attempt to produce illusions of reality.
- OGEE. A double or S-shaped curve. Also refers to the bulging form produced by two ogee curves that mirror one another and meet in a point (i.e., ogee arch).
- Op Art. "Optical art"—that is, works of art which depend for their interest on optical illusion, fugitive sensations, and other subjective visual phenomena.
- OPTICAL COLOR. The apparent color of an object as opposed to its LOCAL COLOR.
- ORDER. Any of the characteristic styles of Classical architecture determined by the particular kinds of ENTABLATURES and COLUMNS used. The three major orders are DORIC, IONIC, and CORINTHIAN. There are also, however, other types and also blends of elements referred to as Composite orders. Applied in broad usage to any systematic treatment of architectural form employing standard components.

- PALETTE. The surface on which a painter mixes his paints. More generally, the habitual set of colors used by a given artist or group.
- PASTEL. PIGMENTS mixed with gum and compressed into stick form for use as crayons. A work of art done with such pigments.
- PATINA. A greenish film that forms on copper or bronze through natural or artificial oxidation. Effects similar to this on other substances.
- PEDIMENT. In Classical architecture, the triangular space formed by the end of a building with a pitched roof.
- PERISTYLE. A continuous colonnade surrounding a building or a court.
- **PERSPECTIVE.** The common name for central projection, a scheme for representing threedimensional objects on a two-dimensional surface in terms of relative magnitude.

PIER BUTTRESS, see BUTTRESS.

- PIGMENT. A substance that has been ground into a fine powder and is used to color paints or dyes.
- PILASTER. A flat, rectangular projection which resembles an ENGAGED COLUMN.
- PLINTH. A block serving as a pedestal for a column or statue.
- POINTILLISM. The application of pigment in small dots rather than by means of the usual brushstroke. Employed by the NEO-IMPRESSIONISTS but also used by other artists.
- POLYPTYCH. A many-paneled altarpiece or devotional picture, sometimes hinged so that it can be folded up.
- POP ART. Serious painting using elements from commercial illustration, cartoons, signs, and ordinary mass-produced objects as subject matter.
- POSTIMPRESSIONISM. A catchall term for the styles employed by painters influenced by IM-PRESSIONISM who modified it into more personal modes of expression. The painters most frequently cited as examples of Postimpressionists are Cézanne, Renoir, Van Gogh, and Gauguin.
- POTTERY. Objects of clay that have been hardened by firing.
- PRECISIONISM. A MOVEMENT in American art that began in the 1920s, typified by the work of

Charles Sheeler and Georgia O'Keeffe. It combines realistic subject matter with extreme formal control.

- PRIMITIVE ART. A term becoming less common because of overuse and pejorative connotations. It has the following meanings, more or less in this order: (1) art produced by tribal cultures; (2) art created by amateur artists in which unsophisticated vision and lack of technical skill have, for one reason or another, come to be counted as virtues; (3) art produced by Netherlandish and Italian painters active before 1500.
- PRINT. A work of art produced in multiple copies by hand methods and printed by the artist himself or under his direct supervision.
- RAKING CORNICE. The molding edge on the slanting sides of a pediment.
- REALISM. A nineteenth-century MOVEMENT in painting which stressed matter-of-fact descriptions of actual things. Frequently, as in Courbet (who coined the name of the style), Realism focused on the squalid and depressing. But Manet's work shows that ignoble themes are not fundamental to the manner. It is really a nonsentimental, rather broad version of NATURALISM.
- REFORMATION. A religious revolution in western Europe during the sixteenth century. It began as a reform movement within the Roman Catholic Church but evolved into the doctrines of Protestantism. Its outstanding representatives are Martin Luther and John Calvin.
- REFRACTION. The bending of a light ray or wave of energy as it passes through a substance.
- REGIONALISM. The name given to the work of certain American painters prominent in the 1930s. Their works tended to represent specific regions and to portray common people in everyday activities. Notable among these are Thomas Hart Benton, Grant Wood, Edward Hopper, and John Steuart Curry.
- RELIEF. In sculpture, the projection of a form from a background to which it is attached. In high relief the figures stand far out from the base. In bas-relief (or low relief) they are shallow.

- RENAISSANCE. Usually signifies the rebirth of art and humane letters (as opposed to divine letters) during the fourteenth and fifteenth centuries, particularly in Italy. Early Renaissance covers the period from about 1420 to 1500 and High Renaissance from about 1500 to 1527 (the date of the sack of Rome by the Holy Roman Emperor Charles V).
- REPOUSSÉ. The forming of a design in metal by working it from the back and leaving the impression on the face. See also CHASE.
- **REPRODUCTION.** The production of multiple images of a work of art by photomechanical processes. (Compare PRINT.)
- ROMANTICISM. A MOVEMENT in painting that first appeared in France during the early nineteenth century. It attempted to express the entirety of human experience, both real and imagined. By extension, applied to any work of art expressing interests thought similar to or characteristic of Romanticism.
- ROSE WINDOWS. The large circular windows of stained glass found in Gothic cathedrals.

SARCOPHAGUS. A stone coffin.

- SCHOOL. A word with a great variety of meanings, all of them based on the assumption of identifiable similarities among the works of various artists who (1) studied with the same master, (2) imitate the same master, (3) work together as a group, (4) express the same interests in their works, (5) lived in the same place and time, (6) have the same country of origin. Thus: the School of Raphael (1 and 2); the French Impressionist School (3); the Pop Art School (4); the School of Florence (5); the Italian School, as contrasted with the French School (6).
- SCULPTURE IN THE ROUND. Freestanding statues, such as Michelangelo's *David*, as opposed to RELIEF sculpture.
- SGRAFFITO. A design produced by scratching through one layer of material into another of a contrasting color. Frequently used in pottery decoration, but also employed by painters and sculptors.
- SHAFT. The long part of a COLUMN between the base and capital.

- SLIP. Clay which has been thinned to the consistency of cream. It can be poured into molds of plaster and thereby cast into pots or can be used as a paint to ornament CERAMIC pieces.
- SOCIAL REALISM. A general term used to describe various styles in art (Courbet's, Daumier's, Grosz's, e.g.) which emphasize the contemporary scene, usually from a left-wing point of view and always with a strong thematic emphasis on the pressures of society on human beings.
- SPANDREL. The triangular space between the curves of two adjacent Arches.
- STEEL-REINFORCED CONCRETE, SEE FERROCON-CRETE.
- STEREOTYPE. In common usage, a standardized mental picture that represents things in a false and oversimplified manner. (For example, the stereotype of women as poor drivers or of Negroes as lazy and superstitious.) In art the term refers to a form that is repeated mechanically, without real thought. In printing it refers to identical relief printing surfaces produced by taking a mold from a master surface and then casting copies. These copies are called stereotypes.
- DE STIJL. A Dutch magazine of the early twentieth century devoted to NEOPLASTICISM. (In Dutch, the title means the Style.) The term is used to refer to the ideas advocated by the magazine; they had a marked influence on the BAUHAUS and on commercial design generally.
- stucco. A finish for the exterior walls of a structure, usually composed of cement, sand, and lime.
- SUPREMATISM. A NONREPRESENTATIONAL style devised by Kasimir Malevich in the early twentieth century. It amounts to a kind of Russian NEOPLASTICISM.
- SURREALISM. The post-World War I MOVEMENT which drew inspiration from Freudian psychology and extended the arbitrary irrationality of DADAISM into a doctrinaire exploration of the unconscious.
- TAPESTRY. A heavy, handmade textile in which the threads (usually the weft or horizontal

threads) are woven to create a picture or abstract pattern.

- TEMPERA. Paint using egg as the binder for the pigment. Technically called egg tempera.
- TERRA-COTTA. A brownish-orange earthenware used for sculpture and pottery or as a building material. Sometimes it is GLAZED, sometimes not.
- TEXTURE. The tangible quality of a surface—that is, its smoothness, roughness, slickness, softness. The simulation of such qualities by illusion in drawing and painting.
- THRUST. The outward force exerted by the weight of an ARCH or VAULT.
- TRACERY. Stone forms that decorate Gothic windows and hold the glass in place.
- TRANSEPT. Either of the arms of a cruciform church that extend at right angles to the NAVE.
- TRIFORIUM GALLERY. In a cathedral, the area above the aisle and between the NAVE ARCHES and the CLERESTORY.
- TRIGLYPH. In the DORIC ORDER, a panel of three projecting members separating the METOPES in the FRIEZE.
- TRIPTYCH. A three-panel altarpiece or devotional picture, usually so designed that the central panel is twice as wide as the other two, with the latter hinged so that they can be folded over to cover the central one.

- TYMPANUM. The recessed face of a PEDIMENT or, in medieval cathedrals and other buildings, the space above a LINTEL and within an ARCH, often containing RELIEF sculpture.
- VALUE. The relative lightness or darkness of a color.
- VAULT. Any roof constructed on the ARCH principle. A barrel vault is a continuous row of arches joined to one another. A groin vault consists of two barrel vaults intersecting each other at right angles. A dome is a hemispherical vault—an arch turned on a central upright axis. Vaults may be of masonry, brick, or concrete.
- VOUSSOIR, see ARCH.
- WARM COLOR. Red and the hues that approach red, orange, and yellow. Sometimes yellowgreen is considered a warm color.
- WATERCOLOR. Strictly, any pigment mixed with water, but usually signifying transparent watercolor in which the binder is gum arabic.
- woodcut. A relief printing surface carved from the plank grain of a piece of wood. The image printed from such a surface.
- wood ENGRAVING. A relief printing surface carved from the end grain of a piece of wood. The image printed from such a surface.

Guide to the pronunciation of artists' names

Correct pronunciation of foreign names has very little to do with artistic understanding per se, but knowing the sound of a name is often helpful in communication. Therefore, I have included the following guide, which contains all names of artists whose work is reproduced in this text with the exception of those pronounced in the customary American way.¹

The guide entails a simplified approach, aiming at *acceptable* pronunciations rather than absolutely perfect ones. The subtleties of variation among tongues make it impossible to illustrate precise discriminations without the use of language records and specialized alphabets and markings. In using the guide, keep in mind the following:

Italicized syllables are to be stressed.

An x indicates a gutteral. (H pronounced while clearing the throat approximates this sound.)

The sounds \ddot{o} and \ddot{u} have no equivalent in English; to say them, shape your lips to say e as in "evil" and sound the o or u.

The French nasal sounds (*an*, *in*, *on*, *un*) can only be conveyed orally, but the general idea is to sound the letters through your nose. Words appearing in parentheses repeat the sound just given.

Vowel sounds are indicated as follows:

a is as in man	eye is as in mine
ay is as in lane	oe is as in oar
ah is as in dart	oo is as in boor
e is as in Ben	o is as in box
ee and ea are as	uh is as in mud
in keen or lean	u is as in use
<i>i</i> is as in <i>in</i>	

ANGELICO, FRA Ahn-djay-li-coe, Frah

ANUSZKIEWICZ, RICHARD Ann-uh-skay-vitch (Not An-noose-kuh-vitz)

- BOCCIONI, UMBERTO Baht (bought)-tshee-oe-nee, Oom-*bar* (bear)-toe
- BOTTICELLI, SANDRO Baht (bought)-tea-tshel-ee, Sand-roe

BOUGUEREAU, WILLIAM Boo-guh-roe, Vill-yam

BRAQUE, GEORGES Brack, Zhor-zh (Often, by error, *brock*.)

BRONZINO, ANGELO Bron-dzee-no, Ahn-djay-loe

BRUEGEL, PIETER Brü-gl, Pea-tr (Often spelled Brueghel, as the artist did until 1559, when he dropped the h.)

CAMPIN, ROBERT Can (French nasal)-pin (French nasal), Rahb-air

CANALETTO, ANTONIO Ca-nal-et-toe, Ahn-toe-nee-oh

- CARAVAGGIO Cahr-a-vadj-gee-oe
- CARPI, UGO DA Cahr-pea, oo-goe da

CÉZANNE, PAUL Say-zann, Pol (doll)

CHARDIN, JEAN-BAPTISTE Shar-din (French nasal), Zhahn Bat-tea-st

CIMABUE Tshee-ma-boo-ay

CORBUSIER, LE Cor-boos-ee-ay, Le (Real name: Charles Edouard Jeanneret)

COROT, JEAN-BAPTISTE CAMILLE Cah-roe, Zhahn Bat-tea-st Ca-mee-y

COURBET, GUSTAVE Coor-bay, Güss-tav DALI, SALVADOR *Dah*-lee, Sal-vah-*dor* (more) DAUMIER, HONORÉ Doe-mee-ay, Oe-nah-ray DAVID, JACQUES-LOUIS Da-vid, Zhahk Loo-ee

DEGAS, EDGAR Duhg-gah, Ed-gar

DELACROIX, EUGÈNE Duh-la-crwa, Oe-zhen

DUCHAMP, MARCEL Dü-chan (French nasal), Mar-sel

DÜRER, ALBRECHT Dü-rur, Al-brext

EYCK, JAN VAN Ay-ick, Yan van GABO, NAUM Ga-boe, Na-oom GÉRICAULT, THÉODORE Zhay-ree-coe, Tay-oe-dor (more) GIORGIONE Djior-dji-oe-nay GIOTTO Djiot-toe GOGH, VINCENT VAN Xohx, Vinn-cent van (But in English, usually van goe) GOYA, FRANCISCO Go (gosh)-ya, Fran-this-coe GRECO, EL Grek-coe, Ell GROSZ, GEORGE Groes (grow), Zhorzh GRÜNEWALD, MATTHIAS Grü-nay-valt, Mat-tea-as GUARDI, FRANCESCO Goo-ahr(are)-dee, Franchess-coe HOLBEIN, HANS Hoel (hole)-beyon (mine), Hans HOOCH, PIETER DE HOe-x, Pea-tr duh KANDINSKY, WASSILY Kan-din-skee, Vass-see-lee KIENHOLZ, EDWARD Keyen (mine)-hoelts (bolts) KIRCHNER, ERNST LUDWIG Kir-xnr, Air-nst Loodvig KLEE, PAUL Klay, Pol (doll) LA TOUR, GEORGES DE La-toor, Zhorzh duh LÉGER, FERNAND Lay-zhay, Fair-nan (French nasal) LEONARDO DA VINCI Lay-oe-nar-doe da Vinntshee LICHTENSTEIN, ROY *Licked*-en-steyen (wine) LORRAIN, CLAUDE LOE-rin (French nasal), K-load (Real name: Claude Gellée) MALEVICH, KASIMIR Mal-ay-vitch, Kah-si-mir MANET, EDOUARD Ma-ne (like net without the t), Ay-dwar MANTEGNA, ANDREA Man-ten-ya, Ahn-dray-ah MARC, FRANZ Mahrk, Frahnts MASACCIO MA-zatsh (watch)-shee-oe MATISSE, HENRI Mah-tea-ss, An (French nasal)ree METSYS, QUENTIN Met-sees, Kwen-tn MICHELANGELO Me-kell-an-djay-loe MIES VAN DER ROHE, LUDWIG Mees (lease) van duhr Roe-heh, Lood-vig MIRO, JOAN Mi (mist)-roe, Xo-ahn MONET, CLAUDE Mo (motto)-ne (Like net without the t), K-load MORISOT, BERTHE Mo (motto)-ree-zo, Ber (berry)-t NOLDE, EMILE Noel-day, Ay-meal

PERUGINO Pay-roo-gee-noe

PICASSO, PABLO Pea-cahs-so, Pah-bloe

POUSSIN, NICOLAS Poohs-sin (French nasal), Neecoel (coal)-ah

PRAXITELES Prak-sit-uhl-eez

PRUD'HON, PIERRE-PAUL Prü-don (French nasal), Pea-air Pol (doll)

RAPHAEL Rah-fa-ell (Not Ray-fay-ell)

- REMBRANDT VAN RIJN *Rem*-brant van Rheyen (Rhine)
- RENOIR, PIERRE-AUGUSTE Ren-wahr (very soft r), Pea-air Oe (oh)-güst
- RODIN, AUGUSTE Rod (not *road*)-in (French nasal), Oe (oh)-güst

ROUSSEAU, HENRI ROOSS-ssoe (so), Ahn-ree

RUBENS, PETER PAUL Roo-bns, Pay-tr Pah-ool

SEURAT, GEORGES Ssö-rah, Zhorzh

STEEN, JAN Stayn (stain), Yan

TINTORETTO Tin-toe-ret-toe

titian *Ti*-shn

velázquez, diego Vayl(veil)-ath-keth, Deeay-goe

VERMEER, JAN Ver (very)-may-r, Yan

WATTEAU, ANTOINE Vat-toe, An (French nasal)twahn (But usually Anglicized to Waht-toe in the United States.)

ZURBARÁN, FRANCISCO DE Thoor-bah-ran, Franthis (thistle)-coe day

1. For a comprehensive list see Gustave E. Kaltenbach, *Dictionary of Pronunciation of Artists' Names* (The Art Institute of Chicago, 1965), a book which I have found indispensable in compiling this brief list.

Bibliography

The following books have been selected because they are (1) of general interest and intelligible to the layman, (2) generally available in college, university, and public libraries, and (3) usually contain bibliographies directing readers to more specialized works.

I. General

- ARNHEIM, RUDOLPH. Art and Visual Perception. Berkeley and Los Angeles: University of California Press, 1954. A classic among writings on the psychology of art.
- ELSEN, ALBERT E. The Purposes of Art: An Introduction to the History and Appreciation of Art. 2nd ed. New York: Holt, Rinehart and Winston, 1967. An art appreciation text written from the point of view of an art historian. The stress is on ways in which different visual forms reveal select examples of thematic content.
- FAULKNER, RAY, and ZIEGFELD, EDWIN. Art Today: An Introduction to the Visual Arts. 5th ed. rev. New York: Holt, Rinehart and Winston, 1969. A very readable and comprehensive treatment of the visual arts, emphasizing

the ways in which they satisfy human needs both aesthetic and practical.

- FELDMAN, EDMUND BURKE. Varieties of Visual Experience: Art as Image and Idea. 2nd ed. Englewood Cliffs, N.J.: Prentice-Hall, 1971. New York: Abrams, 1971. An extremely thorough and all-encompassing text. Examines art in terms of its various functions, styles, and media. Contains a very good section on art criticism in theory and practice.
- FLEMING, WILLIAM. Arts and Ideas. Rev. ed. New York: Holt, Rinehart and Winston, 1968. Considers the histories of art, music, and literature in the light of the dominant ideas of the historical epochs by focusing on exemplary locales and works.
- GILSON, ETIENNE HENRY. *Painting and Reality.* 2nd ed. Cleveland and New York: World, 1967. A prominent Christian philosopher and historian attempts to work out the relationship between painting and being. Interesting less for the author's theories than for all the other things he touches on during the course of his discussion.
- GOMBRICH, ERNST H. Art and Illusion. New York: Pantheon, 1960. A masterful work on the psychology of representation in the visual arts. Erudite and entertaining.
- HUYGHE, RENÉ. Ideas and Images in World Art: Dialogue with the Visible. Translated by Norbert Guterman. New York: Abrams, 1959. An incredibly suave presentation of the artistic expression of all ages and peoples by the former curator of painting in the Louvre.
- PANOFSKY, ERWIN. Meaning in the Visual Arts. Garden City, N.Y.: Anchor Books, 1955. A collection of essays by a great iconographer, written over a period of more than thirty years and covering a wide variety of subjects.
- II. Art history
- I. GENERAL
- CLARK, SIR KENNETH. The Nude: A Study in Ideal Form. New York: Pantheon, 1956. One of

the world's foremost art historians explores the tradition of the nude in sculpture and painting from ancient to modern times. Beautifully written and comprehensible to the layman.

- GARDNER, HELEN. Art Throughout the Ages. 5th ed., revised by Horst de la Croix and Richard G. Tansey. New York: Harcourt, Brace and Jovanovich, 1970. A superb revision of the most famous of all American art history texts (first published in 1926), far more scholarly than earlier editions of the work. However, the editors were forced to sacrifice the discussions of Asian, primitive, and Pre-Columbian art, which the 1936, 1948, and 1959 versions retained.
- GOMBRICH, ERNST H. The Story of Art. 12th ed. rev. and enl. London: Phaidon, 1972. Written for English high school students, this is an incredibly good brief introduction to the history of art.
- HAUSER, ARNOLD. The Social History of Art. Translated in collaboration with the author by Stanley Godman. 2 vols. New York: Knopf, 1951. A synoptic history of art and literature from a sociological slant. Of amazing breadth, the work is rather heavy going for the unsophisticated, and one must be wary of the author's biases. But it is full of stimulating ideas.
- JANSON, H. W. The History of Art: A Survey of the Major Visual Arts from the Dawn of History to the Present Day. Rev. and enl. ed. Englewood Cliffs, N.J.: Prentice-Hall, 1969. New York: Abrams, 1969. An excellent survey of the history of Western art. Highly informed, easy to read, and beautifully illustrated.
- MALRAUX, ANDRÉ. The Voices of Silence. New York: Doubleday, 1953. A famous and highly effective work by the French novelist, scholar, and political thinker.
- PEVSNER, NIKOLAUS. An Outline of European Architecture. 6th (Jubilee) ed. rev. Baltimore: Penguin Books, 1960. The best overview of the history of architecture in Europe.
- sewall, JOHN IVES. A History of Western Art. Rev. ed. New York: Holt, Rinehart and Winston, 1961. A well-informed but rather dry

text that does an especially good job with architecture—usually given rather short shrift in surveys of art history. The author is antagonistic to modern art, and in this revision John Canaday has been given the task of dealing with the late nineteenth and the twentieth century.

2. PREHISTORIC

GRAZIOSI, PAOLO. Paleolithic Art. New York: McGraw-Hill, 1960.

3. AFRICAN AND PRE-COLUMBIAN AMERICAN

- KUBLER, GEORGE. The Art and Architecture of Ancient America. ("Pelican History of Art.") Baltimore: Penguin Books, 1962.
- LOTHROP, S. K.; FOSHAG, W. E.; and MAHLER, J. Pre-Columbian Art. London: Phaidon, 1957.
- WINGERT, PAUL S. The Sculpture of Negro Africa. New York: Columbia University Press, 1959.

4. EGYPTIAN

MICHALOWSKI, KAZIMIERZ. Art of Ancient Egypt. New York: Abrams, 1969.

5. ANCIENT NEAR EASTERN

LLOYD, SETON. The Art of the Ancient Near East. New York: Praeger, 1961.

6. AEGEAN

DEMARGNE, PIERRE. Aegean Art: The Origins of Greek Art. Translated by Stuart Gilbert and James Emmons. New York: Golden Press, 1964.

7. GREEK

ARIAS, PAOLO E., and HIRMER, MAX. A History of 1000 Years of Greek Vase Painting. New York: Abrams, 1963.

- BOARDMAN, JOHN. Greek Art. New York: Praeger, 1964.
- LAWRENCE, ARNOLD. Greek Architecture. ("Pelican History of Art.") Baltimore: Penguin Books, 1957.
- LULLIES, REINHARD, and HIRMER, MAX. Greek Sculpture. New York: Abrams, 1960.

8. ETRUSCAN

RICHARDSON, EMELINE. The Etruscans: Their Art and Civilization. Chicago: University of Chicago Press, 1964.

9. ROMAN

WHEELER, SIR R. E. MORTIMER. Roman Art and Architecture. New York: Praeger, 1964.

IO. EARLY CHRISTIAN AND BYZANTINE

- GRABAR, ANDRÉ. The Beginnings of Christian Art, 200–395. Translated by Stuart Gilbert and James Emmons. London: Thames and Hudson, 1967.
- MOREY, CHARLES RUFUS. Christian Art. New York: Longmans, Green, 1935.
- VOLBACH, WOLFGANG F., and HIRMER, MAX. Early Christian Art. New York: Abrams, 1961.

II. MIDDLE AGES

- BECKWITH, JOHN. Early Medieval Art. New York: Praeger, 1964.
- FOCILLON, HENRI. The Art of the West in the Middle Ages. Edited by Jean Bony and translated by Donald King. 2 vols. New York: Phaidon, 1963.
- FRANKL, PAUL. The Gothic. Princeton, N. J.: Princeton University Press, 1960.
 - ———. Gothic Architecture. Translated by Dieter Pevsner. ("Pelican History of Art.") Baltimore: Penguin Books, 1962.
- MÂLE, EMILE. The Gothic Image: Religious Art in France of the Thirteenth Century. Translated by Dora Nussey. New York: Harper, 1958.

12. RENAISSANCE (LATE GOTHIC)

- PANOFSKY, ERWIN. Early Netherlandish Painting. 2 vols. Cambridge, Mass.: Harvard University Press, 1954.
- WHITE, JOHN. Art and Architecture in Italy, 1250– 1400. ("Pelican History of Art.") Baltimore: Penguin Books, 1966.

13. RENAISSANCE (GENERAL)

- HARTT, FREDERICK. History of Italian Renaissance Art: Painting, Sculpture, Architecture. Englewood Cliffs, N.J.: Prentice-Hall, 1970. New York: Abrams, 1970.
- 14. RENAISSANCE (EARLY)
- BURCKHARDT, JAKOB C. The Civilization of the Renaissance in Italy. Translated by S. G. Middlemore. 3rd rev. ed. London: Phaidon, 1963. A genuine classic in the history of art, first published in 1860.
- DEWALD, ERNEST T. Italian Painting, 1200–1600. New York: Holt, Rinehart and Winston, 1961.

15. RENAISSANCE (HIGH)

FREEDBERG, SYDNEY J. Painting of the High Renaissance in Rome and Florence. 2 vols. Cambridge, Mass.: Harvard University Press, 1961.

16. RENAISSANCE (NORTHERN)

- BENESCH, OTTO. The Art of the Renaissance in Northern Europe. Rev. ed. London: Phaidon, 1965.
- STECHOW, WOLFGANG. Northern Renaissance Art: Sources and Documents in the History of Art. Englewood Cliffs, N.J.: Prentice-Hall, 1966.
- **I7. MANNERIST**
- BOSQUET, JACQUES. Mannerism, the Painting and Style of the Late Renaissance. Translated by S. W. Taylor. New York: Braziller, 1964.

WÜRTENBERGER, FRANZSEPP. Mannerism, the European Style of the Sixteenth Century. Translated by Michael Heron. New York: Holt, Rinehart and Winston, 1963.

18. BAROQUE

- BLUNT, SIR ANTHONY. Art and Architecture in France, 1500–1700. ("Pelican History of Art.") Baltimore: Penguin Books, 1957.
- MILLON, HENRY A. Baroque and Rococo Architecture. New York: Braziller, 1961.
- ROSENBERG, JAKOB; SLIVE, SEYMOUR; and TER KUILE, E. H. Dutch Art and Architecture, 1600– 1800. ("Pelican History of Art.") Baltimore: Penguin Books, 1966.
- STECHOW, WOLFGANG. Rubens and the Classical Tradition. Cambridge, Mass.: Oberlin College, Harvard University Press, 1968.
- WATERHOUSE, ELLIS K. Painting in Britain, 1530– 1790. 2nd ed. ("Pelican History of Art.") Baltimore: Penguin Books, 1962.
- WITTKOWER, RUDOLF. Art and Architecture in Italy, 1600–1750. ("Pelican History of Art.") Baltimore: Penguin Books, 1958.

19. MODERN

- ARNASON, H. H. History of Modern Art: Painting, Sculpture, Architecture. Englewood Cliffs, N. J.: Prentice-Hall, 1968. New York: Abrams, 1968.
- CANADAY, JOHN. Mainstreams of Modern Art. New York: Holt, Rinehart and Winston, 1959. Unlike most texts on modern art, this one gives a good deal of attention to academic painting as the background for the development of modern styles.
- HAMILTON, GEORGE HEARD. 19th and 20th Century Art: Painting, Sculpture, Architecture. Englewood Cliffs, N.J.: Prentice-Hall, 1970. New York: Abrams, 1970.

20. AMERICAN

LARKIN, OLIVER W. Art and Life in America. New York: Holt, Rinehart and Winston, 1964. MENDELOWITZ, DANIEL M. A History of American

BIBLIOGRAPHY 337

Art. New York: Holt, Rinehart and Winston, 1960.

MCLANATHAN, RICHARD. The American Tradition in the Arts. New York: Harcourt, Brace and Jovanovich, 1968.

21. ASIAN

- ALEX, WILLIAM. Japanese Architecture. New York: Braziller, 1963.
- LEE, SHERMAN. A History of Far Eastern Art. New York: Abrams, 1964.
- ROWLAND, BENJAMIN. The Art and Architecture of India: Buddhist, Hindu, Jain. ("Pelican History of Art.") Baltimore: Penguin Books, 1953.
- SICKMAN, LAURENCE and SOPER, ALEXANDER. The Art and Architecture of China. 2nd ed. ("Pelican History of Art.") Baltimore: Penguin Books, 1960.
- YASHIRO, YUKIO. 2000 Years of Japanese Art. New York: Abrams, 1958. A beautiful book, but almost exclusively devoted to painting.

III. Color theory

- BIRREN, FABER. Color, Form, and Space. New York: Reinhold, 1961.
- ITTEN, JOHANNES. *The Art of Color*. New York: Reinhold, 1961.
- MAERZ, A., and PAUL, M. REA. A Dictionary of Color. New York: McGraw-Hill, 1950.

IV. Ceramics

- LAKOFSKY, CHARLES. *Pottery*. Dubuque, Iowa: William C. Brown, 1968.
- NELSON, GLEN. Ceramics. 2nd ed. New York: Holt, Rinehart and Winston, 1966.

V. Commercial art and cartooning

- BECKER, STEPHEN. Comic Art in America. New York: Simon and Schuster, 1959.
- BRUNNER, FELIX. A Handbook of Graphic Reproduction Processes. New York: Hastings, 1962.

COUPERIE, PIERRE, and HORN, MAURICE C. A

History of the Comic Strip. Translated by Eileen E. Hennessy. New York: Crown, 1968.

NELSON, ROY P., and FERRIS, BYRON. Fell's Guide to Commercial Art. New York: Frederick Fell, 1966. Contains an extensive bibliography.

VI. Drawing

- BRIDGMAN, GEORGE. Life Drawing. New York: Dover, 1970. An old standby.
- MENDELOWITZ, DANIEL M. Drawing. New York: Holt, Rinehart and Winston, 1966. Very complete, covering all media and techniques as well as the history of drawing.
- NICOLAIDES, KIMON. The Natural Way to Draw. Boston: Houghton Mifflin, 1941. A complete drawing course from a rather Expressionistic point of departure.
- WATSON, ERNEST W. How to Use Creative Perspective. New York: Reinhold, 1955.

VII. Film

- SPOTTISWOODE, RAYMOND. Film and Its Techniques. Berkeley and Los Angeles: University of California Press, 1966.
- WHITAKER, ROD. The Language of Film. Englewood Cliffs, N. J.: Prentice-Hall, 1970.

VIII. Jewelry

- GRANSTROM, K. E. Creating with Metal. New York: Reinhold, 1968.
- MORTON, PHILIP G. Contemporary Jewelry: A Studio Handbook. New York: Holt, Rinehart and Winston, 1970.

IX. Painting

DOERNER, MAX. The Materials of the Artist and Their Use in Painting. Translated by Eugen Neuhaus. Rev. ed. New York: Harcourt, Brace, 1949. The classic in the field. Very scholarly and extremely historical in its approach.

- MAYER, RALPH. The Artist's Handbook of Materials and Techniques. 3rd ed. rev. New York: Viking, 1970. The most popular of the technical manuals. It contains an extensive bibliography.
- MAROGER, JACQUES. The Secret Formulas and Techniques of the Masters. Translated by Eleanor Beckham. New York: Studio Publications, 1948.

X. Photography

- GERNSHEIM, HELMUT, and GERNSHEIM, ALISON. Concise History of Photography. New York: Grosset and Dunlap, 1965.
- NEWHALL, BEAUMONT, and NEWHALL, N. W. Masters of Photography. New York: Braziller, 1958.
- ZIM, HERBERT S., and BURNETT, R. WILL. Photography. New York: Simon and Schuster, 1956.

XI. Printmaking

- BIEGELEISEN, J. I. Screen Printing. New York: Watson-Guptill, 1971.
- HELLER, JULES. *Printmaking Today*. New York: Holt, Rinehart and Winston, 1958.
- PETERDI, GABOR. Printmaking: Methods Old and

New. New York: Macmillan, 1959.

ROTHENSTEIN, MICHAEL. Relief Printing. New York: Watson-Guptill, 1970.

XII. Sculpture

- MILLS, JOHN W. The Technique of Sculpture. New York: Reinhold, 1965.
- SELZ, JEAN. Modern Sculpture, Origins and Evolution. Translated by Annette Michelson. New York: Braziller, 1963.

XIII. Textiles

- ALBERS, ANNI. On Weaving. Middletown, Conn.: Wesleyan University Press, 1965.
- JOHNSTON, MEDA PARKER, and KAUFMAN, GLEN. Design on Fabrics. New York: Reinhold, 1967.
- KREVITSKY, NIK. Batik: Art and Craft. Rev. ed. New York: Reinhold, 1967.

XIV. Wood

- ROTTGER, ERNST. Creative Wood Design. New York: Reinhold, 1961.
- WILLCOX, DONALD. Wood Design. New York: Watson-Guptill, 1968.

Index

Page numbers are in roman type. Figure numbers of black-and-white illustrations are in *italics*. Colorplates are specifically so designated. Names of artists whose works are discussed are in CAPI-TALS. Titles of works of art are in *italics*.

Abstract Expressionism, 251-53, 255 Abstraction, 164, 190, 222, 251-53, 267 Abstraction and Empathy (Worringer), 222 Abstract Painting, Blue (Reinhardt), 142 Acropolis, Athens, 296 Acrylic paints, 264 Adam and Eve (Dürer), 210, 212, 274; 258, 336; (Rembrandt), 212, 275; 259 ADAMS, NEAL, 139; Green Lantern, 139; 166 African art, 55, 236, 238, 292 Afterimage, 120, 127 After the Hunt (Harnett), 19, 105-6, 107, 109, 223; 5, 144 ALBRIGHT, IVAN LE LORRAINE, 92, 254; Into the World Came a Soul Called Ida, 92; 122 Alien (Jones), 111 Alla prima, 262–63 Allegory, 171 All Things Do Live in the Three (Anuszkiewicz), 131; colorplate 11 Alps, Glen, 272 American Gothic (Wood), 185; 226 Analogous hues, 112 Anatomist (Baskin), 271, 272; 332

Andersen, Hans Christian, 25

- ANDERSON, DAN, 289, 290; Better Idea Cup, 350 ANGELICO, FRA, 174, 175; Annunciation, 174;
- 209 Annunciation (Angelico), 174; 209; (Tintoretto), 174; 210
- ANUSZKIEWICZ, RICHARD, 131; All Things Do Live in the Three, 131; colorplate 11
- Aphrodite of Cyrene, 71; 84
- Aphrodite of Knidos (Praxiteles), 69, 71; 82
- Apparition of a Face and Fruit Dish on a Beach (Dali), 92, 94, 221, 249; 123, 281, 314
- Aqueducts, Roman, 299-300; Segovia, 299; 359
- Aragon, Louis, 247; "Suicide," 247
- Are I (Michael Smith), 346
- Arches, 298-99, 301, 304; 367
- Archetype I: "The Great Gatsby" (Richardson); 275; 338
- Architecture, 295–314; Classical, 296–300; medieval, 301–6; modern, 306–14
- "Arcosanti," project for (Soleri), 313; 376
- Aristocracy, 47, 49
- Arp, Hans, 251
- Art: appreciation of, 13, 14, 15; definitions of, 15-24
- Astigmatism, 29; 20
- At the Stroke of Midnight (Steranko), 110
- Augustus, 45
- Autumn Rhythm (Pollock), 251-53; 316
- Avenging Angel (Michelangelo), 37-38; 37
- Back Seat, Dodge '38 (Kienholz), 19, 294; 6
- Bacon, Francis, 255
- Baroque art, 206-13, 216, 250, 306
- Barzun, Jacques, 227
- Basket of Apples (Cézanne), 185–88, 235; 227, 296; scheme of, 228
- BASKIN, LEONARD, 271, 272; Anatomist, 271, 272; 332
- Baths of Caracalla, Rome, 300
- Beckmann, Max, 253
- Beethoven, Ludwig van, 243
- Belisarius, 43
- Benday process, 19, 285
- Better Idea Cup (Anderson), 350
- Bible, concealed meanings in, 42
- Birth of Venus (Botticelli), 71, 207–9, 257–58; 85, 253, 320
- BLADEN, RONALD, 239, 289; X, 239, 289; 304
- Blaue Reiter, Der (The Blue Rider), 243-44
- BOCCIONI, UMBERTO, 253–54, 292; Unique Forms of Continuity in Space, 253, 292; 319
- Boime, Albert, 200
- Bonnard, Pierre, 255

- BOTTICELLI, SANDRO, 49, 71, 207–9, 257–58; Birth of Venus, 71, 207–9, 257–58; 85, 253, 320; Madonna of the Pomegranate, 49, 258; 52
- BOUGUEREAU, ADOLPHE WILLIAM, 74, 75; Nymphs and Satyr, 74; 88
- Bozzetto, 287
- Brahms, Johannes, 243
- Brancusi, Constantine, 255
- BRANDT, BILL: Nude, 34–35; 28
- BRAQUE, GEORGES, 164, 203, 205; Man with a Guitar, 252
- Brattata (Lichtenstein), 19, 198-201; 8, 241
- Breton, André, 249
- Bride Stripped Bare by Her Bachelors, Even (Duchamp), 247; 313
- Bridge and Castle of St. Angelo with the Cupola of St. Peter's (Corot), 124; 155, 199
- Bronze casting, 292, 294; diagram, 354
- BRONZINO, AGNOLO, 171; Exposure of Luxury, 171; 206
- Brücke, Die (The Bridge), 243
- BRUEGEL, PIETER, 157, 158, 216; Peasant Wedding, 216; 272; Return of the Hunters, 157; 194
- Burin, 273–74 BUSCEMA SAL 38: Defenders 38
- BUSCEMA, SAL, 38; Defenders, 38; 38
- Byron, Lord, 229
- Byzantium, 43-45
- Caesar, Julius, 45
- Calder, Alexander, 255
- CALLICRATES, 298; Parthenon, Athèns, 357
- CAMPIN, ROBERT, 172–74, 175, 203, 259; Mérode Altarpiece, 172–74, 259; 208, 247
- CANALETTO, ANTONIO, 155, 156–57; Santa Maria della Salute, Venice, 155, 156–57; 192
- CANIFF, MILTON, 86, 139, 203; Steve Canyon, 109, 245
- Cantilever construction, 309
- Canvas, preparation of, 261
- Capitalism, 48, 224
- CARAVAGGIO, 86, 88, 92, 107, 124, 166, 250; Christ at Emmaus, 86, 107, 124; 114, 148; follower of, 88; Feast, 88; 115
- Card Players (Léger), 99, 253; 132, 318
- Cartoon (preparatory drawing), 258
- Cartoons (comic strips), 19, 229; illustrations, 22, 23, 31, 32, 33, 34, 35, 38, 39, 70, 71, 72, 109, 110, 111, 138, 196, 216, 217, 218, 219, 220, 221, 222, 240
- CASSATT, MARY, 233; Toilette, 292
- CÉZANNE, PAUL, 162–64, 185–88, 234–36, 239, 253; Basket of Apples, 185–88, 236; 227, 296; Basket of Apples, scheme of, 228; Mont Saint-Victoire, 162–64, 236; 201, 295

- Chagall, Marc, 255
- CHARDIN, JEAN-BAPTISTE-SIMÉON, 99, 224, 225; Still Life: The Kitchen Table, 99; 135; Still Life: The Kitchen Table, scheme of, 134
- Chevreul, Michel, 130
- Chiaroscuro, 84–99, 111, 124, 125, 126, 134, 136, 201
- Chinese art, 86
- Chirico, Giorgio de, 255
- *Christ at Emmaus* (Caravaggio), 86, 107, 124; *114*, *148*; (Rembrandt; 1628–30), 23, 49, 53; *11, 55*; (Rembrandt; 1648), 217; *273*
- Christina's World (Wyeth), 258, 269; 321
- CIMABUE, 45-46, 53, 97, 190-92, 141-43; Madonna Enthroned, 46, 141-43, 190, 192; 49, 131, 167, 231
- *Cire-perdue* (lost-wax) casting, 292, 294; diagram, 354
- City planning, 310-14
- Clark, Kenneth, 72
- Classicism, 164, 224, 226, 227, 234
- Clay (in sculpture), 289-90
- Clerestory, 302
- Collage, 273
- Collagraphy, 272-73
- Colonial Cubism (Davis), 178; 213
- Color, 56, 110-33, 256; emotional effects of, 131-32
- Colorblindness, 79, 133
- Color prints, 272, 284-85; diagram, 334
- Color reproductions: method of, 286; magnified section of, colorplate 10
- Color wheel, 111; colorplate 1
- Colosseum, Rome, 300
- Complementary hues, 112, 117, 120, 130, 132
- Composition, formal, 167, 172–201
- Composition in White, Black, and Red (Mondrian), 63, 65, 134; 76, 159, 277, 301
- Concrete (in construction), 300; reinforced, 300
- CONSTABLE, JOHN, 158, 262, 263; Hay Wain, 158, 262, 263; 197, 324
- Constantine, 45; basilica of, Rome, 300 Constructivism, 239
- Convention (and image creation), 32-55, 136
- CORBEN, RICHARD, 102; Rowlf, 102; 138
- Corbusier, see Le Corbusier
- Corinthian order, 296
- COROT, JEAN-BAPTISTE-CAMILLE, 124, 160; Bridge and Castle of St. Angelo with the Cupola of St. Peter's, 124; 155, 199
- Counter Reformation, 67-68
- COURBET, GUSTAVE, 229, 231, 233; Stone Breakers, 229; 287
- Creation of Adam (Michelangelo), 92, 267; 121, 329

- Criticism (of art), 24
- CROSBY, PERCY, 35, 37; Skippy, 35-37; 33
- Cross-hatching, 94-95; diagram, 126
- Crown Hall, Illinois Institute of Technology, Chicago (Mies van der Rohe), 77
- Cubism, 164-66, 203, 224, 236, 238, 244
- Cypresses and Stars (Van Gogh), 195–96; 237
- Dadaism, 23, 247, 249
- DALI, SALVADOR, 92, 94, 221, 222, 249–50, 255; Apparition of a Face and Fruit Dish on a Beach, 92, 94, 221, 249; 123, 281, 314
- DAUMIER, HONORÉ, 102, 229, 231, 233, 279–80; Laundress, 102; 140, 288; Témoins, 279–80; 342
- David (Michelangelo), 189-90, 287, 289; 229
- DAVID, JACQUES-LOUIS, 226–27, 229, 233, 234; Oath of the Horati, 226; 284
- Da Vinci, see Leonardo
- DAVIS, STUART, 178; Colonial Cubism, 178; 213
- Dawn in the Train (Leighton), 86; 113
- Dead Christ (Mantegna), 153-54, 176; 190
- Death of Sardanapalus (Delacroix), 229; 286
- Deer in a Forest, II (Marc), 221, 244; 279, 311

DEGAS, EDGAR, 37, 38, 95, 97, 154–55, 156, 162, 203, 205, 233, 269–70, 275; Foyer of the Dance, 154–55; 191; Self-Portrait, 37, 38, 95, 97, 269–70, 275; 36, 127, 330; Tub, 250, 293

- DE KOONING, WILLEM, 196–98, 251; Woman and Bicycle, 197; 239
- DELACROIX, EUGÈNE, 158, 229, 263; Death of Sardanapalus, 229; 286
- Demoiselles d'Avignon (Picasso), 59, 299
- Demonstration of Perspective (Dürer), 145; 174
- Derain, André, 243
- Descent from the Cross: By Torchlight (Rembrandt), 99, 102, 275; 136
- Distemper, 257
- Divisionism, 130
- Dix, Otto, 253
- Dogana, San Giorgio Maggiore, le Zitelle from the Steps of the Europa (Turner), 96, 141, 198
- Domes, 300, 301
- Doric order, 296
- Drawing, 14, 35
- Drawing from a Cast (Picasso), 15
- Dream (Henri Rousseau), 88; 116
- Drypoint, 278
- Dubuffet, Jean, 255
- DUCHAMP, MARCEL, 247, 294; Bride Stripped Bare by Her Bachelors, Even, 247; 313; Fountain, 294
- Duchamp-Villon, Raymond, 255
- Dufy, Raoul, 243

 DÜRER, ALBRECHT, 145, 210, 212, 274; Adam and Eve, 210, 212, 274; 258, 336; Demonstration of Perspective, 145; 174; Self-Portrait, 270
 Dutch Masters and Cigars III (Rivers), 201; 242

Edition (in printmaking), 269, 270, 279

Einstein, Albert, 164

Elements of art, 56

Elevations (in mechanical drawing), 143; 171

Elgin marbles, 297

Ellington, Duke, 25

"Emperor's New Clothes" (Andersen), 25

Engraving process, 37, 273-75, 280; diagram, 337

Enlarging frame, 287

Ensor, James, 243

Entasis, 298

Enthroned Madonna with St. Liberalis and St. Francis (Giorgione), 265

Epoxy resin, 290

Etching process, 37, 269, 273, 275, 277, 278, 280; diagram, 340

Euclid, 176

- Exposure of Luxury (Bronzino), 171; 206
- Expressionism, 224, 243-45, 251, 253, 255

Eyck, Hubert van, 259

EYCK, JAN VAN, 80, 92, 105, 107, 109, 203, 259, 260; Giovanni Arnolfini and His Bride, 80, 83, 105, 106, 107, 109, 203, 259; 97, 145, 205

Eye level, 142, 220; in perspective, 145-53

Falling Water, Bear Run, Pa. (Wright), 309-11:373 Fall of Man and the Expulsion from the Garden of Eden (Michelangelo), 267 Fauvism, 224, 243, 245 Feast (follower of Caravaggio), 115 Feininger, Lyonel, 255 Ferro-concrete (reinforced concrete), 300 Feudalism, 224, 225 FINLAY, VIRGIL, 94-95; Untitled, 94-95; 124 Fit for Active Service (Grosz), 252; 317 Flags (Johns), 117, 120; colorplate 7 Flash Gordon (Raymond), 37, 203; 34, 246 Florence, Italy, 48 Folk art, 14 Form and content, relationship between, 167-75 FOSTER, HAROLD, 37, 181, 183; Prince Valiant, 37, 181, 183; 35, 220 Found sculpture, 294 Fountain (Duchamp), 294 Foyer of the Dance (Degas), 154-55; 191 FRAZETTA, FRANK, 183, 185; Howard, Conan,

cover illustration, 183, 185; 225

French Revolution, 224-27

Fresco painting, 267

Freud, Sigmund, 249, 250

Frontality (in painting), 162, 163-64

Frugal Repast (Picasso), 275; 16, 339

Fry, Roger, 162

FUCHS, BERNARD, 183; Sorenson, "Kennedy," illustration, 183; 224

Fugitive sensations, 117, 120, 127

FULLER, BUCKMINSTER, 311, 314; U.S. Pavilion, EXPO 67, Montreal, 311; *375;* Tokyo project, 311, 314

Funeral of St. Bonaventure (Zurbarán), 269

Futurism, 224, 253-54

GABO, NAUM, 239, 289; Linear Construction, Variation, 239, 289; 303

GALLO, FRANK, 290; Swimmer, 290; 351

Gauguin, Paul, 234, 243

- Geodesic domes, 311
- Georg Gisze (Holbein), 171, 192, 212-13; 207, 233, 260
- GÉRICAULT, THÉODORE, 102, 227–29; Raft of the "Medusa," 102, 227–29; 139, 285

Gesso, 258, 261

Giacometti, Alberto, 255

GIELLA, JOE: Flash, 38; 39

GIORGIONE, 71–72; Enthroned Madonna with St. Liberalis and St. Francis, 265; Sleeping Venus, 71–72; 86

GIOTTO, 46, 49, 141–43, 192; Madonna Enthroned, 46, 141–43, 192; 50, 168, 232

Giovanni Arnolfini and His Bride (Van Eyck), 80, 92, 105, 107, 109, 203, 259; 97, 145, 205, 248, 322

Girl Before a Mirror (Picasso), 112, 134, 136, 238; *164*; colorplate 4

Glazes (in oil painting), 259

Goethe, Johann Wolfgang von, 229

GOGH, VINCENT VAN, 78, 121, 132, 174–96, 234, 241–43, 262, 263; Cypresses and Stars, 195–96; 237; Night Café, 121, 132, 241; 153, 306; Starry Night, 78, 195–96, 241; 94, 236, 305

Gold (as symbol of immortality), 45

Golden section, 176-77; diagrams, 211, 212

Gombrich, E. H., 106

Gorky, Arshile, 251

Gothic art, 304-6

Gouache, 264

GOYA, FRANCISCO DE, 102; *Third of May, 1808,* 102; 137

Gravure process, 286

GRECO, EL (Domenico Theotocopoulos), 29, 95, 102; Resurrection, 95; 19

Green Lantern (Adams), 139; 166

Green Stripe (Madame Matisse) (Matisse), 307

Gris, Juan, 255

- GROSZ, GEORGE, 253; Fit for Active Service, 253; 317
- GRÜNEWALD, MATTHIAS, 20–21; Isenheim Altarpiece, 20–21; 10
- GUARDI, FRANCESCO, 155–56; Santa Maria della Salute, Venice, 155–56; 193

Guardian figure, from Bakota area, 236; 58, 300 Guggenheim Museum, New York (Wright), 311

Guggennenn Museum, New Tork (Wright), 511

- Habitat, EXPO 67, Montreal (Safdie), 313–14; 377
- Halftone process, 130-31, 285-86
- Halo (and artistic convention), 45, 46, 49, 53
- HANSON, DUANE, 190, 290; Tourists, 290; 230
- HARNETT, WILLIAM, 19, 105–6, 107, 109, 223; After the Hunt, 19, 105–6, 107, 109, 223; 5, 144
- HART AND HART, Nashville Parthenon, 298; 358
- Haystack at Sunset Near Giverny (Monet), 126, 127, 161–62; 200, 235, 249, 290; colorplate 9
- Hay Wain (Constable), 158, 262, 263; 195, 324
- Head of a Young Girl (Vermeer), 88, 91, 92; 117
- Helmholtz, Hermann von, 127, 160-61, 162
- Hermes and Dionysus (Praxiteles), 71, 287, 289; 83
- HERRIMAN, GEORGE, 181, 183; Krazy Kat, 181; 219
- Highlight, 91; diagram, 120
- HOGARTH, BURNE, 59, 62, 65, 181, 183, 185; *Tarzan*, 59, 62, 181; 72, 217
- HOGARTH, WILLIAM, 136, 139; "Kirby's Perspective," frontispiece, 136, 139; 165
- HOLBEIN, HANS, 171, 192, 212–13; Georg Gisze, 171, 192, 212–13; 207, 233, 260
- HOLDEN, MARTHA, 294; Miss America, 294; 355
- HOMER, WINSLOW, 265–66; Hurricane, the Bahamas, 265–66; 327
- HOOCH, PIETER DE: Woman and Her Maid in a Courtyard, 266
- Horizon line (in perspective), 145-48
- HOWARD, E. R., 183, 185; *Conan*, Frazetta cover illustration, 183, 185; *225*
- Hue, 110, 111-12, 122, 124, 131-32, 162-63
- Hurricane, the Bahamas (Homer), 265-66; 327
- Iconography, 173, 205
- ICTINUS, 298; Parthenon, Athens, 357
- Impasto, 263
- Impressionism (in printmaking), 270, 279
- Impressionism, 129, 130, 160–62, 164, 203, 224, 231–35, 243, 263
- Improvisation Number 30 (Kandinsky), 25, 31, 221, 243; 17, 278, 309
- Indestructible Object (Object to be Destroyed) (Ray), 23, 247, 294; 12, 312
- INFANTINO, CARMEN: Flash, 38; 39

- Intaglio printmaking, 273–79, 280, 282, 286; diagrams, 337, 340, 341
- Intensity (of color), 110, 115–17, 122, 124, 126, 130
- Interior decoration, 132
- International Style of architecture, 306
- Into the World Came a Soul Called Ida (Albright), 92; 122
- Ionic order, 296
- Isenheim Altarpiece (Grünewald), 20-21; 10
- Jeanneret, Charles, see Le Corbusier
- JENKINS, PAUL, 264; Phenomena Point Swing and Flank, 264; 326
- JOHNS, JASPER, 117–20, 254; *Flags*, 117–20; colorplate 7
- JONES, JEFF, 86; Alien, 86; 111
- Joseph the Carpenter (La Tour), 83; 102
- Justinian and Attendants, 43-45; 48
- KANDINSKY, WASSILY, 25, 31, 76, 221, 222, 223, 243, 251, 260; *Improvisation Number 30*, 25, 31, 221, 243; 17, 278, 309; Sunday in Old Russia, 25; 18
- Karp, Ivan, 190

KELLY, WALT, 181, 183; Pogo, 181, 203; 218, 244

- Key (in dark and light), 105, 109, 124; diagram, *143* KIENHOLZ, EDWARD, 19, 254, 294; *Back Seat*,
- Dodge '38, 19, 294; 6
- "Kirby's Perspective": Hogarth frontispiece, 136, 139; 165
- KIRCHNER, ERNST LUDWIG, 221, 243; Street, 221; 280, 308
- KLEE, PAUL, 244, 250, 255; Twittering Machine, 244; 310
- Kokoschka, Oskar, 255
- Krazy Kat (Herriman), 181; 219
- Landscape with Bridge and Willows (Ma Yuan), 86; 112
- Last Supper (Leonardo da Vinci), 66–67, 78, 151, 153, 207, 209–10; 78, 188, 256; diagram, 79; (Nolde), 112; colorplate 3; (Tintoretto), 67–68, 78, 112, 209–10; 54, 80, 189, 257
- LA TOUR, GEORGES DE, 83; Joseph the Carpenter, 83; 102
- Laundress (Daumier) 102; 140, 288
- Lawrence, D. H., 236; Women in Love, 236
- LE CORBUSIER, 309–11; Chandigarh, India, 311; Villa Savoye, 310; *374*
- LÉGER, FERNAND, 97, 99, 253; Card Players, 99, 253; 132, 318
- LEIGHTON, CLARE: Dawn in the Train, 113
- LEONARDO DA VINCI, 14, 66–67, 78, 151, 153, 196, 207, 209–10; Last Supper, 66–67, 78, 151,

153, 207, 209-10; 78, 188, 256; diagram, 79; Mona Lisa, 14, 196; 238

Letterpress process, 285–86

- LICHTENSTEIN, ROY, 19, 198–201, 254; Brattata, 19, 198–201; 8, 241
- LINDNER, RICHARD, 76; 119th Division, 76; 92
- Light and shade, 80–109, 110, 124, 143; diagrams, 98, 101, 105, 106, 107, 108, 118, 119, 120, 125, 126, 130, 133, 134, 143, 146
- Light theory, 111
- Line, 56–79, 201
- Linear Construction, Variation (Gabo), 239, 289; 303
- Linecuts, 285, 286
- Lipchitz, Jacques, 255
- Lithography, 269, 273, 279–82; diagrams, *343, 344* Local color, 127–29
- Loops and Swift Horses Are Surer than Lead (Russell), 62–63; 75
- LORRAIN, CLAUDE, 134, 136, 157, 224; Marriage of Isaac and Rebekah, 134, 136, 157; 163, 195
- Lost-wax (cire-perdue) casting, 292, 294; diagram, 354
- Lovesick Maiden (Steen), 271
- Madonna Enthroned (Cimabue), 46, 141–43, 190, 192; 49, 131, 167, 231; (Giotto), 46, 141–43, 192; 50, 168, 232
- Madonna of the Beautiful Garden (Raphael), 49, 58–59, 192, 194, 223; 53, 68, 234; diagram of movements in, 73
- Madonna of the Pomegranate (Botticelli), 49, 258; 52 Magritte, René, 250
- Ma Jolie (Picasso), 25, 164, 166, 236; 13, 202, 251, 298
- Male half figure, from Ife, 60
- MALEVICH, KASIMIR, 238–39, 255; Suprematist Composition: White on White, 238–39; 302
- MANET, EDOUARD, 71, 74–76, 97, 109, 124–26, 162, 223, 231, 233; Olympia, 75–76, 97, 109, 124–25, 162, 231; 89, 91, 129, 151, 156, 289
- Mannerist architecture, 306
- MANTEGNA, ANDREA, 153-54, 176; Dead Christ, 153-54, 176; 190
- Man with a Guitar (Braque), 252
- Maoris, 53
- Maquette, 287
- MARC, FRANZ, 221, 222, 244–45; Deer in a Forest II, 221, 244; 279, 311
- Marin Island, Maine (Marin), 267; 328
- MARIN, JOHN, 267; *Marin Island, Maine*, 267; *328* Marinetti, Filippo, 253
- Marriage of Isaac and Rebekah (Lorrain), 134, 136, 157; 163, 195

- Marriage of the Virgin (Perugino), 217-21; 275; (Raphael), 217-21; 276
- MASACCIO, 46, 49, 107, 109, 143, 151, 153; *Tribute Money*, 46, 49, 109, 143, 153; *51, 147, 170* Mass communications, 256
- Masson, André, 251
- MASTER OF FLÉMALLE, see Campin
- MATISSE, HENRI, 243, 255; Green Stripe (Madame Matisse), 307
- Matta (Roberto Matta Echaurren), 251
- Matting (of prints), 279
- Maximianus, 45
- Maxor of Cirod (Richardson), 157; 196
- MA YUAN, Landscape with Bridge and Willows, 86; 112
- Media, 256–314; architecture, 294–314; painting, 257–67; photomechanical reproduction, 285–86; printmaking, 268–85; sculpture, 286–94
- Medici family, 48-49, 169, 224
- Mérode Altarpiece (Campin), 172–74, 259; 208, 247 METSYS, QUENTIN: Money Changer and His Wife,
- 268 MICHELANGELO, 37–38, 69, 92, 189–90, 267, 287–288: Avenging Angel 37–38: 37: Creation of
- 287, 288; Avenging Angel, 37–38; 37; Creation of Adam, 92, 267; 121, 329; David, 189–90, 287, 289; 229; Fall of Man and the Expulsion from the Garden of Eden, 267
- Middle Ages, 31, 40-46, 71, 229, 295, 301-6
- Middle class: Renaissance, influence on, 47–49, 53; artistic taste, influence on, 224–25
- MIES VAN DER ROHE, LUDWIG, 63, 306; Crown Hall, Illinois Institute of Technology, Chicago, 77; Seagram Building, New York, 306, 309: 372
- Minimal art, 224, 239
- MIRÓ, JOAN, 221–22, 251; Person Throwing a Stone at a Bird, 222, 251; 282, 315
- Mirror images, 34
- Miss America (Holden), 294; 355
- Model building, 19
- Modeling (in light and shade), 84-99
- Modern art, 75-76, 125, 205, 221-22, 223-55
- Modigliani, Amedeo, 255
- Mona Lisa (Leonardo da Vinci), 14, 196; 238
- MONDRIAN, PIET, 63, 65, 66, 134, 221, 222, 223, 238, 239, 255, 260; Composition in White, Black, and Red, 63, 65, 134; 76, 159, 277, 301
- MONET, CLAUDE, 126–29, 160–62, 194–95, 203, 205, 231, 233, 257, 260, 262, 263; *Haystack at Sunset Near Giverny*, 126, 127, 161–62; 200, 235, 249, 290; colorplate 9
- Money Changer and His Wife (Metsys), 268
- Mont Saint-Victoire (Cézanne), 162-64, 236; 201, 295

Mood: light and dark and, 99, 102; line and form and, 77-79 Moore, Henry, 255 MORISOT, BERTHE, 233; Woman at Her Toilet, 291 Motion, techniques for representing, 37-40 Mouches volantes, 127 Moulin de la Galette (Renoir), 20; 9, 294 Munch, Edvard, 243 Murals, 267 Music and art, 25, 29, 31, 56, 83, 88 Narses, 43 Nashville Parthenon (Hart and Hart), 298; 358 NELSON, ROBERT, 282; "Wagner," 345 Neoclassicism, 224-27, 229, 306 Neoimpressionism, 130-31, 224 Neoplasticism, 224, 238, 239 NEVELSON, LOUISE, 290; Sky Cathedral, 352 New Objectivity (Neue Sachlichkeit), 253, 254 Nicholson, Ben, 255 Night Cafe (Van Gogh), 121, 132, 241; 153, 306 NOLDE, EMIL, 112, 243; Last Supper, 112; colorplate 3 Notre Dame, Paris, 304, 306; 368, 369; nave, 371; transverse section. 370 Nude (Brandt), 34-35; 28; (Weston), 68-69; 81 Nymphs and Satyr (Bouguereau), 74; 88 Oath of the Horatii (David), 226; 284 Offset lithography, 286 Oil painting, 120-22, 196, 259-63, 264 Olympia (Manet), 75–76, 97, 109, 124–25, 162, 231; 89, 91, 129, 151, 156, 289 119th Division (Lindner), 76; 92 Op art, 131, 239 Optical color, 127-29 Optical mixing of colors, 130–31 Orange and Yellow (Rothko), 59, 112; 61; colorplate 2 Orders (of Classical architecture), 296; diagram, 356 Ostensive definition, 22 Othello, 171-72 Overlapping (and spatial order), 136 Painting media, 257-67 Paints, tube, 263 Paleolithic stone carving, 288 Panofsky, Erwin, 14, 173 Pantheon, Rome, 300; 360 Paolozzi, Eduardo, 255

Parthenon, Athens (Ictinus and Callicrates), 296–98; 357 Pascal, Blaise, 227 Peanuts (Schulz), 35, 179, 181, 203; 216, 243

Peasant Wedding (Bruegel), 216; 272

Penumbra, 91; diagram, 120

Person Throwing a Stone at a Bird (Miró), 222, 251; 282, 315

- Perspective: atmospheric, 156–60, 162; of color, 162–63; empirical, 154–55; scientific, 143, 144–56, 162, 176, 187, 220; diagrams, *175, 176, 177, 178, 179, 180, 181, 182, 183, 184, 185, 186, 187*
- PERUGINO, 217–21; Marriage of the Virgin, 217–21; 275

Pevsner, Anton, 255

Phenomena Point Swing and Flank (Jenkins), 264; 326

- Photography: and convention, 39, 53; distortion in, 34; color, 117, 126; light and shade and, 80, 83, 92; line and form and, 68, 69; and perspective, 143, 145, 150–51; photomechanical reproduction, 285, 286
- PICASSO, PABLO, 13, 25, 72, 76, 112, 134, 136, 164, 166, 188–89, 203, 205, 236, 238, 243, 275; Demoiselles d'Avignon, 236; 59, 299; Drawing from a Cast, 15; Frugal Repast, 275; 16, 339; Girl Before a Mirror, 112, 134, 136, 238; 164; colorplate 4; Ma Jolie, 25, 164, 166, 236; 13, 202, 251, 298
- Picture plane, 134, 136
- Pigments, 80, 110, 120–22, 125, 257, 259, 263, 265, 267; chemical, 263; manufacture of, 121; permanence of, 121–22
- Pilgrimage to Cythera (Watteau), 283
- Pissarro, Lucien, 130
- Planographic printing, 279-82, 286
- Playboy nudes, 69
- Pogo (Kelly), 181, 203; 218, 244
- Pointillism, 130
- Pointing machine, 287
- POLLOCK, JACKSON, 251–53; Autumn Rhythm, 251–53; 316
- Polymer paints, 263, 264
- Pop art, 198, 254
- Porter, Cole, 25
- Portraiture, 196
- Post-and-lintel construction, 297
- Postimpressionism, 234, 263
- POUSSIN, NICOLAS, 226; Rape of the Sabine Women, 263
- PRAXITELES, 69, 71, 287, 288; Aphrodite of Knidos, 69, 71; 82; Hermes and Dionysus, 71, 287, 289; 83
- Primary hues, 112
- Primary structures, 239
- Prince Valiant (Foster), 37, 181, 183; 35, 220
- Printmaking, 268-85
- Projections: geometric, 143–44; cabinet, 143–44; *172*; central, 144–45; isometric, 144; *173*

346 | ART: THE WAY IT IS